9/3/98

55

DATE DUE

Picasso
and Photography

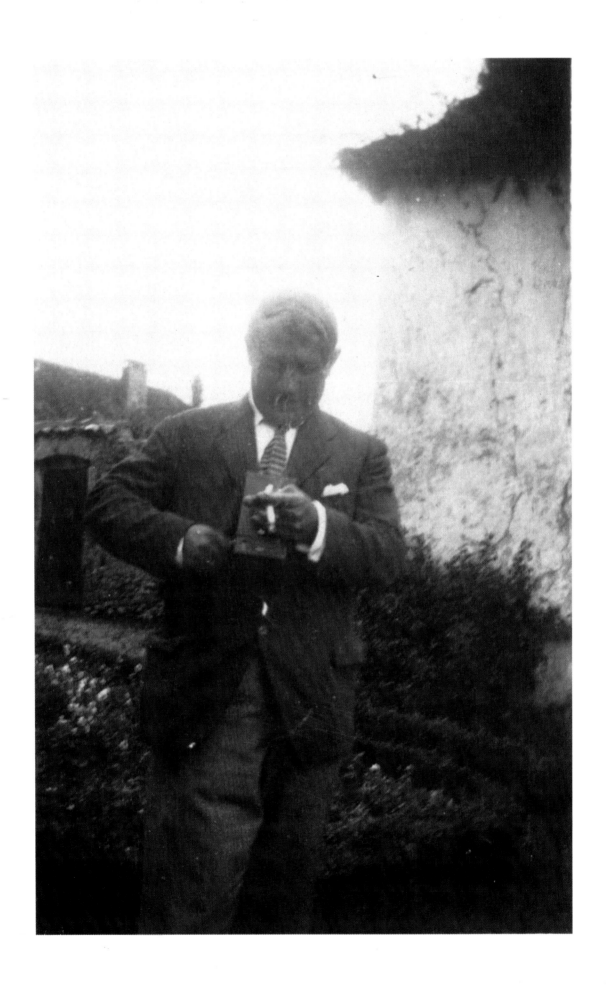

Picasso
and Photography

THE DARK MIRROR

Anne Baldassari

translated from the French by Deke Dusinberre

Flammarion

The Museum of Fine Arts, Houston

The present volume is based on three exhibition catalogues written
by Anne Baldassari, curator at the Musée National Picasso, Paris
and published by the RMN: *Picasso Photographe 1901–1916* (1994),
"À Plus Grande Vitesse que les Images": Picasso et la Photographie (1995),
and *Le Miroir Noir: Picasso, Sources Photographiques, 1900–1928* (1997)

Flammarion
26, rue Racine
75006 Paris

Website: www. flammarion.com

ISBN: 2-08013-646-1 (hardback)
ISBN: 2-08013-649-6 (paperback)
Numéros d'édition:
FA 364602 (hardback)
FA 364903 (paperback)

frontispiece
Fig. 1
[Gertrude Stein]
Portrait of Pablo Picasso
Bilignin, 1931–1932
Gelatin silver print
2 3/4 x 2 in (7 x 5 cm)
APPH 2824
Picasso Archives,
Musée Picasso, Paris

Library of Congress Cataloging-in-Publication Data

Baldassari, Anne.
 Picasso and photography : the dark mirror / Anne Baldassari ;
translated by Deke Dusinberre.
 p. cm.
 Catalog of a traveling exhibition first held at the Museum of Fine
Arts, Houston, Nov. 16, 1997-Feb. 1, 1998; subsequently held at
various European museums.
 Based on three exhibition catalogs written by the author : Picasso
photographe (1994), Picasso et la photographie (1995), and Le miroir
noir (1997) .
 Translated from the French.
 Includes bibliographic references.
 ISBN 2-08-013646-1 (hc). — ISBN 2-08-013649-6 (pbk.)
 1. Photography, Artistic—Exhibitions. 2. Picasso, Pablo,
1881-1973—Exhibitions. I. Picasso, Pablo, 1881-1973. II. Museum
of Fine Arts, Houston. III. Title.
TR647.P512 1997
779 .092—dc21 97-34000

The attributions, dates and locations appearing in square brackets
remain uncertain or are the subject of debate.
For postcards, the proposed date is that of publication
and in certain cases, the publisher is also the photographer.

Abbreviations Used in Captions

MP: Musée Picasso, Paris, inventory number
APPH: Archives Picasso, Musée Picasso, Paris, photograph inventory number
FPPH: Fonds Penrose Photographie, Paris, inventory number.

Acknowledgments

This volume on Picasso's relationship to photography stemmed
from research into the artist's personal archives in preparation for three
exhibitions organized by the Musée Picasso in Paris: *Picasso
Photographe, 1901–1916* (1994), *"À Plus Grande Vitesse que les Images":
Picasso et la Photographie* (1995), and *Le Miroir Noir: Picasso,
Sources Photographiques, 1900–1928* (1997).

A traveling exhibition presenting the major features of that cycle
opens at The Museum of Fine Arts, Houston (16 November, 1997 –
1 February, 1998), and will be shown at the Fotomuseum of the Munich
Stadtmuseum (Spring 1998).

I would like to express my gratitude to Gérard Régnier, director of
the Musée Picasso, for his unflagging support for this project right from
the start. I also benefited from the helpful cooperation of my fellow
curators Hélène Seckel and Brigitte Léal, and from the efficient research
assistance provided by Jeanne-Yvette Sudour, Ivan de Monbrison,
and the museum's documentation department. I would also like to thank
Françoise Cachin, director of the Musées de France, and Irène Bizot,
executor director of the Réunion des Musées Nationaux, who—along
with their staffs—made the three Paris exhibitions and accompanying
catalogues possible. A project of this scope would never have come to
fruition without the cooperation and trust of Sidney and Claude Picasso,
Marina Picasso, Catherine Hutin-Blay, and Bernard Picasso, to whom
I extend my heartfelt thanks. The reception that William Rubin has given
my publications from the beginning has also been a source of encouragement,
for which I would like to express my gratitude.
This research benefited from irreplaceable, unpublished information
from Dora Maar, Maya Widmaier-Picasso, Javier Vilato, André Villers
and André Verdet and from the valuable cooperation of Brigitte Baer,
Véronique Balu, Marie-Laure Bernadac, Laurence Berthon,
Gilberte Brassaï, Anne-Cartier Bresson, Heinz Berggruen, Richard Checani,
Inès Clouzot, Ynes Cramer, Pierre Daix, Philippe David, Francine Dawans,
Roland Doschka, David D. Duncan, Evelyne Ferlay, Yves de Fontbrune,
Pierre Georgel, Martine Gréciet, Jean Jamin, Claudine Jusuf, Jan Krugier,
Quentin Laurens, Paule Mazouet, Dominique de Ménil, Jérôme Monnier,
Hanna Nelson, Maria Teresa Ocaña, Pace McGill Gallery, Joseph Palau i Fabre,
Christian Phéline, Lionel Prejger, William Robinson, Alan Schestack,
Werner Spies, Elizabeth Taylor, Harlow Tighe, Xavier Vilato, Jeanine Warnod,
Richard V. West, Patricia Willis.

Thanks also to Anne Tucker, curator of photography at The Museum
of Fine Arts in Houston, and to Peter C. Marzio, Director of that same
institution, as well as to Dr. Ulrich Pohlmann, director of the Fotomuseum
of the Munich Stadtmuseum, for the sustained attention they have all
brought to bear on my research and for the enthusiasm they showed
in organizing this international exhibition.

Finally, at the initiative of Suzanne Tise, the commitment of two
publishing houses—Flammarion and Schirmer Mosel—has played
a decisive role in producing English and German editions of this volume.
I would like to acknowledge the remarkable work of Deke Dusinberre,
Alexandra Keens, Sheila Schwartz in producing the English text,
and Claudia Rudeck and Thomas Wollermann in preparing the German
version, as well as Bernard Lagacé from the Compagnie Bernard Baissait
for the graphic design.

Anne Baldassari, August 1997.

Translator's Note on Titles

Picasso rarely assigned specific titles to his innumerable art works, a task
he left to critics, biographers, collectors, and cataloguers like Christian
Zervos, Pierre Daix, and others. The standard title for any given work
is therefore often a question of convention (scholars avoid confusion
by systematically citing an inventory number, as Anne Baldassari has
done here). And since convention is rarely the same from one country
to another, French titles cannot always be rendered directly into English;
instead, the translator has to try to establish the local title most commonly
employed for each work. Thanks therefore go to Pierre Daix for making
my job much easier by supplying many English titles for works up to 1916,
as well as to Alexandra Keens for tracking down other titles and details.

Contents

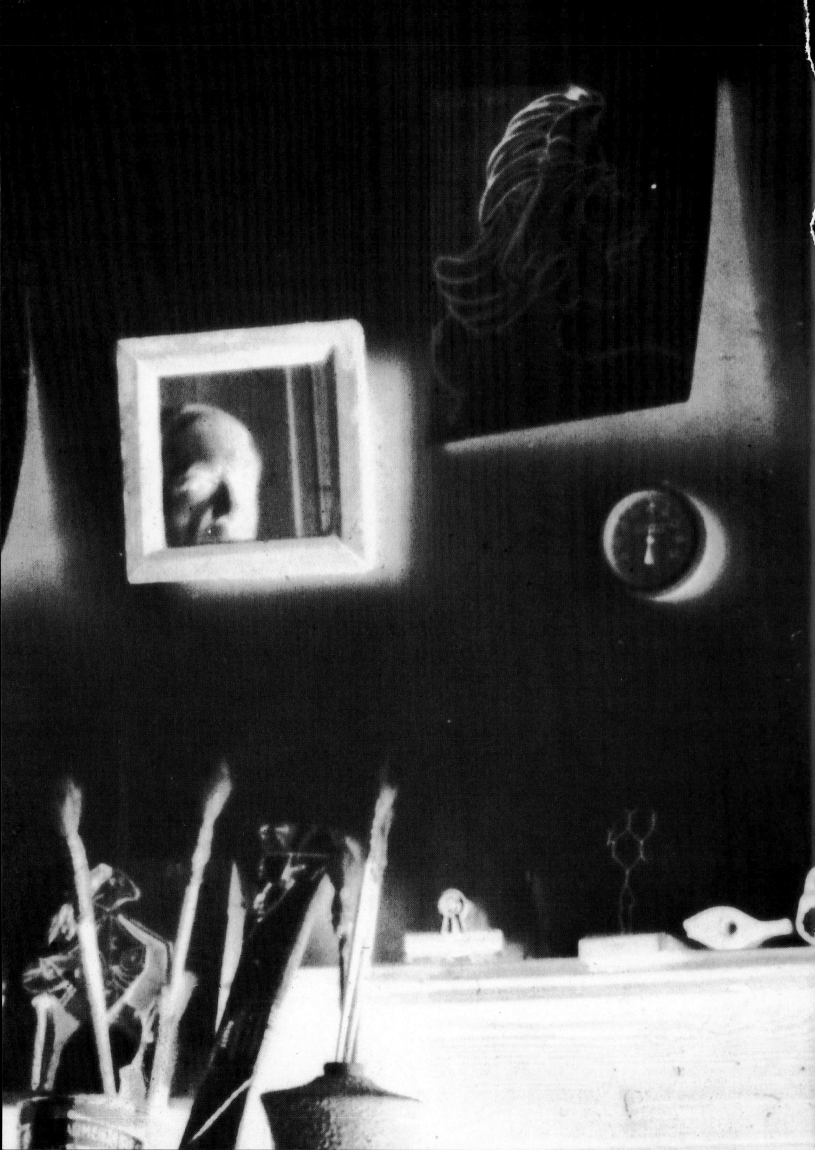

"I'd like to get to the point where no one can see how my painting has been done."[1]

"It's not enough to know the works by an artist, you also have to know when he did them, why, how, under what circumstances. Some day there'll be a science . . . that deals with human creativity I often think of this knowledge, and I want to leave as complete a record as possible for posterity."[2]

These two statements by Pablo Picasso are contradictory only at first glance. Just as Picasso took care to see that each of his works distilled the essence of its meaning, he also carefully bequeathed vestiges and material to history so that those works could be deciphered. Indeed, it was the presence in Picasso's estate of several thousand photographic images of all kinds that prompted this study.[3] Close examination slowly convinced me of the existence of a solid link between many of these photographs and Picasso's creative process. The most urgent task entailed identifying the corpus of roughly one hundred negatives and prints predating the 1920s, which should henceforth be considered as Picasso's own work.[4] This body of work testifies to Picasso's steady use of photography as early as the turn of the century, and to the various roles he assigned it: a record of work in progress, a document of ephemeral experiments, a visual tool of plastic inventiveness, and so on.

Some of these images were published back in the 1950s by Picasso's friends, such as Christian Zervos,[5] Jaime Sabartés,[6] and Roland Penrose.[7] Their largely documentary function, however, did not indicate the full role played by photography in Picasso's oeuvre.[8] And although access to his personal archives led to the publication of previously unknown photos,[9] commentary on Picasso's relationship to photography remained highly fragmentary.

The standard approach is to consider a photograph as the *source* of a painting. Specialists in the relationship of photography to painting have documented a number of such cases in Picasso's oeuvre, although postdate to 1917.[10] Similarly, Picasso experts—referring to six works from the years 1917–1919 listed in Christian Zervos's catalogue raisonné,[11] plus several other known examples—generally consider such use of photographs to be a circumstantial detour specifically related to the period in Picasso's work described as a "recall to order."[12] The art of that period—which initially appears to be more figurative—has been variously labeled "Neoclassical," "Ingresque,"[13] and "photographic." Roland Penrose's Surrealist background did, however, enable him to perceive that "the sublime owes its life to the commonplace."[14] He was therefore the first to stress the metamorphosis that occurred in drawing when Picasso tried to "make copies of photographs and picture-postcards that he picked up by chance," and he

recognized that the large paintings of nudes in the 1920s were indebted to "naive retouching and tinting seen in the enlargements of cheap photographs."[15] Yet apart from such passing comments, Picasso's use of photographs has too often been reduced to a tautological proof of "resemblance" between a final work and a source image, which obviously overlooks not only the epistemological gap between photography and drawing or painting but also the paradoxes specific to this kind of exchange between media.[16] Picasso's 1923 oil *Paulo on a Donkey* (fig. 2),[17] for instance, certainly constitutes the most emblematic example of a painting known to have been "based on a photograph" (fig. 3). Even this straightforward translation nevertheless demonstrates how Picasso reinterprets the proportions of his subject, wrenches it from the contingencies of time and place, and creates a kind of pictographic icon. Painted so that his young son could understand it, the canvas specifies each of its parts in a special language—the sky is blue, grass is green and grassy, the path is earthen, the animal is furry, the lad has pink cheeks and wears dazzling clothes. Picasso thereby underscores the irreducible heterogeneity of the two images: a snapshot record of light and shadow versus the elaborate arrangement of line and color.[18]

More important, it is now known that Picasso kept a great many nineteenth-century photographic portraits and postcards featuring ethnic groups and regional dress. They were stored along with press photos, family portraits, advertising and scientific pictures, etc. Little by little, as this highly disparate collection was inventoried, correspondences emerged between certain photos and Picasso's painted, drawn, and even sculpted works. It now is apparent that he employed photographic imagery as material or as a catalyst for highly diverse pictorial projects.

Thus the more fundamental question of Picasso's relationship to such material has arisen. What, for example, did his eye see in all those nineteenth-century *carte-de-visite* photographs, of which a thousand examples were found in his estate?[19] They probably offered an inventory of poses, gestures, and gazes that enabled Picasso to study—*in vivo*, and at a level somewhere between the individual and the generic—exactly what holds a body in an image. Whereas other artists of his generation were interested in the scientific dissection of human motion, as pursued by Étienne-Jules Marey and Eadweard Muybridge,

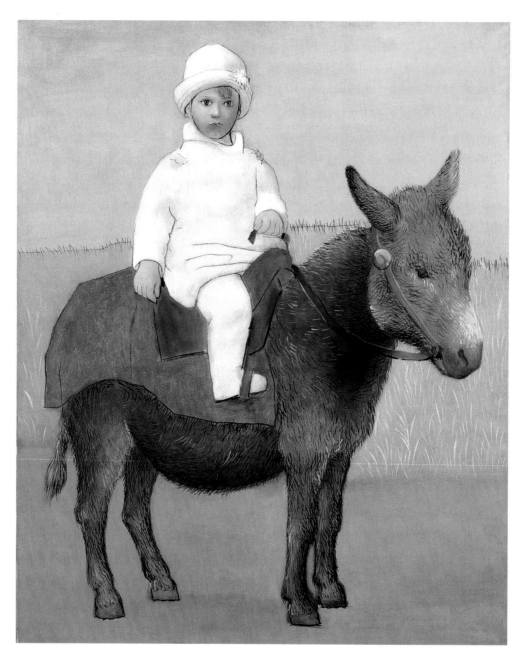

Fig. 2
Pablo Picasso
Paulo on a Donkey
Paris, 1923
Oil on canvas
39 ³/₈ x 31 ⁷/₈ in (100 x 81 cm)
Private collection

Fig. 3
Anonymous
Paulo Picasso in a Public Park
1923
Gelatin silver print
4 ¹/₈ x 6 ¹/₂ in (10.5 x 16.5 cm)
FPPH 42
Gift of Sir Roland Penrose
Picasso Archives,
Musée Picasso, Paris

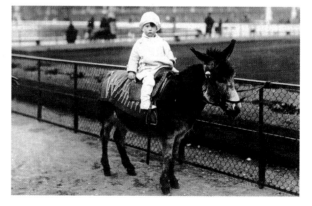

Picasso was drawn to the way these outmoded compositions wove the living and the artificial into a complicated motif placed before a painted backdrop. The bourgeois *mise-en-scène* of these poses leaps to the eye, naive in its solemnities and expressions, commonplace in its domestic universe of armchairs, consoles, and pedestal tables. People, along with their furnishings, are shown as beings "thingified" by the camera, and thereby acquire the troubling permanence that a camera confers on all its subjects. Almost through inertia, a prosaic "realism" comes to contest the historicist or exotic sophistication that beaux-arts academicism expected of photography. In Picasso's eyes, these photos perhaps prefigured the advent of an "everyman," of a body desublimated by anonymity and collectiveness. The standardized format, staging, lighting, and poses used for this photographic record constitute a material representation of social history. And starting with the Blue period, Picasso's painting periodically acknowledged its debt to the constant features of that standard representational idiom—monochromatic hues, a minimal illusion of depth, and codified poses.

Picasso's archives also contained a great number of pre-1914 postcards, usually of one or two people in regional dress. An unusual process of visual inventiveness sprang from these ceremonial garments, where sculptural headgear rises in pleated scaffoldings stranger than the most fantastic Surrealist montages, and where a calligraphy of lace, embroidery, and fabric design weaves countless variations, like oral culture, on the framework of a shared pattern. The effect was further reinforced by photos that were hand-colored and embroidered to give peasants, actresses, and matadors the finery of icons.[20] This is where Picasso gleaned images of a popular culture that charmed him by its virulence, naiveté, and absence of prohibitions. His companion, Fernande Olivier, has mentioned how he had an early "mania for collecting all kinds of little things," such as glass trinkets, rustic pottery, and "gaudy colorprints in frames of plaited straw."[21] As Picasso himself admitted in 1923, "I liked the pretty fairground images, the hairdos, and the milliners' dummy heads. And I still hunger after unusual or charming objects."[22] With Picasso, however, it went beyond a Surrealist taste for "found objects," just as his interest in photographs of "ethnic types" was more than picturesque: "I hasten to add that I hate exoticism."[23] Colonial imagery—albumen prints of Egyptian women from the 1860s–1880s (figs. 35, 36, 38, 207), *carte-de-visite* prints of Oceanic subjects (fig. 65), and a series of postcards devoted to French West Africa (figs. 44, 48, 49, 51, 52, 56, 57, 70)—offered pictures in which natives seem to stare out at the distant spectator who stares back in implacable otherness. The hieratic, if reticent, quality of the subjects, their physical and cultural compactness, and their store of poses, accouterments, and finery would provide Picasso with an original syntax for

depicting the body at several critical moments in his career. Here again, it was paradoxically the distance separating the artist from his models and the repetitive codification of images that offered the eye an apprenticeship in modernity. This modernity did not entail broadening the limits of perceptual experience—as suggested, in a sometimes anecdotal manner, by Futurist painting (to see higher, farther, faster)—but, to the contrary and more simply, it meant a full visual awareness of the new body of images invented by the camera, the proliferating corpus in which individuals from all races and all classes were delivered, in turn, to the gaze. "Photographic realism" is indissociable from a material existence, from a "photographic reality" that reduces a sitter's existence to the chemical substrate of interchangeable photographic plates. The corpus of images thus naturally organized itself into sets or series and, as will be shown below, it was photography's serial effects that usually spurred Picasso's visual inventiveness.

Picasso was also attracted to the specific resources offered by the medium of photography, and his various experiments on the borders of photography, drawing, and engraving found early public expression. In 1937 Man Ray paid tribute to "Picasso the photographer" in a preface to a *Cahiers d'Art* publication of a portfolio of portraits based on Dora Maar. "Yes, like every painter, you've taken photographs," wrote Man Ray, "but with your own eyes and your own hands, not with borrowed cameras. You even thought up the subject."[24] Man Ray was referring to works that paradoxically exploit the resources of the photographic medium while dispensing with its key components—camera, lens, and even negative—since, as will be discussed below, everything was produced by painting on glass plates or from direct contact with light-sensitive paper (figs. 236, 237, 239). Picasso was thereby exploring an approach similar to the photogram technique.[25] It would become, to use Tristan Tzara's phrase, "photography in reverse,"[26] because it went against the ordinary procedure—exposure, development, printing—by moving *from* the support *toward* the vision. Many other examples could be listed, in fact, right up to the late 1960s, in which Picasso submitted the photographic medium to the most inventive of mixed techniques by cutting out negatives, drawing on photos, using plates as a support for engravings, and so on.

Picasso's astonishing knowledge of the chemistry of light nevertheless went back much further in his oeuvre. As early as June 1914, Marius de Zayas told Alfred Stieglitz of a long conversation he had with Picasso in Paris. "The sum and total of his talk was that he confesses that he has absolutely enter[ed] the field of photography."[27] Gertrude Stein, who witnessed the birth of cubism, more specifically referred to the photographic landscapes that Picasso took at Horta de Ebro in 1909 (figs. 91, 93, 94)[28] and the still life of assembled objects dating from 1911.[29] She would even suggest in 1928 that the review *Transition*

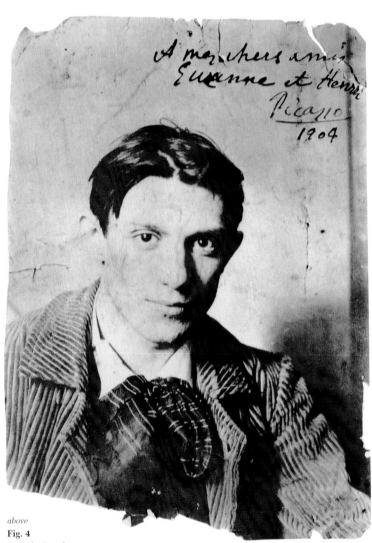

above
Fig. 4
Ricardo Canals
Portrait of Pablo Picasso
Paris, 1904
Gelatin silver print
6 ¼ x 4 ½ in (16 x 11.5 cm)
FPPH 130
Gift of Sir Roland Penrose
Picasso Archives, Musée Picasso, Paris

right
Fig. 5
Pablo Picasso
Portrait of Ricardo Canals
Paris, 1904
Gelatin silver print
Autograph annotation on back
6 x 4 ¼ in (15.3 x 10.7 cm)
APPH 2802
Picasso Archives, Musée Picasso, Paris

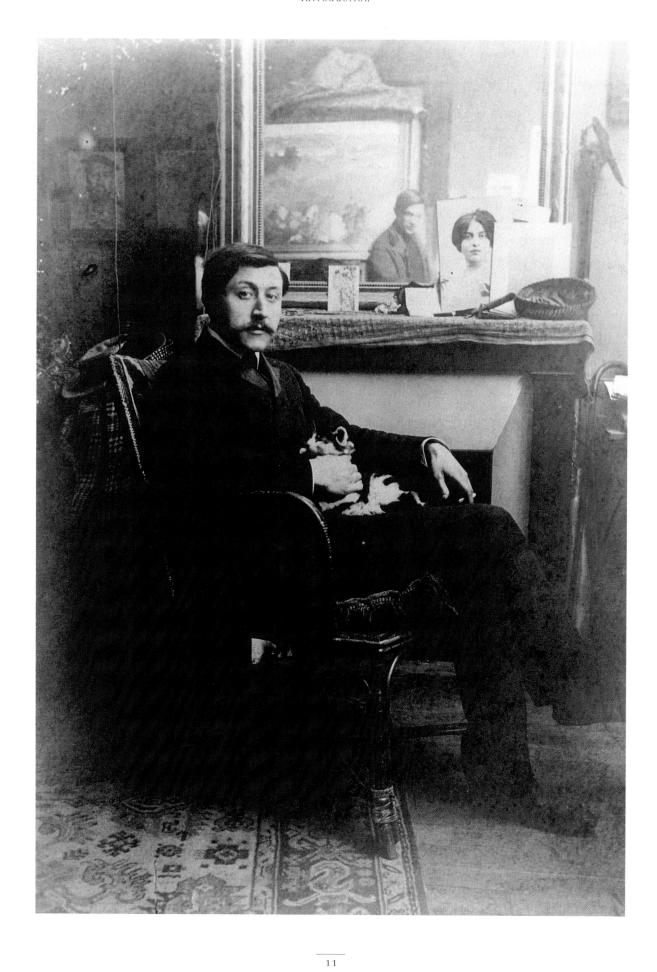

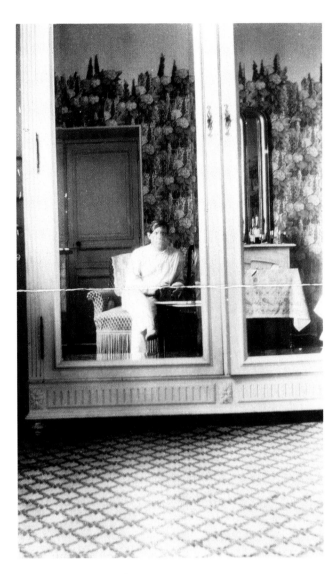

Fig. 6
Pablo Picasso
Self-Portrait
[Fontainebleau, summer 1921]
Gelatin silver print
4 $^1/_2$ x 2 $^7/_8$ in (11.3 x 7.3 cm)
APPH 2797
Picasso Archives,
Musée Picasso, Paris

publish a canvas opposite a photograph showing the village of Horta.[30] As far as Stein was concerned, however, the juxtaposition demonstrated the "realism" of the painting and the truly Spanish nature of cubism.[31] She did attribute, on the other hand, an intrinsic value to Picasso's photographic compositions which, even without being transformed into a painting, brought a change "to things as Picasso saw them."[32] Paul Hayes Tucker used this factual observation as the point of departure for his 1982 article examining Picasso's involvement with photography during the critical summer of 1909, its role in the development of cubism, and indications of Picasso's sustained interest in the medium.[33] Edward Fry, meanwhile, defending a conception of cubism as the "last creative reformulation of classicism," criticized Tucker's assessment of the role played by photography because it reduced cubism to "a more sophisticated formal and visual development of nineteenth-century positivist attempts to apprehend the data of nature and experience."[34] Yet it will be shown below

that the issue remains a dialectical one. As Picasso himself often pointed out, "Whether he likes it or not, man is a tool of nature; [nature] dictates his character and appearance."[35] Even so, the perceptual data of photography was never more than one of many materials employed by Picasso, and it ultimately yielded, as did all other external sources, to "the autonomy of the pictorial approach."[36] That assessment was shared by Andy Grundberg, during an exhibition of Picasso's sketchbooks at the Pace Gallery in 1986, when he viewed several photographs of cubist constructions as being an integral part of the artist's "process of creation and experimentation."[37] Fry, meanwhile, who published the first analysis of the remarkable 1913 photo, *Photographic Composition with "Construction with Guitar Player"* (fig. 133), described it as being "neither a work of art nor a photograph of a work of art, but a manifesto/demonstration. . . ."[38] Similarly, Fry felt that "the most useful explanation of Picasso's Horta photographs is . . . that the artist made them as a means of verification."[39]

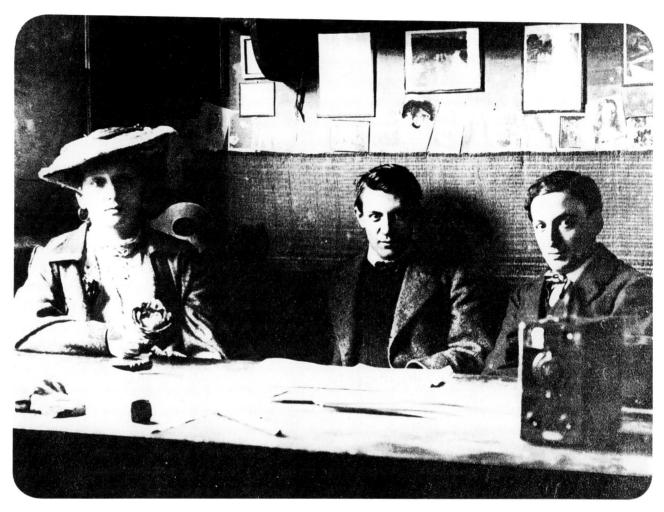

Fig. 7
Joan Vidal Ventosa
Portrait of Fernande Olivier,
Pablo Picasso
and Ramón Reventós
Barcelona, 1906
Gelatin silver print
6 $^{1}/_{8}$ x 8 $^{1}/_{8}$ in (15.5 x 20.5 cm)
FPPH 224
Picasso Archives,
Musée Picasso, Paris

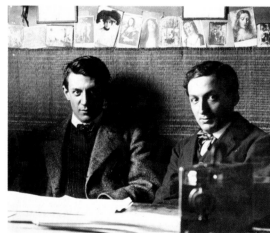

Fig. 8
Joan Vidal Ventosa
Portrait of Pablo Picasso
and Ramón Reventós
Barcelona, 1906
Gelatin silver print
7 x 9 in (17.7 x 22.7 cm)
APPH 15242
Picasso Archives,
Musée Picasso, Paris

Tools for the Eye

The need for a more extensive and more complex approach to Picasso's relationship to photography is confirmed by several written references that provide interesting insights into the material conditions of his picture-taking. In a letter to his parents in August 1904, Picasso indicated that someone would soon lend him a camera so that he could send on a picture of himself. The lender (and photographer) was probably his painter friend Ricardo Canals (fig. 4).[40] In return, Picasso took a picture of Canals that displays great virtuosity (fig. 5): Picasso himself is reflected in a mirror in the middle of the image, wielding the camera. This photograph thereby represents the first *proof*—proof by self-portraiture—of a photograph taken by Picasso himself.[41]

As will be discussed below, however, several turn-of-the-century prints attest to earlier photographic activity on the part of Picasso.[42] It is possible that his apprenticeship in this sphere took place in Barcelona at the prompting of his friend Joan Vidal Ventosa.[43] No later than 1906 at any rate, the year Picasso went to Gosol, Vidal Ventosa took a photo (fig. 7) showing the artist in the company of Fernande Olivier and Ramón Reventós.[44] In the foreground is a camera that looks strangely like a fourth sitter, and may well be the camera used by Picasso at that time. Other, later pictures (figs. 1, 6)[45] indicate that Picasso used these rectangular box cameras—called "Detectives" in the late nineteenth century—into the early 1930s. These cameras had fast lenses with a short focal length that gave a sharp image through great depth of field (which lovers of pictorial gauziness felt to be excessive). Such cameras were held chest high, a ground glass on top of the box serving as viewfinder. Picasso mobilized their potential in the highly conscious, indeed meditative, use that he made of the photographic medium during the years cubism was being forged.

A marked low-angle shot represents the signature of most of the photos—and especially the self-portraits—attributable to Picasso. This angle might be related to his painting technique: "Around 1901, I usually found him in the middle of the studio, near the stove, seated on a rickety chair, perhaps a little low. He was not bothered by the lack of comfort, seemed even to seek it. . . . He set the canvas on the lowest notch of the easel, which obliged him to paint half bent in two."[46] In this ground-level wrestle with the canvas, the painter immersed himself physically as well as visually in the universe created by the work. Similarly, the outsized foregrounds of the photographic portraits seem to lend them a tactile quality. A good illustration of this effect is provided by a photo (fig. 9) apparently showing Georges Braque and Fernande at a bar. The camera, placed at the level of the back of a chair visible in the foreground, concretizes the position of the photographer,

probably crouching. Unlike conventional perspective, where the vanishing points converge on a median horizon, both the space and the perception of bodies are here pitched upward. The face, which a humanistic approach would place at the heart of the picture, is now pushed to the periphery, becoming just one among many elements being depicted. Body and feet, meanwhile, anchor the model to an earthly plinth. The image is rooted in reality at the same time that it imposes a totally self-centered perception of that reality. As Gertrude Stein noted, the eye thus brought to bear on the world is one of proximal fusion. "A child sees [its mother's face] from very near. . . [and therefore] only sees a part of the face of its mother, it knows one feature and not another, one side and not the other, and in his way Picasso knows faces as a child knows them and the head and the body."[47] When combined with the automatism of the photographic method, this atypical approach generates a lively "sur-realism" which simultaneously conveys reality and subjectively appropriates it.

On the back of a letter-card that Leo Stein had sent him in February 1909, Picasso made a list of painting and drawing materials, and reminded himself "recojer la maquina de fotografia cargada" ("pick up the loaded camera"). So on this occasion—probably just before the trip to Horta de Ebro—photography was associated with preparations for pictorial activity right from the start. Picasso's archives also contain a chemical formula, written in Spanish in his hand, for making a "mixed developer."[48] It thus seems probable that Picasso developed and printed his own photos at a certain period. The study of all surviving original prints has revealed that there sometimes exists two or even three prints of the same shot, entailing slight variations in contrast. In certain cases, the tonality of the image is altered through predominantly pink, yellow, or brown toning. In other cases, mirror-image prints were obtained by turning the negative over. Where it is possible to compare print and negative, it usually transpires that the image was printed by simple full-frame contact,[49] which underscores the importance of framing at the time of original exposure. On the other hand, certain prints underwent retouching in ink or employed cutouts and masking, thereby playing on entirely new formal possibilities (as will be discussed below) (figs. 134, 135, 136).[50]

In the years 1910–1914, letters written by Picasso to his art dealer, Daniel-Henry Kahnweiler, contain constant references to photography. During a summer sojourn first at Céret and then at Sorgues, Picasso asked Kahnweiler to send him his paints, painting equipment,[51] and camera,[52] all with the same insistence. One of the letters, referring to his camera, includes valuable confirmation of Picasso's practice of photographic self-portraiture in a mirror: "There are still a few undeveloped plates in it, which I took of myself in front of the mirror."[53] This technique, borrowed from painted self-portraits, was probably not the

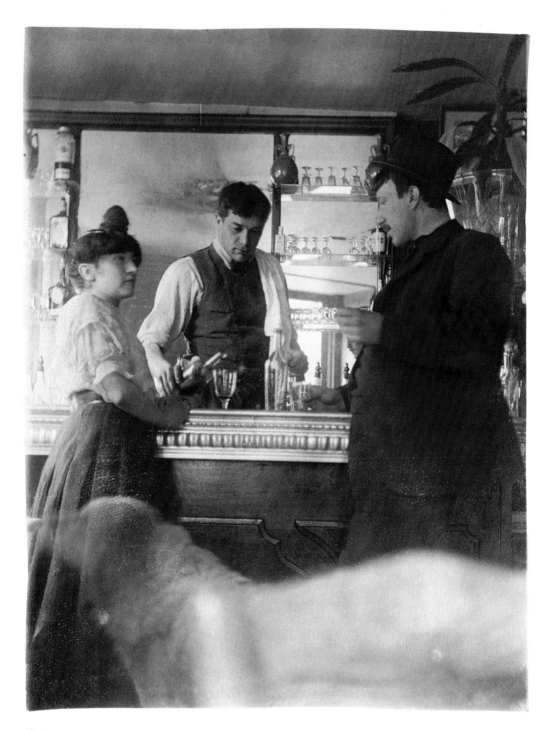

Fig. 9
Pablo Picasso
*Portrait of Fernande Olivier
and Georges Braque*
[Paris, 1908–1910]
Gelatin silver print
4 1/4 x 3 1/4 in (10.7 x 8.2 cm)
APPH 14398
Picasso Archives,
Musée Picasso, Paris

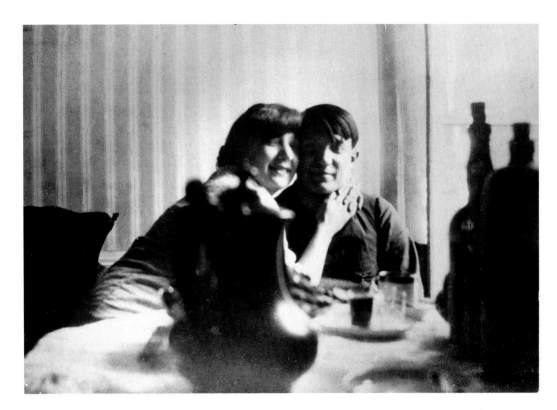

Fig. 10
Pablo Picasso
Self-Portrait with Fernande
Paris, [1910]
Gelatin silver print
5 1/8 x 7 in (13 x 17.7 cm)
Jeanine Warnod Archives, Paris

only one used by Picasso to photograph himself. The highly deliberate staging of many photos suffices to categorize them as "self-portraits," even when the artist recruited the aid of someone else to "take" the picture. Camera technology in the early years of the century nevertheless provided enthusiasts with the means to release the shutter automatically; Picasso certainly used one of these "self-photography" devices for several shots,[54] including a self-portrait in the company of Fernande that bears all the signs of a photo taken with an automatic release (fig. 10).

"If you have the postcards that were there, send them to me in an envelope / it was in an issue of *Vers et Prose* that was on the window shelf."[55] It is worth noting the urgency with which Picasso instructed his dealer—all the way across the country—to send the cards. Only a planned artistic use of the postcards could explain such insistence. Most of the photographic references between the two men, however, concerned photographs of work in progress or recently completed. Kahnweiler regularly had his artists' canvases photographed, usually by Émile Delétang.[56] For instance, in the spring of 1913 Picasso wrote, "Yesterday I received the photos which are good

and please me as usual, since they surprise me. I see my paintings differently from how they are."[57]

Light is shed on this curious phrase—"differently from how they are"—by a comment Picasso made to Christian Zervos. "It would be very interesting to photographically document not the stages of a painting, but its metamorphoses. It could perhaps show the mind's path toward the concretization of its dream."[58] Picasso then went from this hypothetical wish to an account of a real experience: "But what is really very strange is the observation that the painting doesn't change fundamentally, that the initial vision remains almost intact despite appearances. I often see light and shadow. When I put them in my painting, I do all I can to "break" them by adding a color that creates a contrary effect. But when this work is photographed, I realize that what I had added to correct my initial vision has disappeared, and that in the end the image rendered by the photograph corresponds to my primal vision, before my deliberate transformations." Much more than a simple record of work in progress, then, Picasso here confers on photography the "very strange" power to reconstruct the basic scheme of a work, as though the camera's mechanical

viewfinder recovered for him the singularity of his "primal vision."

Picasso commented with interest on those paintings that most resisted photographic recording. "I have just received the photographs and I'm very happy with them. They are beautiful and prove me right. The Ripolin enamel paintings, or Ripolin-like paintings, are the best. . . ."[59] As it turned out, the reds and blues of industrial paint were recorded only as contrasts or textures whose haptic impact reinforces the optical rendering of tonal values. The canvas thus elaborates a dialectical play in which the visual effects of chromatic variations, along with added materials such as sand and real or simulated objects, modify the structural scheme in black-and-white. The photographic record also helped Picasso know exactly when to *finish off* a work in progress, a decision whose difficulty he suggested to Brassaï: "'Finish off' and 'execute' have double meanings, don't they? Not only conclude or complete, but also terminate, put to death."[60] Thus Picasso frequently framed paintings in progress, then took photos of them, as though to judge their progress all the better. A molded frame—like the camera's viewfinder—isolated a canvas from its environment, helped to detach the work from the process of execution. Retranslated into photography's codified format and tonal values, paintings henceforth acquired a polysemic dimension, enabling Picasso to pursue a highly intense visual dialogue in both space and time.

Sometime around 1910, Picasso reportedly declared, under the influence of hashish, "I've discovered photography. Now I can kill myself. I've nothing else to learn."[61] This comment has been interpreted to suggest that Picasso was employing the metaphor of photography to refer more generally to vision or the representational arts.[62] It cannot be comprehended, however, without taking into account what is now known about Picasso's actual use and visual manipulation of photography. His exclamation also loses something of its extravagant nature when compared to a later comment by László Moholy-Nagy—"Photography was invented one hundred years ago, but has just been discovered."[63] Perhaps, then, Picasso was making a factual *observation* about the dialectical impact on his own work of this rediscovery.

Finally, nothing provides better testimony to the extreme acuity of Picasso's photographic eye than the diary kept by Brassaï of an unrealized project. The proposal initially came from Picasso one day in 1946: "I've made paper objects that will exist thanks only to photography. If you come back early tomorrow, I'll show them to you And you can photograph them."[64] Shortly afterward, Picasso confided, "I looked at them the other day against the sunlight It was wonderful . . . they were as translucent as alabaster"[65] But the days went by, as Brassaï noted, "and we returned, for the umpteenth time, to the paper sculptures that unforeseen circumstances have so far kept us from photographing . . . I could have done it without Picasso's presence. But he insists on attending this session because, he feels, for these fragile, ephemeral objects, the final touch means a great deal Picasso: I want to do it together We'll have to spend a whole day at it It takes a long time to find the right angle, the most advantageous lighting"[66] The moment finally came when Picasso showed Brassaï the paper sculptures, "tiny figures in light paper rolled and modeled in his fingers, as fragile as butterfly wings"[67] Picasso wanted the secret and luminous beauty of these perishable sculptures to be confided to photography alone. He felt their very *existence* depended on a photographic record, and he anticipated focusing the same attention on choice of angle or lighting that he had already brought to bear on the varied grading of the tonal values of a painting and its photographic reproduction.[68] And just as he did for these objects "as translucent as alabaster," it was by transparency—against the light—that Picasso later judged work born of his collaboration with André Villers in the 1950s.[69] He called those works, simultaneously photographs and drawings, "apparitions."[70] That term might well apply to everything Picasso took from photography's automatic techniques, from its specific materials, and from the curt "realism" of its images.

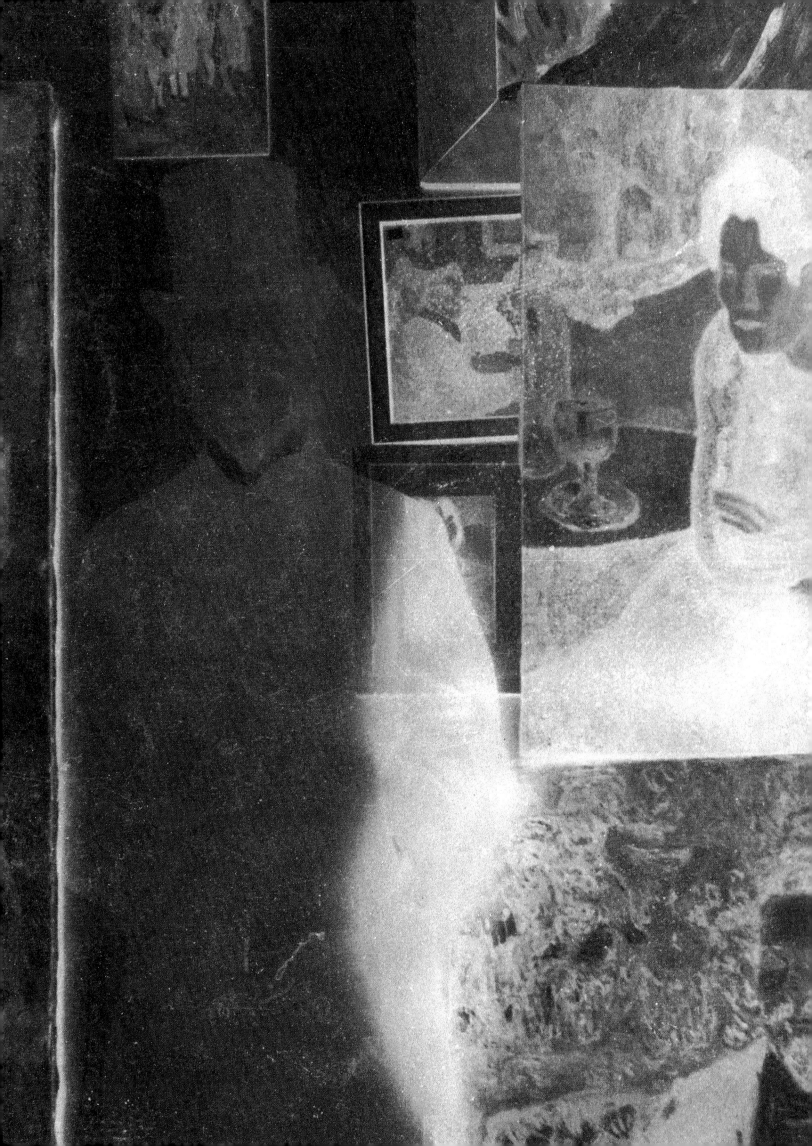

1 9 0 0 ~ 1 9 0 6
Monochrome as Paradigm

"Like all pure painters, Picasso loves color *in itself*," wrote Félicien Fagus during a Picasso show at Vollard's in the summer of 1901.[71] In subsequent months, however, this "pre-Fauve" style would be replaced by a near-monochrome approach prefiguring the Blue Period. As we shall see, a direct contribution to that stylistic change may have come from the way Picasso was using the photographic medium at the turn of the century.

A photograph dating from that same year, *Self-Portrait in the Studio* (fig. 14), shows a section of the studio wall where Picasso's recent canvases are displayed.[72] The wall forms a living support for works hung edge-to-edge, suggesting a continuous, potentially unlimited expanse of pictorial space. Yet the photograph also offers, thanks to superimposition, a ghostly glimpse of Picasso in a top hat, with emaciated face and fixed stare. He seems to be emerging from the wall itself. This unprecedented image is now acknowledged to represent a significant stage[73] in the pictorial series that would evolve, in just a few months, from the triumphant *Yo, Picasso*[74] to the crazed *Self-Portrait* (fig. 11) of 1901[75] and the vacant expression of the blue *Self-Portrait*.[76] The self-referential nature of the photo is further strengthened by a note in Spanish scribbled by Picasso on the back—"This photograph could be titled, 'The strongest walls open as I pass. Behold!'" This enigmatic phrase might be a paraphrase of the passage in Lautréamont's *Chants de Maldoror,* where the walls open as the Creator quits the scene of crime and debauchery, leaving his victim skinned alive from head to foot.[77] The cruelly flayed skin would thus function as a metaphor for the artistic project of turning painting inside out. This young, "decadent" painter, a habitué of cabarets and brothels, was embarking on the most solitary phase of his work. The ghostly self-portrait that he offers here might reflect the moment of withdrawal that Picasso probably evoked years later when he declared, "You go to great pains, suddenly flaying yourself over canvases even though no one forces you to. To the contrary, nobody cares whether you do that or something else. And so you always go for the worst, even when you know they'd prefer a bouquet of flowers."[78] Indeed, numerous bouquets were exhibited at Vollard's gallery in the summer of 1901, and genre scenes met with notable success. Having been obliged to produce the material for this ample show in just a matter of months,[79] Picasso somewhat roughly copied commercial photographs in a few cases.[80] Immediately following this public success, however, Picasso opted for "the worst." He abandoned color and moved toward painting in which form was reduced to a kind of drawing shaped by shadows.

The Blue Studio (fig. 15), a photographic composition from the following year, presents another visual enigma. Like *Self-Portrait in the Studio* (fig. 14), it was designed to show an arbitrary section of wall hung with paintings. This time, the rules of vision are upset not by superimposition, but by other means: the painting that occupies most of the image, *Two Women at a Bar*,[81] is in fact shown "upside down" in relation to the other works.[82] The result is an abstract composition juxtaposing rectangular formats of conflicting patterns with the undulating, luminous curve of the woman's back. The image, built like a puzzle of planes and shifting gray scales that complicate the perception of real objects, hints at a new mode of graphic expression. The butterfly pinned to the wall would thus symbolize a strategy that, beyond mere mimicry, offers the gaze a visual pattern devoid of depth.

Photography's Dark Mirror

It is worth noting that throughout this period Picasso took many photographs of his works, often as they were being executed. The *Portrait of Gustave Coquiot,*[83] typical of the colorful style of early 1901, is thus shown on an easel, already signed (fig. 12). An earlier version of the painting could be seen in the background of *Self-Portrait in the Studio* (fig. 14).[84] In contrast, a final photograph (fig. 13) showing the framed painting reveals a reworking of the background[85] and stronger contours. The photograph thereby marks the progress of the painting and undisputably contributes to an accurate understanding of the way it was composed. Similarly, examination of photos showing canvases from the same period[86] leads to the identification of changes Picasso made after those photographs were taken.[87]

These works display the progressive affirmation of Picasso's Blue Period: paint applied in flat washes, emphasis on outlines, attenuation of chromatic contrasts, and so on. Photographs of them, meanwhile, tend to reduce all hues to a simple scale of tonal values equivalent to a gray-brown grisaille. Recorded thus, painting is reduced to a

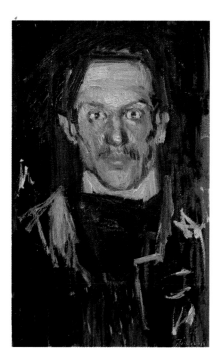

Fig. 11
Pablo Picasso
Self-Portrait
Paris, 1901
Oil on cardboard
21 1/4 x 12 1/2 in (54 x 31.8 cm)
Mrs. John Hay Whitney Collection,
New York

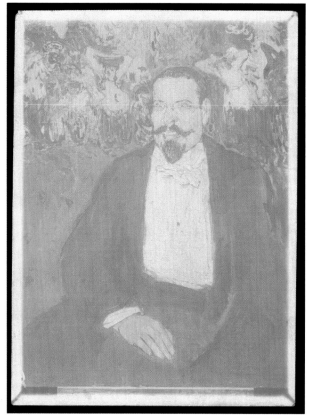

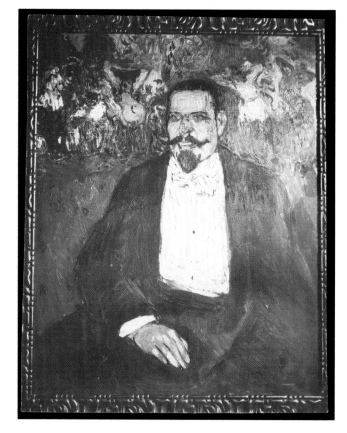

Fig. 12
Pablo Picasso
"Portrait of Gustave Coquiot" in progress (I)
Paris, 1901
Gelatin silver print
4 7/8 x 3 3/4 in (11.8 x 8.8 cm)
APPH 15364
Picasso Archives, Musée Picasso, Paris

Fig. 13
Pablo Picasso
"Portrait of Gustave Coquiot" in progress (II)
Paris, 1901
Gelatin silver print
4 5/8 x 3 1/2 in (12.3 x 9.6 cm)
APPH 15365
Picasso Archives, Musée Picasso, Paris

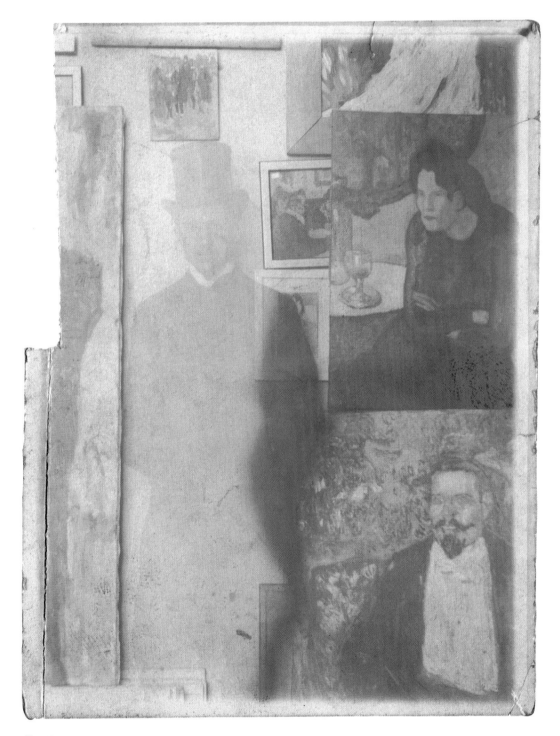

Fig. 14
Pablo Picasso
Self-Portrait in the Studio
Paris, 1901
Gelatin silver print
(superimposition)
4 ³/₄ x 3 ¹/₂ in (12 x 9 cm)
APPH 2800
Picasso Archives,
Musée Picasso, Paris

structure of shadow and light. Such photos would represent a typically Picasso-like version of the "judgment by mirror"[88] as advocated by Renaissance treatises[89] and, more immediately, by Manet's practice of assessing his work by looking at it in a "small dark mirror."[90] Not just a mirror—a *dark* one. Manet also claimed that he preferred to "go suddenly from light to shade rather than accumulate things that the eye does not see and which not only weaken the vitality of the light but attenuate the coloring of the shadows, which should be underscored."[91] Picasso may well have adopted a similar program in the fall of 1901. From that moment onward, the photographic observation of works in progress probably helped him free his painting of pointlessly "added" color; this allowed him, as he would explain to Zervos, to get back to basics—"I see light and shade."[92]

Just as Manet approached Raphael through Marcantonio Raimondi's engravings,[93] so Picasso's generation primarily studied the Old Masters in the form of reproductions issued by art publishers such as Alinari, Brogi, Hauser y Menet, and Jean Laurent.[94] A great many such prints can be found in Picasso's archives. The print of El Greco's *Burial of Count Orgaz*, for instance, is in a faded state which suggests that it remained on the studio walls for years, where it notably served as inspiration for Picasso's parody, *The Burial of Casagemas (Evocation)*.[95] Here, however, the effects of medium and message merge. Viewed through a "mirror of judgment" restricted to a similar monochrome state, the ongoing painting directly confronts the one from the past, permitting the artist to speak the language of Old Masters and to establish a dialogue with them.

This approach, which might be called "tonalist" [*valoriste*], appeared precociously in an illustration (fig. 17) that Picasso executed in 1900 for Joan Oliva Bridgman's poem, "The Call of the Virgins."[96] As Josep Palau i Fabre has pointed out,[97] Picasso subtly reinterpreted a pictorialist photograph (fig. 16) published a few months earlier.[98] Prior to adopting this image of the sleeping female denuded by sleep, Picasso made several preparatory drawings[99] that sought graphic expression for the contradictory gesture of a woman who undresses and simultaneously turns away. One of these sketches (fig. 18), in India ink, employs the reserve technique to underscore the whiteness of the body that the photograph doused in dramatic light.

A photographic *Self-Portrait with a Cane* (fig. 19) dates from Picasso's stay in Barcelona in 1902 and is based on a snapshot of the young artist in the street.[100] The cutout silhouette not only inspired a drawing labeled "Picasso in Spain" (fig. 20),[101] but also evokes the *sombras*, or shadow-puppet show, an entertainment made popular by a cabaret called Els Quatre Gats, after the Chat Noir in Paris.[102] Picasso was undoubtedly aware of the experiments of Miquel Utrillo, who crafted these shows.[103] *Sombras* were cut

from cardboard or metal, and then manipulated in front of a translucent scene lit from behind. Similarly, Picasso's cutout silhouette[104] was isolated from any context until the drawing "situated" it in a highly emblematic landscape framed by a church and a *plaza de toros*. Hence early in the century this little self-portrait combining a cutout figure and a line drawing of an imaginary environment already established the combinatory principle often followed by Picasso when he merged photography, cutouts, and drawing. By its very abstraction, the method simultaneously evoked the mythological origin of portraiture (the outline of a shadow cast on a wall[105]) and a historical precursor of photography, namely "silhouette figures" limited to a black profile on white ground. A similar approach had already inspired a series of sketches of Catalan friends that Picasso exhibited at Els Quatre Gats in February 1900. In the earliest of these, the figures are shown before a descriptive background; later, Picasso "progressively simplified the background, which he ultimately eliminated in order to focus interest solely on the model."[106]

Thus right from the turn of the century a secret dialogue was underway between increasingly monochrome painting and an expressive register specific to the medium of photography. "Blue" might be considered here as a pictorial option for *non-color*.[107] In fact, in Western art azure was the hue historically reserved for the "atmospheric" translation of space. The more shapes dissolved into the perspectival distance, the intenser the blue—in short, blue existed only in proportion to the dematerialization of the depicted object. Here, however, blue clings to the surface of the canvas, in folds, drapes, and shadowy washes, forming a drawing that abolishes depth. Picasso may well have been attracted to blue as a manifesto-color: not long before, it had practically been the symbol of scandalous painting. As a chronicler wrote of Manet, "When one's vision is as violet as that, one should see an eye doctor."[108] The allegation of visual impairment surfaced throughout the anti-Impressionist reaction; Joris-Karl Huysmans, for example, accused Caillebotte's "indigomania"[109] and Cézanne's "afflicted retinas"[110] of being responsible for "the sin of dreadful blue."[111] Picasso's blue, pictorial sign of modernity as much as a means of achromatic expressivity, thus came to the fore just as he was coming to grips with photography.

Although photography was monochrome, it did not preclude variations in tonality. Pictorialist experimentation in toning techniques during the years 1890–1910 led to postcards[112] and movies[113] that commonly presented images in a full range of cool or warm tints. In this context, special interest accrues to the discovery in Picasso's archives of a cyanotype—or blue-tinted print[114]—dating from the beginning of the century: *Young Man with a Fan* (fig. 21). The sitter, seen in profile, is placed before drawings

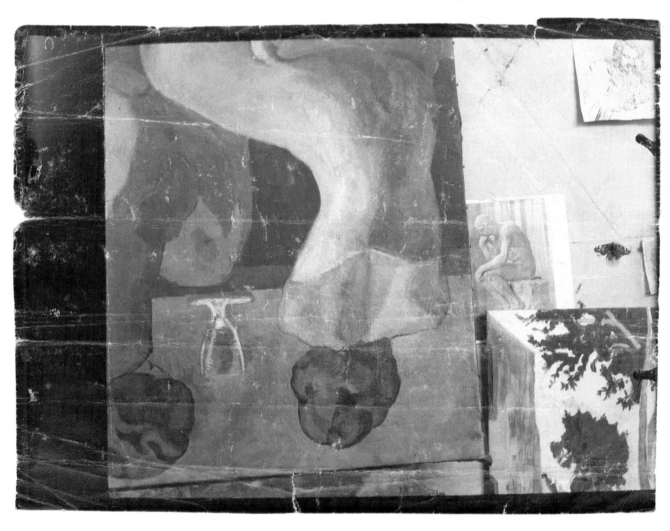

above and right
Fig. 15
The Blue Studio
[Paris or Barcelona, 1902]
Gelatin silver print
4 5/8 x 5 1/8 in (11.8 x 13.1 cm)
APPH 2813
Picasso Archives,
Musée Picasso, Paris

Fig. 16
Anonymous
Portrait of Christiansen
Photograph illustrating
Joan Oliva Bridgman's poem,
"Ode to Phryne"
Joventut, no. 11, April 26, 1900

Fig. 17
Pablo Picasso
Illustration for Joan Oliva
Bridgman's poem,
"The Call of the Virgins"
Joventut, no. 22, July 12, 1900

Fig. 18
Pablo Picasso
Studies for "The Call of the Virgins"
Barcelona, 1900
Pen and ink on paper
18 $^1/_2$ x 12 $^1/_8$ in (46.9 x 30.9 cm)
Museu Picasso, Barcelona

pinned to the wall in an arrangement similar to the photographs of *Self-Portrait in the Studio* (fig. 14) and *The Blue Studio* (fig. 15). The third dimension is suggested here solely through the crumpled architectural sketch and the folds of the fan.[115] The "artistic" staging evokes the group of young bohemians with whom Picasso consorted at the time;[116] the cyanotype, moreover, displays strong similarities with a charcoal *Portrait of Ramon Suriñach i Senties* (fig. 23),[117] where only black smudging indicates shading and modulates the half-tones.[118] The conjunction of these works thus directly paved the way for the principles of shaded drawing implemented in the Blue Period.[119] In a more general fashion, although the identity of the sitter remains uncertain, this photo may have provided—throughout the year of 1900—the formal matrix for several portraits of young people posed in profile before a background of flat washes, such as those of Sebastià Junyer Vidal,[120] Antoni Busquets Punset,[121] and Angel Fernandez de Soto.[122] Above all, it displays strong affinities with a drawing of Carles Casagemas (fig. 22),[123] now known only from a reproduction alongside an obituary in *Catalunya Artistica* following the sitter's suicide.[124] Executed on blue-gray paper, this *memento mori* perhaps combines the aesthetic impact of the cyanotype with various studies of Casagemas made during his lifetime. And it may thus represent a kind of twinning of Ramon Suriñach and Casagemas, two decadent poets, "dark spirits," and stand-ins for Picasso, born the same year as they—1881.

The link between photography and Picasso's new style of painting is also evident in two important canvases from the following years. In *Portrait of Sebastià Junyent*,[125] inspired by a studio photograph, the mimetic handling of the face by glazing and fine hatching contrasts with the blue-streaked background. Jaime Sabartés, meanwhile, has recounted the alleged circumstances behind his own portrait,[126] painted on the spur of the moment one glum evening in 1904. "I was standing, still, a certain distance from his easel. His eyes went from the canvas to me, and from me to the canvas."[127] The painting was reportedly finished the next morning, "after a very short sitting."[128] There is nevertheless an undeniable connection between the painting and the sole old photograph of the sitter that Picasso kept in his archives.[129] The "austerity" that Sabartés finds in the portrait might thus be explained as much by the rigidity of the camera pose as by the precise accuracy of painterly execution.

An anonymous photograph (fig. 24) may also have been behind a motif that recurred in the paintings of 1901–1903, namely, a figure with crossed arms held tightly against the body, in a gesture of distress.[130] The photo, of a South American Indian, is probably one of the old-style police mug shots in which suspects and vagabonds were shown seated, from the torso up, their arms brought forward. The dazed look on the man's face conveys a kind of indifference to the procedure of being photographed as well as an inexpressible suffering. The man nevertheless seems to be literally grasping himself bodily in an effort to cling to life physically and symbolically. This highly evocative pose appeared in identical form in the canvas *Portrait of a Man (Blue portrait)* (fig. 25) as well as in several preparatory sketches,[131] in conjunction with a bearded face purportedly inspired by another source.[132] Although the drawings (fig. 26) show a full-length figure, the hesitant handling of the legs may suggest that Picasso had to invent lower limbs for the bust of the Amerindian. Various figures with crossed arms from this period include such pictorial approximations, perhaps representing the vestige of this unusual photographic composition.[133] An unconventionally sectioned body—neither head, nor bust, nor full-length portrait—might thus constitute the most appropriate depiction of figures alienated from themselves, like this Amerindian tramp and his counterparts in the paintings.

A similar expressive tension underlies a drawing of Paganini (fig. 28)[134] in which Picasso translated a photograph (fig. 27) into lines and hatching that anticipate his technique of the years 1917–1920. Picasso's point of departure[135] was an enigmatic commercial photograph taken in 1900,[136] reproducing a full-length portrait of the virtuoso violinist, bow raised. Although Niccolo Paganini's unusual physique inspired a great many portraits and caricatures, there is no known daguerreotype taken during his lifetime,[137] which suggests that the person in the photograph is actually an actor—perhaps the famous Leopoldo Fregoli[138]—using Paganini as model for a character role. The drawing based on this photograph would then represent a portrait of the violinist only secondarily, its main object being the way in which the actor *interprets* gestural strangeness in a photographic fathoming of a freakish body. Posed in a studio rather than played on stage, the photograph arrests movement at its height. Picasso's drawing further stresses this effect—two outsized hands henceforth extend to the edge of the paper, while strong penciling anchors the bow arm to the body. This photo may also have inspired visual features of other paintings, such as *The Actor*[139] and *Les Bateleurs (Family of Saltimbanques)*,[140] namely, tense body, dramatized face, exaggerated hand.[141]

left
Fig. 19
Pablo Picasso
Self-Portrait with a Cane
Barcelona, 1902
Cutout photograph
(by an anonymous photographer)
Gelatin silver print
2 3/4 x 1 3/4 in (7 x 4.3 cm)
APPH 2778
Picasso Archives,
Musée Picasso, Paris

below
Fig. 20
Pablo Picasso
Picasso in Spain
Barcelona, [July] 1902
Pen and ink on paper
on letter to Max Jacob
8 1/8 x 10 1/4 in (20.5 x 26 cm)
Private collection

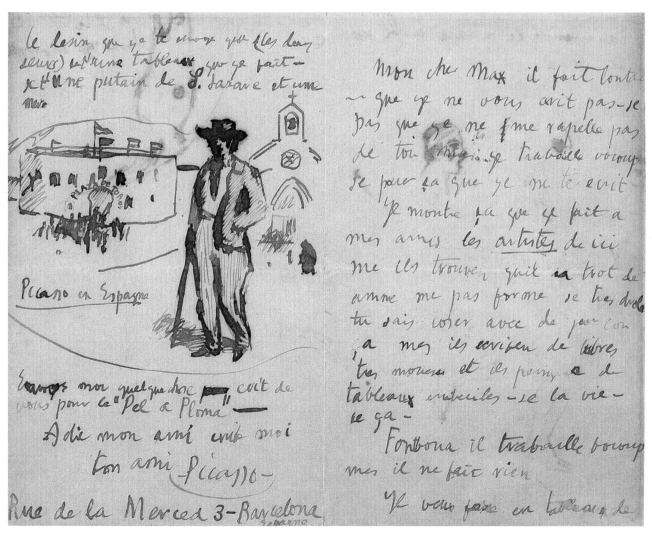

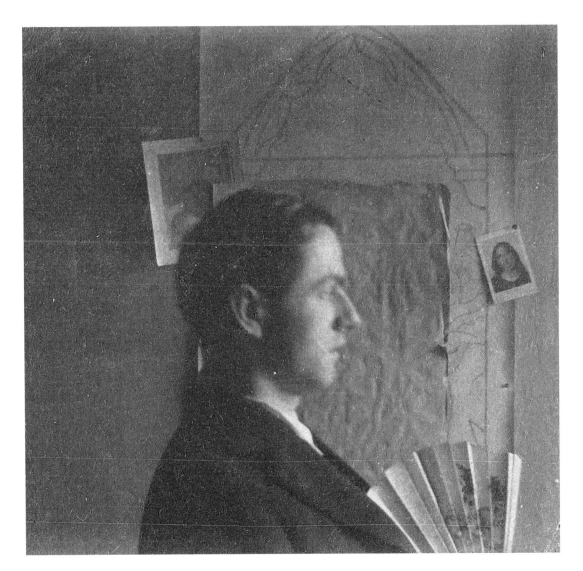

Fig. 21
[Pablo Picasso]
Young Man with a Fan
[Barcelona, 1899–1900]
Cyanotype
2 $\frac{1}{8}$ x 2 $\frac{1}{4}$ in (5.3 x 5.6 cm)
APPH 3622
Picasso Archives,
Musée Picasso, Paris

Fig. 22
Pablo Picasso
Portrait of Carles Casagemas
Barcelona, 1899
Conté pencil
Collection unknown

Fig. 23
Pablo Picasso
Portrait of Ramon Suriñach
i Senties
Barcelona, 1900
Charcoal on paper
7 ⁷/₈ x 5 ¹/₈ in (20 x 13 cm)
Private collection

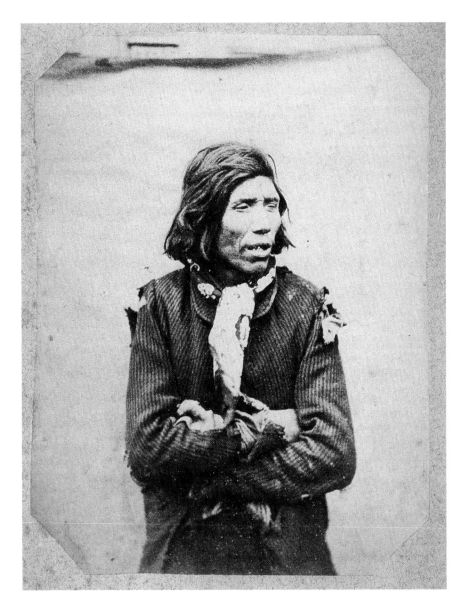

Fig. 24
Anonymous
Portrait of a Man
[1860–1880]
Albumen print pasted
onto cardboard
5 ³/₄ x 4 ³/₈ in (14.6 x 11.2 cm)
APPH 15673
Picasso Archives,
Musée Picasso, Paris

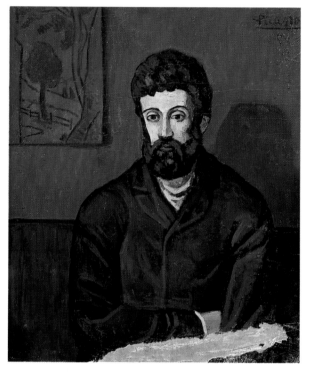

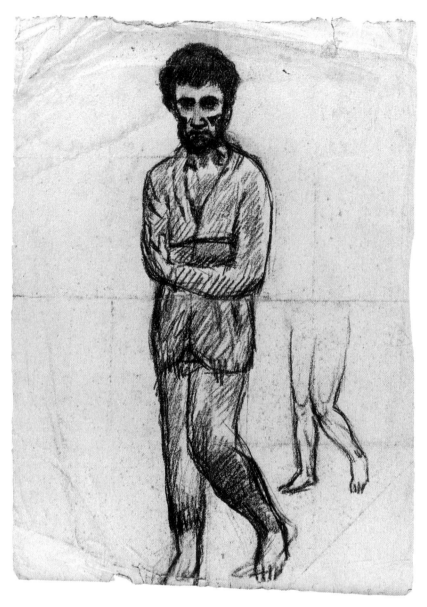

above
Fig. 25
Pablo Picasso
Portrait of a Man (Blue Portrait)
Paris–Barcelona, winter
1902–1903
Oil on canvas
36 ⁵/₈ x 30 ³/₄ in (93 x 78 cm)
MP 5
Musée Picasso, Paris

right
Fig. 26
*Man Standing
with Arms Crossed*
1902
Charcoal
17 ³/₄ x 13 in (45 x 33 cm)
Succ. 352r
Private collection

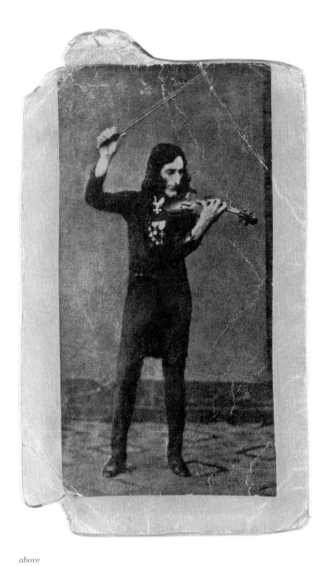

above
Fig. 27
[Ey. G. Fiorini]
[Fregoli] in the Role of Paganini
Munich, 1900
Phototypogravure
5 ³/₄ x 2 ⁷/₈ in (14.5 x 7.4 cm)
APPH 3060
Picasso Archives, Musée Picasso, Paris

opposite page
Fig. 28
Pablo Picasso
Portrait of Paganini (The Violinist)
1905
Pencil
12 ³/₄ x 8 ¹/₂ in (32.5 x 21.5 cm)
Succ. 654
Private collection

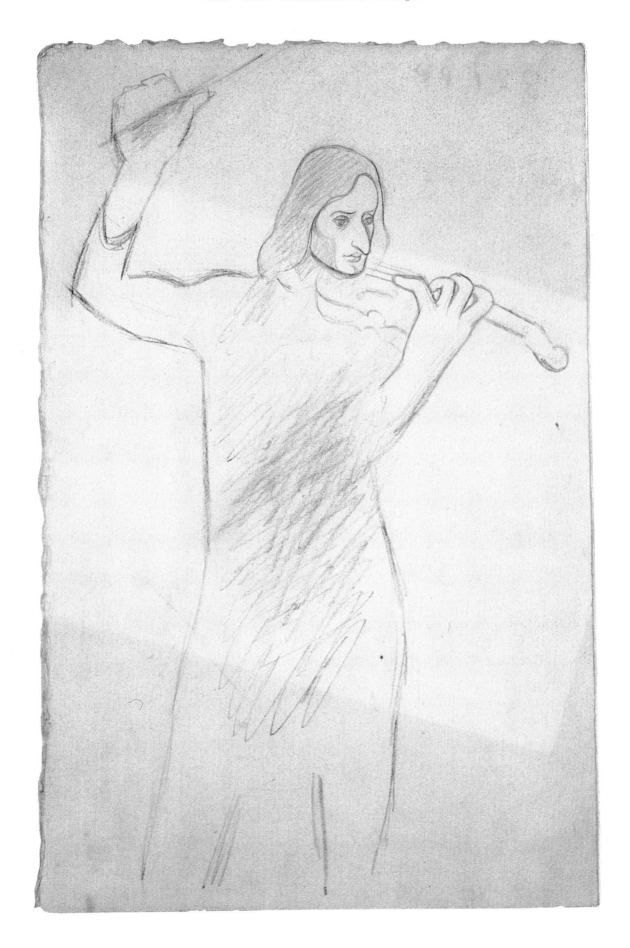

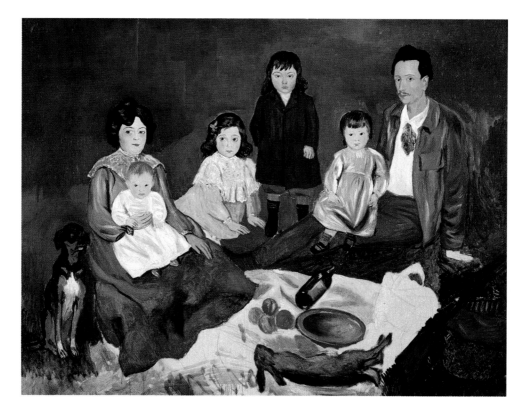

Fig. 29
Pablo Picasso
The Soler Family
Barcelona, summer 1903
Oil on canvas
59 x 78 ³/₄ in
(150 x 200 cm)
Musée d'Art Moderne
et d'Art Contemporain
de la Ville de Liège

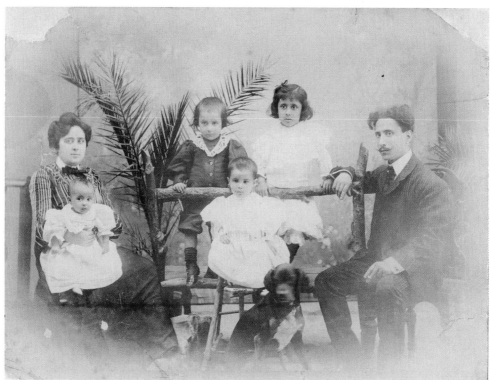

Fig. 30
Anonymous
The Soler Family
1903
Gelatin silver print
4 ³/₄ x 6 ¹/₄ in (12 x 16 cm)
Private collection

A "Modern Masterpiece"

The large 1903 painting of *The Soler Family* (fig. 29)[142] transposed a simple studio photograph (fig. 30) to a monumental scale.[143] Posing in front of a plain cloth backdrop under the harsh light of a glass roof, the photographed subjects lose all relief and all expressiveness; their faces are reduced to masks, their gazes hypnotic. Rustic props may have suggested the picnic setting employed in the painting, which was designed to celebrate family life. The project thus merged, in Picasso's mind, with Manet's *Le Déjeuner sur l'herbe,*[144] where the forest looks like a stage set or photographer's backdrop rather than a natural environment. Picasso therefore gave Señor Soler the seated pose and outstretched legs of Manet's art student, complete with red cravat. The children shift position so that the little boy, like Manet's crouching bather, forms the summit of a classically pyramidal composition. Other transformations circulate between the photograph and the two paintings: the dog in the middle of the photo is replaced by a still life, in prosaic tribute to Manet's; Picasso positioned the tablecloth, which Manet had improvised out of the dress of the nude model, right where the photo features the starchy white gown of the little girl in her Sunday best; his tablecloth then allows the fabric of the canvas to show, as an emblem of Soler the tailor.

In its triangular construction, Picasso's painting nevertheless remains faithful to the photographic alignment of the sitters in a single plane. The figures are arranged from top to bottom rather than from front to back. This flattening effect is accentuated by broad brushstrokes of color. The "block effect" of the plain blue ground attains a rare level of abstraction that accentuates the harshness of the representational features. In a paradoxical way, this portrait evokes a photographic "likeness" even as it systematizes pictorial procedures that are deliberately anti-illusionist: raw brushwork, bare canvas, blocked-out ground, contrasts, etc. A comment pertaining to *Le Déjeuner sur l'herbe* could also apply here: "The ambiguity stems from the fact that this parody—the product of a wager or prank—also embodies the loftiest ambition. Using paintings by old masters as a go-between (Giorgione and Raphael via Marcantonio Raimondi), it proved that simplified and resolutely new pictorial methods could produce a 'modern masterpiece.'"[145] In this respect, the visual ambiguity of *The Soler Family* (fig. 29) perhaps rests essentially on the double constraint that Picasso set himself: to work from a photo yet to work only with the raw means of painting, thereby "demonstrating—and demonstrating to himself—that painting could borrow all of photography's effects and wield them much more impressively."[146] Thus this overly "simple" painting in fact reflects the complexity of its antagonistic allusions: photographic verisimilitude, high pictorial culture (the Renaissance as reinterpreted by Manet), and the imagery and chromatic modernity of a "blue" painting.

The Soler Family (fig. 29) is accompanied by pendant portraits of husband and wife. Although Picasso based all three canvases on the same photograph, they betray somewhat different intentions. The husband,[147] depicted in a café, is handled in an expressionist manner inspired by the sitter's extroverted nature. The wife,[148] meanwhile, conveys a hieratic maternity combining Velázquez-like preciousness with Picasso's casual invention of the arm not seen in the photograph. The whole family scene, finally, conveys the adventure of a rustic picnic for and around the children. The subsequent fate of *The Soler Family* (fig. 29) nevertheless reveals the confusion provoked by its ambiguity. Soler obtained Picasso's permission to have a wooded background added by the painter Sebastià Junyer Vidal, who effected a return to Manet. However, when Kahnweiler purchased the painting in 1913, Picasso reworked it, first attempting to fit the figures into a cubist-like composition and then reverting to the original plain ground.[149] Acquired by the Wallraf-Richartz Museum in Cologne, the canvas was then seized by Nazi authorities as an example of "degenerate art," and sold to the Musée des Beaux-Arts in Liège, Belgium. This may seem a surprising attitude toward an allegory of familial serenity, a commissioned portrait that initially conveys "photographic" realism. From their point of view, however, the Nazi censors perceived that it representes a subtle yet radical attack, made first by the photo and then by Picasso, on both reality and its representation. The sitters were reduced to pale cutouts, figures were flatly superimposed, and color was heading toward monochrome abstraction—an insult, indeed, to common sense.

Photographic Incarnations

Picasso returned with two sketchbooks of drawings from a trip to Holland made early in 1905,[150] along with a few blue and rose oils and gouaches, including *La Belle Hollandaise* (fig. 32).[151] To this day, speculation continues as to the identity of the model who agreed to pose nude for the young painter.[152] The work, however, displays similarities with an old photograph (fig. 31) showing a young woman wearing a woven straw hat: the same tilt of the head (although laterally reversed), the distant expression on the face, the voluminous curves of shoulders and breasts, etc. The nudity may therefore owe its somewhat unlikely anatomy to a daydreaming artist who meditated on the mystery behind this photographic incarnation. The gauzy architecture of the woman's coif simultaneously alludes to and hides female hair.[153] In a typically fetishistic displacement, then, the coif perhaps functions as an equivalent and a substitute for the genitalia hidden from the gaze, warding off both the desire and the alarm potentially provoked by that nudity. Whatever the case, this portrait of a woman in lace bonnet not only represented the ambivalent lifting of a visual taboo, but it was also the first time that the female nude entered Picasso's oeuvre as an autonomous subject. A gouache of *Three Dutch Girls*,[154] meanwhile, can be understood as a landscaped compilation of figures from three separate photographs in the same series.[155]

Picasso's archives also contain several photographs of Oriental subjects. These albumen paper prints, dating from the 1880s and 1890s, were mostly taken in Egypt. It is possible to trace the influence of several of these images on Picasso's pictorial work from 1905 to 1906. Much has been written about how this "first classical period" owed a great deal to Picasso's visits to the Louvre.[156] Also well known is the decisive role played by the discovery of ancient Iberian art, which archaeologists of the day labeled "Phoenician." Another Orient, however, was underpinning Picasso's painting at the time, namely, a photographic Egypt where live antique characters organized bodies, poses, and draped garments into a world of signs awaiting decipherment. Similarly, the chromatic shift of the periods called "Rose" or "Ocher," often described as a subjective reaction to the soil of Gosol,[157] represents a material reflection of the sepia tint of those old prints, of the ineffable rusting that accompanies the erosion of time. Blue and Rose: Picasso thus explored the twin frontiers of the color field. "Often, just when I was going to apply blue, I noticed I didn't have any. So I picked up red and used it instead of blue. So much for intellectualization."[158]

A major canvas of 1905, *Woman with a Fan* (fig. 33),[159] displays more than one connection with *La Toilette*,[160] painted the following year, where the sign of the mirror replaces that of the fan as a symbolic equivalent of the painter's palette.[161] These mysterious figures in profile have sparked theories of an allusion to Egyptian statuary.[162] But they probably owe as much to a picture (fig. 35) of two young Nubian woman posing back to back before the *opus incertum* of an ancient wall.[163] The position of the left arm of the woman holding the stick is only slightly modified for the model holding the fan,[164] which is then literally reproduced in *La Toilette*, where the vertical stick becomes the edge of the mirror (figs. 34, 37).[165] The baggy trousers gathered at the ankle and the sash at the waist that appear in several preparatory drawings[166] are borrowed, moreover, from another photograph (fig. 36) showing a Berber woman, as is the overall handling of space. A deeper relationship to the photographs is perhaps expressed through the contours of the figures and the modeling of light on dark skin, producing a schematic design which unites a still-discernible quiver of life with a kind of transhistoric idealization. The Egyptian sisters in the photograph seem like two poses of the same sitter, mirrored back to back. *La Toilette* would turn them around, confronting the modest gesture of one with the stick-mirror of the other, and suggesting a metaphor for both photography and pictorial representation—life as modeled by the power of the gaze.

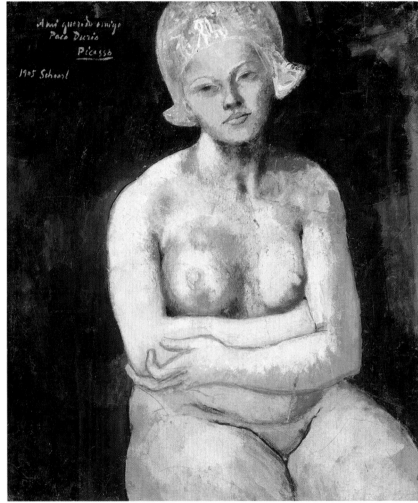

above
Fig. 31
Anonymous
Portrait of a Girl
Holland, c. 1880
Albumen print pasted
on gray-blue cardboard
6 x 4 ³/₈ in (15.3 x 11 cm)
APPH 6039
Picasso Archives,
Musée Picasso, Paris

right
Fig. 32
Pablo Picasso
La Belle Hollandaise
Schoorl, summer 1905
Oil, gouache, and chalk
on backed cardboard
30 ³/₄ x 26 ¹/₂ in
(78 x 67.3 cm)
The Queensland Art Gallery,
Brisbane

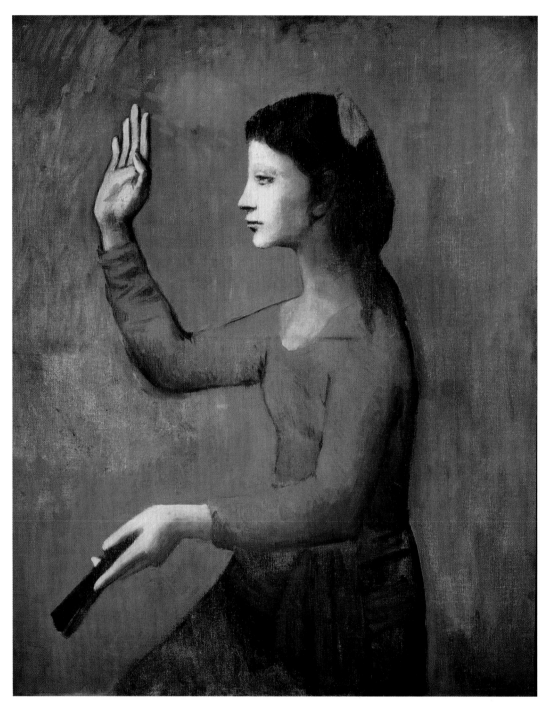

above
Fig. 33
Pablo Picasso
Woman with a Fan
Paris, 1905
Oil on canvas
39 x 32 in (99 x 81.3 cm)
Gift of the W. Harriman
Foundation
National Gallery of Art,
Washington

right
Fig. 34
Pablo Picasso
Nude Holding a Mirror
Gosol, summer 1906
Pen and ink
9 7/8 x 6 3/4 in (25 x 17 cm)
Private collection

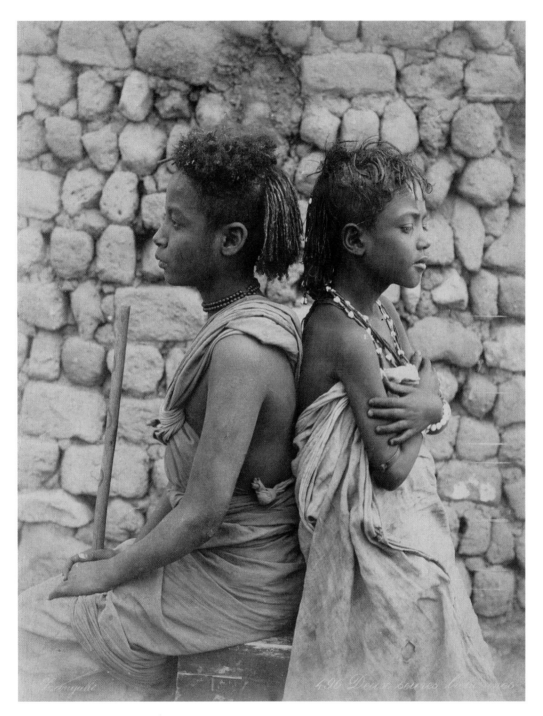

Fig. 35
C. and G. Zangaki
Two Bicharine Sisters
Egypt, [1860–1880]
Albumen print
11 x 8 ¹/₄ in (28 x 21 cm)
APPH 12514
Picasso Archives,
Musée Picasso, Paris

"Hellenistic" canvases such as *The Two Brothers* (fig. 39)[167] and *Two Youths*[168] might also have been inspired by certain Egyptian photographs, including one (fig. 43) by Guglielmo Plüschow, an Italian-based photographer from Germany who, like Baron Wilhelm von Gloeden, specialized in classicized shots of nude youths.[169] Showing eleven young boys in the ruins of a temple, this photograph seems to conjugate various poses of a single nude. In the middle of the group stands an adolescent with eyes closed in bliss. His silhouette and pose find visual echo in *Nude Boy with Raised Arms*[170] and in another composition of *Two Youths* (fig. 42),[171] whose figures are based on this boy as well as several others in the picture.[172] Similarly, works related to *The Two Brothers* (fig. 39)[173] may have borrowed several features from another photo (fig. 38) showing a woman carrying a child, namely, the child's face, the contorted arms, and the uniform background. Beyond correspondences across given works, a deeper link may exist between the world of these Egyptian photographs and the aesthetic moment when Picasso's painting "was made flesh." In addition to a rich weave of allusions (Grecian *kouroi*, the Ingres of *Le Bain Turc*), works peopled with prenubile creatures of often indeterminate sex—the *Two Youths* (fig. 42), the *Three Nudes* (fig. 40),[174] and *The Harem* (fig. 41)[175]—display many analogies with Plüschow's photograph: composition, pose, volumes, and placing of bodies.

Picasso's use of photographic sources, however, went far beyond imitative transcription; he decoded, displaced, and combined each of the signifying units of an image with other sources, as though he wanted to exhaust all their visual and documentary possibilities. He seems to have adopted a kind of "floating" gaze, open to formal suggestions that a "realist" eye would have dismissed. Performing an exercise recommended by Leonardo da Vinci[176] and Alexander Cozens,[177] he could envisage imaginary creatures which nevertheless retain a verisimilitude and a sensual vibration indebted to photography. Something of this remained in the strange imprecision of the paintings of the Rose and Ocher Periods, in which a certain blurriness underscored the monochrome effect. This muted, tonal vision might reflect a gaze that eschews acuity. Picasso freed himself from the photographs that were his starting point by deliberately disordering his vision; all that he retained of his models was their discreet plastic appeal and the lingering aura of their fleeting passage before the camera. This insight might better explain how, from a photograph of Egypt to the Spain of 1906, Picasso's pictorial alchemy could transform the uncouth Catholic villagers of Gosol into figures of an idealized hedonism.

Fig. 36
Anonymous
Berber Woman
[Algeria, 1860–1880]
Albumen print
9 1/2 x 6 7/8 in (24 x 17.5 cm)
APPH 12517
Picasso Archives,
Musée Picasso, Paris

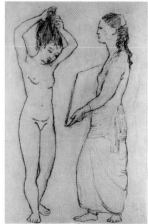

Fig. 37
Pablo Picasso
Study for La Toilette
Gosol, summer 1906
Charcoal on beige paper
24 1/2 x 16 in (62.2 x 40.7 cm)
Alex Hillman
Family Foundation,
New York

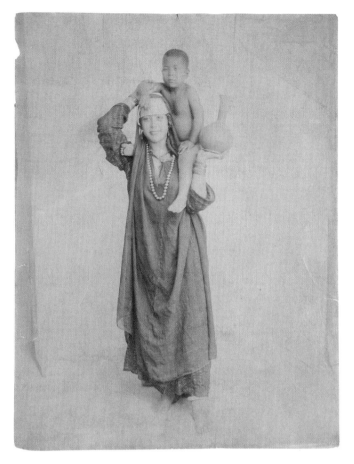

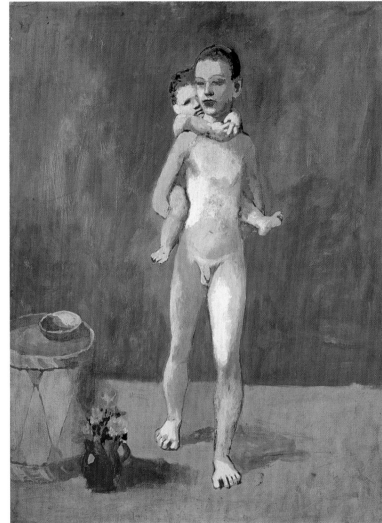

above
Fig. 38
Anonymous
Woman and Child
Egypt, 1860–1880
Albumen print
10 ³/₄ x 8 ¹/₄ in
(27.3 x 21 cm)
APPH 12512
Picasso Archives,
Musée Picasso, Paris

right
Fig. 39
Pablo Picasso
The Two Brothers
Gouache on cardboard
31 ⁵/₈ x 23 ³/₄ in
(80.3 x 60.2 cm)
MP 7
Musée Picasso, Paris

Fig. 40
Pablo Picasso
Three Nudes
Gosol, summer 1906
Gouache on paper
24 3/4 x 19 in (63 x 48.3 cm)
Alex Hillman
Family Foundation,
New York

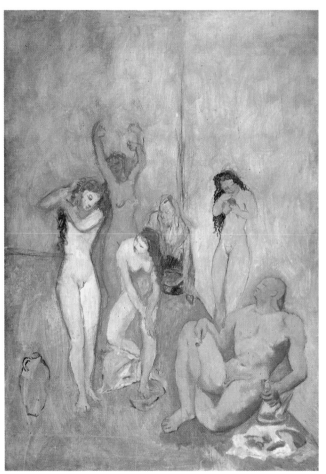

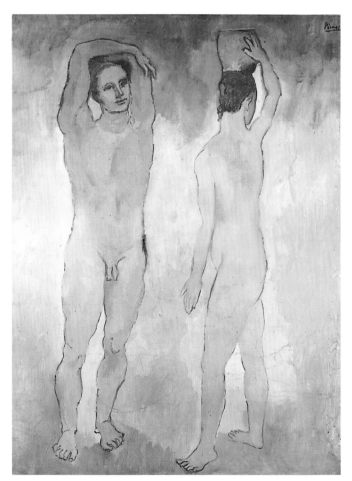

Fig. 41
Pablo Picasso
The Harem
Gosol, summer 1906
Oil on canvas
60 3/4 x 43 1/8 in (154.3 x 109.5 cm)
Bequest of Leonard C. Hanna Jr., 1958.45
© The Cleveland Museum of Art, 1997

Fig. 42
Pablo Picasso
Two Youths
[Gosol-Paris], 1906
Oil on canvas
61 3/4 x 46 1/8 in
(157 x 117 cm)
Musée National
de l'Orangerie, Paris

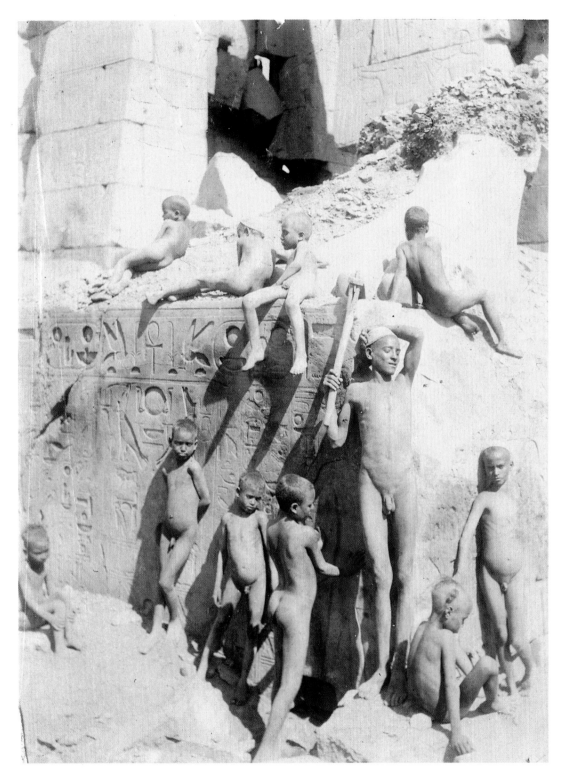

Fig. 43
Gugliemo Plüschow
Nude Youths
Karnak, 1897
Albumen print
8 ¹/₂ x 6 ³/₈ in (21.7 x 16.2)
APPH 12511
Picasso Archives,
Musée Picasso, Paris

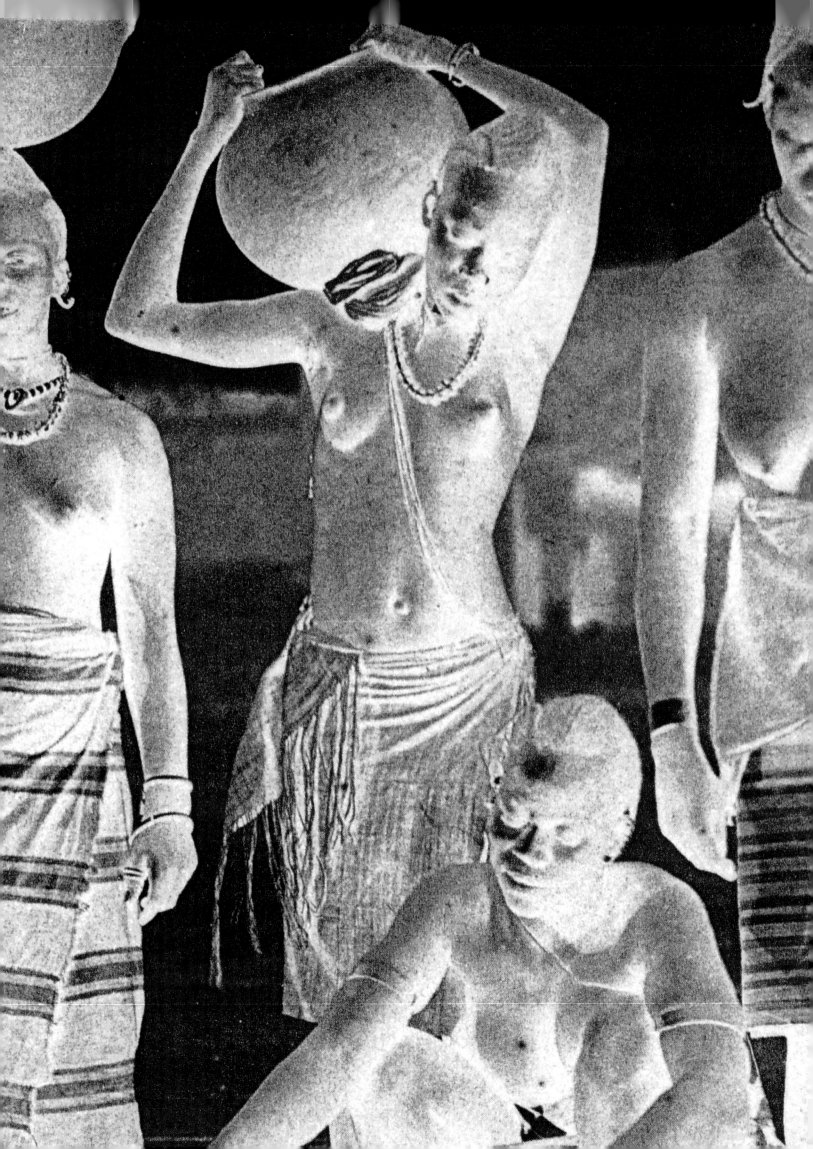

1906 ~ 1909
Grasping the Visible

In the fall of 1906, Picasso began the pictorial cycle that would culminate in *Les Demoiselles d'Avignon* (fig. 59). It has been argued that the *Demoiselles* represented "the invention of colored forms that no longer intended to imitate the external world but only to signify it. The canvas ceased to be a mirror—however deforming—of the visible, in order to become a plastic language [*écriture*]."[178] In the vast debate that still surrounds the genesis of that painting,[179] William Rubin has suggested that the arrangement of the models "may have been influenced by the frontal character of contemporaneous group photographs."[180] Waltraud Brodersen,[181] meanwhile, although unable to offer concrete evidence, also sensed a link between the painting and colonial photographic imagery.[182] Now some forty postcards have recently come to light in Picasso's archives, dating exactly from 1906, most of which claim to be "studies" of women from various African tribes, generally bare-breasted and often with arms raised over the head or folded behind the back. All these photographs were the work of Edmond Fortier, a Dakar-based photographer who was the most prolific publisher of postcards from French West Africa beginning in 1900–1901. According to Fortier expert Philippe David,[183] all the postcards in Picasso's collections date from Fortier's early series, based on photographic expeditions that included the major campaign of late 1905–early 1906.[184] It is therefore physically possible that Picasso came across them in Paris shortly after his return from Gosol.[185] Although research has not yet established the concrete circumstances of Picasso's acquisition of these postcards, the many visual correlations between the photographic images and Picasso's painting in 1906–1907 open the hypothesis to serious consideration.[186]

An African Source
for *Les Demoiselles d'Avignon*

The canvas *Profile of a Woman* (fig. 45),[187] painted in an overall brown that directly evokes photography, might easily be read as a rather literal interpretation of Fortier's *Malinké Woman* (fig. 44)[188] —a broad, pale brushstroke weds the contour of breast and back to the garment on the woman's shoulder, while the white-on-dark outline of the bust echoes the striped fabric in the photograph. The painted head, turned slightly away from the viewer, retains

the geometric arrangement of the hair and, thanks to the prominent cheekbone, mimics the hollow curve separating forehead and nose. As to the scroll-shaped ear, it perhaps merges an "Iberian" image with this African model's elaborate earring. Similarly, an entire series of photographs of African women could be compared, in terms of clear structural equivalences, to bust portraits painted in the winter of 1906–1907.[189] Comparison of the two groups even gives the impression that the canvases were attempting to grasp the distinctive identity of each of the anonymous models. Furthermore, Picasso would likewise base later works on old *carte-de-visite* photographs. It may well be these "found" images, rather than the faces of his friends, that enabled Picasso to forge, paradoxically, a veritable *portrait* technique.[190]

Two Nudes (fig. 46),[191] an important step toward the *Demoiselles*, also shares a number of features with a photograph of a Bobo couple (fig. 48).[192] Like the Fortier image, several preparatory sketches for this canvas[193] stress the physical disparity between the two figures and the gesture of the arm linking them. The final painting leveled them to an identical stature, as though the same figure were seen from opposite sides. Each of the muscular silhouettes is astonishingly similar to the Bobo man,[194] yet at the same time may owe something to postcards labeled *Young Cérère Woman* (fig. 49) and *Young Cérère None Woman*.[195] The analysis proposed here suggests that Picasso's paintings from this period retain a trace of the photography-inspired approach that partly underpinned them. Far from seeking to render his various anatomical borrowings plausible, Picasso apparently sought to retain the singularity and initial orientation of each fragment, openly playing on formal dissonances. The canvas would thereby result from a kind of visual *grafting* which allowed various juxtaposed entities to constitute so many contradictory formal signs. In this way—given the very lack of iconic verisimilitude—the paintings could express a brand-new language, in a decisive step toward Analytic cubism.

This analysis could be applied to several other recurring motifs in the genesis of the *Demoiselles*. Rather than an identical pose, it is the drawing of knees, the cylindrical volumes of legs and torso, and above all the linear reduction of harsh-lit modeling that links the photograph of the *Young Cérère None Woman*[196] to the *Standing Nudes*

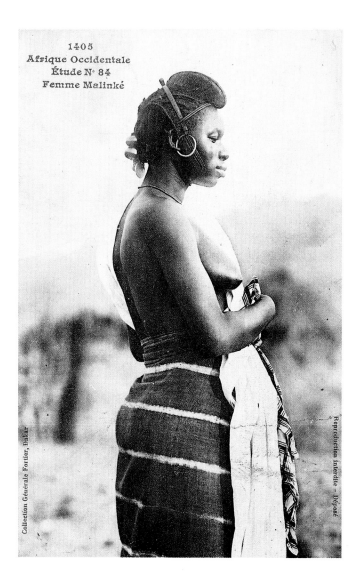

Fig. 44
Edmond Fortier
Malinké Woman
West Africa, 1906
Collotype (postcard)
APPH 14930
Picasso Archives,
Musée Picasso, Paris

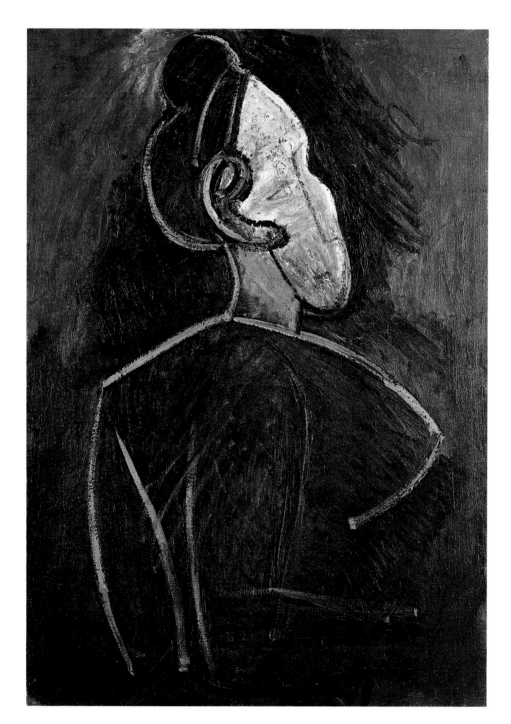

Fig. 45
Pablo Picasso
Profile of a Woman
Paris, winter 1906–1907
Oil on canvas
29 1/2 x 20 7/8 in
(75 x 53 cm)
Private collection

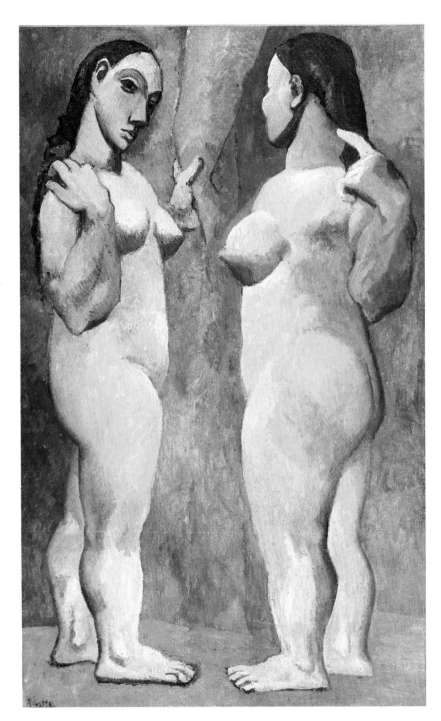

Fig. 46
Pablo Picasso
Two Nudes
Paris, autumn 1906
Oil on canvas
59 5/8 x 36 5/8 in (151.3 x 93 cm)
Gift of G. David Thompson
in honor of Alfred H. Barr, Jr., 1959
Photograph © The Museum
of Modern Art, New York

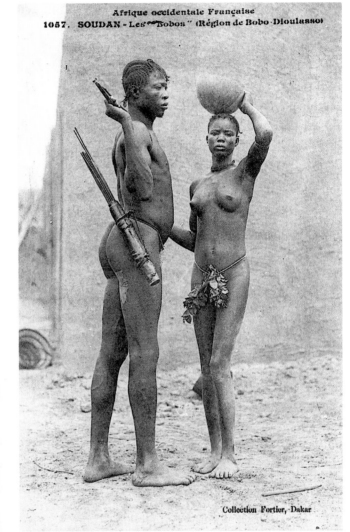

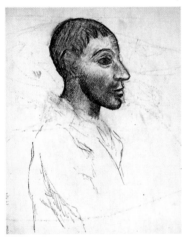

Fig. 47
Pablo Picasso
Study for the Medical Student:
Profile of a Man's Head
Pencil, pen and black ink
9 ⁵/₈ x 7 ⁵/₈ in (24.3 x 19.5 cm)
Carnet MP 1861, 23r
Musée Picasso, Paris

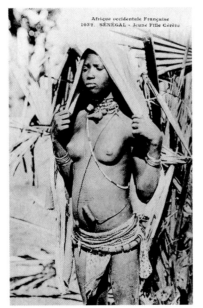

above
Fig. 48
Edmond Fortier
Bobo Couple
West Africa, 1905–1906
Collotype (postcard)
APPH 14918
Picasso Archives,
Musée Picasso, Paris

left
Fig. 49
Edmond Fortier
Young Cérère Woman
Senegal, 1905-1906
Collotype (postcard)
APPH 14916
Picasso Archives,
Musée Picasso, Paris

of April–May 1907,[197] the two studies known as *Front View of a Nude with Raised Arms*,[198] and the paintings *Woman with Clasped Hands*[199] and *Head and Shoulders of a Woman*.[200] In the same way, many of the approximate self-portraits (fig. 50) drawn late in 1906 could be compared to the postcard of a *Young Dancing Girl from the Kouroussa Region* (fig. 51).[201] Meanwhile, the muscular anatomy and helmet-like hair of the drypoints *Standing Nude I* and *II*,[202] the charcoal *Walking Nude in Profile*,[203] and certain sketches from Carnet 1 of the *Demoiselles*[204] may have been inspired by the two lateral figures of a trio of Foulbé women.[205]

My hypothesis is that each of the figures of *Les Demoiselles d'Avignon* (fig. 59) incorporates—via the many preparatory studies—formal elements derived from one or several of Fortier's postcards. Thus the woman on the left of the painting would be a simultaneous composite of the nude profiles, the pose of the Bobo man, and the posture of a *Sonrhai Girl*.[206] Indeed, the Sonrhai girl, who holds a bowl in her hand, could be linked to the male figure who, holding a skull or pulling back the curtain, originally prefigured the *demoiselle* in the final painting.[207] As far as the two central *demoiselles* go, a shared reference point could be found in the numerous photos of women with arms raised or thrown back. The standing figure might also be related to one of the Fortier "studies,"[208] in which the model's sharply bent arms almost exactly correspond to the watercolor *Profile of a Nude with Raised Arms*.[209] Her seated companion, meanwhile, recalls the image of a *Soussou Girl*[210] with one elbow upraised and the other at her waist, hand holding the folds of her cloth skirt. The *demoiselle* standing on the right, peering through a gap in the window, may be a transposition of an image of a Cérère girl pulling her head scarf aside (fig. 49).[211]

Although the overall composition of the painting went through several stages in terms of the number and arrangement of figures (fig. 58), "Picasso seemed to have had in his mind a clear and detailed image of what he wanted to do at the moment that he attacked the canvas."[212] I would suggest that a Fortier postcard titled *Types of Women* (figs. 57, 60, 63) contributed to the formulation of this initial scheme. Picasso would certainly have been struck by the hieratic frontality of this array of females, squatting on the ground or standing with arms raised. In addition to the multiple pictorial allusions naturally accruing to the subject of a brothel scene, then, this photograph may have provided formal ideas for the genesis of certain specific figures and the overall staging. The geometry of the arms of the women labeled C and G in the diagram[213] is echoed in the exploratory *Nude with Raised Arms Seen from the Front* (fig. 60, 61)[214] and *Nude with Raised Arms Seen from the Back*,[215] while figure G may have served as the basis for the *demoiselle* pulling back the curtain[216] as well as the one seated in the middle.[217] Similarly, the three squatting

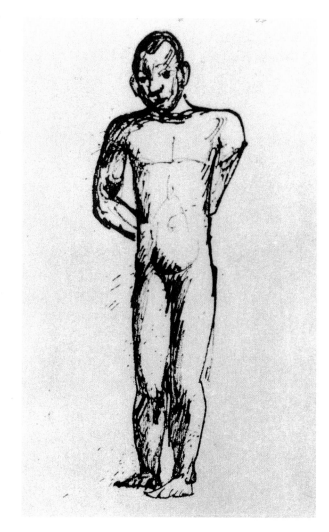

Fig. 50
Pablo Picasso
Nude Youth with Hands Behind His Back
Paris, 1906
India ink on paper
12 1/2 x 9 1/2 in (31.7 x 24 cm)
Succ. 859
Private Collection

women, particularly model H, may have ultimately led to the *demoiselle* with legs wide apart (figs. 63, 64).[218] For the overall composition, Picasso would have focused on the central group alone, retaining the powerful pattern of triangles and the rhythmic orchestration of striped fabrics and hemispherical gourdes (vestiges of which remain in the slice of watermelon on the corner of the table). Leo Steinberg pointed out how this painting "maintains a relentless consistency in isolating each figure" and makes the two on the right appear as "negative shapes reserved on dark ground."[219] This effect may stem from the way that

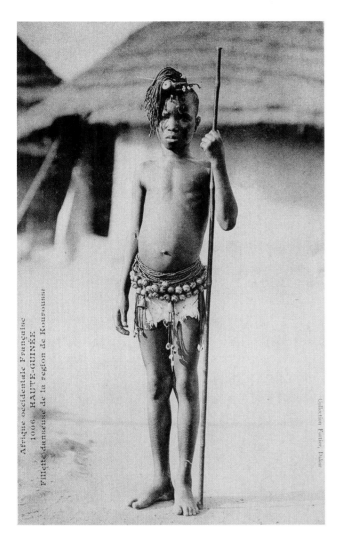

*Afrique occidentale Française
1006 HAUTE-GUINÉE
Fillette danseuse de la région de Kouroussa*

Collection Fortier, Dakar

Fig. 51
Edmond Fortier
*Young Dancing Girl
from the Kouroussa Region*
West Africa, 1905–1906
Collotype (postcard)
APPH 14908
Picasso Archives,
Musée Picasso, Paris

Picasso retained the stark visual contrast of the African photograph, all the while reversing the values (not unlike the retinal persistence of vision in negative, as described by Goethe).[220] In an almost photographic process, he could have treated this image as the "negative" of the painting to come, translating the dark figures of these women at the market into luminous silhouettes: black becomes pink. The pale background values of the photo, shifted vertically, become the semi-abstract bands that close the space of the painting.

The sketchbooks for the *Demoiselles* connect these preparatory drawings to the morphological experiments inspired by Josep Fontdevila, Picasso's innkeeper at Gosol. In this respect, it is worth noting a *carte-de-visite* photo (fig. 65) probably depicting an old Maori man, as well as a Laotian postcard showing a *Group of Nhahoeums* (fig. 68).[221] These photographs may be linked, respectively, to the various portraits of Fontdevila (figs. 66, 69)[222] and to the geometric *Sketch of André Salmon / Head of Man (Josep Fontdevila)* (fig. 67).[223] Just as shared physiognomic structures allowed Picasso to conflate the old innkeeper with André Salmon,[224] so these photographic figures from Asia and Oceania may have found a place in Fontdevila's imaginary genealogy.

Once the *Demoiselles* was completed, the theme of women with raised arms inspired an entire series of works, including the *Nude with Raised Arms* (fig. 71) of 1908.[225] Its proto-cubist manner and the muted violence of its earthy coloring distill the emotional and sensual charge of African photographs (fig. 70) and more directly anticipate the watershed of the Horta de Ebro period. Discussing that period, I once noted—though without realizing the full significance—the words scribbled by Picasso in the spring of 1909: "Feminine humanity, female of Africa."[226] These words assume new resonance in the light of Edmond Fortier's models, who present the gaze with their distant otherness. Like sculpture, they bore ritual scars and exotically architectured hairdos, along with all their finery, foliage, and fabrics. And yet their naked bodies were there before Picasso's eyes, alive and contemporary. Gelett Burgess reported the following exchange with Picasso: "You ask if he uses models, and he turns to you a dancing eye. 'Where would I get them?' grins Picasso, as he winks at his ultramarine ogresses."[227] In an equally elliptical way, Picasso declared in 1920, "African art? Never heard of it."[228] So we are supposed to believe that neither *life* models nor primitive *art* were behind *Les Demoiselles d'Avignon* (fig. 59).[229] Yet the first viewers of the *Demoiselles* who "thought they looked like blacks"[230] or who once spoke of Picasso's "Negro period"[231] were perhaps unwittingly closer to an *other* truth; one that, I would suggest, reveals the faces and bodies of these African women to be a possible source of his proto-cubist inventiveness.

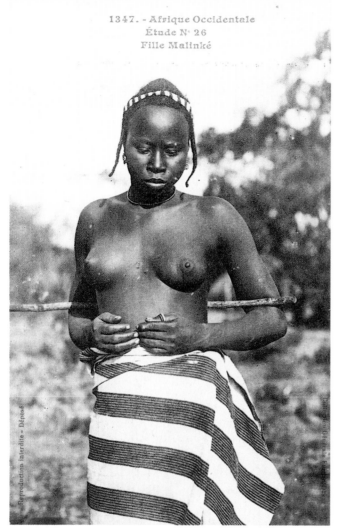

above
Fig. 52
Edmond Fortier
Malinké Girl
West Africa, 1906
Collotype (postcard)
APPH 14959
Picasso Archives,
Musée Picasso, Paris

right
Fig. 53
Pablo Picasso
Head of a Man
Paris, 1908
Oil on wood
10 5/8 x 8 1/4 in (27 x 21 cm)
Hermann-und-Margrit-Rupf-
Stiftung, Kunstmuseum Bern

above
Fig. 54
Pablo Picasso
*Nude with Hands Behind Back
and Profile of a Nude*
Paris, June-July 1907
Pencil and watercolor on paper
12 1/4 x 9 3/4 (31.2 x 24.7 cm)
Carnet 13, MP 1990-96, 2r
Musée Picasso, Paris

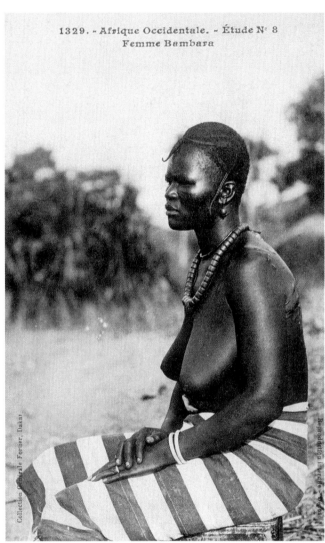

Fig. 55
Pablo Picasso
Head and Shoulders
of a Woman
Paris, summer 1907
Oil on canvas
26 x 23 ¹/₄ in (66 x 59 cm)
Musée National d'Art Moderne,
Paris

Fig. 56
Edmond Fortier
Bambara Woman
West Africa, 1906
Collotype (postcard)
APPH 14935
Picasso Archives,
Musée Picasso, Paris

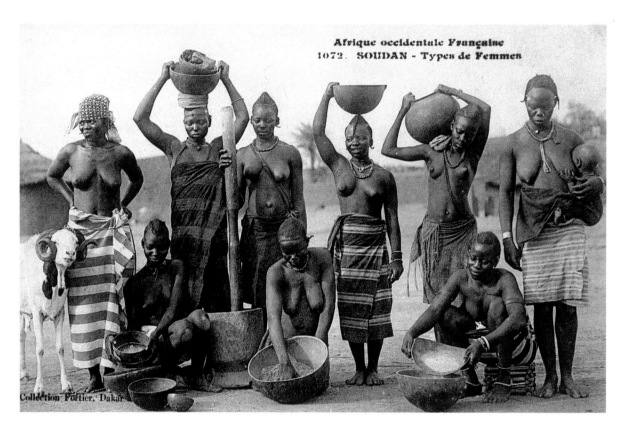

Fig. 57
Edmond Fortier
Types of Women
West Africa, 1906
Collotype (postcard)
APPH 14902
Picasso Archives,
Musée Picasso, Paris

Fig. 58
Pablo Picasso
Study for "Les Demoiselles d'Avignon"
May 1907
Pen and black ink
3 ¹/₄ x 3 ¹/₂ in (8.2 x 9 cm)
MP 533
Musée Picasso, Paris

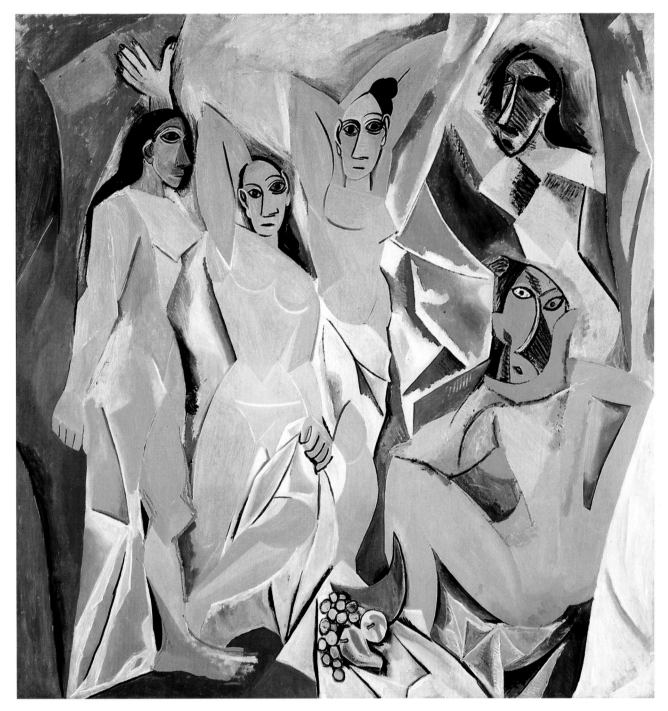

Fig. 59
Pablo Picasso
Les Demoiselles d'Avignon
Paris, 1907
Oil on canvas
96 x 92 in (243.9 x 233.7 cm)
Acquired through
the Lillie Bliss Bequest
Photograph © 1997
The Museum of Modern Art,
New York

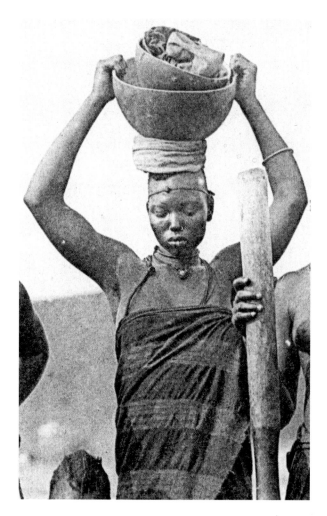

Fig. 60
Edmond Fortier
Types of Women
(detail, woman C)

Fig. 61
Pablo Picasso
Nude with Raised Arms
Seen from the Front
Paris, 1907
Oil, pencil,
and charcoal on paper
51 ⁵/₈ x 31 ¹/₄ in
(131 x 79.5 cm)
MP 13
Musée Picasso, Paris

above
Fig. 62
Pablo Picasso
Head of Woman in Red
Paris, 1906–1907
Gouache on paper
24 ³/₄ x 18 ¹/₂ in
(63 x 47 cm)
Musée National
d'Art Moderne, Paris

above right
Fig. 63
Edmond Fortier
Types of Women
(detail, woman H)

Fig. 64
Pablo Picasso
Study for Squatting Demoiselle
Paris, March-July 1907
Pencil on paper
7 ⁵/₈ x 9 ⁵/₈ in (19.5 x 24.3 cm)
Carnet 9, MP 1861, 47r
Musée Picasso, Paris

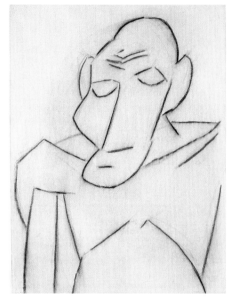

Fig. 66
Pablo Picasso
Head of a Man
[Gosol, 1906]
Gouache and watercolor
on Japan paper
16 x 13 ³/₄ in (40.7 x 35 cm)
Private collection

Fig. 67
Pablo Picasso
Sketch of André Salmon
[*Head of a Man*
(Josep Fontdevila)]
Paris, 1907
Charcoal on paper
24 ³/₄ x 18 ⁷/₈ in (63 x 48 cm)
The Menil Collection, Houston

Fig. 65
The American Photo Company
Head of a Man [Maori]
[New Zealand, c. 1880]
Albumen print (*carte de visite*)
APPH 3444
Picasso Archives,
Musée Picasso, Paris

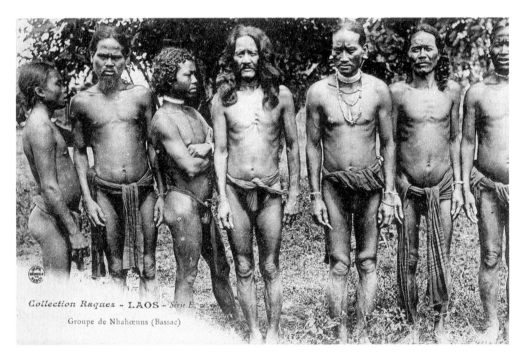

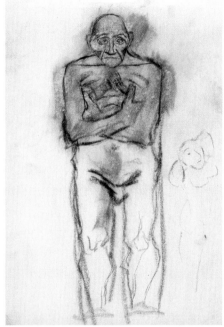

Fig. 68
A. Raquez, Hanoi
Group of Nhahoeums
Laos, [1905–1906]
Collotype (postcard)
APPH 14948
Picasso Archives,
Musée Picasso, Paris

Fig. 69
Pablo Picasso
Portrait of Josep Fontdevila
and Sketch of Nude
with Raised Arms
Autumn 1906
Pencil and ink wash
10 ¹/₄ x 7 ⁷/₈ in (26 x 20 cm)
Carnet 7, MP 1858, 47r
Musée Picasso, Paris

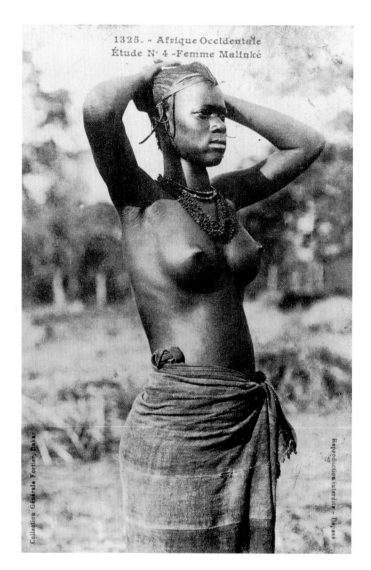

Fig. 70
Edmond Fortier
Malinké Woman
West Africa, 1906
Collotype (postcard)
APPH 14940
Picasso Archives,
Musée Picasso, Paris

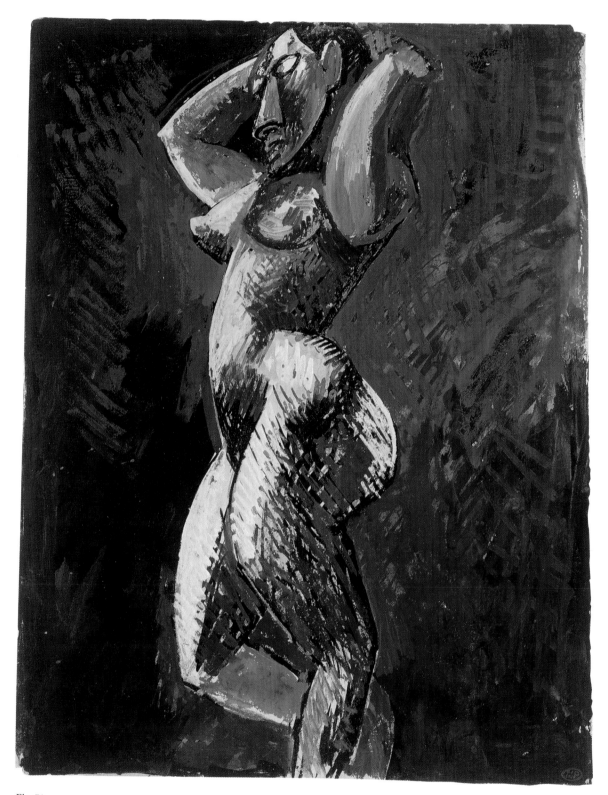

Fig. 71
Pablo Picasso
Nude with Raised Arms
Paris, spring 1908
Gouache on paper
12 ⁵/₈ x 9 ⁷/₈ in (32 x 25 cm)
MP 575r
Musée Picasso, Paris

The Bateau-Lavoir Lab

The photographs taken by Picasso at his studio in the Bateau-Lavoir in Montmartre appear to represent several discrete series, as though he sought to reproduce the working method he applied to the Fortier postcards and the Egyptian portfolio. All these series lend themselves to the pictorial game of either combining elements specific to each photograph or, to the contrary, conflating identical features. Composed of strikingly studied images, they inaugurate a more systematic approach to photography, one that employed posed portraits to effect a careful staging of the studio and works in progress. The notable effect of these photos is to reduce subject and space, sitter and paintings, to a single plane and single range of values. During the Blue and Rose Periods, studio photographs with their plain or sfumato backdrops had contributed to the search for an abstracting monochrome. The movement toward cubism, on the other hand, explored the spatial *passage* of a body into its surroundings in order to organize the pictorial plane along new coordinates.

"Cézannesque" volumetrics and analytic puzzles, then, were fostered by the study of a different type of photograph—ones in which the contiguity of forms wed an illusionist representation of reality to a two-dimensional orchestration of tonal values, thereby spurring a reinterpretation of the picture plane. In these photos, the scale, physical density, and photogenic surface of the live sitter merge with those of depicted figures, as though Picasso contrived this laboratory of images in order to compare and occasionally swap their respective visual effects.

Thus in the winter of 1907–1908, Picasso produced a series of photographic portraits taken in front of a work in progress, *Three Women* (fig. 72).[232] Those pictured in front of this canvas were, in turn, André Salmon (fig. 73), Sebastià Junyer Vidal (fig. 74), and Dolly van Dongen alone and then with Fernande Olivier (fig. 76).[233] Poet, painter, child: each of these photographs contrasts a static human subject with the powerful swirl of the pictorial composition. The lurid effect of the canvas must be restored to the photos in order to convey all the power of a confrontation in which painting and live subject measure themselves against photography's yardstick. The photo showing Dolly and Fernande apparently inspired the overall composition of *Mother and Child* (fig. 77).[234] In a spiraling process that will be seen to recur later, Picasso perhaps had a new painting in mind when he staged live models with canvas.

Another series of images with *Three Women* in the background features a succession of smaller canvases: a 1902 *Portrait of a Man*,[235] *Female Figure* from the summer of 1907,[236] and still lifes such as *Pitcher, Bowl and Fruit Bowl*,[237] *Green Bowl and Black Bottle*,[238] and *"Composition with Skull" in the Bateau-Lavoir Studio* (fig. 78).[239] The right

side of another—probably earlier—photograph (fig. 79) offers a glimpse of *Les Demoiselles d'Avignon*, still in progress. The pyramidal organization of the photo's dense composition of paintings, drawings, sculptures, and objects suggests that it may have served as the matrix for *Composition with Skull*. Indeed, in the optical center of that painting is an inverted image of a female figure comparable to the study for *Standing Nude*[240] that occupies a symmetrical position in the photo. Similarly, the architecture of the skull echoes the charcoal *Head of Josep Fontdevila* seen on the left of the print.[241] The stack of books, palette, and brushes may also reflect the foreground of the photograph.[242] The canvas thereby condenses all these elements of the studio into an ideogrammatic *memento mori*, perhaps inspired by the suicide of Karl-Heinz Wiegels, a young Bateau-Lavoir painter.

Also from that period come three portraits showing Fernande (fig. 82), Picasso (fig. 80), and a young man (fig. 81), all of whom pose in front of a dark cloth tacked to the wall in crude mimicry of a photographer's studio. Unlike the photos described above, this setting seeks to eliminate the visual distractions of the artist's workshop in order to focus attention on each of the sitters. The unequal height of Fernande's shoulders, as William Rubin suggested during the *Picasso and Portraiture* exhibition, may have partly inspired the pre-cubist *Woman with a Fan* of 1908. The portrait of the man, meanwhile, surprisingly includes a plaster model of a famous bust, the *Lady of Elche*. The recent identification of this man[243] may imply a date during the first half of 1908 for this series.[244] It would also explain the presence of a copy of the bust in the Bateau-Lavoir, a presence underscoring the bust's importance as one of Picasso's "Iberian" sources,[245] too often limited to Osuna reliefs and primitive heads from Cerro de los Santos.

Picasso explored a new approach to photography with twin portraits (figs. 83, 84) of art dealer Clovis Sagot in the spring of 1909. Sagot—seated legs apart, hands on knees—is first seen frontally and then in profile, before two sets of paintings executed over the previous ten years. The photos were clearly done in preparation for the *Portrait of Clovis Sagot* (fig. 85),[246] the first of the great portraits from this period of nascent cubism.[247] The front-and-profile approach inevitably evokes not only the then-recent method of criminal identification,[248] but also a "photosculpture" process that claimed to produce busts that were "perfect likenesses" from several photographs of a sitter.[249] Rather than these technical allusions, however, Picasso was probably responding to Rodin's appeal to sculptors to go beyond photographic immutability—yet without rejecting his "theory of profiles"[250]—in order that their work will "still allow one partly to discern what was, and partly to discover what will be."[251] Indeed, that scheme is not far removed from cubism's program to break with a single viewpoint. In this respect, it is worth noting that in the

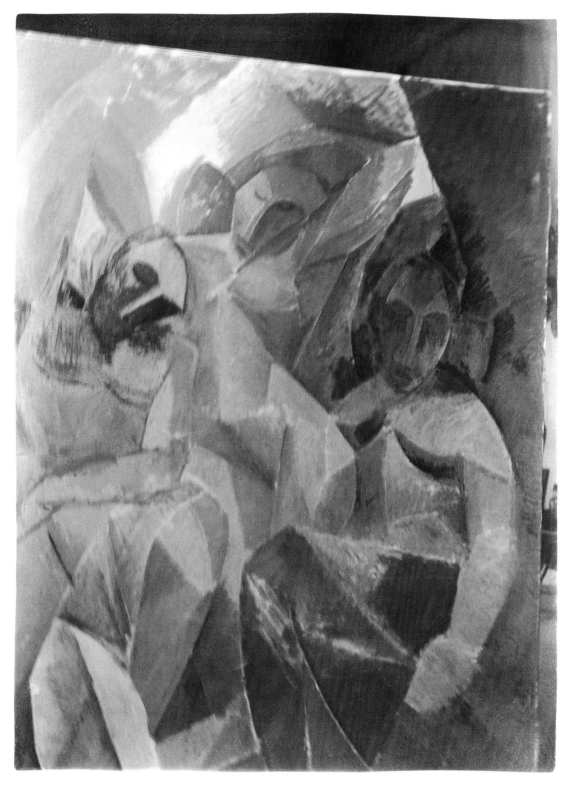

Fig. 72
Pablo Picasso
"Three Women"
in the Bateau-Lavoir Studio
Paris, summer 1908
Gelatin silver print
4 ¹/₄ x 3 ¹/₄ in (10.9 x 8.1 cm)
Private collection

Fig. 73
Pablo Picasso
Portrait of André Salmon in Front of "Three Women"
Paris, Bateau-Lavoir, spring-summer 1908
Gelatin silver print
4 3/8 x 3 1/4 in (11.1 x 8.1 cm)
APPH 2831
Picasso Archives, Musée Picasso, Paris

Fig. 74
Pablo Picasso
Portrait of Sebastià Junyer Vidal in Front of "Three Women"
Paris, Bateau-Lavoir, summer 1908
Gelatin silver print
4 ³/₈ x 3 ³/₈ in (11 x 8.5 cm)
APPH 2807
Picasso Archives, Musée Picasso, Paris

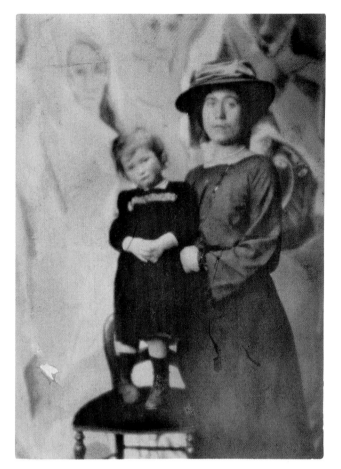

Fig. 75
Pablo Picasso
Guus van Dongen
with Dolly in Front
of "Les Demoiselles d'Avignon"
Paris, Bateau-Lavoir, 1907–1908
Gelatin silver print
7 x 5 ¹/₈ in (17.7 x 13 cm)
Jeanine Warnod Archives, Paris

Fig. 76
Pablo Picasso
Fernande Olivier
and Dolly van Dongen
in the Bateau-Lavoir Studio
Paris, 1908
Gelatin silver print
7 x 5 ¹/₈ in (17.7 x 13 cm)
Jeanine Warnod Archives, Paris

interval separating the two Sagot photographs, everything has been changed and moved—art works, the sitter's pose, and their relationship to space and the photographer's eye. To a certain extent, the classic three-quarter pose seen in the canvas represents an illusionist synthesis of the volumes presented by the photographs from two different points of view. Yet discrepancies between the two views also pave the way for an approach in which the ambivalence of the gaze becomes the very object of painting. With this *Portrait of Clovis Sagot* (fig. 85), the photographic contiguity of sitter and surrounding art works, moreover contributes to a geometric mutation in the handling of the body not unrelated to the "Cézannesque principles" adopted by Picasso following the 1907 Cézanne retrospective.

Picasso's paintings were staged differently in another photograph (fig. 86) dating from that same spring of 1909.

The format was altered by an enigmatically precise cut into one side of the photo. A top-to-bottom line suggested by the right and left edges of two paintings, one above the other, creates the illusion of a plain white vertical band, while the incision into the lower painting, *Seated Nude,* further conflates it with the background. The optical weave of real planes (wall, angle formed by the two paintings) with lines internal to the works, as well as the cropped line of the print, thereby sparks so much perceptual uncertainty that the geometry of angles, shadows, and light tends to overwhelm a realistic vision. The formal breakthrough represented by this photographic work is of a scope that places it beyond the scheme governing the *Portrait of Clovis Sagot* (fig. 85)—it already prefigures the rupture that the *papiers collés* imposed on the system of spatial representation.

Fig. 77
Pablo Picasso
Mother and Child
Paris, [1908]
Oil on canvas
31 $^7/_8$ x 23 $^5/_8$ in
(81 x 60 cm)
MP 19
Musée Picasso, Paris

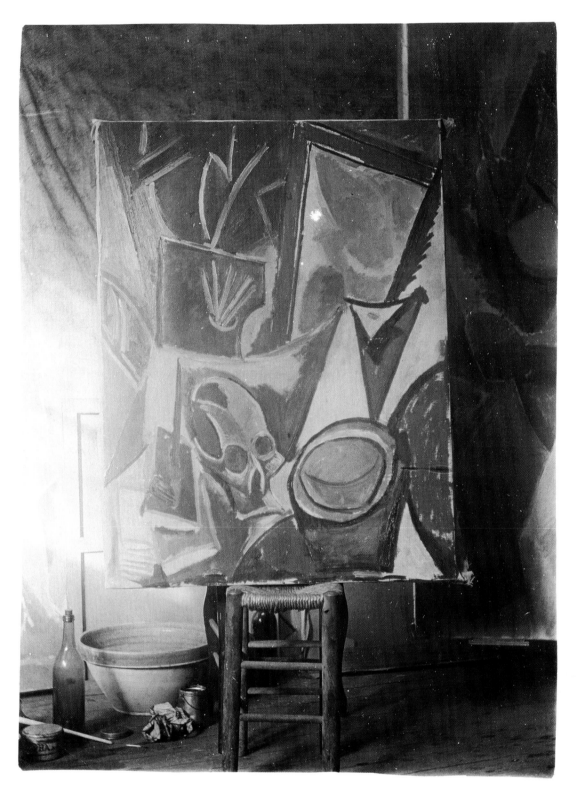

Fig. 78
Pablo Picasso
"Composition with Skull"
in the Bateau-Lavoir Studio
Paris, summer 1908
Gelatin silver print
4 ¹/₄ x 3 ¹/₄ in (10.9 x 8.1 cm)
Private collection

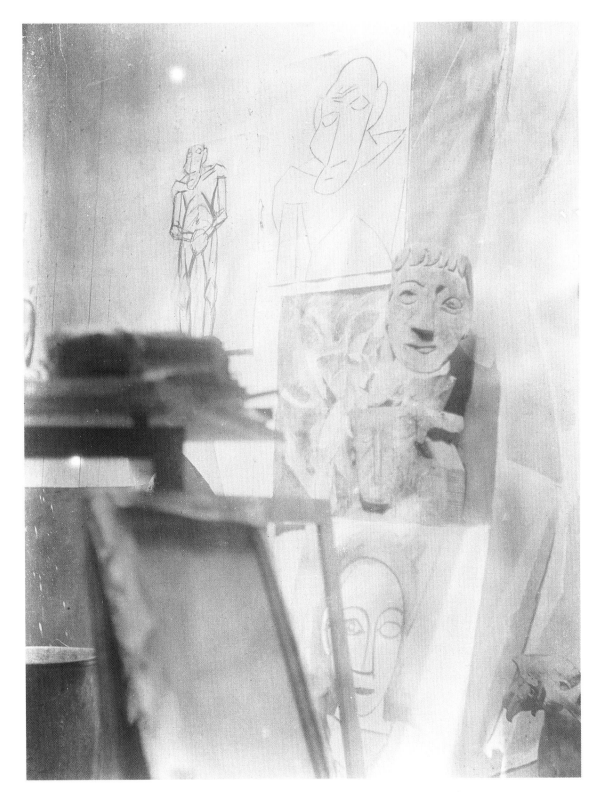

Fig. 79
Pablo Picasso
"Study for Standing Nude"
in the Bateau-Lavoir Studio
Paris, spring 1908
Gelatin silver print
4 ³/₈ x 3 ¹/₄ in (11.1 x 8.1 cm)
Private collection

Fig. 80
[Pablo Picasso]
Self-Portrait
Paris, Bateau-Lavoir, [1908]
Gelatin silver print
6 ³/₄ x 4 ³/₄ in (17 x 12.2 cm)
APPH 2810
Picasso Archives,
Musée Picasso, Paris

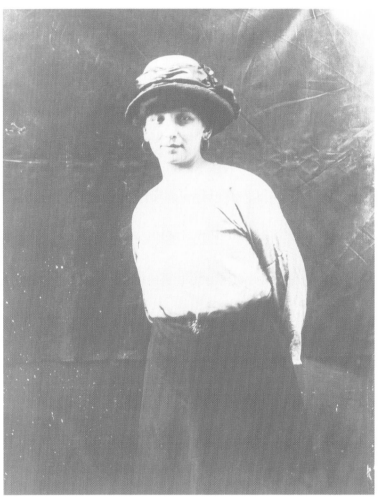

Fig. 81
Pablo Picasso
Portrait of Ignacio
Pinazo Martinez
Paris, Bateau-Lavoir, [1908]
Gelatin silver print
6 3/4 x 4 7/8 in (17 x 12.3 cm)
APPH 2805
Picasso Archives,
Musée Picasso, Paris

Fig. 82
Pablo Picasso
Portrait of Fernande Olivier
Paris, Bateau-Lavoir, [1908]
Gelatin silver print
4 7/8 x 3 3/4 in (12.4 x 9.6 cm)
FPPH 20
Gift of Sir Roland Penrose
Picasso Archives,
Musée Picasso, Paris

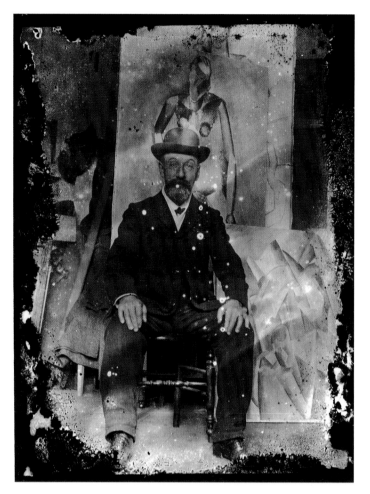

Fig. 83
Pablo Picasso
Portrait of Clovis Sagot (frontal)
Paris, Bateau-Lavoir, spring 1909
Modern gelatin silver print
from original glass negative no. 38
Picasso Archives,
Musée Picasso, Paris

above
Fig. 84
Pablo Picasso
Portrait of Clovis Sagot (profile)
Paris, Bateau-Lavoir, spring 1909
Modern gelatin silver print
from original glass negative no. 39
Picasso Archives,
Musée Picasso, Paris

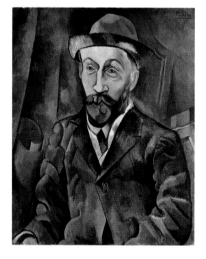

left
Fig. 85
Pablo Picasso
Portrait of Clovis Sagot
1909
Oil on canvas
32 1/4 x 26 in (82 x 66 cm)
Hamburger Kunsthalle,
Hamburg

Fig. 86
Pablo Picasso
"Woman with a Book" in progress
Paris, Bateau-Lavoir, spring 1909
Cropped gelatin silver print
4 3/8 x 2 in (11 x 5.1 cm)
Private collection

A Summer in Horta

The summer of 1909, which Picasso spent in the village of Horta de Ebro, represented a decisive moment in the maturation of cubism. As noted above, the advance preparations for this trip pointed to a photo-pictorial project.[252] Indeed, Picasso took numerous photographs, one of which perfectly encapsulates his personal rite of self-portraiture (fig. 87). Whereas the images recorded by his photographer friends throughout his life are noteworthy for the legendary mordancy of the artist's gaze and expression, here the eyes are vacant—the sitter seems lost in some existential digression while listlessly waiting for the shutter to click. Then there is the revealing placement of the camera which, set very low, shrinks head and trunk while magnifying legs and crotch. The low angle also creates a large blank space above the artist. Here, the white wall radiates; elsewhere, as will be seen, it afforded space to construct an entire wall of paintings.

Picasso also did a veritable photo spread on the village of Horta.[253] Shortly after their arrival, Fernande wrote, "People here think we are photographers, and everyone has been delighted to have themselves 'done in a portrait,' as their saying goes." Apparently unaware of Picasso's experience in the matter,[254] Fernande added that "it is all due to the camera that Pablo unjustly clutches, since he barely knows how to use it. That's how reputations are made."[255] The twenty or so photographs of the inhabitants of Horta hardly confirm Fernande's hasty judgment. Picasso inventoried groups, family acquaintances, and men, such as a seated guitarist (fig. 90). Above all, he recorded a series of mothers and grandmothers presenting their youngest offspring (figs. 88, 89). Details like a giant doll, baroque ornament, and dazzling white linen suffice, from one picture to another, to evoke the intensity of this Mediterranean ritual.

Several days after Fernande's letter, Picasso himself wrote to the Steins. "I have begun two landscapes and two figures. Same thing as usual. I'm thinking of taking photos of here. I'll send them to you when I have them. The country is very beautiful."[256] Later, Gertrude Stein liked to comment, in a paradoxical tautology, that the photographs of the Horta landscape[257] would prove "how naturally cubism was made in Spain."[258] These three photographs nevertheless call for a more dialectical analysis.[259] The "reservoir" is seen first from above, its walls forming an ellipse (fig. 91). The houses that stagger into the distance overlook an arid valley. The second photo (fig. 93), taken somewhat further back, brings into the foreground the roofs and facades of the houses flanking the reservoir. The last photograph (fig. 94) shows a circular patch of ground, probably used for threshing wheat and fighting bulls. A closer look reveals that this angle provides a perfect "countershot" to the first two shots, along an axis linking the "arena" to the "reservoir." This series thus offers two points of view—from above in two of the photos, from below in the third. Two poles are symbolically juxtaposed—a ring of water and a ring of blood.

Numerous visual paradoxes have been noted in the two "reservoir" photographs,[260] such as the visual alignment of rooftop ridges that are in reality separated in space, and the ambiguous arrangement of shadows and light. This ambiguity affects the apparent contours of volumes and the layering of planes, thereby offering correspondences with Cézannesque principles of handling space by tipping it up toward the pictorial surface. In fact, it would be possible to consider this as an equivalent to Cézanne's *passages*, although their effectiveness is basically chromatic.[261] Picasso's paintings of *The Reservoir* and *Houses on the Hill* (fig. 92) clearly depict many of the architectural elements seen in these two photographs. The high-angle view of the two photographs nevertheless leads to a whole series of divergences from ordinary perspective—vertical lines converge toward the bottom while horizontal lines appear distorted, producing the impression, in several places, that volumes "open" upward. Furthermore, the apparent rise of the horizon line may lead to the perception that the most distant buildings, although slightly lower down, are situated above. All these ambiguities in the photographic record were transcribed—even as their significance was totally reversed—first in the drawings and then in the paintings, which combine two handlings of perspective that are, in theory, incompatible: an overall space apparently viewed from a low angle (the houses "on the hill") was composed of elements seen from above. An illusionist reading of the overall space "depicted" by *The Reservoir* and *Houses on the Hill* (fig. 92) would therefore be much closer to the third photograph (where the upper part of the village truly overlooks the orb of the "arena"), even though the architectural elements are in fact borrowed from the first two photographs. In sum, the paintings employ their own internal logic to combine the strictly antagonistic information and viewpoints of the shot/countershot established by the photographs.[262] This can occur only through of a kind of visual folding of depicted space, quite legible in *The Reservoir*. Thus, even when Picasso's painting directly borrows from photographs, it is something other than "a too photographic copy of nature."[263]

Picasso wrote to Stein in a subsequent letter that, "I am working and tomorrow I will send you photographs that I have taken of here and of my paintings." Several times that summer he announced other dispatches. Like the photos taken in the Bateau-Lavoir, these studio shots provided a kind of spatio-temporal précis of the work in progress. In the background common to all these photographs, the wall offers an unchanging set of landscapes, portraits, still lifes, drawings, and paintings that sum up the initial stages of the artistic exploration undertaken that summer. In front of this background are placed works,

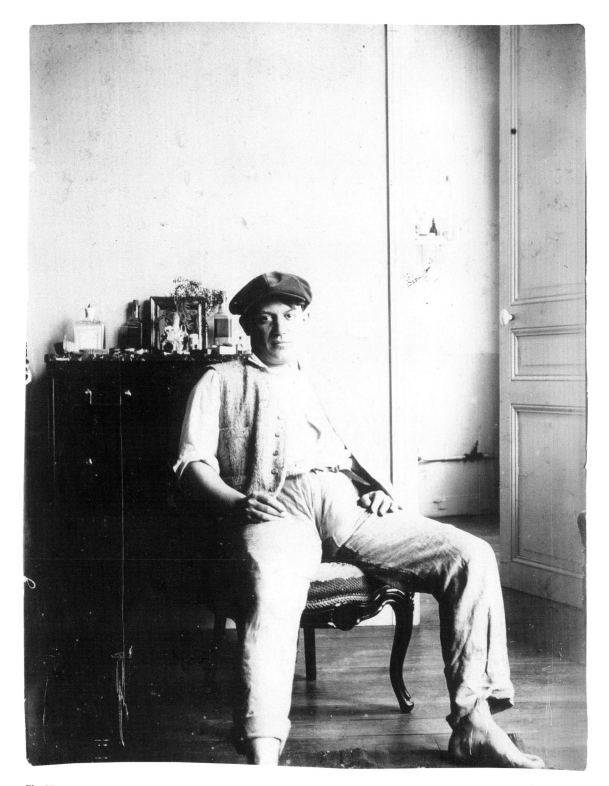

Fig. 87
Pablo Picasso
Self-Portrait
Horta de Ebro, 1909
Gelatin silver print
4 ³/₈ x 3 ³/₈ in (11.1 x 8.6)
APPH 2803
Picasso Archives,
Musée Picasso, Paris

Fig. 88
Pablo Picasso
Portrait of Woman with Child
Horta de Ebro, 1909
Gelatin silver print
4 ³/₈ x 3 ¹/₈ in (11 x 8 cm)
APPH 2854
Picasso Archives,
Musée Picasso, Paris

Fig. 89
Pablo Picasso
Portrait of Woman with Little Girl
Horta de Ebro, 1909
Gelatin silver print
4 ¹/₄ x 3 ¹/₈ in (10.8 x 8 cm)
APPH 2855
Picasso Archives,
Musée Picasso, Paris

opposite page
Fig. 90
Pablo Picasso
Portrait of a Guitar Player
Horta de Ebro, 1909
Gelatin silver print
4 ¹/₄ x 3 ¹/₄ in (10.9 x 8.1 cm)
APPH 2849
Picasso Archives,
Musée Picasso, Paris

Fig. 91
Pablo Picasso
Landscape, Horta de Ebro
(The Reservoir)
Horta de Ebro, 1909
Gelatin silver print
9 x 11 ³/₈ in (23 x 29 cm)
APPH 2830
Picasso Archives,
Musée Picasso, Paris

Fig. 92
Pablo Picasso
Houses on the Hill
Horta de Ebro, summer 1909
Oil on canvas
25 ⁵/₈ x 31 ⁷/₈ (65 x 81 cm)
Nelson A. Rockefeller Bequest
The Museum of Modern Art,
New York

Fig. 93
Pablo Picasso
Landscape, Horta de Ebro (The Reservoir)
Horta de Ebro, 1909
Gelatin silver print
9 x 11 ³/₈ in (23 x 29 cm)
APPH 2809
Picasso Archives, Musée Picasso, Paris

often grouped in pairs, that constitute so many similar yet different "studios" (fig. 95). The juxtaposition of canvases of almost identical dimensions, such as *Head of a Woman with Mountains in the Background*[264] and *Head of a Woman (Fernande)*,[265] seems to offer two subtly shifted states of the same figure. In contrast, the encounter of *Nude in an Armchair*[266] and *Woman with Pears* (fig. 96)[267] works like a brutal zoom on the subject, bringing a corner of a table and some fruit into focus. Such effects work counter to the principle of old stereoscopic viewers,[268] in which the simultaneous view of two photos from slightly different angles reproduced the impression of depth.

Here, the binary juxtaposition of paintings attempts instead to sharpen visual dissonances, to spark an impossible convergence of binocular vision. In the next stage, Picasso would proceed to superimpose two studio photographs (fig. 97) in which a total of seven canvases can be identified. Pictorial faceting is thus multiplied by optical vibrations that intermittently offer glimpses of one or the other of the superimposed works. The perceptual equivocation of this photographic fusion of two images generates a second "reality"—one that is more complex and ambiguous, and that prefigures the development of Analytic cubism up to its so-called "hermetic" phase.

Fig. 94
Pablo Picasso
Landscape, Horta de Ebro (The Open Ring)
Horta de Ebro, 1909
Gelatin silver print
9 x 11 ³/₈ in (23 x 29 cm)
APPH 2804
Picasso Archives, Musée Picasso, Paris

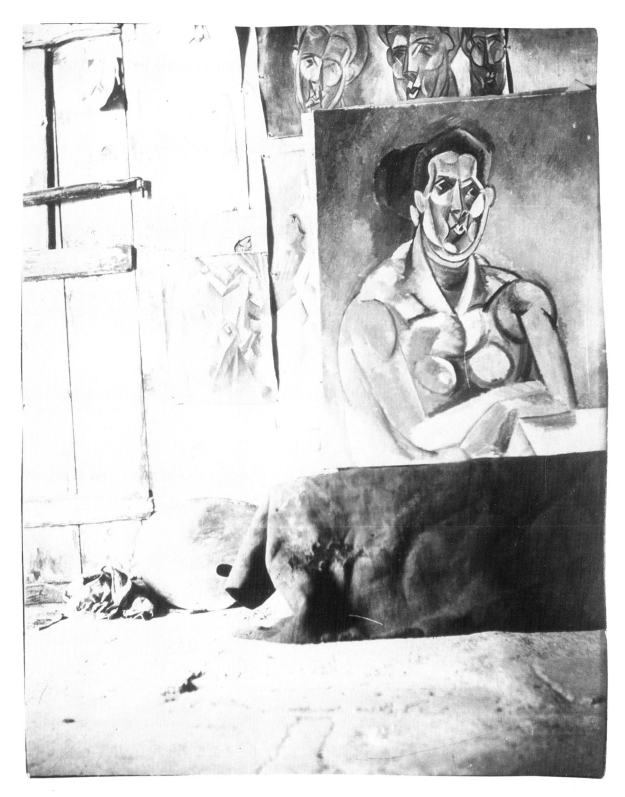

Fig. 95
Pablo Picasso
The Horta de Ebro Studio
("Bust of a Woman")
Horta de Ebro, summer 1909
Gelatin silver print
4 ³/₈ x 3 ¹/₂ in (11 x 8.8 cm)
Private collection

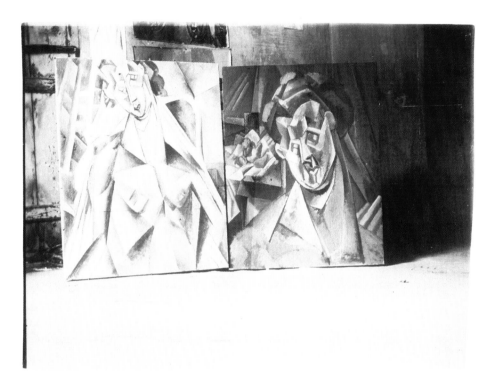

Fig. 96
Pablo Picasso
The Horta de Ebro Studio
(*"Nude in an Armchair"*
and *"Woman with Pears"*)
Horta de Ebro, 1909
Gelatin silver print
3 1/4 x 4 3/8 in
(8.3 x 11 cm)
Private collection

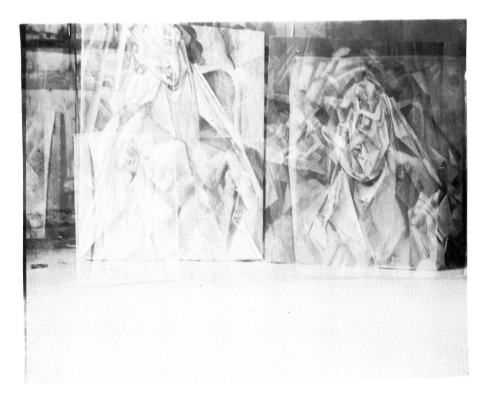

Fig. 97
Pablo Picasso
The Horta de Ebro Studio
Horta de Ebro, 1909
Gelatin silver print
(superimposition)
3 1/4 x 4 in (8.1 x 10.2 cm)
Private collection

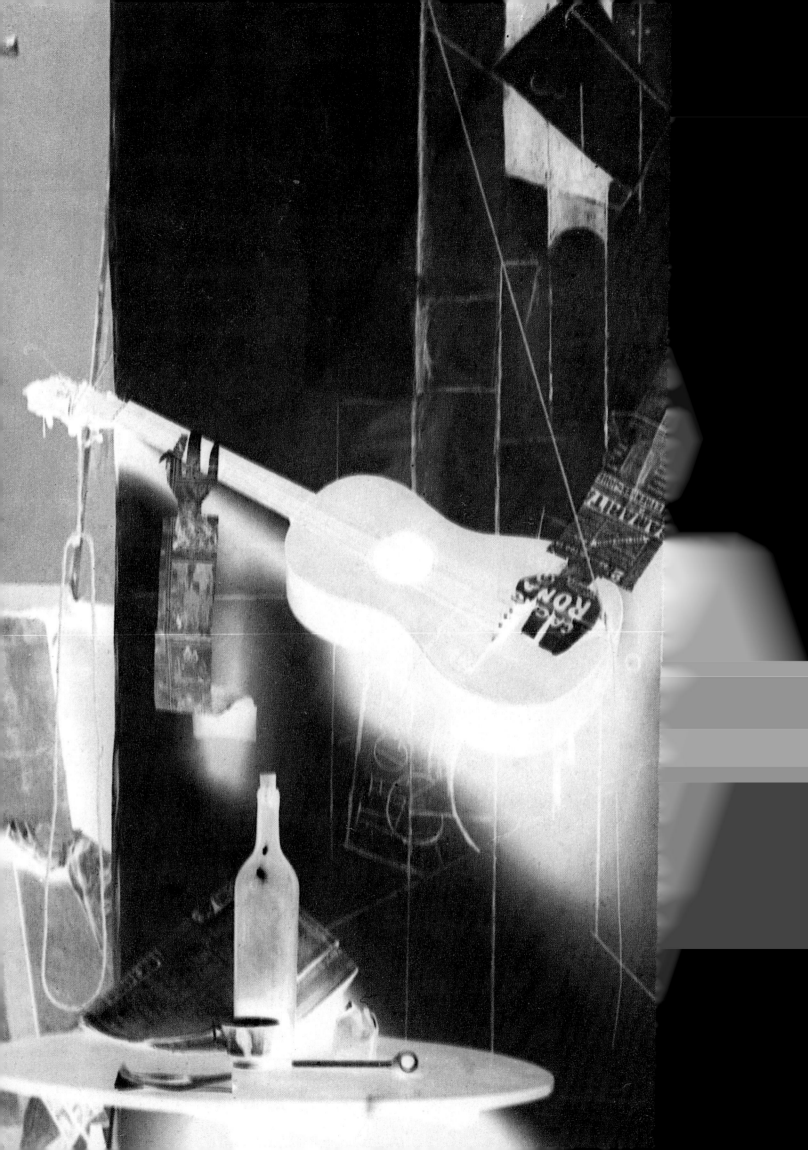

1910 ~ 1914
"Discovering" Photography

A new epoch dawned in Picasso's oeuvre when he moved from the Bateau-Lavoir at the end of 1909 to more "bourgeois" quarters at 11 boulevard de Clichy. Picasso's archives contain two photographs looking out of this studio, one of which plunges straight down onto Impasse Frochot to the south. The photo (fig. 99) places the eye in an almost overhead perspective[269] in imitation of a viewpoint that Picasso's art had precociously adopted in drawings and an oil depicting the Calle de la Riera de Sant Joan in Barcelona,[270] as well as a 1904 watercolor, *The Christ of Montmartre*.[271] Via such works, Picasso would seem to be reversing Delacroix's comment to his pupils: "You have to be able to draw a man falling from the seventh floor."[272] Here it is rather a question of being the man who falls, and being able to capture his Icarus-like vision in an inhuman, photographic manner—a "snapshot." A small oil painting of 1911, *Avenue Frochot Seen from the Studio* (fig. 100),[273] merits comparison with the photograph.[274] From this high-angle viewpoint, each "flattened" volume tends to be reduced to a diagrammatic projection, to an image crushed onto the horizontal plane.[275] The second photograph (fig. 98), taken deeper within the studio, frames the large windows to the north; in front of the windows stands a Baoulé statue while the outline of Sacré-Cœur can be seen in the distance.[276] The vertical lines of the windows and the mirrored wardrobe fragment the landscape, which is laterally multiplied via reflections.[277] The image retains only darkest and lightest values, while perspective is cancelled by the frontality of the viewpoint. The "window," symbol of an illusionist representation of depth, is here reduced to the flatness of its surface. Shapes are projected onto the pane of glass just as they were flattened on the ground in the shot of Avenue Frochot. This visual approach is not only similar to the principles guiding cubist representation, it also prefigures the effects associated with "photograms," namely objects seen in profile on a transparent plane, backlighting, and collapse of the third dimension.

Studio Portraits

Georges Braque was the sitter for the first known photographic portrait (fig. 103) taken by Picasso at his boulevard de Clichy studio, apparently after his return from Horta. Braque, hand on hip, stands between an engraving of Cézanne's *Bathers at Rest* and Picasso's 1908 *Nude with Raised Arms*. The photograph merits comparison with a canvas done in the winter of 1909–1910 and generally known as *Portrait of Braque* (fig. 104),[278] even though Picasso declared that "it was painted in the studio, without a model. It was later that Braque and I said it was his portrait. He wore a hat a little like that."[279] Indeed, the face conveys fairly accurately the volumes and tonal values recorded by the photograph. Furthermore, the arm is brought forward in a way that created the same folds of cloth seen in the photo, and a line runs behind the head at the same level as the molding in the photograph. So, executed "without a model" other than this photograph, the painting may well pursue the approach initiated with Sagot, namely a productive to-and-fro between a photo that reduces real volumes to their flat coordinates and a pictorial reinterpretation of that photographic record into anti-illusionist tessellation.

Picasso and Braque reappear in twin portraits (figs. 115, 118) photographed during Braque's military leave in the spring of 1911. Both models sit in similar poses in the middle of the studio, gazing away from the camera. Picasso is clearly wearing his friend's overly large uniform.[280] Next to Braque, the juxtaposition of kepi and mandolin evokes some secret *vanitas*, not unlike the anamorphically hidden skull in Holbein's *Ambassadors*. A drawing appropriately titled *The Painter* (fig. 116)[281] would seem to combine elements from these two photographs. The easel seen to Picasso's right is on the other side of the drawing. The two men's poses are combined into a single three-quarter view, while the volume of the head would suggest that it is Braque's.[282] In a material metaphor of its double origin, this drawing was executed on two sheets, whose crude join coincides with the line in the photograph created by the picture frames. Meanwhile, a curious painting sometimes titled *Head of a Man in a Hat on a Red Ground* (fig. 117), variously dated between 1913 and 1916,[283] may well have been executed in two stages, the first contemporary with the drawing of *The Painter* and the second marked by the addition of the flat red ground. The composition also exhibits an interplay of divergent angles that evokes the stacked canvases in the photos. This may well be a unique self-portrait in military uniform,[284] in which the head of Picasso, crowned by a kepi, is reduced to its simplest geometry so that his left ear, as in the photograph,

Fig. 98
Pablo Picasso
View from the boulevard de Clichy Studio
Paris, 1909–1912
Modern print from original
flexible negative no. 80
Picasso Archives, Musée Picasso, Paris

Fig. 99
Pablo Picasso
Impasse Frochot
Paris, 1909–1912
Modern print from original
flexible negative no. 78
Picasso Archives,
Musée Picasso, Paris

Fig. 100
Pablo Picasso
*Avenue Frochot Seen
from the Studio*
Paris, autumn 1911
Oil on canvas
9 1/2 x 7 1/2 in (24 x 19 cm)
Private collection

stands out against a rectangle composed of the shadow on the cheek and the shadow in the background.

"We are the two greatest artists of the age, you in the 'Egyptian' style and I in the modern," Le Douanier Rousseau reportedly said to Picasso.[285] A photographic portrait (fig. 101) of the aging master taken by Picasso in Le Douanier's studio on rue Perrel, shows him in front of a dense arrangement of sketches, landscapes, and postcards occupying most of the picture.[286] There exists, however, a negative in which a second exposure (of Rousseau's *Monkeys in the Virgin Forest*, still in progress) is superimposed over the portrait (fig. 102). This image—painting over photo, painting over painting—is over-saturated and clouded by signs, and displays two levels of legibility whose fusion creates a new entity. The geometric grid of wall and frames forms an optical filter for the baroque swirls of an imaginary jungle. Picasso here employed photography as a hermetic rebus—half-representational, half-abstract—that interrogates the visual material and takes the gaze beyond appearances. He thereby subjected his friend Rousseau to the fusion technique employed in the 1901 *Self-Portrait in the Studio* (fig. 14), which established an equivalence between the top-hatted painter and the space of his canvases. Reduced to the filmic existence of the photographic print, Picasso's own body thus participated in the fictional life of his creations. Similarly, Picasso used the effect of photographic superimposition to enable Le Douanier Rousseau to join his own imaginary universe, one woven of images, photo albums, and chimeras.

On returning to Paris after having spent the summer of 1910 in Cadaqués, Picasso took an especially rich series of photographic portraits, all set in the same place, probably the "little sitting room" described by Fernande Olivier.[287] The series began with Apollinaire (fig. 106): book in lap, pipe in mouth, the poet is flanked by a Tiki figure from the Marquesas Islands. A letter from Picasso to Apollinaire suggests that the photograph dates from September 1910.[288] At this same moment, Picasso was once again attacking, in a new manner, the series of cubist portraits he had initiated prior to summer with paintings of Ambroise Vollard and Wilhelm Uhde. His new model was Daniel-Henry Kahnweiler (fig. 107).[289] Sittings began early in October and continued throughout the autumn.[290] It was probably during this development phase that Picasso took a photograph (fig. 108) of his sitter, with a pensive, upward gaze suggesting that Kahnweiler was already accustomed to the pose. Picasso would also take photographs of Max Jacob (fig. 110) and the Catalan painter Ramon Pichot (fig. 111). He thereby pursued in a fairly systematic way his project of recording images of his friends. A photo bearing the date of December 1910 shows Picasso (fig. 105) himself, with his Siamese cat in his lap. The distinctive features of his photographic self-portraiture recur: the vacant stare and the low camera angle that produces a strong foreground effect. Other photos would follow in 1911, notably the uniformed portrait of Braque discussed above, as well as pictures of Auguste Herbin (fig. 114), Marie Laurencin (figs. 112, 113), and Frank Burty Haviland (fig. 109).

Neither Picasso nor any of his sitters ever mentioned these photographic sessions. A look at Kahnweiler's portrait, however, prompts the hypothesis that pictorial use was made of these photographs, as supported by correspondences between a series of drawings of Haviland and his photo taken in the studio on boulevard de Clichy.[291] Indeed, by disseminating form across the pictorial space, Analytic cubism adopted an approach perhaps similar to that of an African man described by Fernande Olivier; asked to execute a portrait of a naval officer on the basis of a photograph, the native artist drew the silhouette "in the style of African idols" and "thought it pointless to place the buttons in their proper place—instead he placed them all around the face! He did the same with the insignia, which he placed beside the arms and above the head." Fernande added, "After that, many strange things were to be seen in cubist paintings"[292] Numerous visual elements from the surrounding studio have been detected in the *Portrait of Daniel-Henry Kahnweiler* (fig. 107).[293] I myself would stress the obvious formal and symbolic relationship between the dealer's portrait and this photograph. The Punu mask hanging on the wall is notably echoed in the striped pattern and oval shape seen in the upper left of the canvas, and the mask's meditative air is similarly reflected in Kahnweiler's expression. In a more complex way, *Man with a Pipe*[294] borrows numerous features from the photograph of Apollinaire[295]—on the open book, shown in tilted perspective, are two scroll shapes that evoke the highly particular curled pattern of the ears of the Tiki figure.[296] A similarly coded transposition is at work in *The Poet*,[297] which probably condenses elements borrowed from two portraits, those of Ramon Pichot and Max Jacob, taking advantage of their highly similar staging.

This play of visual allusions and permutations shows that Picasso did not hesitate to combine freely the characteristics of given individuals or to redeploy them in a purely generic fashion.[298] It is not so much a question of depicting a unique individual as of discovering a unity shared by all (or several): the face of a friend of the artist, a pipe smoker or poet, a way of living and being, and so on. The exercise thereby exploits the consistent features of the relatively uniform setting, where a few subtle changes discreetly record the passing of time. Portraiture, theoretically devoted to eliciting an individual image, here provides a stock of collective material. And photography, here constituting a series, offers material in the form of "real" images particularly conducive to the pictorial dispersion or synthesis of signs. Just as dreams weave fanciful narratives from tiny scraps of recollections of the day's generally

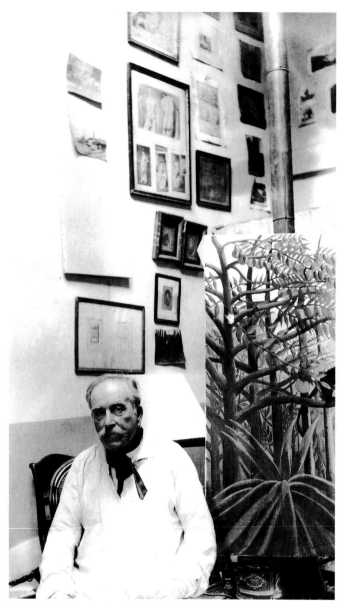

Fig. 101
Pablo Picasso
Portrait of Le Douanier Rousseau
Paris, 1910
Modern gelatin silver print
from flexible negative no. 117
Picasso Archives,
Musée Picasso, Paris

Fig. 102
Pablo Picasso
Portrait of Le Douanier Rousseau
Paris, 1910
Modern gelatin silver print
from flexible negative
(double exposure) no. 118
Picasso Archives,
Musée Picasso, Paris

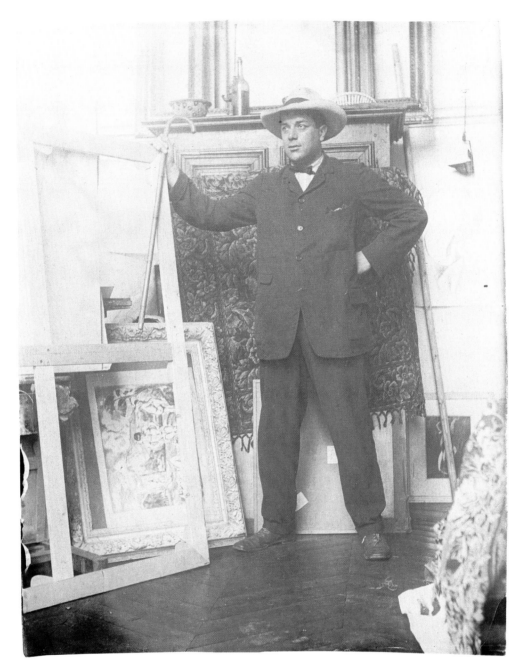

Fig. 103
Pablo Picasso
Portrait of Georges Braque
Paris, boulevard de Clichy
studio, autumn 1909
Gelatin silver print
4 x 3 ³/₈ in (10 x 8.7 cm)
Private collection

Fig. 104
Pablo Picasso
Portrait of Braque
Paris, winter 1909–1910
Oil on canvas
24 x 19 ⁵/₈ (61 x 50 cm)
Private collection
© bpk, Berlin, 1997

Fig. 105
Pablo Picasso
Self-Portrait
Paris, boulevard de Clichy studio, December 1910
Gelatin silver print
5 ³/₄ x 4 ⁵/₈ in (14.7 x 11.6 cm)
APPH 2834
Picasso Archives, Musée Picasso, Paris

Fig. 106
Pablo Picasso
Portrait of Guillaume Apollinaire
Paris, boulevard de Clichy studio, autumn 1910
Gelatin silver print
8 5/8 x 6 7/8 in (21.9 x 17.4 cm)
APPH 2817
Picasso Archives, Musée Picasso, Paris

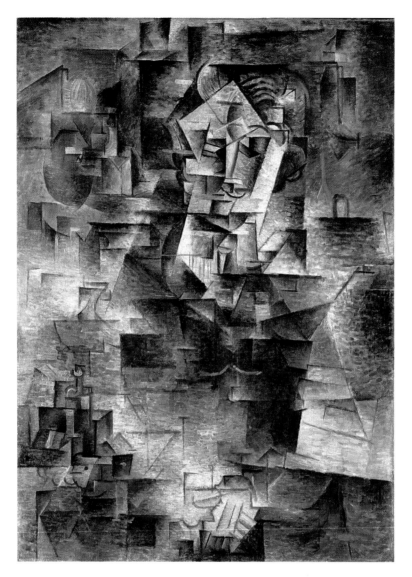

above
Fig. 107
Pablo Picasso
Portrait of Daniel-Henry Kahnweiler
1910
Oil on canvas
39 ⁵/₈ x 28 ⁵/₈ in (100.6 x 72.8 cm)
Gift of Mrs. Gilbert W. Chapman
in memory of Charles B. Goodspeed 1948. 561
Photograph © 1997
The Art Institute of Chicago.

opposite page
Fig. 108
Pablo Picasso
Portrait of Daniel-Henry Kahnweiler
Paris, boulevard de Clichy studio,
autumn 1910
Modern gelatin silver print
from original glass negative no. 45
Picasso Archives,
Musée Picasso, Paris

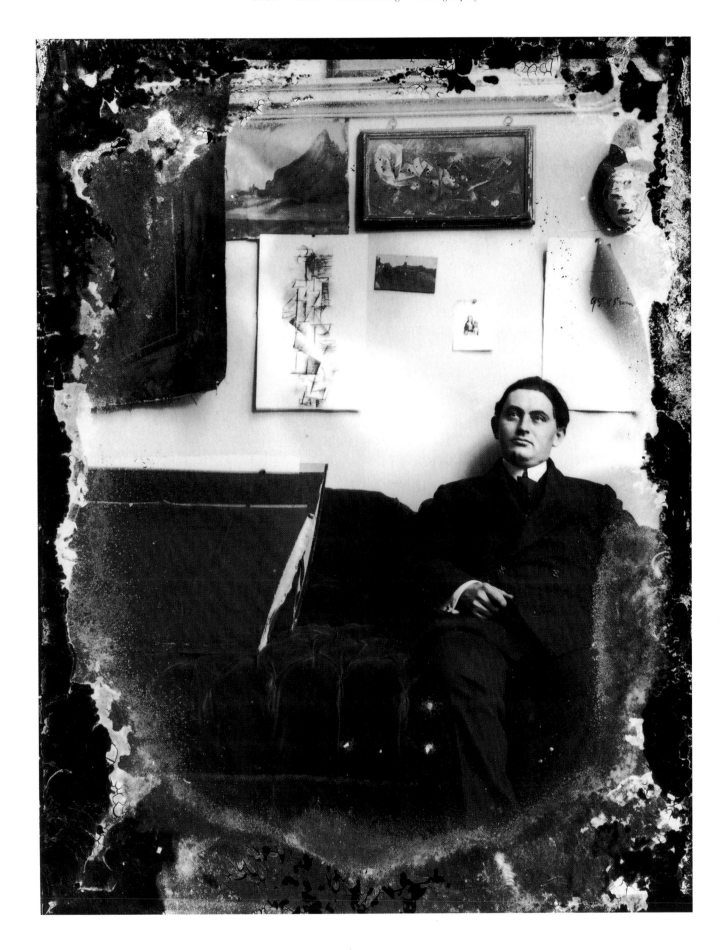

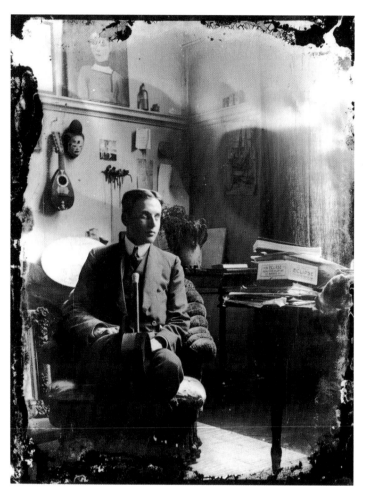

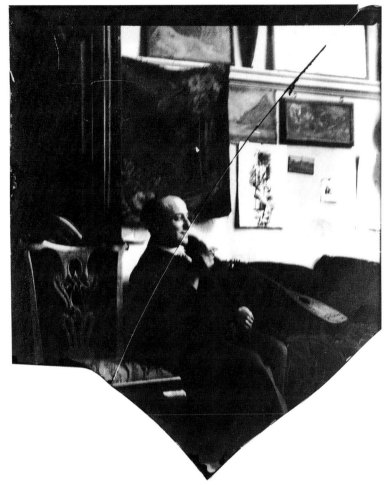

Fig. 109
Pablo Picasso
Portrait of Frank Burty Haviland
Paris, boulevard de Clichy studio,
[1911-1912]
Modern gelatin silver print
from original glass negative no. 46
Picasso Archives, Musée Picasso, Paris

Fig. 110
Pablo Picasso
Portrait of Max Jacob
Paris, boulevard de Clichy studio,
autumn-winter 1910
Modern gelatin silver print
from original glass negative no. 59
Picasso Archives, Musée Picasso, Paris

opposite page
Fig. 111
Pablo Picasso
Portrait of Ramon Pichot
Paris, boulevard de Clichy studio,
autumn-winter 1910
Gelatin silver print
11 ³/₄ x 9 ¹/₂ in (29.9 x 24 cm)
APPH 2836
Picasso Archives, Musée Picasso, Paris

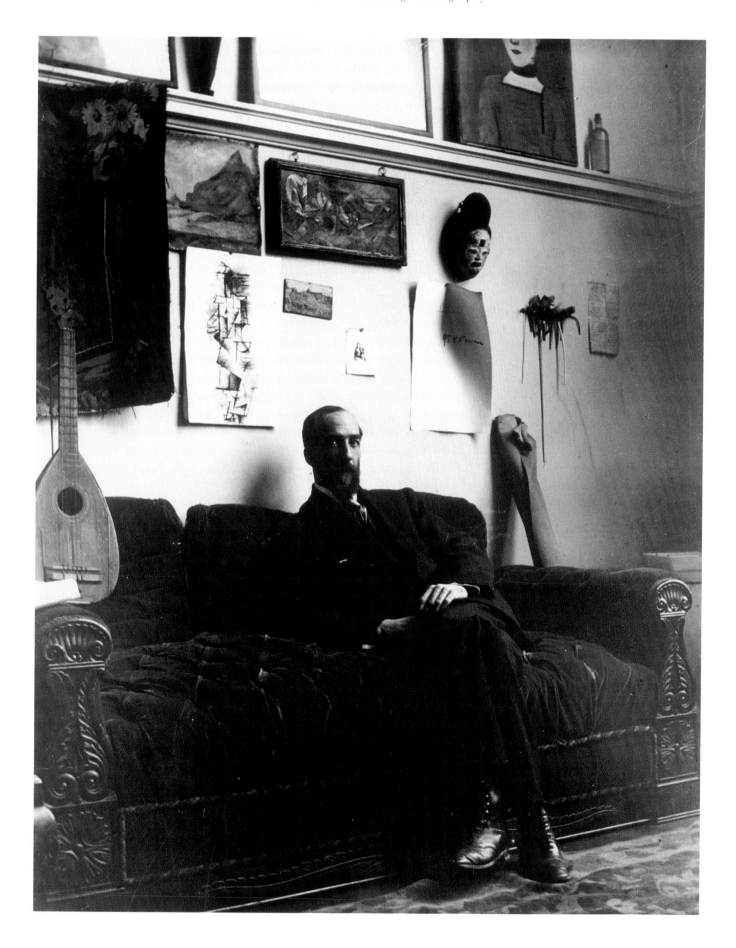

Fig. 112
Pablo Picasso
Portrait of Marie Laurencin
(Standing, Three-Quarter Pose)
Paris, boulevard de Clichy studio,
[autumn 1911]
Modern gelatin silver print
from original glass negative no. 42
Picasso Archives, Musée Picasso, Paris

Fig. 113
Portrait of Marie Laurencin
(Seated, Frontal)
Paris, boulevard de Clichy studio,
[autumn 1911]
Modern gelatin silver print
from original glass negative no. 43
Picasso Archives, Musée Picasso, Paris

opposite page
Fig. 114
Pablo Picasso
Portrait of Auguste Herbin
Paris, boulevard de Clichy studio,
early 1911
Gelatin silver print
4 $^{3}/_{8}$ x 3 $^{3}/_{8}$ in (11 x 8.6 cm)
Picasso Archives, Musée Picasso, Paris

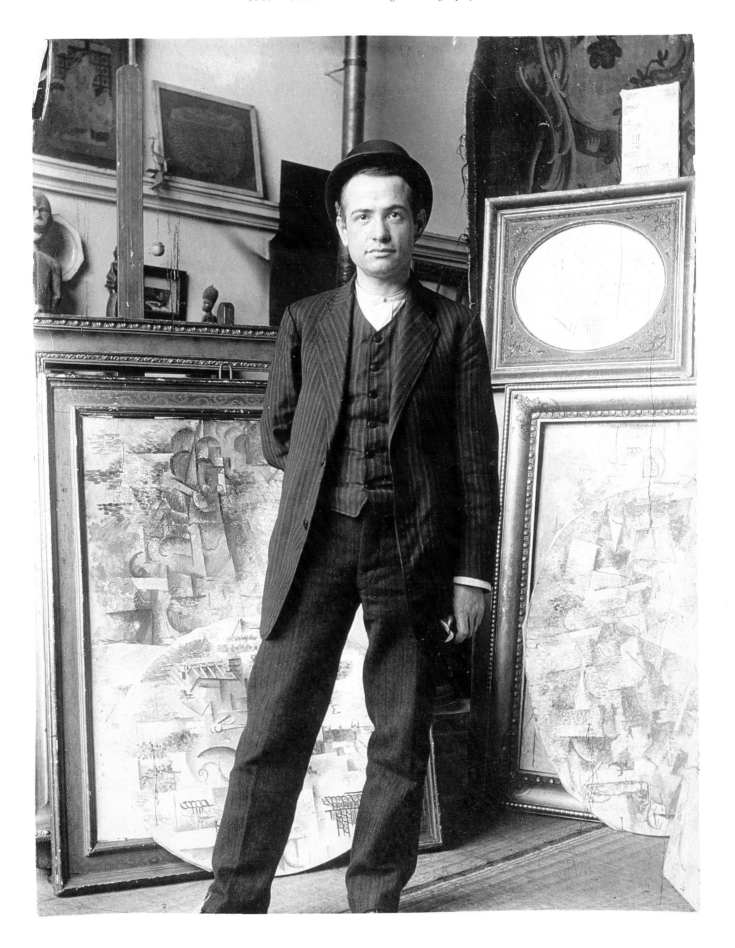

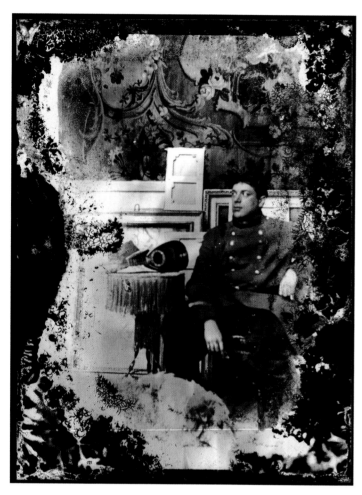

Fig. 115
Pablo Picasso
Portrait of Georges Braque
Paris, boulevard de Clichy studio,
March 1911
Modern gelatin silver print
from original glass negative no. 40
Picasso Archives,
Musée Picasso, Paris

Fig. 116
Pablo Picasso
The Painter
1912–1913
Pen, brown ink and pencil
on two sheets pasted together
15 x 8 in (38 x 20.2 cm)
MP 688
Musée Picasso, Paris

Fig. 117
Pablo Picasso
Head of a Man in a Hat
on a Red Ground
Paris, [1913–1916]
Oil on canvas
24 ³/₄ x 20 ¹/₈ in (63 x 51 cm)
Private collection

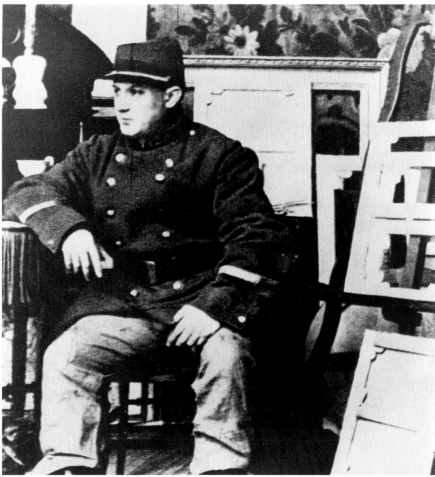

Fig. 118
Georges Braque
Portrait of Pablo Picasso
Paris, boulevard de Clichy studio,
March 1911
Modern gelatin silver print
from original glass negative
Private collection

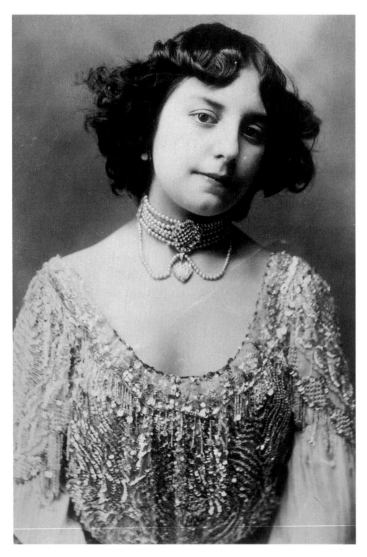

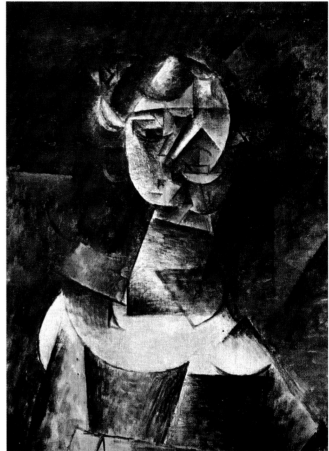

Fig. 121
Pablo Picasso
Portrait of Mademoiselle Léonie
Paris, 1910
Oil on canvas
25 ⁵/₈ x 19 ⁵/₈ in (65 x 50 cm)
Private collection

above
Fig. 119
Anonymous
Bella Chelito (Frontal)
Barcelona, [1900–1903]
Gelatin silver print
(postcard)
APPH 15363
Picasso Archives,
Musée Picasso, Paris

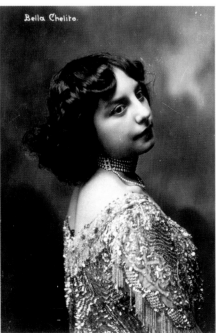

left
Fig. 120
Anonymous
*Bella Chelito
(Three-Quarter Pose)*
Barcelona, [1900–1903]
Gelatin silver print
(postcard)
APPH 15362
Picasso Archives,
Musée Picasso, Paris

opposite page
Fig. 122
Pablo Picasso
*Study for Portrait
of Mademoiselle Léonie*
Paris, 1910
Pencil and ink on paper
25 x 19 ¹/₂ in (63.4 x 49. 5 cm)
Marina Picasso Collection (inv. 1270),
Courtesy Galerie Jan Krugier,
Ditesheim & Cie, Geneva

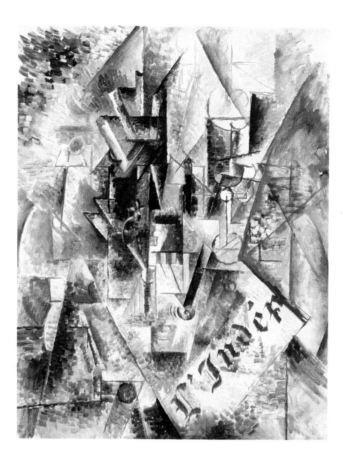

Fig. 123
Pablo Picasso
"The Fan (L'Indépendant)"
in Progress
Céret, 1911
Gelatin silver print
4 x 3 ¼ in (10.3 x 8.2 cm)
Private collection

insignificant events,[299] so cubist paintings made it possible for the decomposition of the pictorial surface into geometric facets and transparent planes to coexist with the fortuitous emergence of fragmentary visual signs.

Other examples illustrate the role played by photography in the elaboration of cubist syntax in the years 1910–1911. As Picasso would later declare, "You always have to start with something. And then you can remove any appearance of reality; it's no longer dangerous, because the idea of the object has left an ineradicable trace."[300] Two photos showing a legendary figure from Picasso's youth, the actress Bella Chelito (figs. 119, 120),[301] thus provided a source for the painting of *Mademoiselle Léonie* (fig. 121)[302] as well as for a preparatory pencil drawing (fig. 122) (both of which are usually thought to depict a performer from the Médrano Circus).[303] Whereas the mass of hair remains immediately recognizable, the drawing employs a principle of deconstruction based on the sharp lateral shift of the shadow formed by the nose and left eyebrow.[304] Thus cubism's specific formal code retained a "trace" of photography's indexical property, all the while radically transcending it.

A postcard addressed to Kahnweiler on 13 August, 1911 indicates that Picasso had a camera during his stay in Céret.[305] He took working shots of several canvases executed that summer, including *The Fan (L'Indépendant)* (fig. 123),[306] an early instance of the use of typographic-style lettering. The photo was probably designed to assess the efficiency of the new structural "grid" that Picasso was testing.[307] Moreover, Picasso bought many post cards of landscapes and typical Catalan figures.[308] One of them (fig. 125), featuring a mountain shepherd, inspired the drawing *Head of a Man* (fig. 126)[309] which faithfully transcribes the structure of the face capped by a jaunty Catalan *barettina*.[310] The peasant's monochromatic gray and black garments of wool, broadcloth, and felt find an equivalent in the strongly tactile effects of charcoal and black pencil.[311]

Another heretofore unpublished image would seem to have played a more fundamental role in the pictorial maturation of the summer of 1911.[312] It is a postcard (fig. 124) commemorating a leading *trabucaire*, or outlaw, guillotined in Céret in 1846.[313] For Picasso, the fate of Spanish Catalans, as political outlaws in Spain and clandestine refugees in France,[314] probably evoked the *Setmana Tràgica* (or Tragic Week) of 1909 that led to the execution of anarchist leader Francisco Ferrer.[315] Yet it was above all the formal organization of the image that must have caught Picasso's attention.[316] Next to an old engraving of the outlaw, a photo reproduces, like the holy veil of Veronica, the Masonic scarf he wore during his execution. Whereas

Fac-Simile du Foulard que SAGALS portait au cou, en allant à la Guillotine

Joseph BALME, dit SAGALS
un des Chefs des " Trabucayres "
exécuté à CERET, sur la
Place du Château, le 27 Juin 1846

Fig. 124
L. Roque (Publisher)
Céret, [1905–1910]
Joseph Balme,
a.k.a. Sagals,
a "Trabucaire" Leader
Phototype (postcard)
APPH 15155
Picasso Archives,
Musée Picasso, Paris

Veronica's veil recorded the sacred face of Jesus, this non-figurative facsimile employs strikingly efficient metonymy—brushed by the blade of the guillotine, the unfolded scarf offers a "cut away" diagram of the decapitated body. In a frame formed by the rope and tassels of the "chain of alliance," ritual motifs immediately function as ideograms even though drawn in a naturalistic way. Their value as *icons*—signs that "resemble" a given object—gives way to their role as a set of standard *symbols*.[317] The combinatory logic is symbolized by the "tracing board,"[318] a geometric matrix for the Masonic alphabet, all the letters of which are expressed as right angles or as diagonals in the form of the cross of St Andrew.[319] Picasso could hardly have been indifferent to such an image at a time when he was exploring elliptical representation, employing referential allusions while rejecting illusionist perspective, and structuring the pictorial surface to underscore its flatness. *The Fan (L'Indépendant)* (fig. 123) may thus have been influenced by the Masonic diagram's triangular and diamond-shaped arrangements, its hieroglyphic imagery,[320] and its emblematic typography.[321] Picasso's cubist grid, like a vertical "tracing board," subjects his structural design—and the visual reference points inscribed (or "inscripted") therein—to the same spatio-visual logic.[322] It was therefore the unusual formal features—rather than

the esotericism—of the executed outlaw's *memento mori* that drew Picasso's attention. He might have even somewhat humorously identified his own quest with the visual trajectory from the raw stone of "rough ashlar"—an unshaped fragment of reality—to the finished "ashlar," which is here reduced to the basic concept of a cube.[323] Picasso's encounter with this symbolism might be compared to another one, just then occurring, between his painting and music: a repertoire of formal ideograms borrowed from music—scrolls, strings, concertinas, tubes, reeds—was being combined with a visual code of clefs, notes, staves, etc. Here, too, Picasso was rummaging through another semantic realm in search of elements of vocabulary and syntax—an ordered systems of signs—that could provide material for his own visual idiom.

Fig. 125
Labouche Frères (Publishers)
Toulouse
A Mountain Shepherd from La Preste
Phototype (postcard)
APPH 15135
Picasso Archives, Musée Picasso, Paris

opposite page
Fig. 126
Pablo Picasso
Head of a Man
1910–1911
Charcoal and pencil on paper
25 ¹/₄ x 19 ¹/₈ in (64.2 x 48.6 cm)
MP 643
Musée Picasso, Paris

Photographic Staging and Compositions

In 1911, as a forerunner to the more systematic hangings and installations at his boulevard Raspail studio, Picasso —still in his studio on boulevard de Clichy—arranged mandolin, zither, bottle, books, cup, and shawl into a specifically photographic still life known as *Photographic Composition: Still Life on a Pedestal Table* (fig. 128).

This photograph relates to a comment made by Gertrude Stein: ". . . It was the height of the intimacy between Braque and Picasso, it was at that time they first began to put musical instruments into their pictures. It was also the beginning of Picasso's making constructions. He made still lifes of objects and photographed them."[324] According to Stein, the impact of these compositions was so great "that it was not necessary that he paint the picture."[325] Judged by the traditional standards of "art photography," the image is noteworthy for its skillful arrangement of objects set against an empty background, and for the sharp lighting that etches each thread of the fringe. Here, however, Stein's literal acceptance of it as a visually self-sufficient accomplishment diverged from the dynamic use that Picasso would in fact make of this photo in developing his pictorial oeuvre.

It is worth noting that the "plinth" for the composition was in fact an unusual piece of furniture—a wrought-iron pedestal table with curvilinear tripod base, covered by a cloth decorated with braiding and long fringe. The object had already been featured in other photos taken in the boulevard de Clichy studio: Picasso was leaning on it in the picture Braque took of him (fig. 118), and it appeared next to Braque (fig. 115) and Marie Laurencin (figs. 112, 113) in their respective photos. A connection has often been made between the motif of braided rope— common in canvases from the years 1911–1914—and the heavy braiding of the tablecloth on this pedestal table. In the spring of 1912, however, with *Notre avenir est dans l'air*[326] and *Still Life with Chair Caning* (fig. 129),[327] this braid was no longer merely depicted but became an integral part of the painting even as it constituted a frame. In the latter painting, often described as the first "collage," imitation caning incorporated into the pictorial surface is doubly heterogeneous—it is a manufactured item, yet offers a "quasi-photographic illusionism."[328] Another connection with the photograph, however, concerns the new use of the oval format, or tondo, which mimics the very contour of the pedestal table in upturned perspective.[329] This reference to an everyday table means that the still life no longer aspires to the picturesque or the scholarly; rather, it is the sprawling surface of domestic life that the photographer's eye (followed by that of the painter) has grasped from a high-angle view that collapses perspective and reduces each object to an emblematic sign. By turns ordinary object, plinth, painting, and even potential sculpture,

this metal-and-cloth furnishing is rendered linear; it can be simultaneously flat and hollow, can function as both framework and covering. It thereby displays—in an "everyday baroque" register—formal paradoxes similar to the Grebo mask that had such an impact on Picasso's "cubist" constructions, as noted by Kahnweiler.[330]

Late in 1919, a remarkable series of graphic variations in ink and gouache would develop a counterpoint to the *Photographic Composition* (fig. 128) of 1911.[331] Basic structural components were the ellipse of the table's surface, its sinuous legs, the curtain of fringe, the curve and strings of the mandolin (become guitar and score), and the geometric shadows. As to the vertical thrust of the zither, it was echoed in the shape and scale of the window behind this edifice of interlocking surfaces. Picasso's use of the pedestal table thereby confirms his sculptural mise-en-scène of that object; nor, as will be seen, was it the last example of this.[332]

Installations of *papiers collés* in the studio at 242 boulevard Raspail provided the subject for three photographs, two of which were published by Christian Zervos as a supplement to his catalogue raisonné.[333] Discussion concerning the date of the works pictured in these photos has finally settled on the winter of 1912.[334] Each photograph shows a different set of works (no. 1 fig. 130, no. 2 fig. 131, no. 3 fig. 132); only the cardboard construction *Guitar*[335] is present in all of them. The series could therefore be seen as a record of a particularly productive period. It it worth noting, however, that not all of the *papiers collés* displayed on the wall have been completed;[336] scraps of material scattered on the floor confirm the hypothesis that the photographs were taken during an intermediate stage of development. Even as he was photographing them, then, Picasso was completing works that were still mere *drawings*, by pasting pieces of paper or newspaper to them. The addition of a piece of newspaper to the right side of *Violin,* for example, significantly alters the initial composition. Once again, the studio wall functions as a test site for experiments then under way, and photography made it possible to monitor progress continuously, to establish relationships between works, and to encourage the interplay of associations and contrasts that generates unforeseen plastic solutions.

This phase of photographic detachment, meanwhile, induced Picasso to juxtapose works in progress side-by-side, to unite them in a fictional meta-space. In the center he hung the *Guitar*, the first of his "constructed sculptures."[337] The debt owed to African art by this object (which "displayed depth yet did not present a complete, closed form"[338]) as well as its formal relationship to a Grebo mask owned by Picasso have been well established.[339] André Salmon reported that when Picasso made a metal replica of the object,[340] the artist said to him, "You'll see. I'll keep *el guitarron*, but I'll sell *el* plan; then everyone will be able to do it."[341] The comment has been taken literally

Fig. 127
Pablo Picasso
Self-Portrait in Front of "Construction with Guitar Player"
Paris, boulevard Raspail studio, summer 1913
Gelatin silver print
6 1/$_2$ x 3 7/$_8$ in (16.6 x 10 cm)
APPH 2857
Picasso Archives, Musée Picasso, Paris

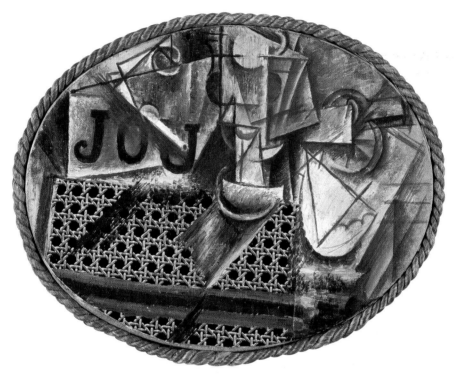

following double pages
Fig. 130 (I)
Pablo Picasso
Wall Arrangement of Papiers Collés
in the boulevard Raspail Studio (No. 1)
Paris, winter 1912
Gelatin silver print
3 1/2 x 4 5/8 in (8.9 x 11.9 cm)
Private collection

Fig. 131 (II)
Pablo Picasso
Wall Arrangement of Papiers Collés
in the boulevard Raspail Studio (No. 2)
Paris, winter 1912
Modern print from original glass negative no 112
Picasso Archives, Musée Picasso, Paris

Fig. 132 (III)
Pablo Picasso
Wall Arrangement of Papiers Collés
in the boulevard Raspail Studio (No. 3)
Paris, winter 1912
Gelatin silver print
3 3/8 x 4 1/2 in (8.6 x 11.5 cm)
Private collection

preceding page
Fig. 128
Pablo Picasso
Photographic Composition:
Still Life on a Pedestal Table
Paris, boulevard de Clichy
studio, 1911
Modern gelatin silver print
from original flexible negative no. 104
Picasso Archives,
Musée Picasso, Paris

above
Fig. 129
Pablo Picasso
Still Life with Chair Caning
Paris, spring 1912
Oil and oilcloth on canvas,
framed by rope
9 x 14 5/8 in (23 x 37 cm)
MP 36
Musée Picasso, Paris

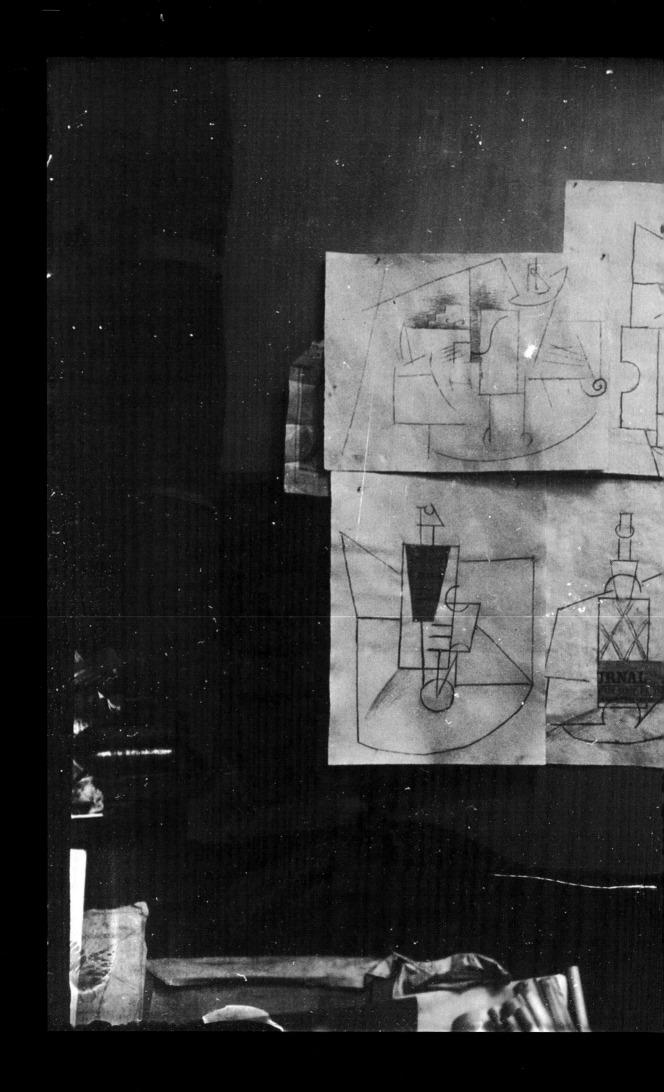

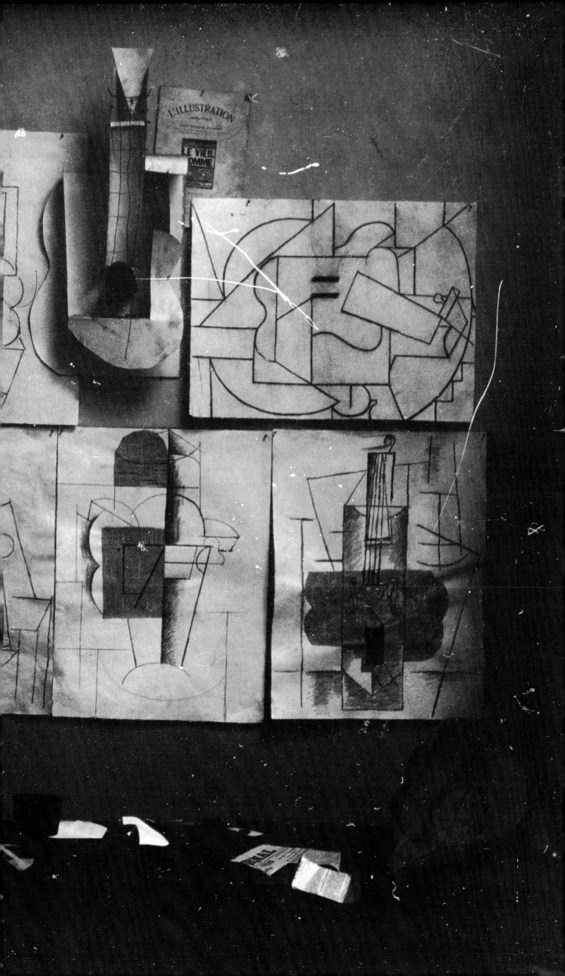

as marking "a precedent in multiple sculpture that [went] far beyond a simple edition and [implied] the idea of participation."[342] The installation prepared for the photograph thus suggests a more complex form of multiplication in which the *Guitar*, hanging in the middle, served as both yardstick and "generator"[343] of the whole set of *papiers collés*. From drawing to photograph, and from photo to *papiers collés*, Picasso's gestural reflexes—spurred at every step by photographic observation—multiplied all the equivalences, variations, and dissonances provoked by the guitar motif that dominated these wall arrangements. This sequence thus coheres around the ongoing exchange between the camera and *el guitarron*. The work of the *papiers collés* can be seen to function vertically, right there on the wall; piece by piece, newspaper cutouts add relative depth and values to the drawn lines. So, via a slightly different use of the photographic "judgment by mirror" to which he had submitted his canvases of 1901, Picasso was able to see this work emerging. He would occasionally take a photograph, returning the rest of the time to the two-dimensional world to which the viewfinder reduced both studio and work in progress. Furthermore, these photographs offer an almost epigraphic glimpse, in the upper center, of the cover and title of a magazine: *L'Illustration*. These *papiers collés* therefore graphically *illustrate* precisely what the guitar materially embodied— and photography could indeed be seen as one of the agents of that metamorphosis.

The resources of photographic staging were also mobilized for a picture of the studio showing a *Construction with Guitar Player* (fig. 133), which was destroyed upon completion. A structural design spanning two pieces of canvas was complemented by two arms of newspaper and a real guitar. Initially, two photographs of the assemblage were taken, with a slight lateral shift between viewpoints, as though creating a "stereoscope" image that would virtually convey the *volume* of the studio and confirm not only the sculptural dimension of the work but also its nature as a contextual installation. Also visible in the photos are a section of a poster for a Picasso show in Munich in February 1913, a *papier collé* still life titled *Au Bon Marché*,[344] a drawing of a typical Anis del Mono bottle, a construction of a *Violin*, several rectangular and oval stretched canvases, a sheet of newspaper, and a pedestal table bearing various objects. This "extraordinary photograph,"[345] called here *Photographic Composition with "Construction with Guitar Player"* orchestrates a complex confrontation between the real world, the imaginary space of the drawing on the canvas, manufactured objects (guitar, pedestal table, bottle, etc.), a three-dimensional construction (the violin), a figurative newspaper cutout (the arm), and stylized representation (the bottle of anisette).

Here, then, photography does much more than merely document an ephemeral assemblage for the record. Its overall design entertains strong correspondences with several other works from the same year,[346] as though the photographic image enabled Picasso to analyze and generalize structural possibilities. Yet he did not stop there, as demonstrated by three remarkable prints of this shot of the studio. One cropped print (fig. 134) limits the view to the canvas, whose composition has been modified by ink lines added directly to the photo; two diagonal shafts with arcs suggest arrows, while strong vertical strokes divide the surface of the painting into three sections. This new constructive grid would be echoed in the canvas titled *Man with Guitar*,[347] begun at Céret in spring 1913, which also features several other elements evoking the retouched photograph.[348]

Going one step further, Picasso directly intervened in the printing of *Photographic Composition with "Construction with Guitar Player"* (fig. 133) by partly masking the negative with a set of cardboard masks. The two resulting contact prints (figs. 135, 136) thereby combine, in the strictly flat plane of the photograph, the techniques of cutout and collage that are the basis of the *papiers collés*. Or rather, photography provides *its solution* to a shared question: how can visually and materially heterogeneous elements be forged into a visual unity that is sufficiently convincing to the eye? Once "equalized" by the photograph into a play of black-and-white values, the man, the guitar, the studio space, and the real and depicted objects all lend themselves to unlimited permutation, transmutation, and so on. Here, the cutout shape becomes an angular ideogram for guitar, and the vertical lines drawn on the canvas represent its network of strings. These graphical strings are superimposed on the real string holding the guitar, whose dark shape henceforth becomes a hand playing the imagined instrument.

The transfer of one medium to another and of signs into new signs thus confirms photography's active intervention as a tool of semantic transformation at several key moments in Picasso's pictorial development. In such circumstances at least, the role he conferred upon photography far surpasses the simple function of "verification" or even "manifesto/demonstration" that Edward Fry accords it in Picasso's invention of cubism. Indeed, the medium boasts the ability to *condense*—within the continuous and homogeneous plane of its sensitive surface—all real and depicted elements, whatever their differences in status, materiality, or durability, whatever their mode of spatial existence (flat or solid, near or far). Everything fuses here into a new, purely representational entity in which heterogeneity can be conceived as unity, discontinuity as continuity. A photographic self-portrait (fig. 127) showing Picasso in front of *Construction with Guitar Player* (cf. figs. 133, 134) when it was being dismantled or destroyed may constitute an epilogue to the experiment.[349] His hands seem to be holding an invisible guitar as though, thanks to a

thoroughly photographic substitution, the artist has taken the place once occupied by his ephemeral creature of paper and string.

Moreover, the technico-material apparatus of the masked prints could be compared with the structure of the first cubist "constructions" dating from the same period.[350] Indeed, they all play on the contradiction of combining flat volumetrics with the depth inherent in the layering of several materials (here, the triple superimposition of light-sensitive paper, cutout cardboard masks, and glass negative). Strong links thus exist between one of these masked prints and the construction *Guitar and Bottle of Bass* (fig. 139),[351] as Kahnweiler had it photographed for publication in *Les Soirées de Paris.*[352]

Kahnweiler's photograph is itself the source of an exploration conducted by Picasso along the frontiers of several media. As part of the printing process, a half-tone copper plate of the photo was made, translating the values of the original image into the relief of the dotted screen. Picasso then used this plate as the support for an engraving that generated a new cubist composition. This work on copper (fig. 138), combining a relief printing process with intaglio engraving techniques, sparked a contradictory play of values: after being inked, the engraved motifs appeared in positive while everything that remained of the original photograph appeared in negative.[353] It is also worth noting that whereas the initial states of the engraving concentrate on the central motif of the construction itself, later states extend work to the surrounding studio environment visible on the photograph. Finally, as though attempting to get closer to the material reality of *Guitar and Bottle of Bass* (fig. 137), Picasso ultimately employed

the beechwood plank that originally held the copper plate to make a new engraving, *Guitar on the Table.*[354]

It is thus tempting to reread this chain of transformations —from the *Photographic Composition with "Construction with Guitar Player"* (fig. 133) to the masked prints of that photo (figs. 135, 136), then on to the intermediate state of *Guitar and Bottle of Bass* (fig. 139) as recorded by Kahnweiler's photograph, through the sequence of engravings on the half-tone plate, and on to the engraving done on the wooden backing—as so many stages leading toward the final version of the construction *Guitar and Bottle of Bass* (fig. 137). This last incarnation could then be seen as a condensation of the successive transmutations of techniques and processes, the repeated inversion of values, and the incessant self-generation of motifs. Moreover, the final version of the construction displays formal elements belonging to each stage thus traversed. One of the more surprising stages was the final detour via an engraving on a photographic support, which dialectically surpasses preceding experiments in which the eye, on being confronted with inked lines on top of a photo, immediately perceived the superimposition of two heterogeneous images. The use of photographic masks similarly implied a brutal rupture in the spatial continuity of the visual material. Experimentation on the engraving thereby drew theoretically incompatible elements into greater formal cohesion: the photographic referent was entirely preserved even as it was being thoroughly reworked plastically. Despite the violence done to each one of these media, the sequence of engraved states concretizes the steady *development* of the project—not unlike a photograph slowly developing into the realm of the visible.

preceding page
Fig. 133
Pablo Picasso
Photographic Composition with
"Construction with Guitar Player"
Paris, spring-summer 1913
Gelatin silver print
4 ⅝ x 3 ⅜ in (11.8 x 8.7 cm)
Private collection

above
Fig. 134
Pablo Picasso
Photographic Composition with
"Construction with Guitar Player"
Paris, 1913
Cropped gelatin silver print
with ink drawing
3 ⅛ x 2 ¼ in (7.8 x 5.8 cm)
Private collection

Fig. 135
Pablo Picasso
Photographic Composition with
"Construction with Guitar Player"
Paris, 1913
Masked gelatin silver print
4 ¹/₂ x 3 ¹/₂ in (11.4 x 8.8 cm)
Private collection

Fig. 136
Pablo Picasso
Photographic Composition with
"Construction with Guitar Player"
Paris, 1913
Masked gelatin silver print (variant)
4 ³/₈ x 3 ¹/₂ in (11 x 9 cm)
Private collection

above
Fig. 138
Pablo Picasso
Guitar, Clarinet, and Bottle of Bass
Paris, 1913–1914
Engraving on industrial copperplate
4 x 4 ³/₈ in (10.1 x 11.1 cm)
MP 3521
Musée Picasso, Paris

Fig. 137
Pablo Picasso
Guitar and Bottle of Bass
Paris, 1913–1914
Construction of wood, *papier collé*,
paint, and charcoal on wood
35 ¹/₄ x 31 ¹/₂ x 5 1/2 in
(89.5 x 80 x 14 cm)
MP 246
Musée Picasso, Paris

opposite page
Fig. 139
Kahnweiler Gallery Photo
Guitar and Bottle of Bass
Paris, 1913
Gelatin silver print
5 x 3 ³/₄ in (12.8 x 9.4 cm)
APPH 2827
Picasso Archives,
Musée Picasso, Paris

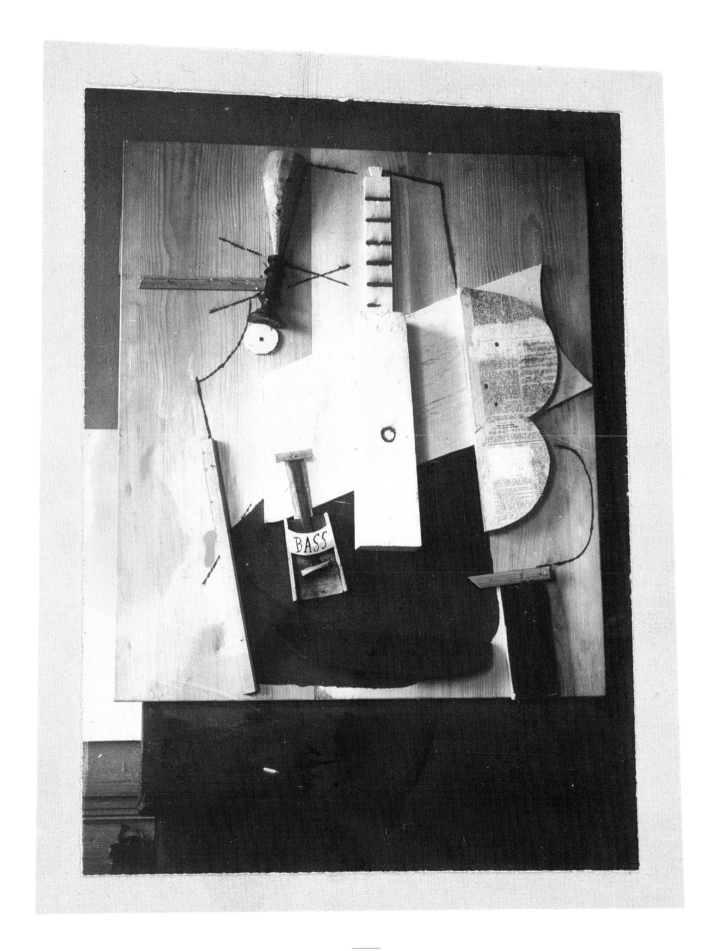

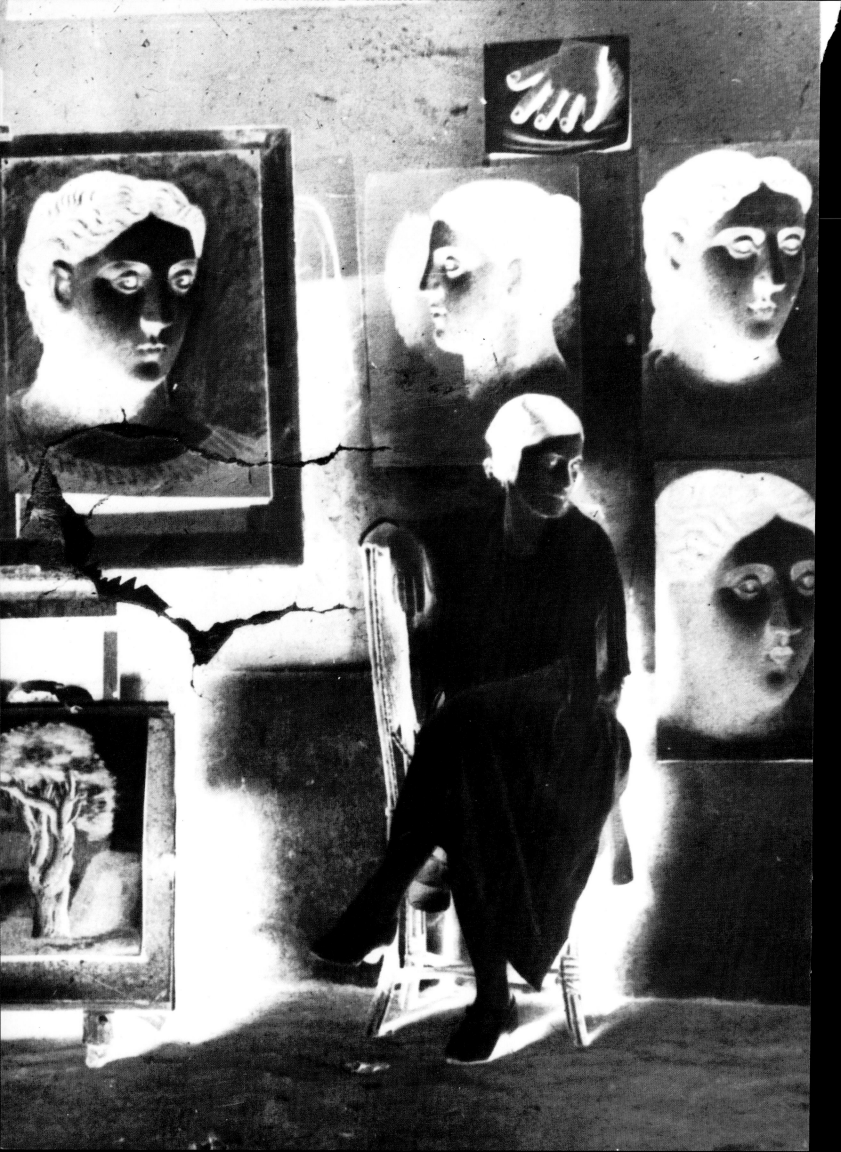

1914 ~ 1923
Figurative Disorders

The Artist and His Model

Paradoxically, the last known photographic composition from the period that ended with World War I centers on one of Picasso's earliest paintings, *Girl with Bare Feet* (fig. 150),[355] which was set amid the creative disorder of the studio on rue Schoelcher. The new eye with which Picasso looked at such a canvas in 1914 coincided with a progressive return to naturalistic representation, as indicated, in a thoroughly emblematic way, by a work titled *The Artist and His Model* (fig. 151).[356] Significantly, this contradictory period of transition is studded with numerous references to photography.

Thus, two drawings—*Woman in an Armchair*[357] and *Old Woman* (fig. 141)[358]—were inspired by a *carte-de-visite* portrait (fig. 140) of a peasant woman, whose features they reproduce to the point of beastliness. Armchair, apron, scarf, and pleated skirt are reduced to their constructive elements, becoming rectangle, parallelogram, triangle, and parallel lines that highlight unanticipated relationships between the body and the objects surrounding it. This approach would lead to two paintings, *Portrait of a Girl*[359] and *Seated Man with Glass*,[360] in which optical reconstruction is splintered into allusive fragments of photographic *trompe-l'oeil*.

That same year of 1914 saw the start of a series that alternated naturalism with abstraction in the depiction of a seated man, several sources for which have been identified. Thus the drawings *Man Seated at a Table*[361] and *Man Sitting Near a Table*[362] partly derive from a postcard showing the entomologist J. H. Fabre at his work table. Similarly, a watercolor, *Man Reading a Newspaper* (fig. 143),[363] and the oil *Seated Man with Glass*[364] probably reconstitute the main elements of an old stereoscopic view of a café scene (fig. 142): seated man, top hat, poster lettering, round pedestal table, and so on. The original image would thus have simultaneously prompted a drawing that shuffled perceptual planes on top of one another and an oil that flattened the primary signs into so many ideograms.

A series of *carte-de-visite* portraits (fig. 144) produced by a Turkish photography studio, Abdullah Frères,[365] directly inspired naturalistic drawings such as *Man Leaning on a Column*[366] and *Man with Mustache Leaning on a Balustrade* (fig. 145),[367] which display the same setting as the old photographic pose. Another photograph (fig. 147)

from the same studio showing an old man with his elbow on a table is a direct source for a drawing *Bearded Man with a Pipe, Seated at Table* (fig. 146),[368] itself a straightforward inspiration for the male figure in *The Artist and His Model* (fig. 151), where the weary expression seen in the photograph is translated into a profound reverie. Indeed, this final version endows the aging body with a face borrowed from other, younger models in the Abdullah series. The youthfulness, dress, and straw-bottomed chair in *The Artist* thus strongly evoke the self-portrait of Picasso in front of his *Construction with Guitar Player* (fig. 127). Just as Picasso sat in front of his cubist assemblage, so his symbolic twin is set before the blue-green-brown ground of a putative canvas hanging on the wall of the studio.[369] The nearly nude model belongs as much to that canvas—the ground—as to the real space of the studio. It apparently represents Eva, Picasso's companion at the time, in what is a rare realistic depiction of her. This hypothesis would seem to be borne out by a photograph taken of Eva in Avignon during the summer of 1914 (fig. 149),[370] seated at a table whose balustered legs, oval shape, and tablecloth are fairly accurately reproduced on the right-hand side of *The Artist and His Model* (fig. 151). This female figure nevertheless also borrows several features from the girl painted in La Coruña in 1895: the dark, loose hair; the dull, almost mulish gaze; the drape of the white garment; the nakedness of the feet that has now spread to the whole body. The oil also merits comparison with another photograph (fig. 148) found in the Picasso archives, a glass plate on which, accidentally, only the lower half was exposed, showing the crossed legs of a young man seated on a straw-bottomed chair. The upper half of the negative is invaded by a dark zone where the latent image did not emerge. Similarly, *The Artist and His Model* (fig. 151) plays on the visible and the invisible, reality and representation, finished and unfinished. Its incompleteness, then, combined with a tribute to the means of representation, was a way of establishing the terms of a new problematics in painting.

The permutations described above were pursued in the fertile series of *Man with a Pipe, Seated at Table* (which extended into 1916),[371] as well as in the decoratively geometric *Man in a Bowler Hat, Seated in an Armchair*.[372] Finally, the repetitive orchestration of motifs borrowed from various prototypical "seated men" provided the

structure for the large canvas painted between 1915 and 1916, *Man Leaning on a Table*.[373] In a typical ploy, Picasso used this painting, while still in progress,[374] as the background for his most remarkable series of photographic self-portraits.

Several important photographs were taken in the studio at 5[bis] rue Schoelcher, where Picasso moved in the fall of 1913. The first could be dated early 1915, and shows the artist confronting his work once again; the print, flipped left-to-right, shows a carefully dressed Picasso leaning on the imposing carved frame of *Musical Instruments on a Pedestal Table* (fig. 152).[375] In the second photograph (fig. 154), Picasso poses with the large, almost-completed *papier collé* called *The Smoker*[376] and a carved figure from Mali, thereby constituting a secret conclave between man, fetish, and paper portrait. The strange theatricality of this image is reinforced by a band of stray light and the stack of sheet-covered canvases. A final photo (fig. 153) shows Picasso at work or, more probably, feigning work. Taken from a pronounced low angle, the picture lends a monumental dimension to the artist and the work with which he is posing, an initial version of the large *Man Leaning on a Table*.[377]

This photo was followed by a whole series of shots recording the progress of *Man Leaning on a Table*.[378] The studio comes across as a construction site where a rite of creative power is underway, with Picasso himself physically expressing the creative tension. Two of these photographs (figs. 156, 158) show Picasso wearing a cap, a roofing worker's jacket, and a strange pair of two-tone trousers; a third (fig. 155) shows him in an elegant three-piece suit.[379] Two further photographs (figs. 159, 160)—taken in another part of the studio where *Seated Man with Glass* and *Harlequin Playing the Guitar* can be seen in intermediate stages of execution[380]—convey an ambiguous atmosphere in which physical exhibitionism is undercut by the seriousness of Picasso's gaze. Sturdily planted on spread legs, body magnified by the low angle, the artist seems to be challenging the photographic apparatus. Such images recall many works from the turn of the century that showed Picasso naked,[381] notably the drawings from 1902[382] and the self-portraits drawn on newsprint in 1906–1907.[383] Much later, in the 1950s, Picasso would select some of the photographs taken on rue Schoelcher for the biographical publications being prepared by his friends.[384] Rather than depicting an artist who has already made it, they show painting's forced-laborer, the "good-looking bootblack,"[385] the distillation of virility and artistic arrogance.

Completed in November 1915, a *Harlequin* (fig. 157)[386] in which the character can be identified "only by the play of colored diamonds across the totally geometricized body,"[387] probably also represents a painter at his easel. I therefore think it may derive fairly directly from one of the photos

above
Fig. 140
Anonymous
Portrait of an Old Woman
[1860–1880]
Albumen print (*carte de visite*)
APPH 2776
Picasso Archives,
Musée Picasso, Paris

opposite page
Fig. 141
Pablo Picasso
Old Woman
[Avignon], 1914
Pencil on paper
7 1/8 x 5 3/8 in (18 x 13.5 cm)
Marina Picasso Collection,
Courtesy Galerie Jan Krugier,
Ditesheim et Cie, Geneva

taken at rue Schoelcher, having borrowed the figure's central axis and the variegated geometry of costume and hanging canvases. A profile image of Picasso's head has been detected in a white rectangle in the painting,[388] which would confirm the identificatory function of a work inspired by a photographic self-portrait.

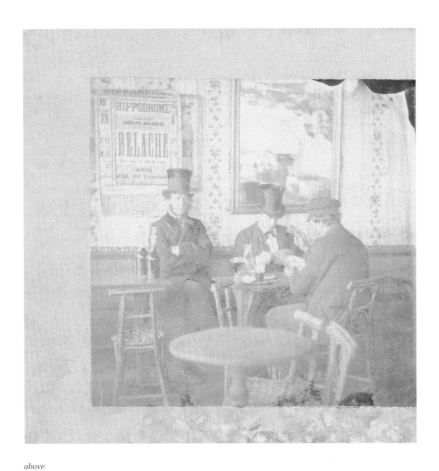

above
Fig. 142
Anonymous
Café Scene
[1860]
Albumen print
(stereoscopic view)
2 ⁵/₈ x 2 ³/₄ in (6.7 x 7 cm)
APPH 3620
Picasso Archives,
Musée Picasso, Paris

opposite page
Fig. 143
Pablo Picasso
Man Reading a Newspaper
Avignon, summer 1914
Pencil and watercolor on paper
12 ⁵/₈ x 9 ³/₈ in
(32.1 x 23.9 cm)
MP 759
Musée Picasso, Paris

Fig. 144
Abdullah Frères
Portrait of a Young Man
Istanbul, [1860–1890]
Albumen print (*carte de visite*)
APPH 3146
Picasso Archives,
Musée Picasso, Paris

Fig. 145
Pablo Picasso
*Man with Mustache Leaning
on a Balustrade*
[Avignon], 1914
Pencil on paper
11 ⁵/₈ x 7 ⁷/₈ in (29.5 x 20 cm)
Private collection

Fig. 146
Pablo Picasso
Bearded Man with a Pipe,
Seated at Table
Avignon, summer 1914
Pen and brown ink on paper
8 ¹/₄ x 8 ⁵/₈ (20.9 x 21.8 cm)
MP 744
Musée Picasso, Paris

Fig. 147
Abdullah Frères
Portrait of an Old Man
Istanbul, [1860–1890]
Albumen print (*carte de visite*)
APPH 3147
Picasso Archives,
Musée Picasso, Paris

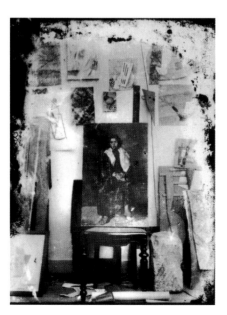

Fig. 148
Pablo Picasso
Seated Man (Self-Portrait?)
[Avignon, 1914]
Modern print from original
glass negative no. 115
Picasso Archives,
Musée Picasso, Paris

above
Fig. 149
Pablo Picasso
*Eva Gouel
(Marcelle Humbert)*
[Avignon, 1914]
Gelatin silver print
8 ³/₈ x 6 ¹/₄ in
(21.3 x 16 cm)
FPPH 48
Gift of Sir Roland Penrose
Musée Picasso, Paris

left
Fig. 150
Pablo Picasso
*"Girl with Bare Feet"
in the rue Schoelcher Studio*
Paris, 1914
Modern gelatin silver print
from original glass
negative no. 106
Picasso Archives,
Musée Picasso, Paris

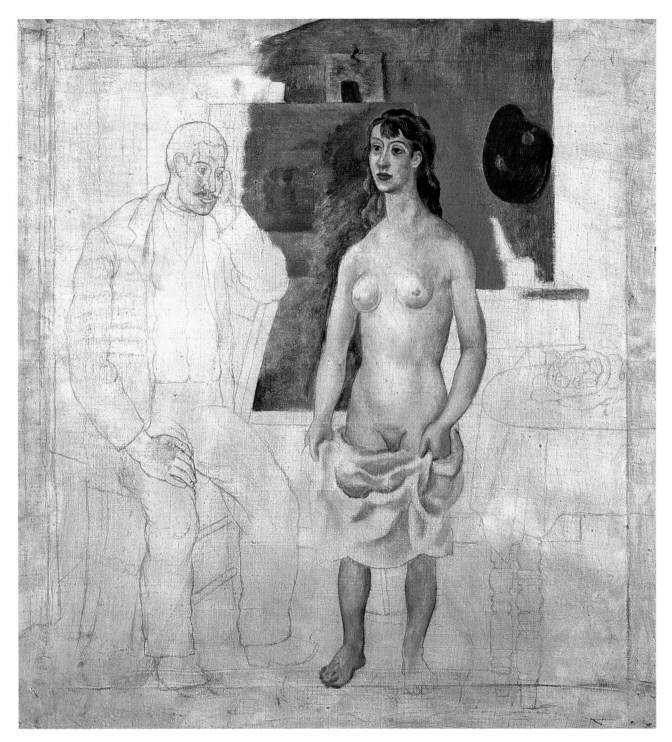

Fig. 151
Pablo Picasso
The Artist and His Model
Avignon, 1914
Oil and pencil on canvas
22 ⁷/₈ x 22 in (58 x 55.9 cm)
MP 53
Musée Picasso, Paris

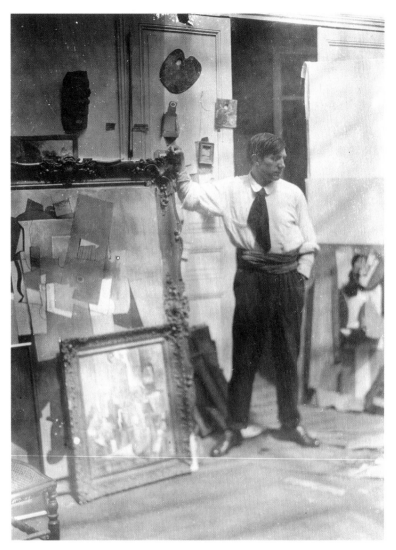

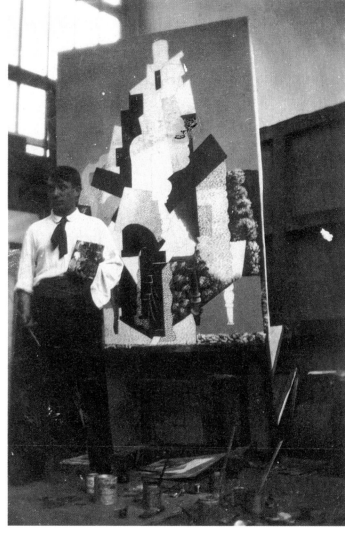

Fig. 152
Pablo Picasso
*Self-Portrait with "Musical
Instruments on a Pedestal Table"*
Paris, rue Schoelcher studio,
[1915]
Gelatin silver print,
flipped left-right
7 1/3 x 5 1/8 in (18 x 13 cm)
APPH 2818
Picasso Archives,
Musée Picasso, Paris

above
Fig. 153
Pablo Picasso
*Self-Portrait with "Man Leaning
on a Table" in Progress*
Paris, rue Schoelcher studio,
[1915-1916]
Gelatin silver print
2 1/2 x 1 7/8 in (6.5 x 4.7 cm)
APPH 2859
Picasso Archives,
Musée Picasso, Paris

opposite page
Fig. 154
Pablo Picasso
Self-Portrait with "The Smoker"
Paris, rue Schoelcher studio,
[1914–1916]
Gelatin silver print
7 1/8 x 5 1/8 in (18 x 13 cm)
APPH 2826
Picasso Archives,
Musée Picasso, Paris

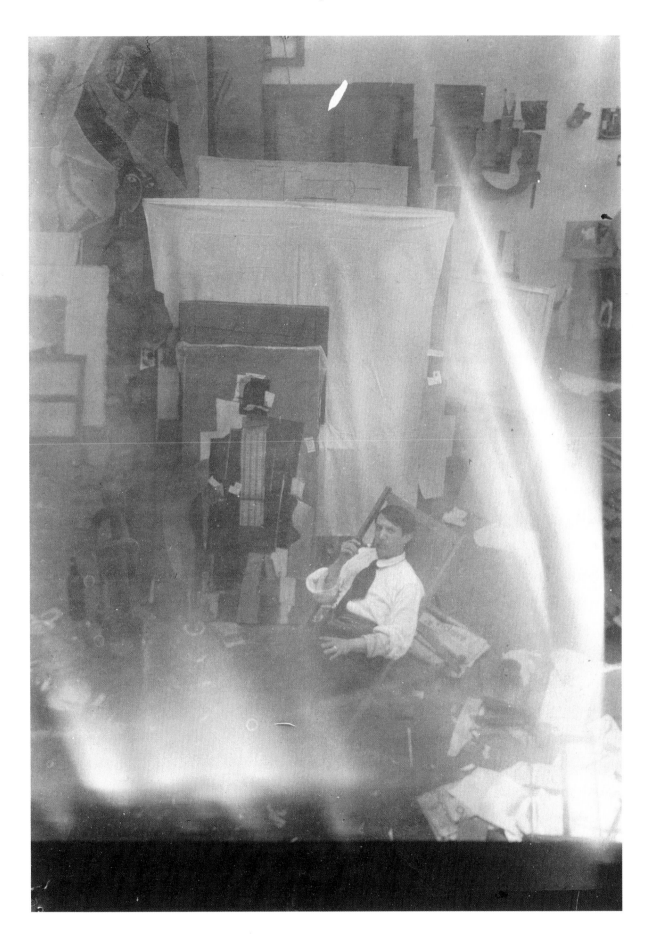

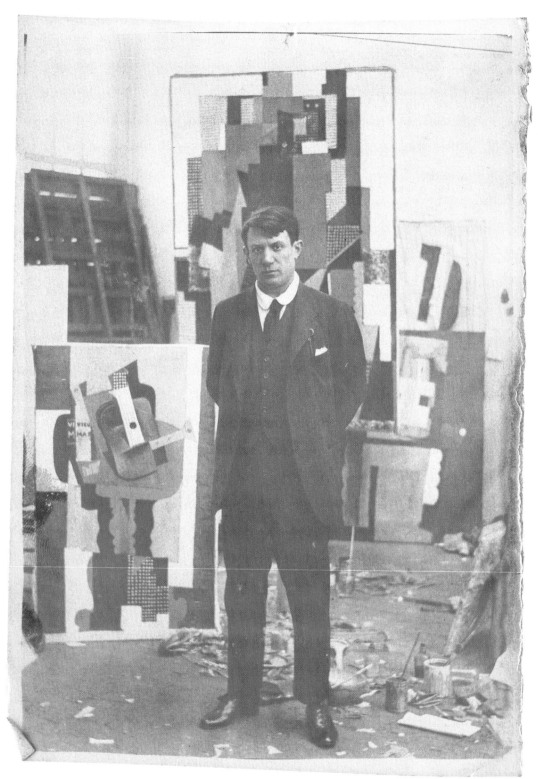

Fig. 155
Pablo Picasso
*Self-Portrait with "Man Leaning
on a Table" in Progress*
Paris, rue Schoelcher studio,
[1915–1916]
Gelatin silver print
7 3/8 x 4 5/8 in (18.8 x 11.8)
Private collection

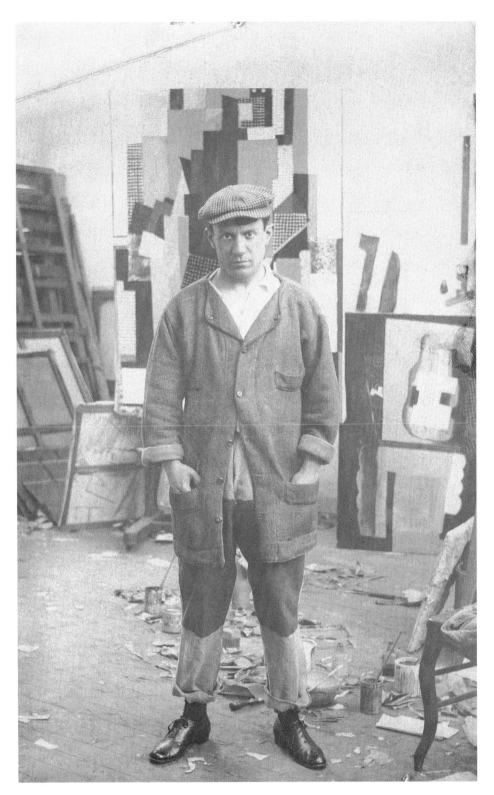

Fig. 156
Pablo Picasso
*Self-Portrait with "Man Leaning
on a Table" in Progress*
Paris, rue Schoelcher studio, [1915–1916]
Gelatin silver print
7 3/8 x 4 5/8 in (18.8 x 11.6 cm)
Private collection

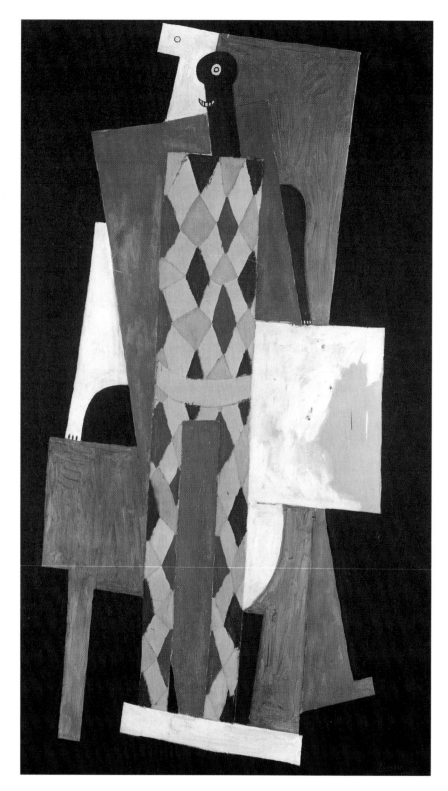

Fig. 157
Pablo Picasso
Harlequin
Paris, November 1915
Oil on canvas
72 ¹/₄ x 41 ³/₈ in (183.5 x 105.1 cm)
Acquired through the Lillie P. Bliss Bequest
Photograph © The Museum of Modern Art,
New York

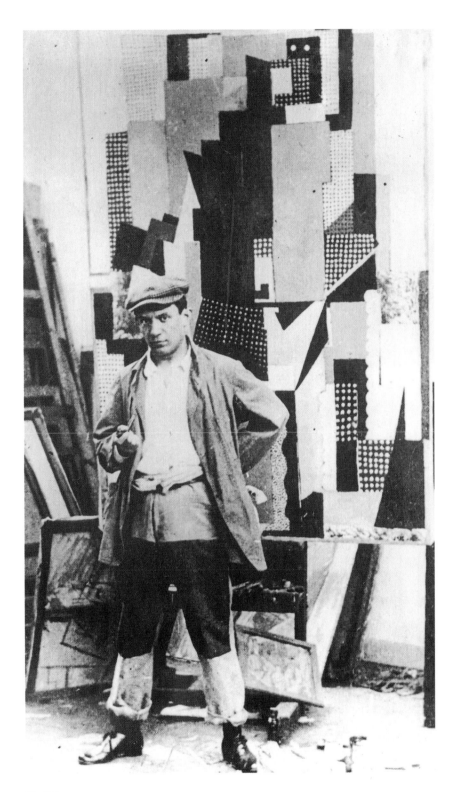

Fig. 158
Pablo Picasso
Self-Portrait with "Man Leaning on a Table" in Progress
Paris, rue Schoelcher studio, [1915–1916]
Gelatin silver print
5 ⁷/₈ x 3 ³/₈ in (14.9 x 8.6 cm)
FPPH 10
Gift of Sir Roland Penrose
Picasso Archives, Musée Picasso, Paris

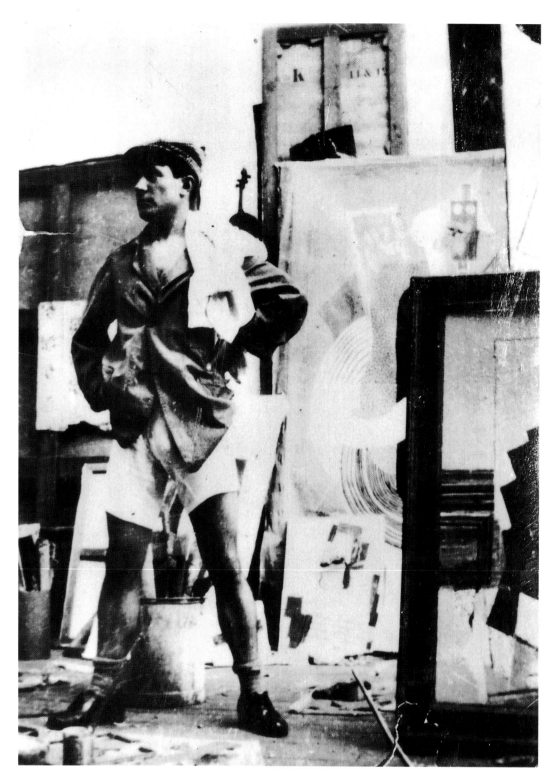

Fig. 159
Pablo Picasso
Self-Portrait with "Seated Man with Glass" in Progress
Paris, rue Schoelcher studio, [1915–1916]
Gelatin silver print
5 7/8 x 3 3/8 in (14.9 x 8.6 cm)
FPPH 11
Gift of Sir Roland Penrose
Picasso Archives, Musée Picasso, Paris

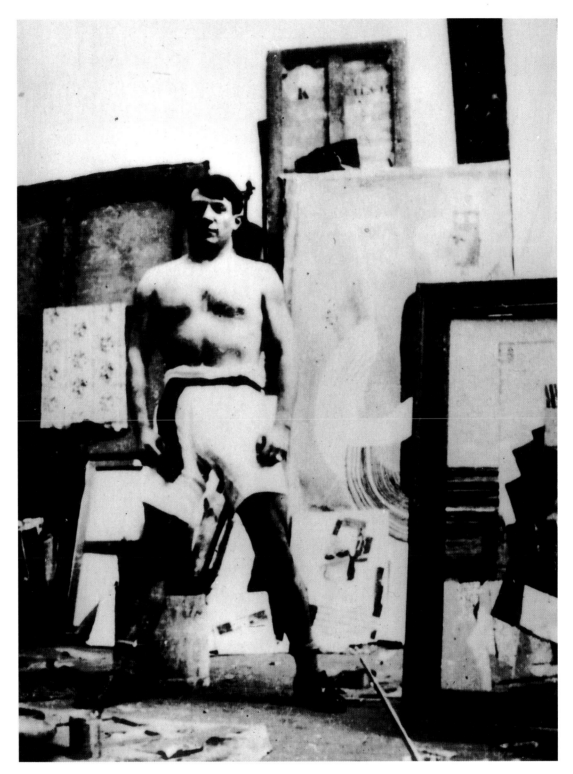

Fig. 160
Pablo Picasso
Self-Portrait with "Seated Man with Glass" in Progress
Paris, rue Schoelcher studio, [1915–1916]
Gelatin silver print
9 5/8 x 7 1/4 in (24.3 x 18.3 cm)
FPPH 12
Gift of Sir Roland Penrose
Picasso Archives, Musée Picasso, Paris

Light and Line—Drawings "Based on a Photograph"

In a short lampoon published in January 1917 under the title "Penitent Picasso," Francis Picabia accused the artist of "returning to the School of Fine Arts."[389] The article targeted the *Portrait of Max Jacob* (fig. 163),[390] executed two years earlier, and reproduced an ironic collage, described as a "Kodak," that combined a line drawing with a photo of the face of Max Goth (fig. 161). Picasso's "new classicism" was thereby identified with the ordinary mimicry of photography. As distinct from cubism, critics were describing—in a highly imprecise way— the *Portrait of Max Jacob* (fig. 163) as practically photographic.[391] The portrait does in fact display clear similarities with a studio photo dating from 1905–1907 (fig. 162),[392] as though Picasso had complemented sittings with attentive study of this image.[393] The result was a fortuitous juxtaposition of a photo-like grisaille bust with an outline that brutally foreshortens the rest of the body. Picabia's parody, by underscoring this dysfunction, touched upon one of the deliberate paradoxes illustrated by Picasso's classicizing efforts: the "resemblance" in fact destroys perspectival illusionism just as it denies any live presence of the sitter. To demonstrate this contradiction, Picabia was obliged to adopt an artistic approach unusual for the day, unexpectedly producing what appears to be the first photomontage.[394]

A much earlier portrait of Max Jacob[395] had already offered another interpretation of the same photograph by geometricizing it in a proto-cubist manner. Both approaches make it possible to measure the unbridgeable gap between a photographic image, where the play of values reconstitutes the light reflected on a subject, and drawings, where signs dominate any "imitation" of reality. This is what Picasso meant when he said, "Yes, line drawings have their own light—created, not imitated."[396] Even when a drawing, like a photo, attempts to convey volumes through shades of gray, it contrasts with a medium of analogic continuity insofar as an art of lines, slashes, and discontinuity generates contours that indicate form only where a given form comes to an end. This gives the full measure of the ambiguity of Picasso's "photographic" style of 1915, when he said he wanted to "draw like everybody else."[397]

Three drawings of Guillaume Apollinaire, done the following year, explored a different path. One is a simple bust in profile, while the other two (figs. 164, 165) are seated portraits offering a glimpse of the rue Schoelcher setting.[398] Even if Apollinaire sat for one session, this would not exclude a visual allusion to a group photograph (fig. 166) taken at the Italian hospital in Paris,[399] where Apollinaire appears in similar pose and dress. The drawings also waggishly borrow details from other members of the group.[400] As to Apollinaire's face, the two portraits with bandaged head—one in profile, the other in

Fig. 161
Francis Picabia
Portrait of Max Goth
From a reproduction in *391*,
no. 1, January 1917

three-quarter pose (fig. 165)—both exploit, in different ways, the strange photographic head which turns away even as Apollinaire's eyes remain riveted to the lens. The portrait with cap (fig. 164), furthermore, resembles Apollinaire's face and expression in a 1911 photograph (fig. 167) taken during the legal investigation into the theft of Iberian sculptures from the Louvre.[401] Exhibiting what Apollinaire would call "a kind of sur-realism,"[402] Picasso thereby conflated an image of distress with the tribute that he hoped this drawing would pay to his friend, the wounded World War I veteran.

Picasso's return to "portraiture" assumed greater scope in 1919–1920 with his rubbed charcoal drawings of musicians Igor Stravinsky, Manuel de Falla, and Erik Satie,[403] artists Pierre-Auguste Renoir (fig. 169)[404] and André Derain,[405] and art dealer Berthe Weill.[406] It is known that sitters posed for at least some of these drawings, which nevertheless share the visual idiom of the photo-based works that defined the "photographic style." Picasso's erasures, revisions, and obliterations formed a sediment from which the final outline emerged. Effects that enlarge forms also tend to imply unexpected foregrounds; even as they lose depth, the drawings seem to flutter, perceptually oscillating between front and back. Everything thus encourages the beholder to accept, at first sight, the "photographic" faithfulness of representation only to doubt it the next instant. This game of ambivalence allowed Picasso to sustain

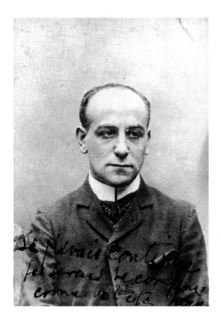

Fig. 162
Anonymous
Portrait of Max Jacob
[1905-1907]
Gelatin silver print
Bibliothèque Littéraire
Jacques Doucet, Paris

Fig. 163
Pablo Picasso
Portrait of Max Jacob
Paris, 1915
Pencil on paper
13 x 9 ³/₄ in (33 x 24.8 cm)
Private collection

Fig. 164
Pablo Picasso
Portrait of Guillaume Apollinaire
Paris, 1916
Pencil on paper
19 ¹/₄ x 12 (48.8 x 30.5 cm)
Private collection

Fig. 165
Pablo Picasso
Portrait of Guillaume Apollinaire
Paris, 1916
Pencil on paper
12 ¹/₄ x 9 in (31 x 23 cm)
Private collection

above
Fig. 166
Anonymous
Guillaume Apollinaire
with a Group at the Italian Hospital
on Quai d'Orsay
Paris, spring 1916
Gelatin silver print
3 ¹/₂ x 7 ¹/₈ in (9 x 18 cm)
APPH 4291
Picasso Archives,
Musée Picasso, Paris

Fig. 167
Anonymous
Guillaume Apollinaire
with his Lawyer, José Théry
Paris, September 1911
Gelatin silver print
4 ⁷/₈ x 7 ¹/₈ in (12.5 x 18 cm)
APPH 4292
Picasso Archives,
Musée Picasso, Paris

above
Fig. 168
Vollard Gallery Photo
Portrait of Pierre-Auguste Renoir
[Vence, 1913]
Gelatin silver print
11 1/2 x 9 1/4 in (29.3 x 23.5 cm)
APPH 2764
Picasso Archives,
Musée Picasso, Paris

opposite page
Fig. 169
Pablo Picasso
Portrait of Pierre-Auguste Renoir
Paris, 1919–1920
Pencil and charcoal on paper
24 x 19 3/8 in (61 x 49.3 cm)
MP 913
Musée Picasso, Paris

Fig. 170
Saul Bransburg
Ballerinas from
the Ballets Russes
in "Les Papillons"
[Monte-Carlo, April 1914]
Gelatin silver print
7 1/8 x 9 3/8 in
(18 x 23.8 cm)
APPH 4856
Picasso Archives,
Musée Picasso, Paris

Fig. 171
Pablo Picasso
Dancers
1919
India ink on paper
7 5/8 x 10 3/8 in
(19.5 x 26.5 cm)
Private collection

his prior rejection of illusionism even as he urged a representational "recall to order." It was, moreover, a "naturalistic" drawing—an early portrait of Stravinsky dating from 1917[407]—that prompted Italian military authorities to declare, "[This] is not a portrait, but a plan."[408] Far from swallowing what Picabia called the "Kodak" style, then, ordinary eyes saw this image for what it was—a system of signs.

The *Portrait of Renoir* (fig. 169) is known to have been based on a Vollard gallery photograph (fig. 168) of which Picasso owned a print.[409] The photo reveals all the brutality of the deformations that age and illness imposed on Renoir, as well as showing the lively acuity of his eyes. Picasso's charcoal drawing allows each line to be intuited through a *kinetic* effect in which the deformed hand seems to cling to the extreme edge of the paper by making successive clutches at the arm of the chair. The narrowly framed *Portrait of André Derain*, meanwhile, treats the painter's hands in similar fashion, in a movement that draws them into the foreground. Challenging the usual figurative hierarchy centered on the face, Picasso tipped head and body backward. He imposes what might be called a haptic[410] approach to the subject, focusing on both the bodily presence and the psychological authenticity of the sitter. The drawing thus adopts that special viewpoint espoused by Picasso in his photographs: low-angle view, enlargement of frontal planes, shrinking of head and upper limbs, and a decentering of planes and perspective.

The kinetic approach to these portraits was systematized in *Italian Peasants* ("based on a photograph"[411]) and in the series of rubbed charcoal drawings inspired by the Ballets Russes. To meet the challenge of graphically expressing the very concept of corporal dynamics Picasso reportedly offered this rule: "You have to get ahead of movement in order to freeze an image, otherwise you're always behind. Only at that moment, for me, is it real."[412] Thus Picasso's 1919–1920 drawings of choreographic subjects did not employ production stills that attempted to record dance as a physical and artistic performance. Instead, he used photos by Bransburg (fig. 170)[413] or White (figs. 172, 175)[414] that showed figures carefully posed for the lens—not a photographed ballet but a static group simulating dance. Picasso's drawings superimposed lines over ghostly outlines so that these "frozen" models suddenly become "haunted" with new life. His *Dancers* (fig. 171),[415] furthermore, ignored the luxuriant setting of a Mediterranean garden in order to underscore the poses comprising the "tableau." He concentrated on drawing the hands and arranging the strongest shadows of these figures, which occupy the entire page of the sketchbook. *Two Dancers*,[416] based on another photograph, eliminates everything but the central couple formed by Olga Khokhlova and another ballerina. *Group of Seven Figures*

(fig. 173)[417] and *Seven Dancers* (fig. 174),[418] meanwhile, offer two interpretations of the same illustration (fig. 172). The India ink and watercolor version retains the overall composition and medallion effect; Olga, lying in the foreground, is the only figure to be wholly presented to the gaze. The deformed perspective produced by this foreground is underscored by the miniaturization of the heads of several of the models. The other drawing, in a vertical format, pushes this effect even further through out-of-scale foreground details (Olga's arms) which contrast with the ballerinas in the background, transformed into tiny caryatids. Picasso's angular line nevertheless traces a single overall motif that merits comparison with certain drawings of foliage done in the 1920s.[419] The powdery charcoal lends a fully tactile quality to the paper, as though endowing it with the continuum effect specific to photography. *Three Dancers* (fig. 176),[420] inspired by another White photograph (fig. 175), takes this transposition even further. Framed vertically, the ballerinas' faces are pushed to the point of caricature. Picasso multiplied the lines of the transparent skirts and extended this approach to the handling of the bodies. As discussed above, the superimposition of certain photos of Horta (fig. 97) could evoke a shifting viewpoint around the object; some ten years later, the Futurism associated with Ballà and Bragaglia must have reminded Picasso of such experiments, all the while orienting them toward the temporal and spatial project of the kinesthetic sedimentation of movement. A final work, also titled *Three Dancers* (fig. 177)[421] stemmed from the same photo. The woman on the left combines the pose of Olga, one hand before her face, with the raised arm of her neighbor. Frontal, profile, then turned away to the left: the ballerina seems to spin in slow rotation, as though the drawing has captured her at different moments in her rotation, like a chronophotograph. A double portrait of Sergei Diaghilev and Alfred Seligsberg (figs. 178, 179),[422] also part of the series on the Ballets Russes, applied this same quest for a vibrating line to portraiture. A few effaced lines establish the sitters' bodily outlines and suggest modeled shading which "freezes the image" so that "reality" can surface.

The years 1919–1920 also produced several examples of drawings in which Picasso—in a movement counter to the one that led him to elaborate the generic cubist paintings of 1919–1911 from photographs of his friends—was concerned to convey the singularity of "found" photos. As he had done several times previously, he employed old photographic *cartes de visite* (figs. 181, 182, 184), using either images of strangers for drawings like *Man at a Stand* (fig. 180)[423] and *Family Portrait* (fig. 185),[424] or famous figures for *The Family of Napoleon III* (fig. 183).[425] The emperor's family is posed in the same triangular arrangement as the family of the anonymous bourgeois gentleman; this latter figure seems so strangely similar in

left
Fig. 172
The White Studio
Ballerinas from the Ballets Russes in "Les Sylphides"
[New York, January 1916]
Program illustration
APPH 2690
Picasso Archives,
Musée Picasso, Paris

below
Fig. 173
Pablo Picasso
Group of Seven Figures
1919
India ink and watercolor
on paper
10 3/8 x 15 1/2 in
(26.5 x 39.5 cm)
Private collection

Fig. 174
Pablo Picasso
Seven Dancers
Paris, early 1919
Pencil and charcoal on paper
24 $^5/_8$ x 19 $^5/_8$ in (62.6 x 50 cm)
MP 841
Musée Picasso, Paris

Fig. 175
The White Studio
*Ballerinas from the Ballets
Russes in "Les Sylphides"*
[New York, January 1916]
Gelatin silver print
8 1/8 x 10 in (20.6 x 25.5 cm)
APPH 2683
Picasso Archives,
Musée Picasso, Paris

Fig. 176
Pablo Picasso
Three Dancers
Early 1919
Pencil and charcoal on paper
24 5/8 x 18 1/2 in (62.7 x 47)
MP 834
Musée Picasso, Paris

Fig. 177
Pablo Picasso
Three Dancers
1919–1920
Pencil on three sheets of paper
14 3/4 x 12 5/8 in (37.5 x 32 cm)
MP 840
Musée Picasso, Paris

the first two photographs that it is hard to say whether they recorded the same individual or two different men whom photography has reduced to a single type.

In studio settings, a sitter would dialogue with a plinth, pilaster, or balustrade—anthropomorphic allusions that sufficed to suggest a "classic" landscape. In both *The Family of Napoleon III* (fig. 183) and *Family Portrait* (fig. 185), Picasso tightened the composition to focus on the figures' busts and the circle formed by hands and gazes. The drawing of the imperial trio is highlighted in pastel, a doubly paradoxical transcription of an image whose expressive idiom disregarded both line and color. Here, the addition of chromatic washes, far from constituting additional "realism," evokes instead the popular color illustrations known as *images d'Epinal*, whose three-color palette it symbolically reflects.[426] Picasso was apparently attacking a more anodyne subject when he transposed a portrait of an anonymous *Man at a Stand* (fig. 180). Here his furry lines suggest the density of an image that conveys to the eye not only the exposure time of the photo but also the time separating us from it. "The [photographic] process itself made sitters live not outside the instant but within it: for the long duration of the exposure, they installed themselves, so to speak, inside the image."[427] Warm gray paper, graphite pencil, hazy charcoal shading—Picasso's method provides a material equivalence for the sepia photograph and its double recording of the *passage* of time. He thereby developed an "anonymous" portraiture in which the careful recording of appearances simultaneously registers the banality of the image and its particularity of being a real trace, an *index*,[428] of an existential experience.

"Don't move!" The sitter stiffens, making a show of this tension for the image. *Family Portrait* (fig. 185) thus unites a giant-sized mother, the elongated bust of a man, and the disproportionately tiny head of a child. Whereas the rest of the work is a line drawing, the miniature face is handled with fine hatching that reconstructs photographic modeling. Its denser matter is inscribed, like a collage, at the precise intersection of its diagonals; note that the effect is very similar to the one demonstrated by Picabia's mocking "Kodak" (fig. 161). The figures are endowed, however, with enormous hands, like heavy links underscoring the image of their familial chain. In this instance, the effect does not seem to be due to any true proximity of perspective.[429] The interlinked gesture distills the almost painful energy of the frozen action of posing; hands cling to their support, hug one another like the sensuous roots of a body locked into social convention. The sitters thus appear cut off from themselves, dislocated in a swarm of partial representations. The man is there, body leaning with all its weight on a neoclassical balustrade, as though called to the bar to testify to the enigma of his presence in this world.

The year 1923 finally supplied the first example of a drawing (fig. 186) actually executed *on* a photograph rather than simply "based on" one. The front page of an illustrated daily, *Excelsior*, provided the excuse for this graphic extension. Jaime Sabartés has recounted how Picasso, as a young child in La Coruña, would send his family handwritten four-page newspapers of his own making, covered with little drawings and explanatory captions.[430] Paper, typography, illustrations—newspapers would resurface in the highlighted cutouts of 1906–1907 and the *papiers collés* of the 1911–1914 period, employed by Picasso as plastic material for highly varied goals. He was drawn to press photos not only for their images but also for their texture, the color specific to newsprint, the play of lettering, the organization of the sheet, etc. And for Picasso, who was obsessed with precise dating,[431] newspapers ultimately served as a literal sign of up-to-dateness. The drawing *Fragment of "Excelsior"* thus allows the date of 23 July to be read immediately.[432] It is nevertheless an antique-style, timeless drawing that appears in the middle of the newspaper, over the photograph of the winner of the Tour de France bicycle race, accompanied by his wife. The drawing provides a face for the wife, who turns her head away; like the adjoining, much larger figure, it evokes a major painting of that same year, *The Woman in White*. The cyclist, meanwhile, now has two faces; one turns to the left, whereas the other, more legible one turns toward his wife. A biographical interpretation of *The Woman in White* as an amorous tribute to Sara Murphy has recently been proposed.[433] And, sure enough, the drawing *Fragment of "Excelsior"* is not only placed below an epigraph from Goethe,[434] but it also includes subtle formal similarities to a set of snapshots taken on the beach that summer of 1923, showing Picasso in the company of Sara Murphy (fig. 187) and her husband Gerald.[435] Kenneth Silver, although seeing the timelessness of this figure as "Picasso's greatest postwar meditation on the endurance of culture,"[436] nevertheless queried the process: "We have here a rare opportunity to watch the artist in the very process of transforming the mundane present into an idealized past Over an illustrated piece that bears the title 'Le maréchal Foch a inauguré le parc mémorial du Bois Belleau,' Picasso has made a sketch for . . . *The Woman in White* Whether Picasso was consciously aware that this beautiful sitter was being given form, literally, on top of the tragic memory of war, we will probably never know"[437] Whatever the case, *Fragment of "Excelsior"* appears as a instructive case of a work being superimposed over the very image that was its source, right on the original document. An observer can thus discern—as though through tracing paper—not only the measure of idealization involved in Picasso's return to figurative art, but also everything which, by nature, *divides* the expressive modalities of a photograph from the methods specific to painter or draftsman.

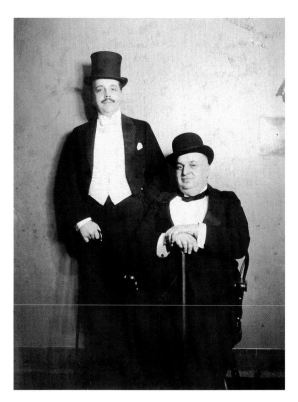

above
Fig. 178
Count Jean de Strelecki
*Sergei Diaghilev, Director
of the Ballets Russes,
and Alfred F. Seligsberg*
New York, [April] 1916
Gelatin silver print
9 ¹/₄ x 6 ⁷/₈ in (23.5 x 17.5 cm)
APPH 4834
Picasso Archives,
Musée Picasso, Paris

right
Fig. 179
Pablo Picasso
*Portrait of Sergei Diaghilev
and Alfred F. Seligsberg*
Early 1919
Charcoal and pencil
25 ⁵/₈ x 19 ⁵/₈ in (65 x 50 cm)
MP 839
Musée Picasso, Paris

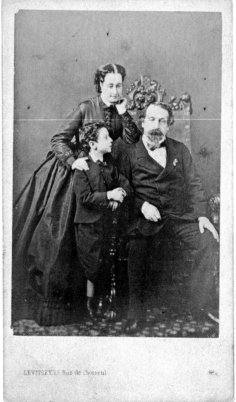

Fig. 180
Pablo Picasso
Man at a Stand
Paris, 1920
Pencil and charcoal
on gray paper
18 ⁷/₈ x 15 ³/₈ in
(48.1 x 39.1 cm)
MP 912
Musée Picasso, Paris

above right
Fig. 181
Antonin Studio
Portrait of a Man
Paris, 1870
Albumen print (*carte de visite*)
APPH 2763
Picasso Archives,
Musée Picasso, Paris

right
Fig. 182
Levitsky Studio
*Napoleon III, Empress Eugénie,
and the Crown Prince*
Paris, c. 1865
Albumen print (*carte de visite*)
APPH 2766
Picasso Archives,
Musée Picasso, Paris

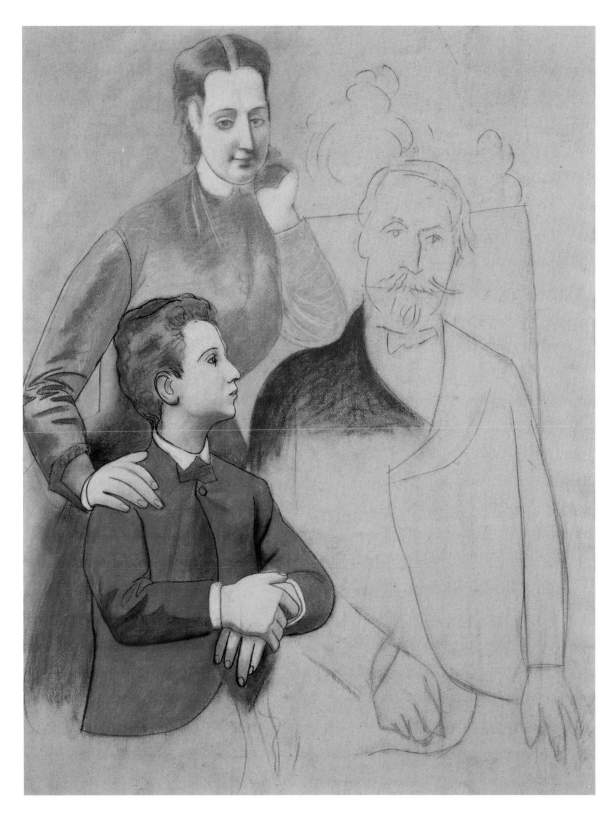

Fig. 183
Pablo Picasso
The Family of Napoleon III
1919
Pastel on paper
24 ³/₈ x 18 ⁷/₈ in (62 x 48 cm)
Private collection

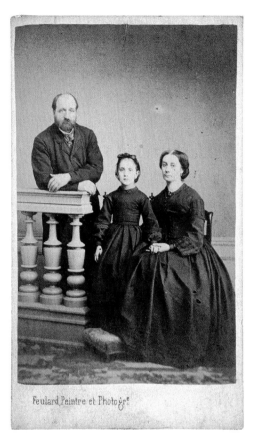

Feulard Peintre et Photogre

above
Fig. 184
A. Feulard
Family Portrait
[1870]
Albumen print (*carte de visite*)
APPH 3615
Picasso Archives,
Musée Picasso, Paris

opposite page
Fig. 185
Pablo Picasso
Family Portrait
1919
Pencil and charcoal on paper
33 ¹/₈ x 27 in (84 x 68.5 cm)
Private collection

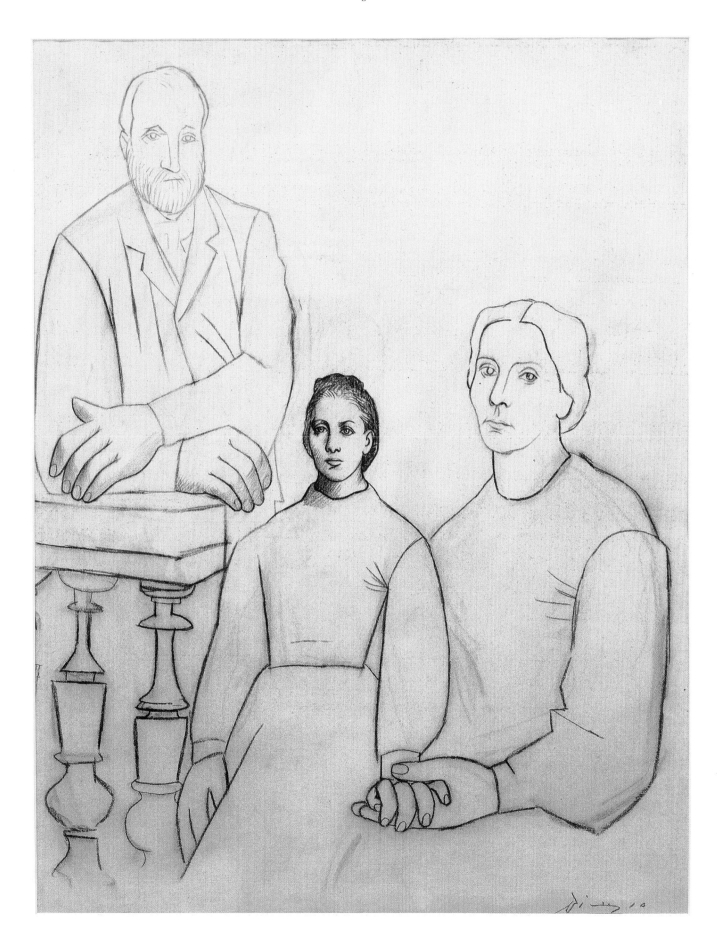

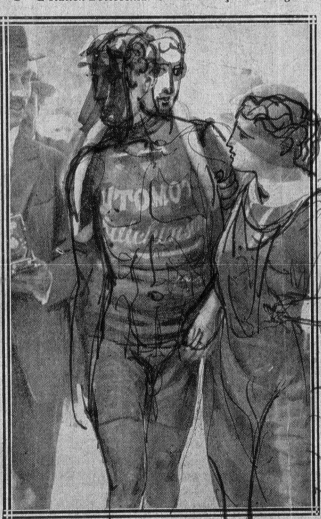

LA BELGIQUE ESTIME QUE LES PROPOSITIONS BRITANNIQUES SONT

EXCELSI

14e Année. — N° 4.606.
Pierre Lafitte, fondateur

PARIS SEINE SEINE-ET-OISE ET SEINE-ET-MARNE 15 centimes
Départements. Colonies. Provinces rhénanes occupées 20 centimes
Belgique Luxembourg 30 centimes (Voir prix des abonnements au bas des pages)

«Le plus court croquis m'en dit plus lo...
Tél. Gut. 02.73 - 02.75 - 15.00. — Adr. Télé...

. A VILLERS-COTTERETS

AUX MORTS DE LA GUERRE

LE CHAMPION FRANÇAIS HENRI PÉLISSIER
A GAGNÉ LE TOUR DE FRANCE CYCLISTE

2me *L'Italien Bottecchia.* 3me *Le Français Bellenger*

À M. POINCARE LES NOMS DES MORTS

...de 1918, le président du Conseil a pré-
... morts de Villers-Cotterets. Le maré-
... à cette cérémonie, au cours de laquelle
...s que nous publions d'autre part. Un

LE VAINQUEUR ET SA FEMME AU QUARTIER DES COUREURS

La dernière étape du Tour de France disputée hier sur le par-
cours Dunkerque-Paris n'a pas changé l'ordre du classement
... Pélissier, qui monte une bicyclette Auto-moto
...utchinson, sort vainqueur de la grande épreuve.

LDAT INCONNU

Fig. 186
Pablo Picasso
Fragment of "Excelsior"
(Classical Figures in Profile)
Antibes, summer 1923
Ink on the front page
of the July 23, 1923 edition
of *Excelsior*
13 ³/₈ x 14 in (33.9 x 35.5 cm)
MP 984
Musée Picasso, Paris

...COURAGEANTES

...OR

...n long rapport ? — NAPOLÉON
...Paris. — 2? rue d'Enghien, Paris.

LUNDI
23
JUILLET
1923

Le sentiment est tout;
le nom n'est que bruit
et fumée, un brouil-
lard qui nous cache la
splendeur des cieux.
La meilleure partie de
l'homme est ce qui
tressaille et vibre en lui.
GŒTHE.

...E MARÉCHAL FOCH A INAUGURÉ HIER
...E PARC MEMORIAL DU BOIS BELLEAU

...ES AMÉRICAINS TIRENT UNE SALVE ; 2. ON HISSE LE DRAPEAU ; 3. DISCOURS DU M.ªˡ FOCH

...maréchal Foch a solennellement inauguré hier le Parc Memorial aménagé par
...Belleau Memorial Association sur le terrain où, pour la première fois, les
...oupes du général Pershing barrèrent le chemin aux Allemands. Ce parc, des-
...é à symboliser le champ d'honneur des troupes américaines, couvre une super-
...ie de 80 hectares. De nombreuses personnalités civiles et militaires assistaient
...cette émouvante cérémonie du souvenir. (Photos de notre envoyé spécial.)

...A FÊTE DE L'APRÈS-MIDI AU CHAMP-DE-MARS

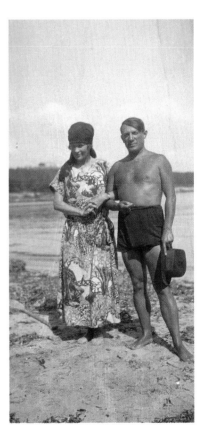

Fig. 187
Anonymous
Picasso and Sara Murphy
Antibes, 1923
Gelatin silver print
Picasso Archives,
Musée Picasso, Paris

Pictorial Variations

To those who condemned his stylistic oscillations between cubist and figurative art, Picasso replied in 1923: "When I hear people speak of the evolution of an artist, it seems to me that they are considering him standing between two mirrors that face each other and reproduce his image an infinite number of times, and that they contemplate the successive images of one mirror as his past, and the images of the other mirror as his future, while his real image is taken as his present. They do not consider that they all are the same images in different planes."[438] This metaphor might describe not only the coexistence of Picasso's reputedly antagonistic styles of painting, but also the entirely dialectical relationship between his painting and its photographic sources, as will be examined through a number of themes that engendered variations in the years following 1917, when it was not uncommon to see a single visual reference jointly inspire figurative expression and synthetic cubist experimentation. In several instances, the same photograph inspired interpretations that were alternately naturalistic and cubist. This dialogue suggests that the "modernism" versus "recall to order" dichotomy should be transcended, in order to address a more complex exchange in which images stemming from reality are superimposed and mutually reflect one another—"the same images", only "in different planes"—in their quest to inhabit every instance of likeness and pretense. For it is never a question of reality or truth, but of visual strategies brought to bear on things, and of the means by which a work records them.

Ever since it was compared to a photograph (fig. 189) taken in the Montrouge studio,[439] the painting of *Olga in an Armchair* (fig. 190)[440] has apparently offered a textbook case for studying the relationship of photography to painting during Picasso's so-called neoclassic period.[441] The recent discovery of the original negatives for this photo of Olga[442] as well as the letters sent by Picasso to Gertrude Stein concerning this portrait "in the style of a photographic enlargement"[443] now indicate a date of early spring 1918 for both photo and canvas. The new date[444] makes it possible to link the painting to several sketches previously thought to be later, notably *Olga Picasso Seated,* in which the young woman is sitting on the same upholstered chair and wearing the same dress.[445] Echoing the dialogue between Olga and the Baga fertility figures in the photograph,[446] the painting intensifies, like some nuptial display, the symbolic "flowering" that overwhelms chair, fan, and dress. The meticulous rendering of these patterns extends to the handling of flesh and face. Where the photograph contrasts the refined arabesques of the pose to the disorder of the studio, however, the unfinished canvas comes across as a collage combining a figure—the seated woman—with monochrome geometry, namely,

the expanse of blank canvas.[447] Pictorial facsimile ultimately leads—as did naturalistic drawing in the *Portrait of Max Jacob* (fig. 163)—to an emptying of photographic illusionism in favor of an entirely *flattened* representation. Thus it exhibits nothing of the photograph's "live" aura, nor of the "completion" expected of a veritable Ingresque portrait.[448]

This painting shares with the 1908 *Woman with a Fan*[449] a structure in which the model's asymmetrical pose[450] is set off by a flat, rectangular wash of color, and in which a half-folded fan serves as epicenter. Ten years earlier, this motif[451] prefigured cubist decomposition of the perspectival pyramid by layering superimposed, translucent planes over one another, revealing and masking their subject in a multiplicity of viewing angles. And at the conclusion of that pictorial adventure, the symbolic fan is found once again at the heart of Olga's portrait. In a new form of anti-perspectival ambiguity, representation henceforth plays on a broad deployment of planes, like so many sheets whose edges are carefully matched to form a single surface.[452]

Furthermore, the painting should be compared to another painting of similar size and tonality, *Woman in an Armchair* (fig. 188),[453] which presents itself as a cubist twin. The main structural lines of this latter canvas are dictated by the geometry of the art works and frames visible in the photograph.[454] The confrontation between these twin canvases thereby reveals antagonistic approaches to a shared strategy of interpreting photographic material.

Subsequent to this picto-photographic encounter, *Olga in an Armchair* (fig. 190) figured in the center of one of three photographs (figs. 191, 192, 193) that Picasso took of his wife, now a mother, in their room at Fontainebleau during the summer of 1921. Thanks to pivotal angles, the three photos reveal the entire space of the room. The third shot (fig. 194) shows Olga at the piano, her profile set against the arrangement of drawings and paintings on the wall; it might have inspired a canvas titled *Studies* (fig. 195),[455] which stylistic analysis now dates to 1922.[456] At the center of the painting is an antique-style profile, flanked by a grid of small cubist and neoclassical canvases, perhaps designed to play an exorcising role, given the repeated motif of the ace of clubs. These imaginary works not only allude to the ones visible in the photograph of Olga via multiple formal allusions, but they also sum up, in emblematic fashion, the dualism of that pictorial moment.

In the 1918 *Harlequin with Violin (Si tu veux)*[457], the trellised grid of the harlequin's costume is successively conjugated in gray, blue, pale-green, and finally a dark contrast of red and black.[458] This garment, simultaneously gaudy and regular, thus operates as a metaphor for all the paradoxes of the pictorial expanse, recalling a comment by Cézanne: "A motif, you see, is this. . . . Oh yes! (He repeats the gesture of spreading his hands, fingers wide,

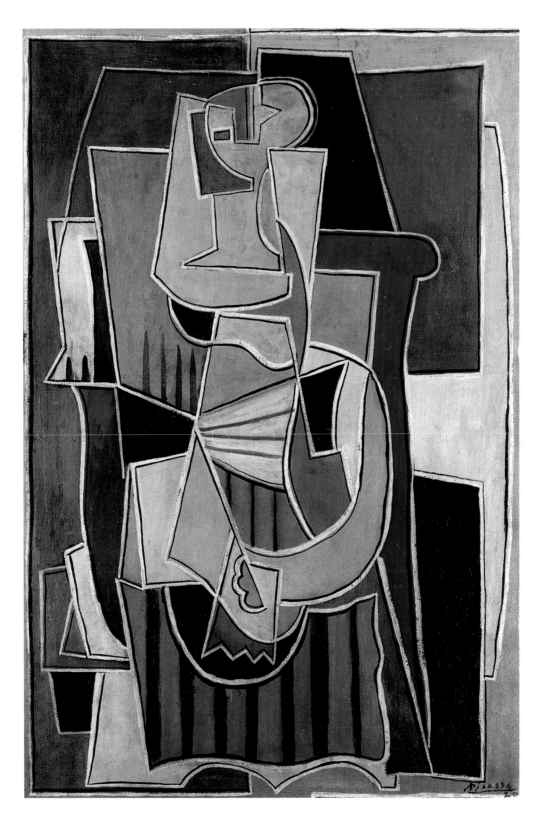

Fig. 188
Pablo Picasso
Woman in an Armchair
Paris, [1918–1920]
Oil on canvas
51 1/8 x 35 in (130 x 89 cm)
Private collection

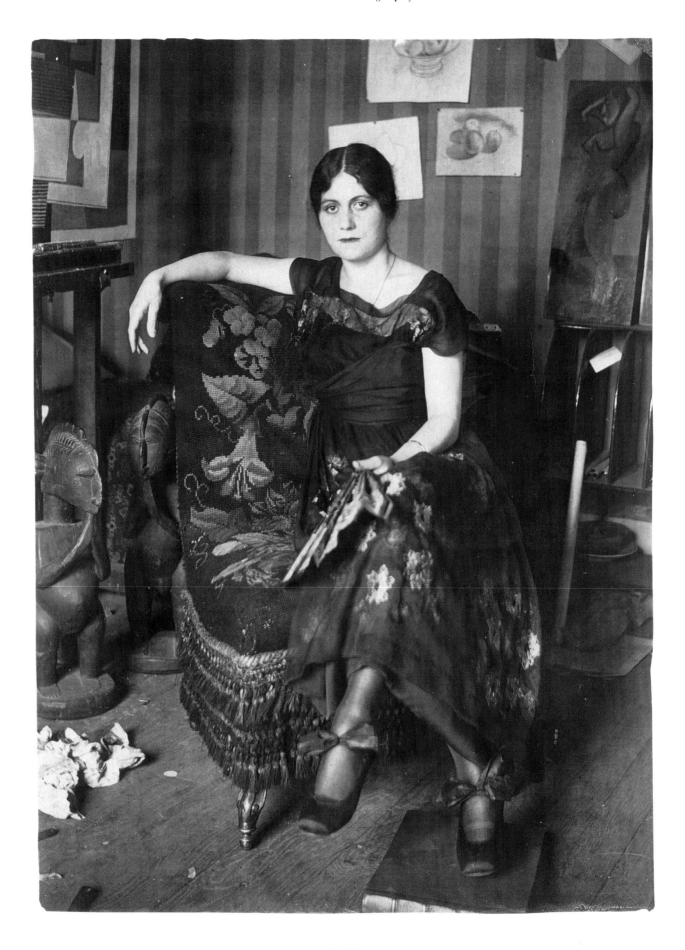

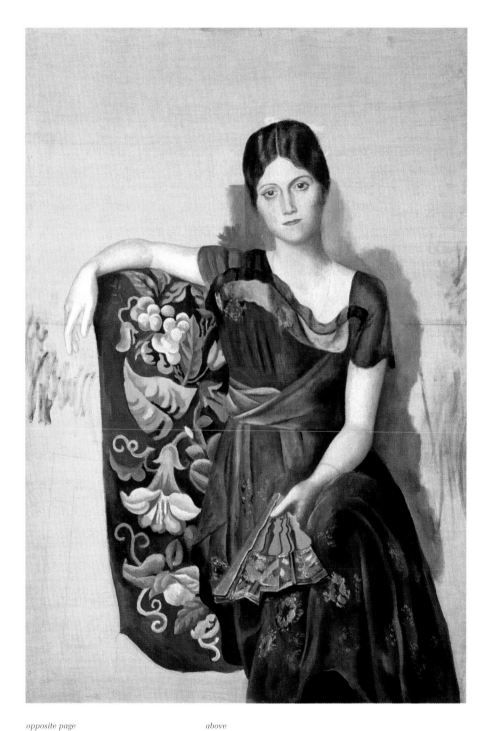

opposite page
Fig. 189
[Pablo Picasso]
Olga Khokhlova
in the Montrouge Studio
Montrouge, [spring 1918]
Gelatin silver print
8 7/8 x 6 1/2 in (22.5 x 16.5 cm)
APPH 271
Picasso Archives,
Musée Picasso, Paris

above
Fig. 190
Pablo Picasso
Olga in an Armchair
Montrouge, [spring 1918]
Oil on canvas
51 1/8 x 35 in (130 x 88.8 cm)
MP 55
Musée Picasso, Paris

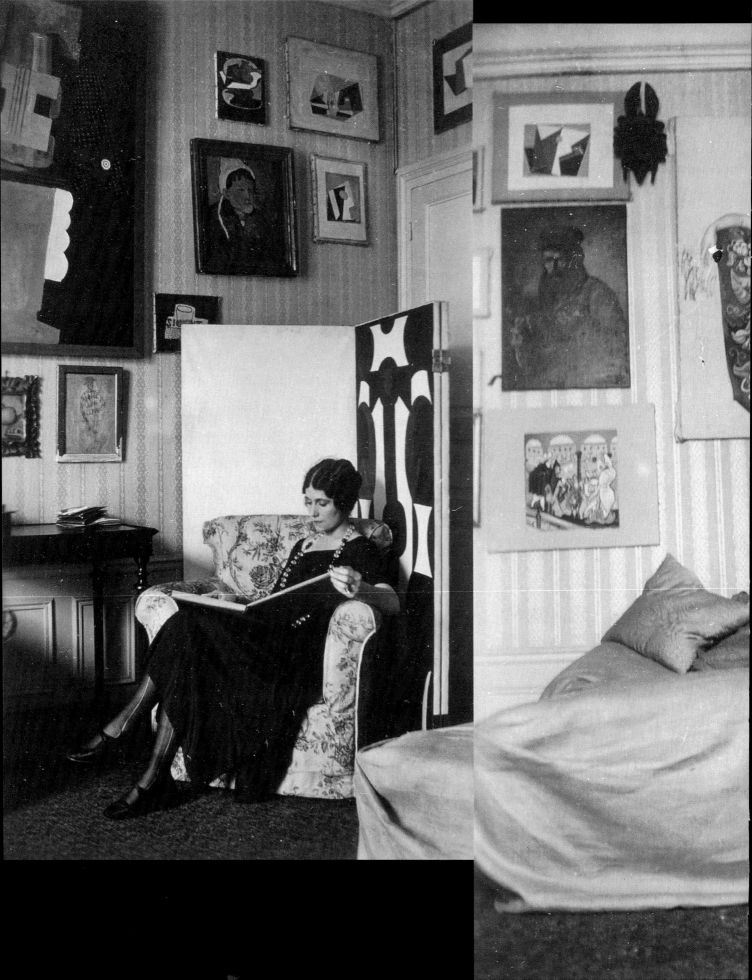

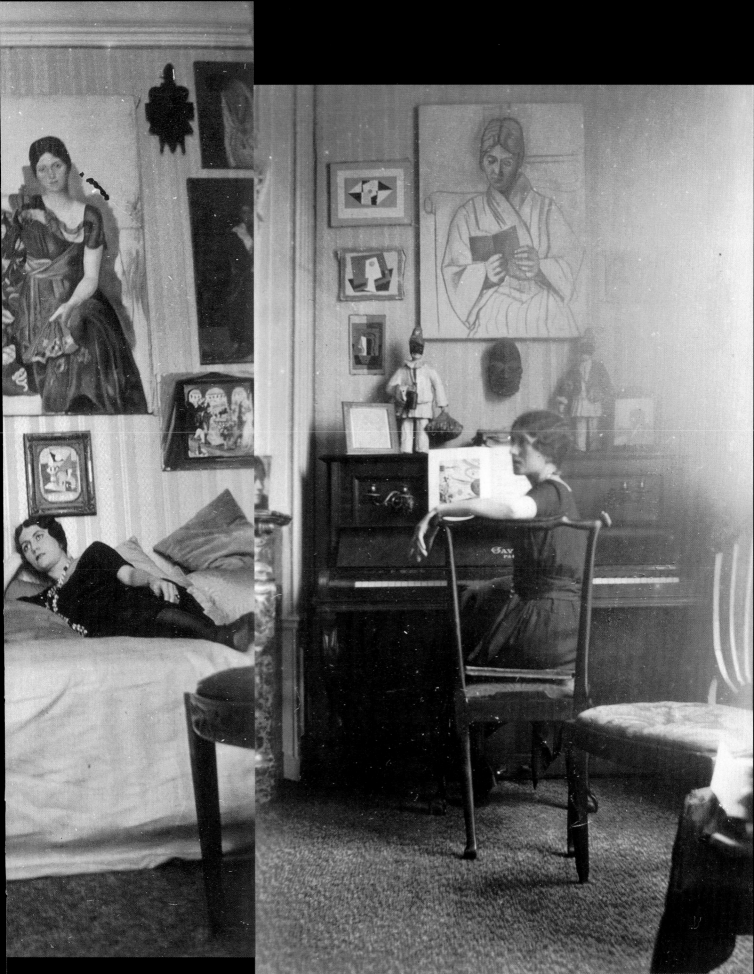

Fig. 195
Pablo Picasso
Studies
[Fontainebleau–Paris],
1921–1922]
Oil on canvas
39 3/8 x 31 1/2 (100 x 80 cm)
MP 65
Musée Picasso, Paris

23. Vizcaínos

Fig. 196
Jean Laurent
Basque Peasants
Madrid, 1878
Collotype (postcard)
APPH 15139
Picasso Archives,
Musée Picasso, Paris

opposite page
Fig. 197
Pablo Picasso
Pierrot and Harlequin
Summer, 1920
Gouache and pencil on paper
10 1/8 x 7 3/4 in (25.7 x 19.7 cm)
Gift of Mrs. Gilbert W. Chapman
National Gallery of Art,
Washington

Fig. 198
Pablo Picasso
*"Harlequin and Woman
with a Necklace" in Progress*
Rome, 1917
Gelatin silver print
11 ³/₄ x 9 ¹/₄ in (30 x 23.5 cm)
APPH 11843
Picasso Archives,
Musée Picasso, Paris

Fig. 199
Pablo Picasso
*Igor Stravinsky, Pablo Picasso,
and Gerald Thyrwitt (Lord Berners)*
Rome, 1917
Gelatin silver print
9 ¹/₂ x 11 ³/₄ (24 x 29.8 cm)
APPH 6042
Picasso Archives,
Musée Picasso, Paris

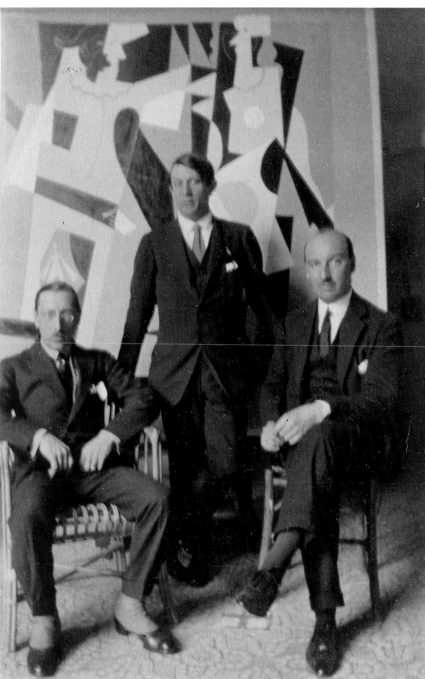

Fig. 200
Pablo Picasso
Igor Stravinsky, Pablo Picasso,
and Gerald Thyrwitt (Lord Berners)
Rome, 1917
Gelatin silver print
11 ³/₄ x 9 ¹/₂ in (30 x 24 cm)
APPH 6044
Picasso Archives, Musée Picasso, Paris

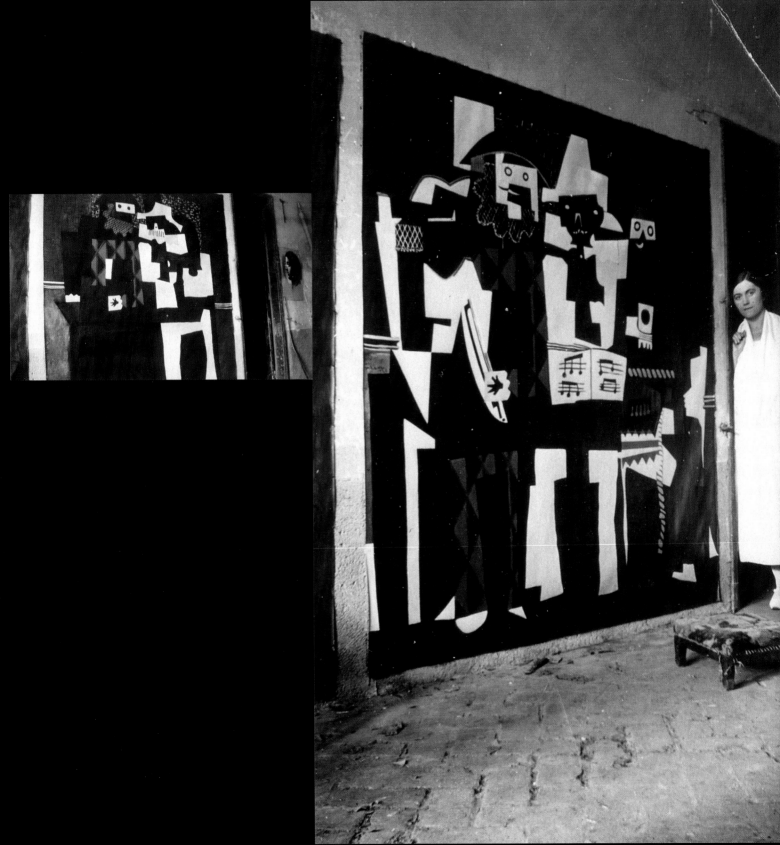

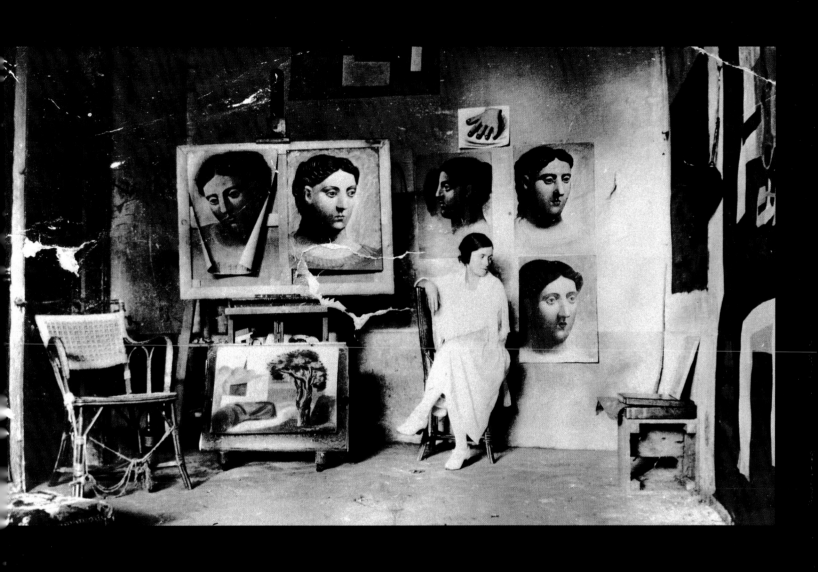

then brings them together slowly, very slowly. Then he joins them, clasps them, tenses them, makes one penetrate the other). That's what you have to attain. . . . There must not be a single stitch too large, a hole through which emotion, light, and truth might escape."[459] Cézanne's painting has thus been described as expressing "the predominance of formal and especially of chromatic combinations over the individual bodies depicted".[460] Similarly, Picasso's recurring figure of Harlequin should be seen as a medium for "formal combinations" at least as much as a stand-in for the artist.[461] As already discussed with the 1915 *Harlequin* (fig. 157)[462], in more than one instance photography inspired certain features of the visual treatment. A series of gouaches done in the summer of 1920 on the theme of Pierrot and Harlequin (fig. 197)[463] may thus be partly based on a postcard (fig. 196) showing two Basque peasants. In one of these gouaches,[464] Harlequin's hand literally transcribes the hand of the man on the left of the photo, whereas the contrasting patterns of peasant dress are extrapolated for the overall composition. Picasso, for whom "color [was] only efficient insofar as it represents one of the elements of constructional interplay"[465] may thus have derived the two-dimensional vocabulary of his decorative cubist exercise from these garments with their unusual formal characteristics. Other postcards from the same source[466] display the geometric shadow that the men's hats draw across the top of their faces, in a pattern strongly suggesting the mask that Picasso often attributed to Harlequin.[467] The motif might have also drawn inspiration from elements specific to Kabuki theater, as inferred from recognizable similarities between certain actors seen in Japanese postcards and the expressive geometry of cubist works from the summer of 1914, such as *Man in a Hat Playing the Guitar*[468] and *Man in a Mask Playing the Guitar*.[469]

Also worth mentioning are two photographs (figs. 199, 200) taken during Picasso's stay in Rome in 1917,[470] showing Picasso, Stravinsky, and Lord Berners in front of *Harlequin and Woman in a Necklace* (fig. 198).[471] The eye inevitably reads the painting's two-dimensional geometry and play of values as depicting a virtual space. And when preparing his designs for the ballet *Parade*, Picasso had to confront the challenge of stage illusionism and the latter's reversal of the cubist approach.[472] In their stylistic dissonance, the stage curtain (a falsely naive version of classical representation[473]), sets (Synthetic cubism), and costumes (Constructivist volumetrics) thus appear to be moments in an initiation into contemporary vision. The eye vainly attempts to focus on structures in which everything rejects perspective, and it finally renounces any Euclidean recognition of space. The numerous drawings titled *Idea for a Construction* which, together with photographic experiments, accompanied the *Construction with Guitar Player* (fig. 133), were ultimately manifested in the costume for the role of The Manager.[474]

The staging of the group portraits at Rome is suggestive of a new composition, and I have argued that these photographs may underlie the two versions of *Three Musicians*.[475] Both were painted in 1921, depict the character of Harlequin once more, and could be seen as a painterly assimilation of the three figures who posed before *Harlequin and Woman in a Necklace* in 1917 (fig. 198).[476] The version of the *Three Musicians* belonging to the Museum of Modern Art in New York not only borrows a number of partial motifs from the photographs but also imitates the poses of the three figures fairly literally; Harlequin/Picasso has been taken from the horizontal photo, while Pierrot/Stravinsky and the Monk/Lord Berners derive from the vertical shot. It is generally felt that the New York version, which is more abstract and synthetic, was executed second. Two photographs (figs. 202, 203) taken in Picasso's Fontainebleau studio in the summer of 1921, however, show the Philadelphia version still unfinished,[477] while its twin can just be glimpsed opposite, in a very advanced state. So Picasso may have gone so far as to work on both versions simultaneously, multiplying allusions and variations with all the freedom implied by the two source photographs, which were identical yet different, like "syncopated jazz music being translated visually."[478] In another photograph (fig. 201), meanwhile,

preceding double page (from left to right)

Fig. 201
Pablo Picasso
"Three Musicians" in Progress
Fontainebleau, September 1, 1921
Gelatin silver print
2 5/8 x 4 1/4 in (6.6 x 10.7 cm)
APPH 6460
Picasso Archives, Musée Picasso, Paris

Fig. 202
Pablo Picasso
Olga Picasso
in the Fontainebleau Studio
1921
Gelatin silver print
4 1/2 x 2 3/4 in (11.5 x 7 cm)
APPH 6461
Picasso Archives, Musée Picasso, Paris

Fig. 203
Pablo Picasso
Olga Picasso
in the Fontainebleau Studio
Autumn 1921
Gelatin silver print
2 3/4 x 4 3/4 in (7 x 12 cm)
Pushkin Museum of Fine Arts, Moscow

it is possible to make out the presence, just to the left of the Philadelphia canvas, of the oil variation on *Three Women at the Spring*. Was Picasso working on that neoclassical pair in a face-off similar to the cubist one between the *Three Musicians?* It would seem likely. He would thus have organized the thematic and stylistic opposition of both pairs into a force field where painting could be tested dialectically.

The large, cubist *Italian Woman* of 1917 (fig. 206)[479] was directly inspired by colored postcards showing young models in traditional dress.[480] One of them, *Italian Woman Leaning on a Fence* (fig. 204), was the basis for pencil and watercolor sketches.[481] The second, *Italian Woman with Flower* (fig. 205), generated multiple variations,[482] including some that translated the graininess of the chromolithograph into divisionist dots of color.[483] The composition of the painting itself strictly combines the motifs of the two postcards even as it laterally flips the "leaning woman."[484] A formal language inherited from cubism thereby borrowed popular imagery's angular interplay of shifting limbs and costumes. The twinned, almost stereoscopic view of these two source images can also be detected in the diagonal rectangles forming the structural framework of the canvas,[485] in the alternately positive and negative handling of the fence, and in "the almost humorous use"[486] of the full-face/profile technique.

The classicizing version of *Italian Woman*, meanwhile, dates from 1919 and is a translation of Raphael or Corot[487] that incorporates the cerulean skies of Roman colored postcards as well as another picture of a little girl in regional dress.[488] A drawing from that same year, *Woman with Pitcher* (fig. 208)[489] has been related to an old print belonging to the series of Oriental photographs (fig. 207) used by Picasso during his Rose Period.[490] Yet the ghostly erasures of arms and bust, the disproportionate features of the face, and the careful modeling all go beyond an imitation of the photograph and prefigure the large canvas of 1921, *Three Women at the Spring* (fig. 212)[491] as well as other, related paintings,[492] all of which share chiaroscuro volumetrics, a chalky monochrome effect, a simplified architecture of limbs, faces, and drapery, and a rhythmic play of poses. From Egypt to Italy via French Catalonia (figs. 209, 210),[493] photography would thus have nourished the pictorial vocabulary of what was perceived as a "classical translation" of the *Three Women* of 1908 (fig. 72).[494]

An advertising photo published by the Grandval studio (fig. 214) inspired Picasso's 1919 painting *The First Communicants* (fig. 215)[495] and two companion female studies,[496] which obviously hark back to the *First Communion*, painted when Picasso was not yet fifteen years old.[497] The same photo was also behind a small, cubist-style canvas (fig. 213).[498] Here red and blue flutter brightly in an invented curtain effect, in contrast to the atonal color and material of the naturalistic canvas. The flat lighting of the photograph, with neither shadow nor relief, thus finds an equivalent in this painted image of absence, where bodies seem to exhibit an existential weightlessness all the more troubling for being "portraits."[499] Like other canvases based on studio photographs,[500] the pictorial layer is so thin that it almost appears to peel away, thereby mimicking photography's own thin film. The cubist version of *The First Communicants* is structured around the axis of the open missal that divides each figure's space; the back of the prie-dieu, aligned with the frontality of the figures, extends this vertical divide, as though the two sections of the painting were cut with scissors and artificially cemented, in a pointed reminder that there has been loss and suture. A variation on this painting[501] retains traces of that cubist cut-and-paste effect. The painting ultimately returns to the scenic staging of the photograph by underscoring—to the point of malaise—its areas of tension: the girl's disproportionate hands, the boy's dislocated shoulder and formless legs.[502]

Contemporary with *The Communicants*, the canvas titled *The Lovers* (fig. 219)[503] promotes the adolescent couple to the level of a more carnal union.[504] Although this canvas explicitly alludes to Manet,[505] it was also inspired by certain photographs of couples owned by Picasso: a sentimental postcard (fig. 217),[506] a *carte-de-visite* photo of newlyweds (fig. 216),[507] and, more directly, a studio portrait (fig. 218) taken of Lola Ruiz-Picasso and her husband, Dr. Vilato, around 1910. The painting, animated by a sweet, urbane, and modern gaiety, is thus part of a cycle—as is *The Communicants*—based on Picasso's sister. Here the photographic vector offered material and a pretext for attacking the pictorial problems then spurring the artist: how to explore the surface of two bodies, their modes of physical separation and contact, and the juxtaposition of their formal signs.[508]

Fig. 204
Stengel & Co. (Publisher)
Italian Woman
Leaning on a Fence
Dresden, c. 1900
[Chromolithograph] (postcard)
APPH 14388
Picasso Archives,
Musée Picasso, Paris

Fig. 205
Stengel & Co. (Publisher)
Italian Woman with Flower
Dresden, c. 1900
[Chromolithograph] (postcard)
APPH 2762
Picasso Archives,
Musée Picasso, Paris

Fig. 206
Pablo Picasso
Italian Woman
Rome, spring 1917
Oil on canvas
58 ⁵/₈ x 39 ³/₄ in (149 x 101 cm)
Foundation E. G. Bührle, Zurich

above
Fig. 207
G. Lekegian
Woman with Ballas
Egypt, [1860–1880]
Albumen print
10 $^7/_8$ x 8 $^1/_4$ in (27.5 x 21 cm)
APPH 12513
Picasso Archives,
Musée Picasso, Paris

opposite page
Fig. 208
Pablo Picasso
Woman with Pitcher
1919
Pencil over charcoal on paper
25 $^3/_4$ x 19 $^1/_8$ in (65.5 x 48.5 cm)
Gift of Wright S. Ludington, 1946
Santa Barbara Museum of Art,
California

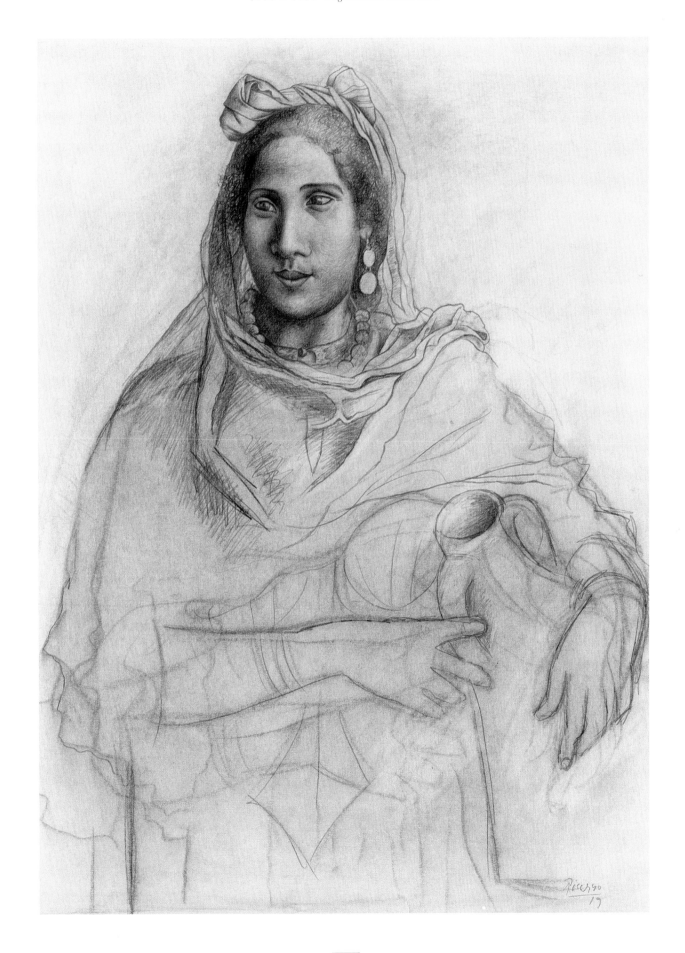

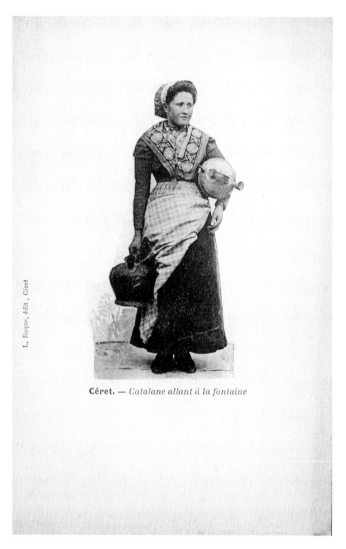

Céret. — *Catalane allant à la fontaine*

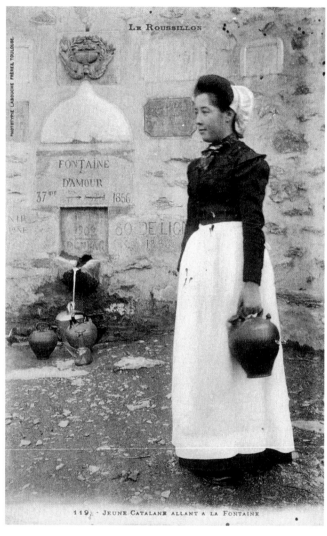

Fig. 209
L. Roque (Publisher)
*Catalan Woman Going
to the Fountain*
Céret, [1905–1910]
Phototype (postcard)
APPH 15115
Picasso Archives,
Musée Picasso, Paris

Fig. 210
Labouche Frères (Publisher)
Catalan Woman at the Fountain
Toulouse, [1905–1906]
Phototype (postcard)
APPH 15114
Picasso Archives,
Musée Picasso, Paris

Fig. 211
Pablo Picasso
Woman with Pitcher
Paris, 1919
India ink
9 ⁷/₈ x 7 ¹/₂ in (25 x 19 cm)
Private collection

Fig. 212
Pablo Picasso
Three Women at the Spring
Fontainebleau, summer 1921
Red chalk and oil on canvas
79 ¹/₈ x 63 ³/₈ in
(201 x 161 cm)
MP 74
Musée Picasso, Paris

above

Fig. 214
De Grandval
The First Communicants
Paris
Advertising photo
Private collection

left

Fig. 213
Pablo Picasso
The Communicants
1919
Oil on canvas
13 3/4 x 9 1/2 in
(35 x 24 cm)
Private collection

Fig. 215
Pablo Picasso
The First Communicants
1919
Oil on canvas
39 3/8 x 31 7/8 in (100 x 81 cm)
MP 1990–6
Musée Picasso, Paris

Fig. 216
J. Yrondy
Newlyweds
Paris, [1875-1880]
Albumen print
(*carte de visite*)
APPH 3431
Picasso Archives,
Musée Picasso, Paris

Fig. 217
Lotus Editions
Loving Couple
Postcard with color highlights
APPH 15197
Picasso Archives,
Musée Picasso, Paris

Fig. 218
Amer Studio
*Dolores Ruiz-Picasso
and Dr. Vilato*
Barcelona, c. 1910
Gelatin silver print
(postcard)
APPH 14389
Picasso Archives,
Musée Picasso, Paris

opposite page
Fig. 219
Pablo Picasso
The Lovers
1919
Oil on canvas
72 7/8 x 55 1/8 in
(185 x 140 cm)
MP 62
Musée Picasso, Paris

1925 ~ 1945
Metamorphoses

Autoscopy

Known from a negative discovered only in 1994,[509] a photographic self-portrait (fig. 220) dating from the mid-1920s might initially seem the product of an involuntary double exposure. Yet the complexity of this composition owes nothing to chance. The foreground is half-invaded by the shadow of Picasso's head, set against a framed drawing in the background. The glass over the drawing reflects light from a French window opposite. Also discernible, if barely perceptible, is a more distant twin of the main profile. Picasso's profile merges with the bridge of the nose of the three-quarter face seen in the drawing; the drawing, although not yet identified, undoubtedly belongs to the series of studies for *Les Demoiselles d'Avignon* (fig. 59). Hence the visual puzzle not only interlinks Picasso's feminine and masculine features, the twin faces of his profile, but it also unites past and present through the power of a composite self-portrait.

This image seems to have haunted Picasso's oeuvre in the years 1927–1929. A series of canvases repeated this motif of shadow-profile in combination with the fragmented signs of window, frame, reflection, and twin, as though exhausting all possible variations (fig. 221).[510] These transmutations culminated in a return to the initial photograph via a 1929 canvas significantly titled *Self-Portrait*.[511] The shadow cast on the frame becomes the work that is framed, occupying the exact position it had in the photograph; the superimposed profile is a study of a head that acknowledges its metamorphosis into a *demoiselle*. Here Picasso craftily employs the effect of shadows and twinning to hide and then suddenly reveal a profile, evoking a feminine visage even as he dissimulates it. Roland Penrose recounted a similar experiment, conducted sometime around 1932: "Working at night in the studio at Boisgeloup he had first built up a very complicated construction of wire which looked quite incomprehensible except when a light projected its shadow on the wall. At that moment the shadow became a lifelike profile of Marie-Thérèse. He was delighted at this projection from an otherwise indecipherable mass. But he said, 'I went on, added plaster and gave it its present form.' The secret image was lost but a more durable and splendid version, visible to all, had been evolved."[512] A painting called *The Sculptor*[513] testifies to this outcome: the artist confronts the completed work, while on the wall behind—like a distant memory—a tiny frame encloses a profile.

"A Profound Sculpture Out of Nothing. . . "

An account by André Breton[514] and a photograph by Brassaï[515] are all that now testify to *Object* (fig. 222), a strange improvised sculpture of which William Rubin has written: "[F]ew of Picasso's constructions or assemblages resemble tribal objects, but from time to time he signals his consciousness of the latter by a quasi-parodistic gesture. I take this to be the meaning of the 'fetish' he created by adding a horn and a feather duster to a mass of philodendron roots."[516] Rubin's intuition has been confirmed by the discovery in Picasso's archives of a photograph (fig. 224) by Paul Guillaume related to the pictures he took for an album of *Sculptures nègres* published in 1917.[517] The image shows an object of probably Oceanic origin,[518] comprising a leather pouch into which are stuck a tuft of feathers and pieces of fur.

When Brassaï photographed *Object*, he was certainly not aware of the earlier photo. The sculpture's own logic nevertheless led him to frame it in much the way Paul Guillaume did: the feather is shown at the same angle as the Oceanic fetish, the horn curves like the strap of fur, and the pot itself echoes the leather pouch. Brassaï's knowing eye thus retraced the artistic reflex and, through it, its unavowed source. Like a primitive *grigri* (i.e., magic talisman), *Object* seems to combine relics with visual lures in order to ward off some domestic evil spell. It so happens, however, that Brassaï took another shot (fig. 223), discovered only though examination of the photographer's work sheets.[519] Here the angle imitates Guillaume's point of view even more closely, playing on the opposition of the respective plastic qualities of object and plinth. It also reveals that Picasso, in erecting this monument, once again employed the Rococo pedestal table used in the 1911 *Photographic Composition: Still Life on a Pedestal Table* (fig. 128).[520] Furthermore, the photo shows that a cross-section from the trunk of a petrified tree has been placed between the sculpture and table, physically linking those elements and giving birth to a composite tree whose roots are represented by the fringe on the table and whose branches are echoed in the feather duster.

Yet *Object* should also be understood in the context of the plastic experiments conducted by Picasso in the years 1927–1928 for a proposed "Monument to Apollinaire."[521] It evokes many buried links between the dead poet and

Fig. 220
Pablo Picasso
Self-Portrait in Profile
[Paris, 1927]
Modern gelatin silver print
from original flexible negative
Flexible negative no. 119
Picasso Archives,
Musée Picasso, Paris

the artist—a reliquary pouch, a rite of memory, a reference to their shared discovery of "African art"—as though it were nothing less than the "profound statue [made] out of nothing, like poetry and glory" that Apollinaire himself invoked.[522] In this respect, it displays symbolic affinity with the disturbing anthropomorphic constructions that Picasso produced in August 1928.

Similarly, Surrealist equivalences might link Picasso's musings on the Apollinaire memorial with an oil painting of 1929, *Bather with Beach Ball* (fig. 225),[523] based on a photograph (fig. 226) he took of Marie-Thérèse Walter on the beach at Dinard. The painting's small format and

subdued tones echo the luminous grisaille of the photo, even though all that remains of the model is a deadly if highly sexed entity evoking, in its own way, the petrified roots and erectile appendages of *Object*.[524]

The opening lines of Ovid's *Metamorphoses* —"Of bodies changed to other forms I tell"[525]—might well apply to the transgression of the limits of figuration epitomized in 1933 by a series of drawings titled *Anatomy* (figs. 228, 229),[526] whose organico-mechanical protuberances perhaps echo a photograph (fig. 227), kept by Picasso, of a hand-less man laboring over a work bench.[527] Does this photo show malformation or mutilation, the work of nature or mankind? The dreadful appropriateness of the cleft limbs for the tool expresses both the man's inventive resignation and humanity's total plasticity. This portrait harks back to the one of the South American vagabond of the year 1900 (fig. 34):[528] arms crossed against social adversity have become tool-arms equipped against the irreparable. This type of photo nevertheless remains the exception within Picasso's archives even though, referring to his visit to the Trocadero ethnological museum in 1907, he confessed his profound feeling of the world's hostility: "I always looked at the fetishes. I understood—I, too, am against everything. I, too, think that everything unknown is the enemy!"[529] Elsewhere, the artist added, "[and] I realized that this was what painting was all about. Painting isn't an aesthetic operation; it's a form of magic designed as a mediator between this strange, hostile world and us, a way of seizing the power by giving form to our terrors as well as our desires."[530] Similarly, these graphic variations may have helped to overcome the emotional shock produced by the sight of such a photograph. The artist, as exorcist and ferryman, thus straddles the borderline between two dimensions of the image, effecting transformations in the forces and phenomena of vision. Ovid, for instance, described how rocks were metamorphosed into bodies:

Those stones. . . gave up their hardness;
Their rigidness grew slowly soft and, softened,
Assumed a shape, and as they grew and felt
A gentler nature's touch, a semblance seemed
To appear, still indistinct, of human form,
Like the first rough-hewn marble of a statue,
Scarce modelled, or old uncouth images.
The earthy part, damp with some trace of moisture,
Was turned to flesh; what was inflexible
And solid changed to bone; what in the stones
Had been the veins retained the name of veins.[531]

In reversing this genesis, Picasso's polymorphous creatures transgress the limits of the living. They are simultaneously one thing and another, part of this world and the other, part real and part imaginary. Picasso's plastic elaboration thereby led to the "unfigurative."

Fig. 221
Pablo Picasso
The Studio
1928–1929
Oil on canvas
63 $^3/_4$ x 51 $^1/_8$ in
(162 x 130 cm)
MP 111
Musée Picasso, Paris

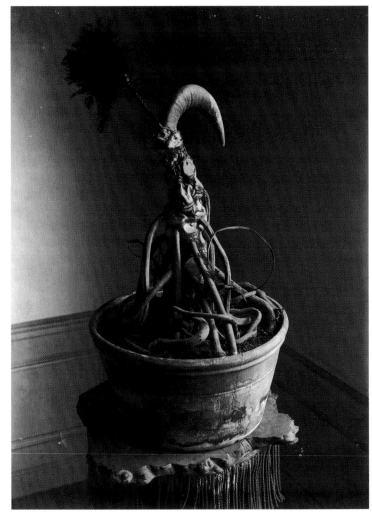

Fig. 222
Brassaï
Photograph of "Object"
Paris, rue La Boétie studio,
[1932]
Gelatin silver print
11 $^3/_8$ x 8 $^3/_8$ in
(28.8 x 21.2 cm)
MP 1996–33
Musée Picasso, Paris
© Gilberte Brassaï

Fig. 223
Brassaï
Photograph of "Object"
Paris, rue La Boétie studio, [1932]
Modern print from original negative
11 $^3/_4$ x 8 $^5/_8$ in (29.8 x 22 cm)
Private collection
© Gilberte Brassaï

opposite page
Fig. 224
[Paul Guillaume]
Object of Oceanic Origin
Paris, 1917
Gelatin silver print
11 x 8 $^1/_8$ in (27.8 x 20.5 cm)
APPH 12554
Picasso Archives,
Musée Picasso, Paris

Fig. 225
Pablo Picasso
Bather with Beach Ball
Dinard, September 1, 1929
Oil on canvas
8 ⁵/₈ x 5 ¹/₂ in (21.9 x 14 cm)
MP 118
Musée Picasso, Paris

Fig. 226
[Pablo Picasso]
Marie-Thérèse Walter
on the Beach at Dinard
Dinard, [summer 1928 or 1929]
Gelatin silver print
Private collection

Fig. 227
Anonymous
Man at Work
[1920]
Gelatin silver print
4 ¹/₈ x 3 in (10.5 x 7.6 cm)
APPH 5310
Picasso Archives,
Musée Picasso, Paris

Fig. 228
Pablo Picasso
An Anatomy:
Three Women
[Paris], February 27, 1933
Pencil on paper
7 3/4 x 10 3/4 in
(19.8 x 27.4 cm)
MP 1095
Musée Picasso, Paris

Fig. 229
Pablo Picasso
An Anatomy: Three Women
[Paris], February 27, 1933
Pencil on paper
7 7/8 x 10 5/8 in (20 x 27 cm)
MP 1093
Musée Picasso, Paris

At the same time as he was preparing to illustrate Ovid's *Metamorphoses*, Picasso executed three drawings that used photographs as a physical support. In one (fig. 232), an astronomical photo of a first-quarter moon served as the basis for the profile of a dead horse, drawn in a manner similar to the cave paintings at Altamira. Picasso's lines employ the geography of the moon's speckled surface to give body to the animal,[532] prompting a double meaning: steed put to death and heavenly body scarred by light (as are the dust of a bullring and the earth of a sacrificial mound).

Another astronomical photograph (fig. 230) of the planets, this time turned upside down, inspired a graphic interpretation of the encounter of Mars and Venus. The lines of ink that join circle to half-circle can be read as fusing two faces into a single entity, all the while suggesting the bodies of two female characters. This stellar choreography finds repeated echo in the ballerinas, acrobats, and bathers-with-ball of the years 1925 to 1931. In a more calligraphic mode, a series of drawings dated 20 October, 1930 and titled *Circles and Signs*[533] also explores the forces of attraction and repulsion between circles of different sizes.

Finally, Picasso used a photogram (fig. 231) of a luminous spiral, taken from a magazine. He cut out the center, leaving the outline of a profile in reserve, then drew a second profile facing the other way, and finally cut the whole thing into the shape of an open hand, not unlike the negative imprints found in cave paintings.[534] Light is first reflected on planetary bodies, then leaves a trace of the opaque object that intercepted it in the photogram; this drawing, with its negative and positive profiles, ink-darkened passages, and cropped shapes fully acts as a metaphor for photography in the making.

In the early 1930s, moreover, Picasso demonstrated great freedom in his use of materials and techniques, either borrowing certain photographic effects or, to the contrary, going against the grain of the medium. Thus in 1932 he tested a new engraving process, erwinography,[535] that employed glass plates coated with light-sensitive gelatin. This technique yielded *Head with Feather and Tarlatan*,[536] which combines the possibilities of drawing with those of a photogram insofar as the prints bear the direct imprint of pieces of fabric, a feather, tobacco seeds, and a cut-out paper head. Various states of the work were produced through successive layering of the profile motif.[537] This work on a transparent support was exactly contemporary with an experiment Picasso made with engraving on photographic film, as reported by Brassaï. The photographer had forgotten an unexposed plate at Picasso's; Picasso "couldn't hold out for long against the temptation to attack a surface as smooth and uniform as the ice of a frozen lake." A few days later, Picasso showed Brassaï the profile of a woman engraved with a needle, "seen in transparence."[538]

Fig. 230
Pablo Picasso
Composition with Two Figures
Juan-les-Pins, September 5, 1930
India ink on photograph of Saturn,
Jupiter, Mars, and Venus
5 1/2 x 3 1/8 in (14 x 8 cm)
MP 1035
Musée Picasso, Paris

The following year, a newspaper photo accompanying a *Paris-Soir* report on the uprising in Morocco pictured "Ely, a rebel chief" (fig. 234).[539] The portrait obviously caught Picasso's attention, for he executed an ink equivalent (fig. 233).[540] As magnified by the drawing, the rebel's face reveals the earnestness of his expression, the change in scale lending monumentality to the loftiness already suggested by a low-angle shot. Furthermore, once wrenched from the immediate circumstances conveyed by the printed page, the figure of Ely assumes universal dimensions, becoming an archetype of man in his irreducible humanity. As opposed to fascination with otherness, then, this drawing implies a strong identification with the model; perhaps Picasso perceived him as one of those solar creatures incarnating the figure of painter or sculptor, as exemplified by the engraving *Sheet of Studies, Bearded Man and Seated Woman*,[541] in which Picasso continued his experimental work on celluloid.[542]

Fig. 231
Pablo Picasso
Hand with Two Profiles
Juan-les-Pins, September 6, 1930
India ink on newspaper
5 $^7/_8$ x 6 $^7/_8$ in (15 x 17.5 cm)
MP 1036r
Musée Picasso, Paris

following double page
Fig. 232
Pablo Picasso
Horse
Juan-les-Pins, September 5, 1930
India ink on a photograph
of the moon
3 $^1/_2$ x 5 $^1/_2$ in (8.8 x 14 cm)
MP 1034
Musée Picasso, Paris

Fig. 233
Pablo Picasso
Portrait of a Moroccan Rebel
Cannes, August 15, 1933
Pen and black ink on sketchpad
13 3/8 x 17 3/4 in (34 x 45 cm)
MP 1876
Musée Picasso, Paris

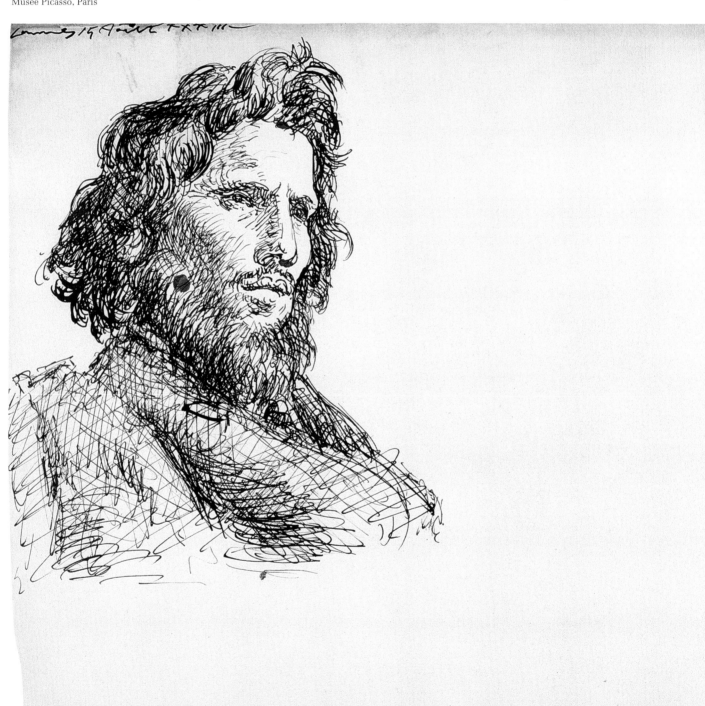

AU CŒUR DU MAROC INSOUMIS

Aux portes de Smara la cité interdite

Devant nous, nos quatre guides avancent désarmés. Tout désormais semble les laisser indifférents. Ils savent que Slimane va les livrer aux Reguibats comme on offre un cadeau et qu'ils sont condamnés à mort

(De notre envoyé spécial Jean FEUGA)

Ely, un chef des « Partisans ».

Nous passons sur ce qui fut le camp des nomades. Il ne reste que des cendres, et pêle-mêle des cadavres et des charognes. Un chien rôde en hurlant. Gardon se penche sur les morts, cherchant les trois esclaves. Il ne les reconnaît pas. Sans doute, les Reguibats les ont-ils capturés. Nous poursuivons notre route sous le soleil qui nous brûle les yeux. Devant nous, à bonne portée de fusils nos quatre guides Oulad Delim avancent désarmés. Tout désormais semble les laisser indifférents. Ils savent que ben Slimane va les li-

trouvions en vue de Smara avant la nuit.

Lorsque l'ombre s'entasse dans les vallonnements, l'horizon est désert. Nous lançons nos bêtes au trot et au moment de la chute du jour, droit devant, sur un plateau à peine plus haut que les dunes qui bordent l'oued à notre gauche : Smara.

Smara

J'éprouve un serrement de cœur. Elle est la cité interdite que

M. Roosevelt envoie d'urgence des vaisseaux de guerre à Cuba

Ceux-ci protégeront les citoyens américains contre de nouveaux troubles inévitables

(Par câble, de notre correspondant particulier)

Washington, 14 Août.
Les troubles de Cuba menacent d'entrer dans une seconde phase, bien plus grave que la première. Alors qu'il y a une semaine, le peuple était révolté contre le président Machado, et que quelques troupes américaines auraient suffi à rétablir l'ordre, aujourd'hui une lutte sanglante menace d'éclater entre les deux fractions des révolutionnaires victorieux.

Le président Roosevelt, envisageant la situation avec pessimisme, a donc jugé indispensable d'envoyer immédiatement des navires pour protéger les citoyens américains à Cuba. Deux torpilleurs vont lever l'ancre et ils seront rejoints par un croiseur venu des Antilles.

M. Roosevelt a souligné qu'il ne s'agissait que d'une mesure de protection et non d'une intervention militaire, et que les commandants des navires recevraient des ordres stricts dans ce sens. Évidemment, comme il l'a dit, Washington approuve et soutient le nouveau gouvernement cubain. Mais l'envoi de ces navires n'est-il pas un aveu éclatant qu'on juge ce nouveau gouvernement trop faible pour pouvoir réprimer à lui seul les troubles ? Et qui peut dire si ceux-ci ne seront pas accrus par l'arrivée de la flotille américaine ?

Jean Marquis.

Avan

Le général

Le dima
s'est pa

Sur le "Jo
Co

a

"Faster than Images. . . "

In 1935, a time when his personal relationships were breaking down, Picasso temporarily neglected painting and began experimenting with writing, which he would continue into the 1940s. As André Breton pointed out, concerning Picasso's metaphorical texts. "Nothing would be more erroneous nor more offensive to the author than the idea that [these writings], *because poetic*, do not take immediate reality as their point of departure."[543] Such an approach recalls the way Picasso previously assimilated photography, as reflected in a literary fragment from 1940: "The photographic plate spinning on an axis faster than the images dancing around it . . . the see-saw play of light illuminating it bears the whole weight of the scaffolding of coarsely ground colors on the transparent curtain of initially unperceived sensations. . . ."[544] In a highly revealing way, this poetic formulation suggests a vision that emerges from within the very interior of the photographic medium as much as from the objective universe. Indeed, Picasso's most decisive experiments in the medium tended to lend the sensitive *surface* a kind of third dimension.[545] It is this very *density*—as material as it is psychic—that yielded such original images, both photographic and non-photographic. Another literary fragment suggests that Picasso's paradoxical confrontation with the medium involved the innermost core of his being: ". . . The plate prepared with hundreds of bewitching ointments completely envelop[s] me, and the camera at the deepest core of my body [is] ready for the most unpleasant surprises"[546] The photographic apparatus and the body of the artist-at-work tend toward a kind of mutual assimilation in which both henceforth obey the same reflexes.[547] As Man Ray wrote in his piece on "Picasso the Photographer," published in *Cahiers d'Art* in 1937, "Then along comes a man who put himself in the place of the eye, with all the risks that gesture entails. Have you ever seen a living camera?"[548]

The same issue of *Cahiers d'Art* published Picasso's engraving *Nude in the Studio* (fig. 235),[549] accompanied by a short commentary, probably by Christian Zervos: "In his constant quest to enrich art, Picasso has just conducted a new experiment that may produce remarkable results. This initial trial involves combining a means of mechanical reproduction with an original engraving. He is also preparing to merge an original photograph with an original engraving, a trial that has already led to an infinite number of combinations." The point of departure was a half-tone plate from a photograph published the previous year in a special issue of *Cahiers d'Art* titled "Picasso 1930–1935,"[550] which showed "a corner of Picasso's studio, Paris, January 1934."[551] This new experiment in engraving on a photograph transformed the picture of the studio into a composition that forcefully evokes a Rembrandt engraving, *The Artist Drawing from a Model: Unfinished Plate*.[552]

Not only does the female figure adopt a pose similar to Rembrandt's model, but a more profound correspondence exists in the way the engraving exploits Rembrandt's different handling of background and foreground through a violent contrast of positive and negative. The being who suddenly appears on Picasso's photographic plate, however, might also be indebted to Lucas Cranach the Elder.[553] Picasso owned several postcard reproductions of *Lucretia, Venus,* and *Venus and Cupid*, all showing a nude woman draped in a transparent veil—*Nude in the Studio* (fig. 235) would seem to represent a composite version of those models.

Technically, the successive stages of *Nude in the Studio* (fig. 235) retrace Picasso's exploration into the transfer and merging of media.[554] The process has been reconstructed as follows.[555] First state: "the outline of the woman was etched onto the photographic plate"; since the raised surface was inked, the etched lines appear in white while the photograph printed positive. Second state: the part of photographic plate inside the outline of the model's body was almost entirely scraped away; copper-plate prints were pulled in two versions, in which engraving and photograph alternatively appear in negative. Successive variations permitted new handlings of the woman's body "by some photo-sensitive (gelatin?) process,"[556] then "probably with the aid of a photographic negative producing an effect of light coming from the right,"[557] and finally by a more or less uniform "re-texturing."[558] In the final state, done with etching acid and a graver, a sudden highlighting of the shaded side of the model dramatizes the composition in an effect that, imitating Rembrandt, seems "to create supernatural light within a natural light."[559]

The rayographs published in that same issue of *Cahiers d'Art* opened another line of research based on photography. The four photographs reproduced there had a fifth companion, which long went unpublished.[560] These works represent a complex combination of the modernist photogram technique[561] with the old cliché-verre process.[562] Dora Maar described Picasso's approach: "[He] spread a thick layer of oil paint on glass and then drew lines in the paint with a knife blade—a process like engraving—and thereby obtained a negative."[563] At this stage the technique followed the cliché-verre process as described as early as 1856: a drawing done on a glass plate used as a negative to print a photographic positive.[564] Dora Maar added that only two glass plates were used for the five "prints." Comparing the prints derived from the same plate thus makes it possible to reconstruct Picasso's working method. For *Profile of Dora Maar* (fig. 239),[565] the glass was set straight onto the light-sensitive paper. On the left side of the plate, the paint was probably wiped off with a cloth, printed black, outlining the white profile; the features of the face and hair, engraved with a knife blade, were also rendered as black. A piece of checkered muslin with an ace-of-spades pattern was placed between

the plate and the light source, adding another layer to the glass and light-sensitive paper arrangement as well as generating an all-over pattern that trips up, as it were, this portrait of a woman. *Woman in a Mantilla* (fig. 237) was also printed from the same glass plate, but this time a piece of lace placed straight on the paper produces an ambiguous impression making it difficult to tell whether the pattern is reproduced in positive or negative.

The second cliché-verre received a simple drawing done with the point of the blade, the layer of paint having been left opaque over most of the surface. For *Woman in Lace*, pieces of paper, embroidery, and pendant jewelry were interposed for varying exposure times. The masked sections remain white, except for the previously printed lines of the face and for the modulated grays of the scraps of paper. *Woman with a Chignon* was also printed from this same negative, slightly reworked with a brush in order to dilute the pictorial matter. When printed, a gap left between the glass plate and paper enlarged the scale of the image at the same time that it made it less sharp. Finally, the last rayograph, *Portrait of Dora Maar* (fig. 236), is probably the product of a yet another reworking of this same cliché-verre, which was partly repainted, flipped over, and printed, like the previous version, as an "enlargement."[566] The impression given here is of an image printed in negative; the parts of the face with the brightest highlights are rendered in black, while the normally darker areas (receding curve of the forehead, eye sockets, edge of face) appear white. This may explain the paradoxically greater "photographic" appearance of this rayograph, yielding an impression similar to the one produced by "solarized" photographs.[567]

It is fairly obvious that three photographs of Dora Maar taken by Picasso represent sketches for the elaboration of the rayographs described above. In the profile shot (fig. 238), the model's pose conveys a certain refusal—the young woman turns away, fleeing the gaze. Dora Maar herself, of course, was an "accomplished photographer," and it was under her artful eye that Picasso was venturing into a "charming field,"[568] where plastic inventiveness merged photograms with painting and engraving. The profile photo, moreover, seems to have served as the point of reference for the first cliché-verre (figs. 237, 239). The outline drawn in the layer of paint is so clear that Picasso may well have used the photographic negative to make a direct image-to-image copy, the hand engraving in light the image seen in transparence, replacing it little by little with its painterly equivalent. In any case, Picasso's three photographs and five rayograms constitute an "identificatory" puzzle of Dora's image, the elements of which would be synthesized in canvases over the coming years through a new figurative geometry, namely the brutal juxtaposition of eyes seen frontally with a nose seen in three-quarter view.[569]

Fig. 235
Pablo Picasso
Nude in the Studio
Paris, 1936–1937
Copper plate
10 7/8 x 7 in (27.7 x 17.9 cm)
MP 1996-10
Musée Picasso, Paris

Fig. 236
Pablo Picasso
Portrait of Dora Maar
Paris, 1936–1937
Cliché-verre and photogram
Reproduced in *Cahiers d'Art*,
nos. 6-7, 1937, p. 189

above
Fig. 237
Pablo Picasso
Woman in a Mantilla
Paris, 1936–1937
Cliché-verre and photogram
Reproduced in *Cahiers d'Art*,
nos. 6-7, 1937, p. 193

left
Fig. 238
Pablo Picasso
Portrait of Dora Maar
Paris, 1936–1937
Gelatin silver print
9 1/2 x 7 1/8 in (24 x 18.2 cm)
APPH 13880
Picasso Archives,
Musée Picasso, Paris

Fig. 239
Pablo Picasso
Profile of Dora Maar
Paris, 1936-1937
Gelatin silver print
(cliché-verre and photogram)
11 ³/₄ x 9 ³/₈ in (29.8 x 23.9 cm)
MP 1987–145
Musée Picasso, Paris

Charnel Houses

Although Picasso slowly abandoned photography from the 1920s onward, he remained attracted to the photographic observation of work in progress. The task of documentation, however, was henceforth confined to his photographer friends. The series of photos taken by Brassaï in Picasso's studios on rue La Boétie, at Boisgeloup, and then on rue des Grands-Augustins not only represented a remarkable "conversation" between the two men,[570] but also constituted a log of Picasso's work. Many of these photographs show improvised hangings hastily organized by Picasso for his friends—the resulting "house of cards" was usually devoted to a theme that evolved and shifted to make room for another, expressing Picasso's obsession with keeping his painting in view.

The photographic record reached particular intensity when Dora Maar entered Picasso's life, especially during the execution of *Guernica*,[571] to which she was a privileged witness. Nine photos and shots of the artist at work record each stage of the painting's progress (figs. 241–243).[572] More than a documentary report for publication,[573] it would seem that the photographs were an integral part of the pictorial task. *Guernica's* coloring was clearly inspired by news photos of the bombing of the Basque village by Nazi aircraft,[574] which the painting's gray-black-white tonality transposes onto a level of tragedy surpassing all realism. The violence of the composition, rather than being based on a single source, represents a pictorial interpretation of media shock at the event, of the visual clash of front-page headlines and photographs (fig. 240).[575] The formulation of Picasso's new idiom nevertheless relied on a constant visual dialogue between the work in progress and the photographic record of that progress; the motif of the electric eye at the top of the canvas, for instance, rather than to originating from an external image,[576] may have been inspired by the harsh spotlight used for the photograph (fig. 242).[577] Beginning with the sketch, the "rise" of dark values can be observed with each new photo, even as the motifs evolve until they reach their full dramatic acuity. Dark hues invade the canvas from bottom to top, following the movements of the artist's body. As with Picasso's experiments in engraving on half-tone plates, this progressive darkening mimics the slow emergence of a latent image as it appears in a photographer's developing tray. Only then did the intermediate values appear, following a trial phase using paper cutouts whose effect was subjected to photographic assessment (fig. 243). The cutouts may have been used to achieve the right range of grays, rather than intimating the use of color.[578] Several witnesses have recounted how Picasso tore off the last scraps of red paper in order to give the completed work its austere grisaille.[579] The various patterns, stripes, spots, lines, and arabesques introduced by

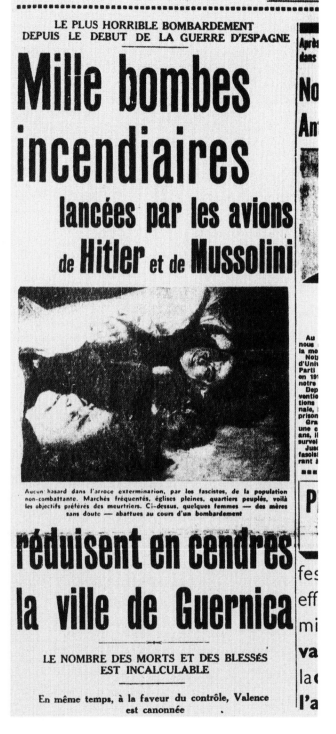

Fig. 240
*Women Killed During
the Guernica Bombing*
Press photo
from the April 28, 1937 edition
of *L'Humanité*
L'Humanité Archives, Paris

fig. 241
Dora Maar
"Guernica" in Progress,
State I
Paris, 1937
Gelatin silver print
9 1/2 x 11 7/8 in
(24.2 x 30.3 cm)
APPH 1376
Picasso Archives,
Musée Picasso, Paris

Fig. 242
Dora Maar
"Guernica" in Progress, State III
Paris, 1937
Gelatin silver print
8 1/8 x 11 5/8 in
(20.5 x 29.4 cm)
APPH 1373
Picasso Archives,
Musée Picasso, Paris

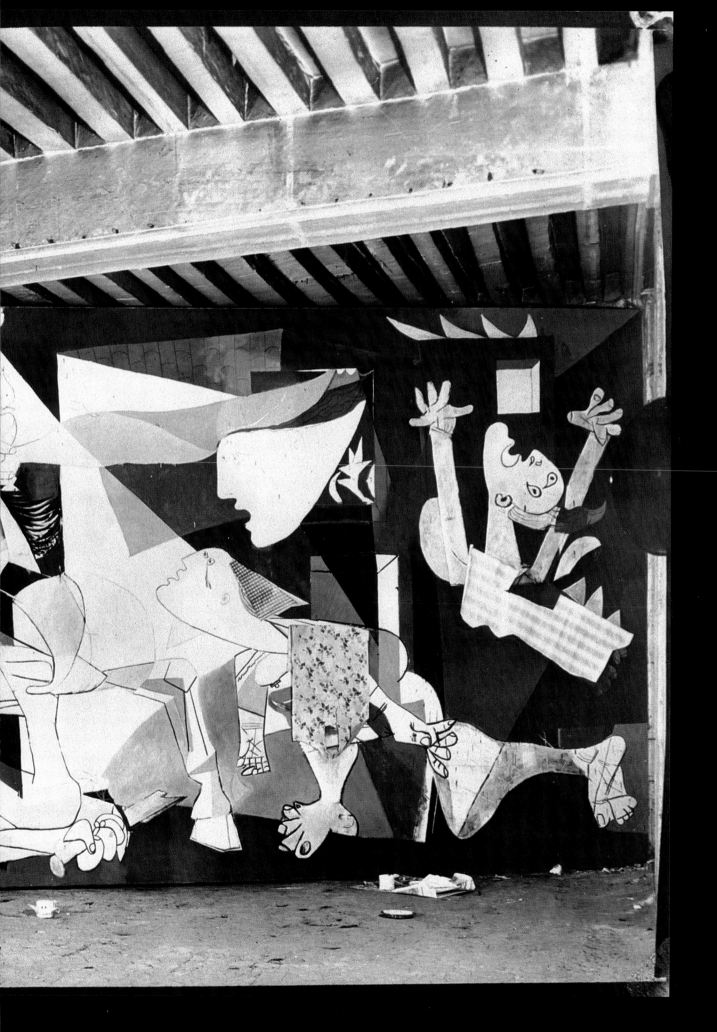

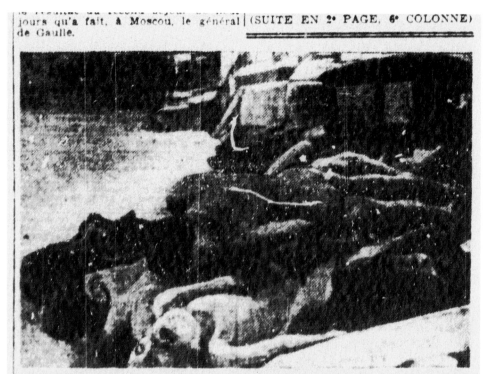

jours qu'a fait, à Moscou, le général (SUITE EN 2ᵉ PAGE, 6ᵉ COLONNE)
de Gaulle.

Encore un document recueilli sur un soldat allemand qui le conservait pieusement en témoignage sans doute de la « civilisation » nazie : des cadavres horriblement mutilés de victimes soviétiques entassées pêle-mêle

Fig. 244
Corpses of Soviet victims
Photograph found on a German soldier,
reproduced in the December 13, 1944
edition of *L'Humanité*
L'Humanité Archives

preceding double page
Fig. 243
Dora Maar
"Guernica" in Progress, State VI
Paris, 1937
Gelatin silver print
9 1/2 x 12 1/8 in
(24 x 30.7 cm)
APPH 1372
Picasso Archives,
Musée Picasso, Paris

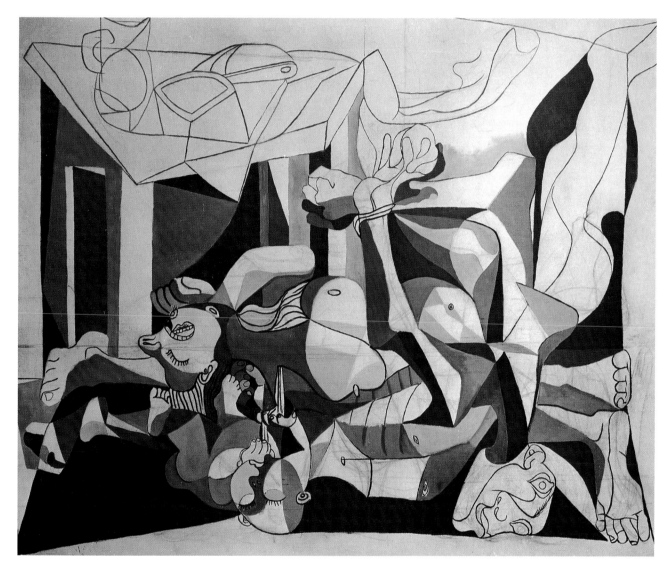

Fig. 245
Pablo Picasso
The Charnel House
Paris, 1945
Oil on canvas
78 $^5/_8$ x 98 $^3/_8$ in (199.8 x 250 cm)
Mrs Sam A. Lewisohn Bequest
(by exchange)
and Mrs Marya Bernard Fund
in memory of her husband,
Dr. Bernard Bernard
and anonymous funds
Photograph © 1997
The Museum of Modern Art,
New York

the paper suggested the dotted grid that ultimately adorned the body of the horse, "which looked like it was cut from newsprint."[580] The effect of such a work was probably best expressed by Michel Leiris: "In the black and white rectangle through which we view antique tragedy, Picasso has sent us a note of bereavement—everything we love will die. Which is why it was so necessary, just as in an outpouring of grand farewells, to encapsulate everything we love in something unforgettably fine."[581]

Picasso was at Royan when war was declared in September 1939. Another photographic self-portrait dates from this period (fig. 249). Tightly framed in a small mirror hanging on the wall of his studio, Picasso's gaze is full of tense interrogation.[582] Two drawings (fig. 248)[583] that imitate the position and framing of face in the photograph fully convey the weight of anxiety. Later, in 1941, the German occupation inspired a drawing titled *Women at Work* (fig. 247)[584] executed directly on top of a news photo (fig. 246) published in *Paris-Soir*, which had by then become the main Paris mouthpiece for pro-Nazi propaganda.[585] Not without irony, Picasso would use pages from *Paris-Soir* as an improvised palette,[586] as a ground for large oil drawings,[587] and for cutting out symbolic skulls.[588] A closer relationship, however, exists between the drawing of June 1941 and the illustration that inspired it, which accompanied an article praising the "voluntary" departure of French women to work in the Third Reich. Picasso's graphic violence comes across as the most efficient way of pointing to the falsity of such images. A striking compression forces the entire face of the first woman into the limited space of cheek and forehead. Her friend undergoes a harsh distortion of face and profile that shifts eye, mouth, ear, and hair to her cheek. "Who knows the meaning of ugliness?" asked Leo Steinberg, discussing the extreme deformations to which Picasso subjected his female figures in early 1940.[589] For Steinberg, this attack on beloved features and bodies exposed to the world the horribly twisted face of war and dictatorship. The ultimate meaning of *Women at Work* might thus reflect the convic-tion expressed by Picasso to a German officer who, visiting his studio and seeing a reproduction of *Guernica* (fig. 243), asked, "Did you do that?" "No," replied Picasso, "you did that."[590]

Painted after the World War II, *The Charnel House* (fig. 245)[591] directly echoes *Guernica*.[592] Its development was also documented photographically, by Christian Zervos; unlike Dora Maar's photos of *Guernica*, however, this documentation remained external to the making of the work.[593] Furthermore, Picasso apparently modified the canvas somewhat in subsequent years, adding a fourth, blue-gray hue that simultaneously softened outlines and "gave a mortal chill to the tonality."[594] Although he reportedly declared in 1944 that "[he] didn't paint the war because [he was] not the type of painter who goes around looking for something to show, like a photographer,"[595] it has been suggested that *The Charnel House* (fig. 245) was initially inspired by the first news photos of the concentration camps after their discovery by the Allies in April 1945.[596] Van Deren Coke has detailed the potential similarities between the faces and limbs on the canvas and a photograph of stacked corpses taken at the Belsen camp.[597] He also mentions Picasso's close links to Lee Miller, who had taken similar photographs at Dachau.[598] This theory nevertheless needs to be reconciled with the chronology given by Christian Zervos who, as an eyewitness, dates the first stage of the canvas to February.[599] If any visual shock triggered this canvas, then, it is more likely to have been the first photos of corpses published by *L'Humanité* on 11–12 February, 1945,[600] or even one that appeared as early as 13 December, 1944 (fig. 244).[601] Without succumbing to factual realism, *The Charnel House* (fig. 245) follows a schema identical to those two images—a strong diagonal separates the pile of bodies from the background in the upper left where Picasso ultimately placed an allusive still life.[602] The painting thereby conflates the savagery of war as seen in the photographs with the domestic allegories through which Picasso was evoking the daily reality of war.[603]

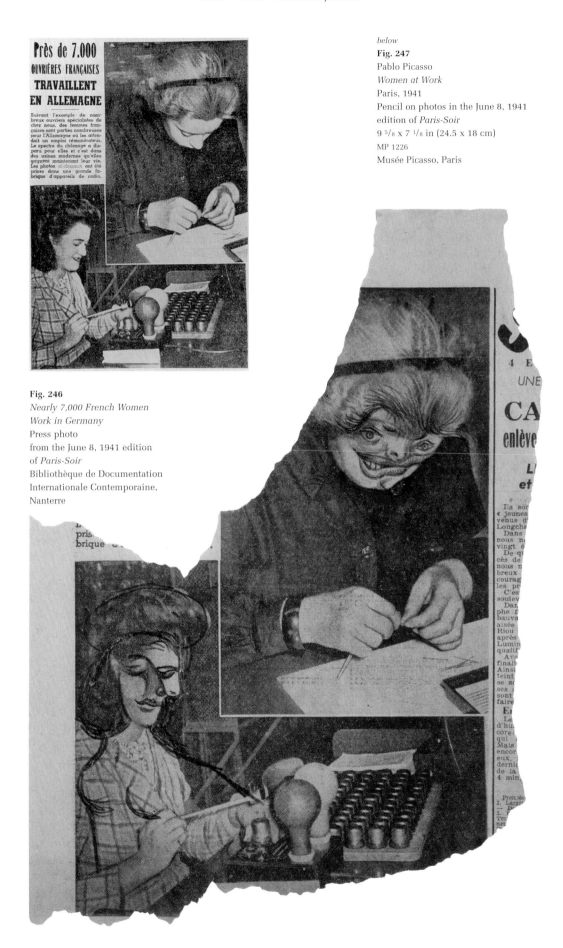

Près de 7.000 OUVRIÈRES FRANÇAISES TRAVAILLENT EN ALLEMAGNE

Suivant l'exemple de nombreux ouvriers spécialistes de chez nous, des femmes françaises sont parties nombreuses pour l'Allemagne où les attendait un emploi rémunérateur. Le spectre du chômage a disparu pour elles et c'est dans des usines modernes qu'elles gagnent maintenant leur vie. Les photos ci-dessous ont été prises dans une grande fabrique d'appareils de radio.

Fig. 246
Nearly 7,000 French Women Work in Germany
Press photo
from the June 8, 1941 edition
of *Paris-Soir*
Bibliothèque de Documentation
Internationale Contemporaine,
Nanterre

below
Fig. 247
Pablo Picasso
Women at Work
Paris, 1941
Pencil on photos in the June 8, 1941
edition of *Paris-Soir*
9 5/8 x 7 1/8 in (24.5 x 18 cm)
MP 1226
Musée Picasso, Paris

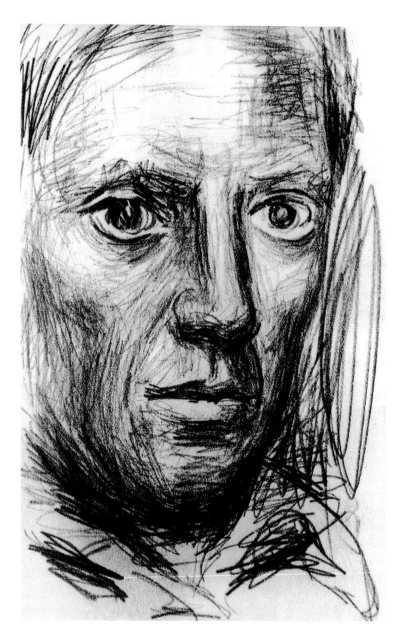

Fig. 248
Pablo Picasso
Self-Portrait
August 11, 1940
Pencil on paper
6 ¹/₄ x 4 ³/₈ in (16 x 11 cm)
Private collection

opposite page
Fig. 249
Pablo Picasso
Self-Portrait in the Studio
Royan, Villa Les Voiliers, 1940
Gelatin silver print
6 ¹/₈ x 4 ³/₄ in (15.5 x 12 cm)
FPPH 2801
Gift of Sir Roland Penrose
Picasso Archives,
Musée Picasso, Paris

1 9 5 0 ~ 1 9 6 0

Beyond Appearances

"Space Drawings"

In 1949, Gjon Mili approached Picasso on the beach and showed him some photographs in which "the luminous trace of an ice-skater's leaps [were] obtained by putting tiny lightbulbs on the tips of her skates."[604] Mili later recounted that "Picasso reacted immediately. Even before I was able to open my mouth to explain, in a flurry of excitement he began to draw increasingly evocative shapes in the air with his index finger."[605] Such enthusiasm echoed the interest shown much earlier in the century by avant-garde movements for the "photographs of motion" produced by Eadweard Muybridge or Étienne-Jules Marey.[606] Mili has explained the method he employed: "Two cameras were operated simultaneously: sometimes to record the same drawing from two different angles and sometimes to photograph from the same point of view, in black and white and in color."[607] Some of these "space drawings" were taken in a dark room so that only the luminous trail was recorded on the film. With others, however, intermittent flashes of light allowed the photographs to reveal not only the completed "drawing" but also the artist's expression and his body at work. The resulting trails of light testify to the power and speed of a gesture with all the precision of a chronophotograph. "The lens follows every of a point of light held as a pencil in the artist's hand, and records on film the completed picture of what he himself saw only in his mind's eye," wrote Edward Steichen. "Picasso's eyes rarely look on his drawing hand, but intensely concentrate on the image he mentally projects into space."[608] The image is projected into time as well as space, as Mili confirms when describing how Picasso appears in the photograph of *Le Centaure*: "His pose seems linked not merely to the beginning of the gesture, but to the entire work he had in mind."[609] Picasso crouches near the ground, ready to spring, apparently mimicking the luminous creature in advance. These images further confirm that Picasso drew with his entire body and in every dimension of space.[610]

As Mili stresses, "these lines of light are snapshot Picassos," by which he means that they fully reveal "the automatic reflex between hands and brain."[611] The process, because divorced from concrete reality, presupposes a kind of voluntary blindness (fig. 250)—it meant that Picasso could see "with the eyes of Saint Lucy,"[612] as he wrote in a poetic fragment explicitly referring to photography.[613] This blind scrutiny focused on the self as well as the emerging work, "a fine figure on a plate of silver."[614] The exercise could thus be compared to "drawings done around 1933 in the dark with eyes closed, in which organs—eyes, nose, ears, lips—no longer occupied their usual places."[615] It was also similar to earlier experiments in drawing techniques that were free of hesitation and rectifications. Already in 1907, Picasso's spontaneous illustrations for Apollinaire's *Bestiaire* were designed to be more hieroglyphic than representational. The same thing applied, around 1920, to the swirling *Harlequins*,[616] the studies for Stravinsky's score *Ragtime*,[617] and those for the ballet *Mercure*.[618] These drawings, like the light sculptures of 1949, generate an open spiral that pulls the inside out and vice versa, without any break or rupture. When drawing with eyes closed, the tip of the instrument must never lose contact with the paper, must not lose itself in the darkness of the labyrinth. At some point, however, the hand loses its frame of reference, as though the line had suddenly shifted into another dimension. Several studies for *Lysistrata*,[619] done in 1933, provide an example of this deregulated drawing. Similarly, Mili's photos show Picasso—gaze directed inward, toward some kind of hypnagogic vision (fig. 251)[620]—mobilizing all his draftsman's skills to guide his trail of light without getting lost: "If you want to draw, close your eyes and sing!"[621]

The "space drawings" ended with a recently rediscovered short film that documented the duration of a choreographed drawing by Picasso. Other filmmakers were also tempted by the challenge of capturing Picasso as he wrestled with the creative process. The following year a film by Paul Haesaerts[622] was shot through a pane of glass on which the artist drew with a brush—Picasso's presence, gaze, and hand all project their image onto a screen that also constitutes the material support of the work in progress.[623] Thus in Mili's photographs and Haesaerts's film, the painter is seen through a skein of lines that progressively covers the entire transparent surface. In July 1955, Henri-Georges Clouzot's *Le Mystère Picasso* employed, at Picasso's suggestion, another system involving translucent paper stretched over a vertical frame onto which he drew, back-lit, with a felt pen.[624] The camera being on the other side, the luminous screen functioned as a perfect metaphor not only for the film being projected in the theater but also for the film being exposed in the camera.

Fig. 250
Gjon Mili
Picasso Drawing
with the Pencil of Light
Vallauris, August 1949
Gelatin silver print
13 3/8 x 10 1/4 in (33.9 x 26 cm)
APPH 1416
Picasso Archives,
Musée Picasso, Paris

opposite page
Fig. 251
Gjon Mili
Picasso Drawing
with the Pencil of Light: Bull
Vallauris, August 1949
Gelatin silver print
11 5/8 x 9 in (29.4 x 23 cm)
APPH 1420
Picasso Archives,
Musée Picasso, Paris

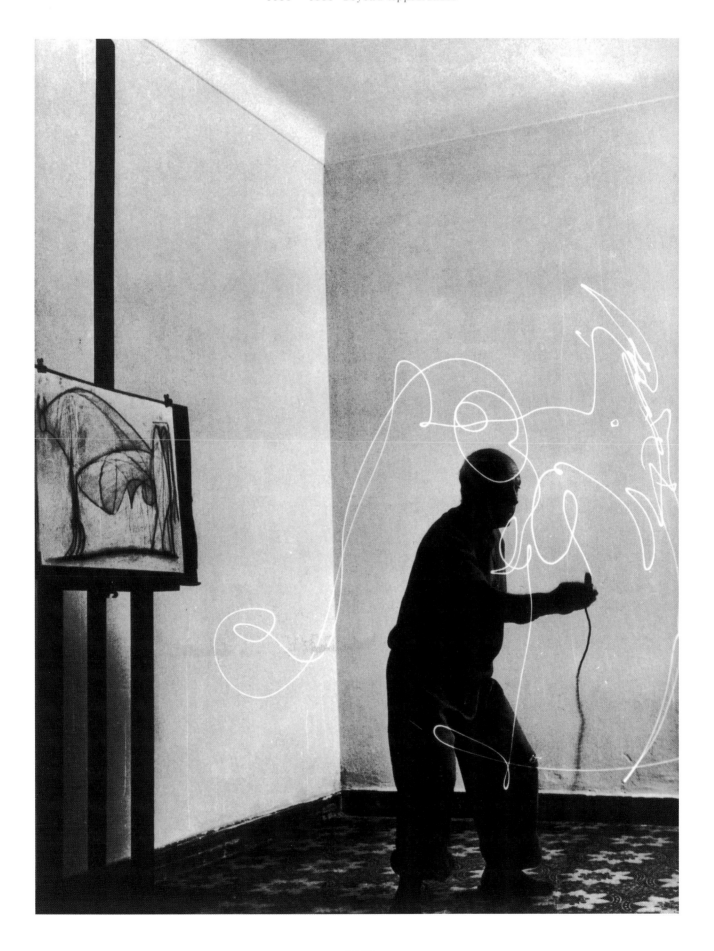

According to film critic André Bazin, "everything the screen shows us is supposed to extend indefinitely into the universe."[625] Hence a painting, once filmed, "participates in a virtual pictorial universe that stretches beyond it on all sides."[626] In fact, *Le Mystère Picasso* indeed captures painting in the "third dimension"—space as traversed by light—as well as in the continuous flow of time during which the work grows and changes.[627] "Here is a form of animated drawing or painting that does not rely on the frame-by-frame technique. Instead of starting with still drawings that have to be mobilized through the optical illusion of projection, the canvas exists beforehand like a screen, which needs merely be filmed in real time."[628]

Photographic Cutouts

André Villers was only twenty years old when he met Picasso. The friendship that sprang up between them soon led to a joint project. "In 1954, Pablo said to me: 'The two of us must do something together. I'll cut out little figures and you'll take photos. You can use the sunshine to bring out the shadows. You'll have to take thousands of shots.'"[629] Here it was a question of exploring the resources of an essentially photographic space. "Picasso became interested in the possibilities I offered him for playing with transparency and creating images on top of images in the new realm of photographic emulsion, with everything always remaining visible, a unique effect that only photography could offer."[630]

It all started with a little cutout faun that Picasso gave to Villers one day, saying, "Play with that."[631] Thus began a constant, nearly decade-long exchange between the photographer's skill and Picasso's art of paper cutouts. "Several days later, when I arrived at his place, a delighted Jacqueline said to me, 'Pablo has done a lot of work for you.' In the studio, where the dining table was, there were a great number of photos everywhere, spread out, cut up (fig. 255)."[632] Usually the shapes fit into one another like the pieces of a puzzle, the same line perfectly defining two equally significant areas. The figure of *Man with a Bird* was cut out, as both a solid and a void, from a photograph of a landscape. On one side the figure was glued to two sheets of paper, onto which Picasso drew a cluster of marks in black ink (figs. 253, 254). On the other, the negative silhouette was partly backed by a white sheet, and Picasso then added new incisions, an irregular thin line of India ink, and a mask with unequal eyes.[633] Sometimes Picasso exploited the effects of transparency and superimposition differently, by reemploying the old method of "photogenic drawing."[634] On a piece of adhesive paper he drew or stuck feathers, sawdust, and cutout shapes, which would be placed between the light source and the sensitive paper during printing. In another example, a round head, a bird, a figure, and a bull were orchestrated into a self-portrait (fig. 252), which in turn engendered new prints, each different, of new cutouts. In this wordless dialogue, the work advanced step by step toward an unknown destination; with great premeditation, however, Picasso seemed to maintain advance control over his still-virtual images, perfectly mastering effects of cutouts, collage, and transparency even in their role as *negatives*. Villers stresses the highly conscious sophistication that Picasso brought to the shared undertaking: "I mean he knew, Picasso, what the photograph should . . . what it should be, while I and all the others were still wondering what the photo was."[635] Elsewhere, Villers added, "Is it still necessary to speak of Picasso's inventiveness? . . . When he handled photographic plates or paper, his imagination allowed us to glimpse new ways of teasing things from the emulsion."[636]

The artistic team of Picasso and Villers ended in 1959 with a final experiment: "I made a selection from my old negatives which I exposed on photographic paper where, during printing, I placed Picasso's cutouts, which allowed me to place garments, plants, skin, etcetera in Picasso's heads and forms."[637] At that stage, the photographic image covered the entire photo-sensitive surface, printing itself right "into Picasso's forms." These plates constituted the substance of *Diurnes*, published in 1962 with a text by Jacques Prévert.[638] Picasso vaunted his knowledge of the medium by declaring to Villers: "I've painted and drawn on photos. Hypo, developer, I know it all, you see. Is it hard to get an enlarger? We could do the photos here, we could set up a darkroom and we'd place branches, string, feathers on the prints."[639] Another time, he imagined the most far-fetched of photograms. "We could use a photo to make a life-size figure, I'd do it nude and we could cover it with vermicelli, that would be amusing, don't you think?"[640] Yet these plans came to naught—Picasso's desire ultimately gravitated toward *primary* photography, the pure imprint of light rather than a representation of the world.

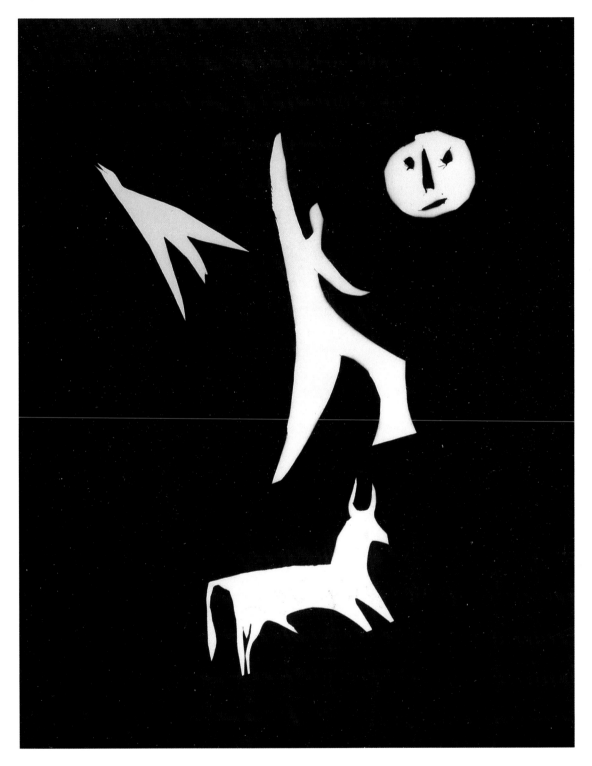

following double page

Fig. 252
Pablo Picasso and André Villers
Face
Cannes, Vallauris, [1954–1961]
Gelatin silver print
11 ⁷/₈ x 9 ³/₈ in (30.3 x 23.8 cm)
APPH 2280
Picasso Archives,
Musée Picasso, Paris

Fig. 253
Pablo Picasso
Photographic Cutout: Man with a Bird
Vallauris, [1954–1961]
Gelatin silver print cutout and glued
to two sheets of stationary,
reworked in India ink
15 ¹/₄ x 10 ³/₈ in (38.8 x 26.3 cm)
André Verdet Collection, Mougins

Fig. 254
Pablo Picasso and André Villers
Man with a Bird
Vallauris, [1954–1961]
Gelatin silver print
15 ³/₄ x 11 ⁷/₈ in (40 x 30.3 cm)
APPH 2156
Picasso Archives,
Musée Picasso, Paris

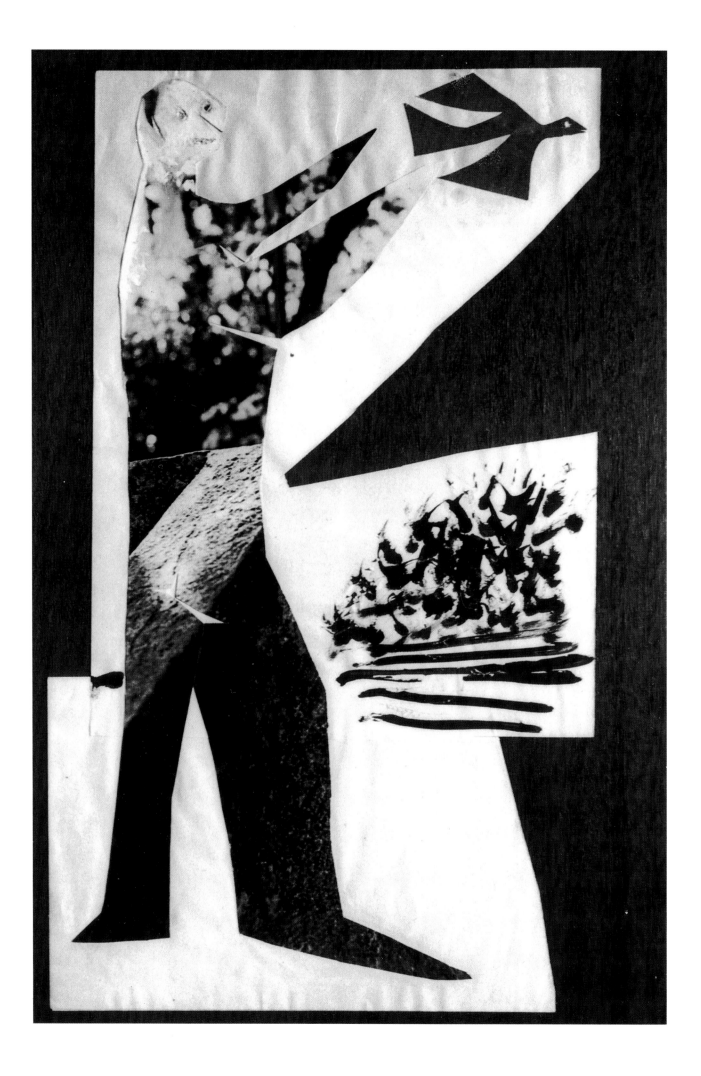

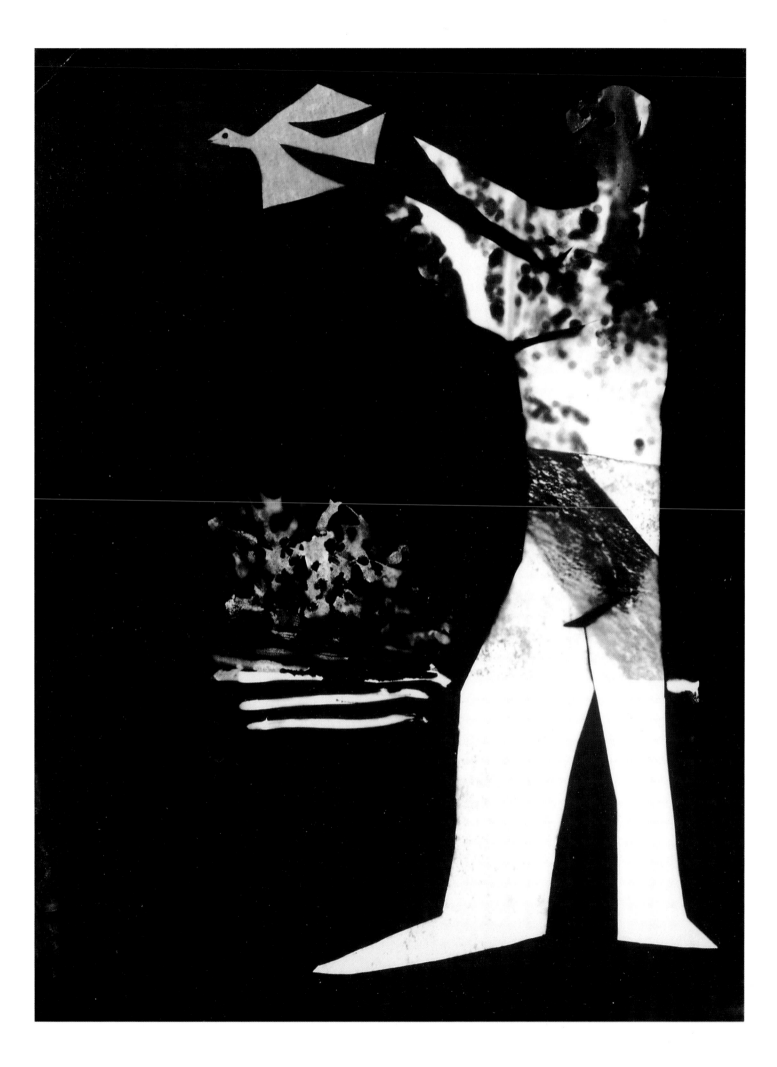

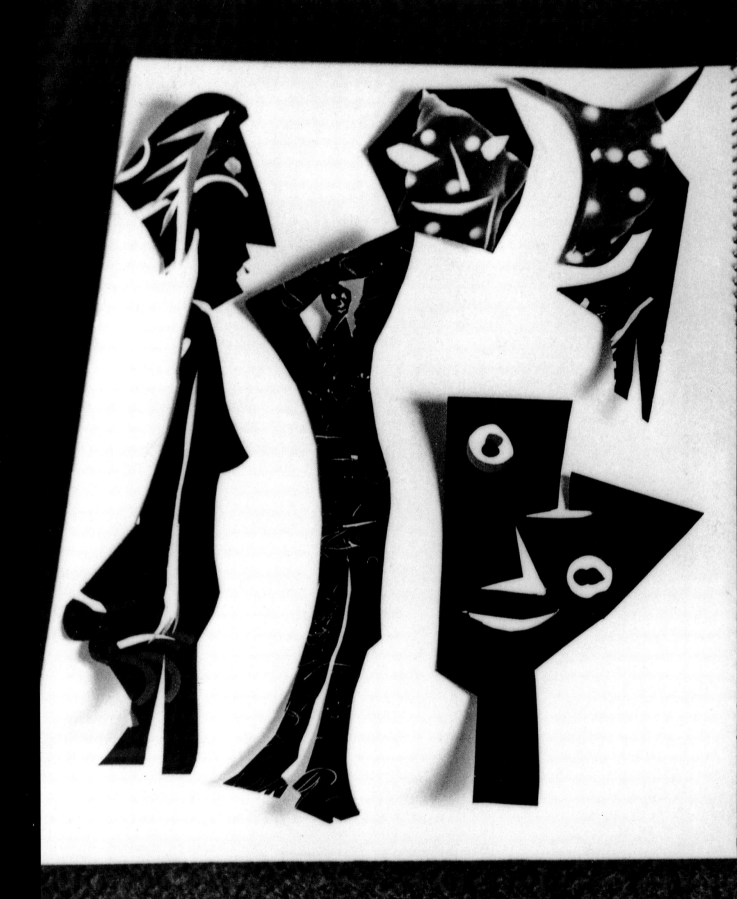

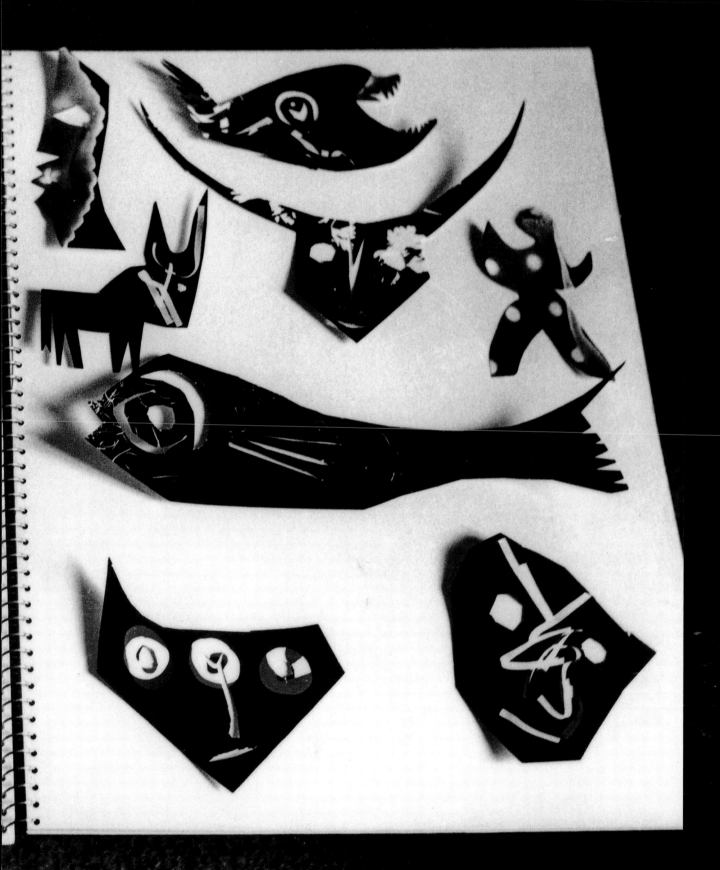

"Someone is scrawling. . ."

"It's silent, except for some scraping—someone is scrawling. Picasso's at work."[641] Thus Villers described another photographic experiment dating from 1957–1958, which directly echoed the one witnessed by Brassaï back in 1932.[642] The method used by Picasso on this occasion was precisely that of the cliché-verre: "I brought him 6 x 9 photographic plates which I had already exposed, developed, and fixed to produce a black ground. I said nothing, just watched him there His eye passed through the glass, his knife cut into the gelatin. Fine silhouettes like metal filings or lino shavings fell onto the table and floor. He looked through it, and the palm trees in the garden entered the landscape. Then he underscored the rays of the sun and, drawing the blade width-wise, pulled off the emulsion and blew it away."[643]

These plates of black emulsion or of transparent glass[644] became the basis of *Dancers* (fig. 257), which elaborated a recurrent theme in the work of 1955 to 1959. A final engraving was executed on a rectangular plate that already bore a 6 x 6 contact print by Villers showing a Picasso cutout of a faun and flute player set in a rocky garden (fig. 258). Engraved onto this glass, a laurel-wreathed man crosses the boundary separating the original photograph from the off-frame space. The image thus reunites, in a simultaneously coherent and contradictory fashion, the flat shape of the cutout, the perspective specific to photography and the engraver's incisive attack on it. The tension is all the stronger when printed, since the lines appear in positive and the print in negative.

Gjon Mili witnessed a similar approach to the photographic medium in 1967: "One day when I was showing him a 35mm slide of the bare studio wall (thinking it would make a good background for his portrait), Picasso couldn't resist the temptation to play with it. Instantly, and without the least hesitation, he took his knife and began tracing three different drawings directly onto the film.. . .The meticulously controlled lines of the knife were like fine filigree" (fig. 256).[645] On a fish-eye shot of the interior of the Notre-Dame-de-Vie studio, Picasso thus etched a woman's bust, a self-portrait and, in the middle, a figure that might be the photographer (fig. 259). In scraping away the emulsion, therefore, he combined, in a double

transparence, the preexisting positive image (the architectural interior enhanced by the wide angle) with a drawing of luminous incision. And Mili went on to add: "He showed me several slides he had already engraved beforehand, others that he had pricked with a pin, and still others that he had painted" (fig. 260).[646] In *Portrait of Jacqueline*, Picasso seems to have used the unexposed end of a film strip; as the ink dried, he etched away areas precisely describing background, face, and hair. Another drawing, *Bearded Portrait, Portrait of Jacqueline, Figure*, also seems to be made on a blank surface where prismatic green, yellow, and red bands section the space horizontally.

It should be noted that each of the works thus obtained is unique, and must be rephotographed on a light box if it is to be reproduced. Its status is therefore similar to the rayographs of 1936–1937 in which objects placed directly on photographic paper produced just a single print.[647] Here, however, there is no pairing between negative and print, even if unique. With slides, the lens of the eye and the lens of the light source occupy opposite sides of a transparent screen,[648] in an optical system comparable to the photo-cinematic experiments of 1949–1955. What seems to have attracted Picasso to these non-multiple works was not the "technical reproducibility" of film, but rather the pleasure offered by the medium for direct, cursive, graphic work.[649]

At the end of the 1950s, the publisher Pierre-André Benoit once again drew Picasso's attention to the qualities of celluloid film as an engraving medium. "Instead of attacking hard metal, it offers a soft matrix that can be carved and even perforated. Thus black lines become white, the grain of the paper can breath. All the hand's sensitivity becomes visible."[650] Picasso's illustrations for numerous texts[651] subsequently explored the possibilities of engraving, piercing, burning, and cutting into this substance. In his work on Pindar's *VIIIth Pythic*,[652] he developed a method for cutting up celluloid in which each fragment served as matrix for a new engraving[653] It should be noted that such experiments were parallel to the ones then being carried out with André Villers, which explored the qualities of a medium traversed by the flow of light. "Holding a photo up to the light, he assessed its transparence and decided on printing."[654] A zigzagging thread thus runs through Picasso's attempt to violate the ambiguous borders that divide and unite engraving and photography. He pushed their shared techniques in every direction: from positive to negative, from left to right, from plate into print and vice versa. He mobilized, either simultaneously or successively, the work of the hand and the action of light, combining photo-sensitive processes with printing techniques. He conjugated various media—copper, glass, celluloid, paper—as well as active principles—light, acid, ink. Thus motifs were formed and unformed, done and undone, as Picasso struggled to grasp every possibility, that would give birth to new images.

preceding double page
Fig. 255
André Villers
Picasso's Cutouts
Vallauris, [1954–1961]
Gelatin silver print
12 x 15 7/8 in (30.4 x 40.2 cm)
André Villers Collection

Fig. 256
Gjon Mili
Picasso Engraving a Slide
with a Knife
Mougins, 1967
Gelatin silver print
11 x 10 ⁷/₈ in (28 x 27,5 cm)
© Richard Cecani, courtesy
Howard Greenberg Gallery

Fig. 257
Pablo Picasso
Dancers
Cannes, September 3, 1958
Knife engraving on glass
photographic plate
2 ¹/₂ x 3 ¹/₂ in
(6.5 x 9 cm)
Marina Picasso Collection,
Galerie Jan Krugier,
Ditesheim & Cie, Geneva

Fig. 258
Pablo Picasso
Faun and Flute Player
Cannes, September 3, 1958
Knife engraving on glass
photographic plate
2 ¹/₂ x 3 ¹/₂ in (6.5 x 9 cm)
Marina Picasso Collection,
Galerie Jan Krugier,
Ditesheim & Cie, Geneva

above
Fig. 259
Pablo Picasso
Bust of Woman,
Profile of Bearded Artist,
Figure
Mougins, 1967
Knife engraving
on a photographic slide
7/8 x 1 3/8 in (2.3 x 3.5 cm)
Richard Checani Collection

right
Fig. 260
Pablo Picasso
Dancer
[Mougins, 1967]
Perforations
in a photographic slide
7/8 x 1 3/8 in (2.3 x 3.5 cm)
Richard Checani Collection

Fig. 261
Pablo Picasso
Bride and Satyr
Vallauris, May 1951
Reed pen and ink on page 22 of *Vogue,*
May 1951
12 ⁵/₈ x 9 ¹/₂ in (32 x 24 cm)
APR 1
Picasso Archives, Musée Picasso, Paris

Graffiti

"The artist is a receptacle for emotions that come from everywhere—the sky, the earth, a piece of paper, a passing figure, a spider's web," declared Picasso, adding, "that's why you shouldn't distinguish between objects. Degrees of nobility don't exist for them. You have to accept good wherever you find it, except in your own works."[655] Indeed, in the 1950s Picasso would often gather random items and scrap on the road leading to his Fournas studio; he would link and bind these *objets trouvés* with plaster prior to casting them as bronze sculptures. Images underwent a fairly similar fate at his hands. Leafing through a spring 1951 issue of *Vogue*,[656] Picasso covered it with obscene graffiti that challenge the ideal of fashion photography at least as much as they offend morality (figs. 261, 263).[657] On the pink-marbled cover, for instance, a model in butterfly sleeves undergoes an anamorphic reduction that endows her with the head of an insect; the eye of the beholder, caught in the optical trap of disproportion between giant body and dwarf mask, madly attempts to reconstitute a plausible entity. The opposite fate, meanwhile, befalls a model in a piqué dress, on whom genetic mutation has grafted the outsized face of a bearded creature. Picasso's shafts of wit go straight to the very body—the sexuality—of the feminine ideal. This Sadean subversion of images raises, in its own way, questions of likeness and likelihood: Do these photogenic creatures still resemble women? To what extent do they withstand all the parasitical partners and countless accessories—not to mention the changes in scale, dimension, and intent—to which Picasso exposes them?

Throughout 1957, Picasso sent his childhood friend Jaime Sabartés a series of small posters of pinups, which were likewise adorned with graphic additions and handwritten comments (fig. 265).[658] The whole set might be read as a sequence that makes Sabartés the protagonist of a highly ridiculous sexual assault. Just as in the cinema, where Technicolor was all the rage, these images indulge in a baroque formalism of pose and color in which "clever censorship of clothing" competes with "unmistakable anatomical affirmations."[659] Rejecting this aestheticism, Picasso perfunctorily restores sex to the image, and an image to sex. He strips decorative convention from the pinups' sleek bodies, forcing dream women to coexist with caricatures. This simulated abuse, however, liberates a new plastic space that combines photographic color and bawdy graffiti with the swirl of Picasso's inscriptions.[660] The result converges, in a way, with his great 1957 series of *Las Meninas*, variations on Velázquez that began in black-and-white but swiftly evolved toward highly virulent colors.

In 1960, brightly colored touches were also added to black-and-white photos taken by David Douglas Duncan. Picasso turned one of them into a theatrical hero complete with beard, mustache, and wig topped by a plumed hat. Several days later, pictures of his reunion with a childhood friend, Manuel Pallarès, were similarly travestied into an ironic allegory of friendship: heads wreathed in laurel, the figures indulge in a paroxysmal comedy of emotions worthy of Aristophanes (figs. 269, 270). The following year, another Duncan photograph—this time showing Picasso, his daughter Paloma and stepdaughter Catherine—was similarly reworked in an approach echoed in a series of colored engravings[661] on the "Ingresque" subject of *Family Portrait*.[662]

A graphic, felt-pen reinterpretation of an issue of *Life* magazine attacked advertising imagery as well as pictures of the new heroes of the American way of life—businessmen, movie stars, and famous Abstract Expressionistic artists—with Picasso's typical disrespect.[663] On one two-page spread, an ad for pens (two symmetrical hands that seem to be writing directly onto the magazine itself) flanks the picture of a Finnish deserter who had remained in hiding for nearly forty years. Picasso's additions to eyes and mouth suffice to turn this distressed figure into a macabre mask that evokes not only the mirror drawings of 1940,[664] but also Picasso's final self-portraits[665] in the form of skulls with vacant eye sockets.

Although acquaintances often noted Picasso's phobia regarding mirrors,[666] Brassaï reported a comment suggesting that Picasso's attitude stemmed from intense curiosity: "On waking up and seeing myself in the mirror with ruffled hair, you know what I thought? Well, I was sorry I wasn't a photographer! . . . One should make a hole in a mirror so that the lens can record your most intimate face on the spur of the moment."[667] Brassaï nevertheless added, "Picasso was perhaps thinking of the horrified expression on his face that sad day in November 1918, when he was told of the death of Guillaume Apollinaire. He was shaving at the Hôtel Lutétia . . . Ever since then he has hated mirrors—all mirrors Having seen the shadow of death pass that day, he stopped drawing and painting himself"[668]

"Mirrors lie, and photographs lie," Picasso reportedly told Max Jacob.[669] Yet from the 1950s onwards, he became "far and away the most photographed of living artists."[670] His exhibitionist games for photographers who sought him out was perhaps another form of the same denial: "Don't look at yourself in the mirror any more." This was ultimately his way of foiling—by extravagantly acknowledging—pictures that unfailingly reduced him to an endless display of genius in flesh and blood. In all these "clowning Picassos" (fig. 267),[671] the artist put on a highly conscious show, transforming his photographer friends into collaborators on a perpetual self-portrait.[672] Replacing celebrity with celebrity, he took a photo showing himself surrounded by admirers, and blithely transformed his own head into Charlie Chaplin's Hitler, thanks to a few pencil strokes indicating mustache and lock of hair (fig. 266).[673] In 1972, a year before his death, he once added hair, black beard, and a monocle to a photograph by Lucien Clergue, along with a comment written to a friend: "I've done this to show you how differently we perceive ourselves and others, which is often just a caricature of ourselves and others" (figs. 271, 272).[674]

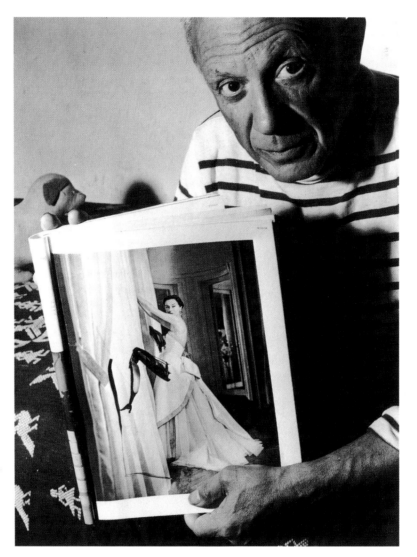

Fig. 262
Robert Doisneau
Pablo Picasso with a Redrawn
Page from Vogue (May 1951)
Vallauris, 1952
Gelatin silver print
9 ¹/₂ x 7 ¹/₈ in (24 x 18.2 cm)
APPH 554
Picasso Archives,
Musée Picasso, Paris

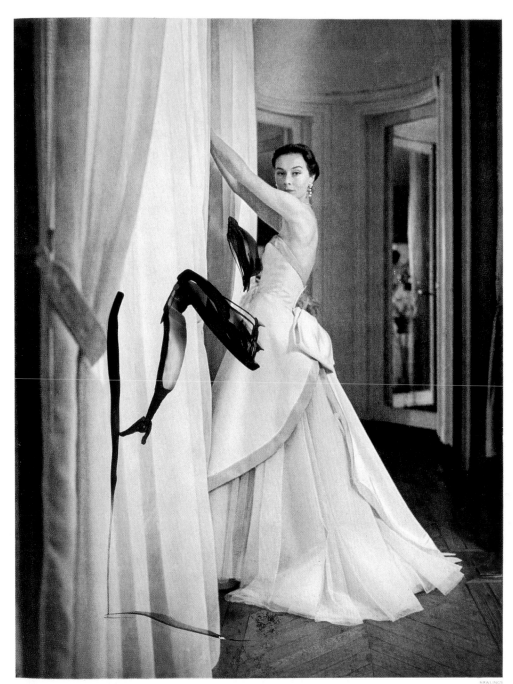

Fig. 263
Pablo Picasso
Satyr-Woman
Vallauris, May 1951
Reed pen and ink on page 33 of *Vogue*,
May 1951
12 5/8 x 9 1/2 in (32 x 24 cm)
APR 1
Picasso Archives, Musée Picasso, Paris

Fig. 264
Pablo Picasso
Humorous Composition:
Paul Claudel and a Ballerina
[1962]
Photographic collage and blue crayon
11 1/2 x 10 1/8 in (29.3 x 25.7 cm)
Museu Picasso, Barcelona

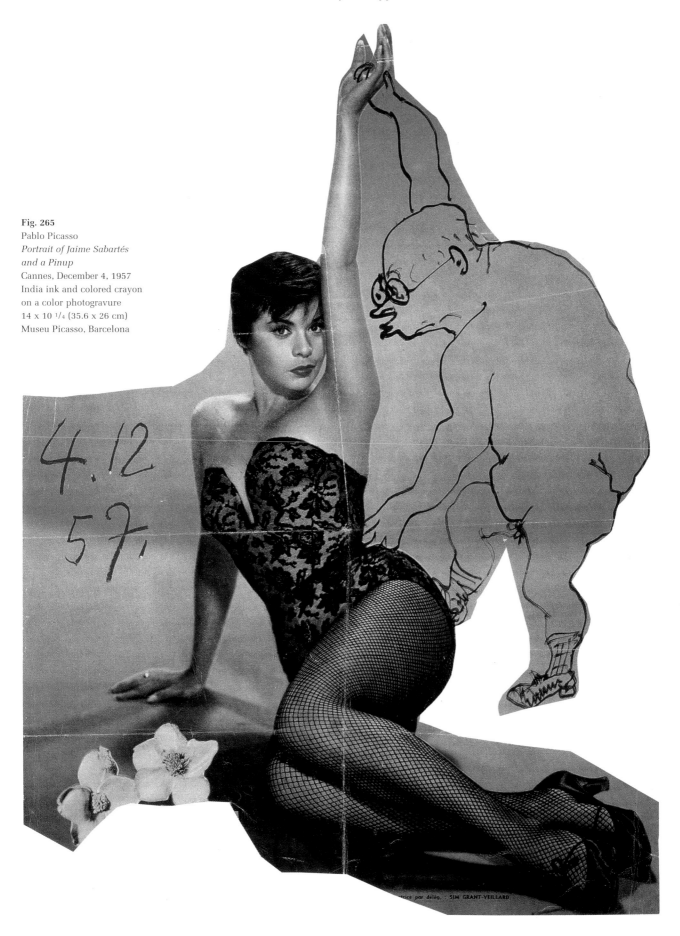

Fig. 265
Pablo Picasso
*Portrait of Jaime Sabartés
and a Pinup*
Cannes, December 4, 1957
India ink and colored crayon
on a color photogravure
14 x 10 ¹/₄ (35.6 x 26 cm)
Museu Picasso, Barcelona

Fig. 267
David Douglas Duncan
Picasso Disguised as a Clown
Cannes, 1957
Gelatin silver print
Private collection

Fig. 266
Pablo Picasso
Self-Portrait
Vallauris, [1948-1955]
Anonymous photograph
reworked in pencil
5 ¹/₈ x 3 ³/₈ in (12.9 x 8.7 cm)
APPH 1379
Picasso Archives,
Musée Picasso, Paris

opposite page
Fig. 268
Pablo Picasso
38-year Saga of the Scared Finn
Vallauris, 1959
Black felt pen on the November 16,
1959 issue of *Life*
APR 2
Picasso Archives,
Musée Picasso, Paris

SCARED FINN CONTINUED

38-YEAR SAGA OF

THE SCARED FINN

The furtive eye shown peering through a farm shed crack on the preceding page belongs to a frightened 58-year-old Finn named Vaino Johannes Kilpinen, and the narrow strip of landscape pictured beside it is all that he customarily saw of the world for most of his life. Vaino, shown below, is an ex-farmboy from the village of Vehmainen in central Finland. The shed, on his father's farm, is where he skulked like a hunted animal since the day he deserted the army 38 years ago. Last month Vaino's hideaway was discovered. Now, legally free and a minor celebrity in Finland, Vaino at last feels at liberty to move openly about his father's farm, to see and be seen, and even to take trips to neighboring villages. He has told the world his astonishing story.

Horses were Vaino's undoing—but not in the usual way. One of

seven children, Vaino knew no trouble except poverty until his 20th birthday. Then he was drafted into the Finnish army. Posted to a cavalry regiment 175 miles from home, Vaino was soon sporting a fine pair of red Dragoon breeches. This was great. But he soon found his fine breeches were no compensation for the knocks he took as he kept falling off his horse. He didn't like horses. He couldn't ride them. And he didn't like his commanding officer either. One morning in May 1921, Trooper Vaino Johannes Kilpinen walked past the sentry gate. Challenged, he said he was ill and was going to the hospital. That, until October 1959, was the last the army heard of him. He wasn't ill, he was just a hardheaded Finnish boy who didn't like horses. And he was headed home to his father's farm (*next page*) and a strange life (*p. 64*).

TURNING TO THE BRIGHT WORLD AFTER A LIFETIME SPENT IN SHADOWS.

THE FACE OF VAINO JOHANNES KILPINEN IS MARKED BY BEWILDERMENT

CONTINUED

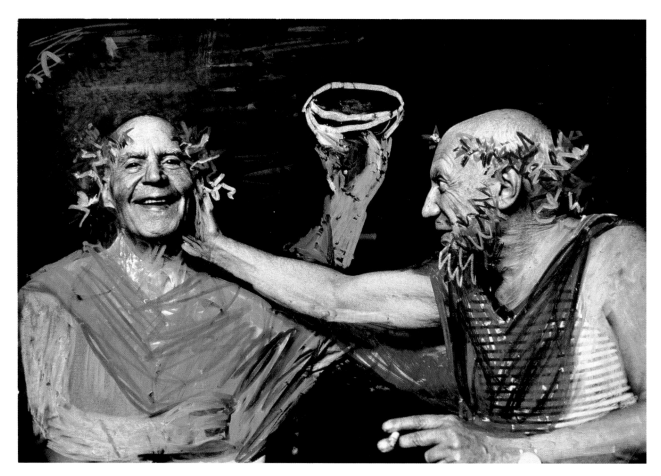

Fig. 269
Pablo Picasso
and David Douglas Duncan
Picasso and Manuel Pallarès
Cannes, October 5, 1960
Colored crayons
on gelatin silver print
8 7/8 x 13 3/8 in (22.5 x 34 cm)
Private collection

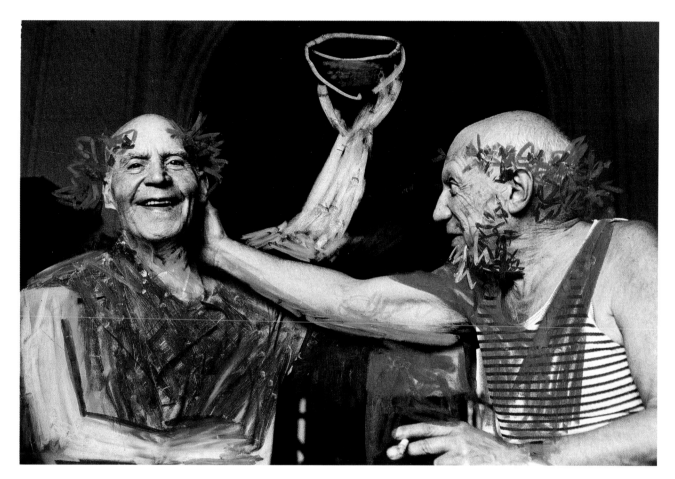

Fig. 270
Pablo Picasso
and David Douglas Duncan
Picasso and Manuel Pallarès
Cannes, October 5, 1960
Colored crayons
on gelatin silver print
8 $^7/_8$ x 13 $^3/_8$ in (22.5 x 34 cm)
Marina Picasso Collection (inv. 0783),
Courtesy Galerie Jan Krugier,
Ditesheim & Cie, Geneva

above left
Fig. 271
Lucien Clergue
Portrait of Pablo Picasso
Mougins, 1971
Gelatin silver print
Private collection
Photography © 1997
by Lucien Clergue

above right
Fig. 272
Pablo Picasso
Self-Portrait
Mougins, January 15, 1972
Ink on poster
Private collection
Photography © 1997
by Lucien Clergue

Conclusion

What is to be learned from this photographic passage through Picasso's grand oeuvre? Perhaps a better grasp of how his eye functioned. A photo puts the productive process on "hold" for an instant, providing so many freeze frames in which to observe the true motive behind the work in progress. Picasso used this mirror effect himself to analyze his own vision at moments as decisive as the Blue Period, his stay in Horta, and his arrangement of the *papiers collés*. Photographic observation places a grid on gestural virtuosity, brings unbounded creative practice to a halt, produces a gap that facilitates monitoring and reflection. During the invention of cubism, for example, the reinterpretation of existing images, the staging of works in progress, and the manipulation of negatives or prints all helped Picasso test prototypes of new visual approaches. Photography thus functioned as a "machine for seeing" that provided distance on pictorial *poiesis* and brought the eye's micro-events into the realm of consciousness.

On several occasions, Picasso himself stressed how photography gave him access to "primal visions," the ones that initially spring to an artist's mind, governing the development of a work and surviving the metamorphoses of its materialization. A latent image, simultaneously revealed and revealing, develops from the dense matrix of the medium: in Picasso's writings of 1935–1940, photographic *apparition* was often used as a metaphor for all creativity. Paintings, drawings, engravings—orchestrated in sets, in multiple variations, in series—elucidate their successive states in an attempt to get ever closer to the primal source. Picasso's collaborations with Dora Maar, Brassaï, Mili, and Villers attest to the fascinated pursuit of a single quest: how and where do images arise?

Photography not only puts the flow of time *on hold*, turning mysteries of consciousness and the medium into *apparition*, it also functions as a *visual switch*. It transcends the figure/ground issue by optically leveling all objects and planes. It chromatically limits the incidence of light to black, white, and gray. It crops and pastes the unbounded space of reality into an incontrovertible expanse. Photography's systematic operations may have been taken as a "model" at several key moments in Picasso's pictorial exploration. Direct applications have been noted in the framing effects of the year 1901, in the successive choices of blue, rose, ocher, gray, and sepia tones that marked the monochrome variations up to 1914,

in the optical decomposition of volumes in 1909, and in the elaboration of the cubist grid between 1910 and 1912. Furthermore, the doubling and subsequent multiplying of the cubist viewpoint may even be fruitfully compared to the principles behind stereoscopic plates and certain sequential series of instantaneous photography. Such images leave a trace both here and there, imprints of the clashes that vision provokes between reality and consciousness.

Despite all this switching of signals, of course, photography never abdicates its unique semantic ability to "resemble." Simultaneously index and icon, its aptitude for creating a technico-theoretical *analogon* of the object turns it into a site of insurmountable tension where the question of representation is physically anchored in the real world. Jean-Paul Sartre has nevertheless stressed how, in the phenomenology of the imaginative faculty, the stronger a mental image—and, in that respect, the stronger its "resemblance"—the more it loses analytical consistency and accuracy, the more "its material appears essentially impoverished."[675] The desubstantialization of an image, its failure to perceive or represent, would therefore be the condition for a surplus imprint on the *psyche*. This paradox of the imaging conscious finds its equivalent in the way that photography succeeds through its very poverty as a medium. Limited to a few sets of flat shadows, it is perceived as the most convincing representation of reality—literally speaking, a twin image of reality. This is the sense in which it has been noted that "photogenic quality is that complex and unique sense of shadow, reflection, and twinning that enables affective powers specific to the mental image to affix themselves to a photographic reproduction."[676]

At the end of his cubist period, Picasso painted a portrait of his wife colored like all those tiny nineteenth-century photos highlighted with gouache (fig. 190). This painting, "like a photographic enlargement," would be described by Gertrude Stein, who witnessed Picasso's earliest encounters with a camera, as "perhaps the best [he had] ever done."[677] Having become the symbol of Picasso's picto-photographic research, it literally materializes Sartre's observation: that the more things resemble, the less they resemble. The material is impoverished, perception is effaced, and the image—thinned to the point of letting the support show—is merely the idiosyncratic trace of the subject that consciousness retains. When confronted with a live sitter, Picasso vacillated between infinite scrutiny—the

"eighty or ninety sittings" he demanded of Gertrude Stein in 1906,[678] sudden blindness ("I can't see you any longer when I look"[679]), and later restitution (the portrait of Dora Maar "done from memory"[680]). It is perhaps in this perceptual gap that photography becomes necessary, a tool which, in Picasso's hands, was less a recording or technical device than a heuristic one; it offered a way of approaching reality when it was already imaged, testing the visual motives of the unconscious, using light in order to "hold" [savoir] as much as to "behold" [voir].[681] This approach, as has been shown, could spur both cubist deconstruction and a surprising return to representation. As an art of cropping and reducing, an art of appearing and disappearing, photography was thus one of the inner frontiers along which Picasso pursued his exploration of the undersides and othersides of appearances.

Notes

Notes to the Reader

Full citations to abbreviated references cited in notes appear in the Bibliography.

Other abbreviations correspond to the following inventories and catalogues:

MP: Musée Picasso, Paris, inventory number

APPH: Archives Picasso, Musée Picasso, Paris, photograph inventory number

FPPH: Fonds Penrose Photographie, Paris, inventory number.

MPB: Museu Picasso, Barcelona, inventory number.

Succ.: Succession (Picasso's estate), inventory number

Z.: Christian Zervos, *Pablo Picasso: Œuvre catalogue*, Paris, Cahiers d'Art, 1932–1978.

D.-B.: Pierre Daix and Georges Boudaille, *Picasso 1900–1906: Catalogue raisonné de l'œuvre peint*, Neuchâtel, Ides et Calendes, 1988.

D.-R.: Pierre Daix and Joan Rosselet, *Le cubisme de Picasso: Catalogue raisonné de l'œuvre peint 1907–1916*, Neuchâtel, Ides et Calendes, 1979.

Baer: Brigitte Baer, *Picasso peintre-graveur*, Berne, Kornfeld, vol. 1–7, 1986–1996.

Glimcher: Arnold Glimcher and Marc Glimcher, eds., *Je suis le cahier: Les carnets de Picasso*, Paris, Bernard Grasset, 1986.

Spies: Spies, Werner, *Picasso, Das Plastische Werk*, Stuttgart, Verlag Gerd Hatje, 1983.

1. Pablo Picasso, quoted in Zervos 2, p. 174.

2. Pablo Picasso, quoted in Brassaï 1, p. 123.

3. These archives are now housed in the Musée Picasso in Paris. This volume is the culmination of research into that collection, which also yielded a cycle of three exhibitions in Paris between 1994 and 1997. See Baldassari 1, 2, and 4.

4. In addition to the prints and negatives held by the Musée Picasso, a set of original prints was found in the sketchbook labeled Carnet 4, still in the artist's estate.

5. Zervos 4, pp. 277–284.

6. Sabartés 2.

7. Penrose 1.

8. Picasso was cited as photographer only in the case of two portraits, one of Braque, taken in 1911 (Sabartés 2, no. 97, p. 314), and one of Kahnweiler, taken in the fall of 1910 (Penrose 1, fig. 85).

9. See especially the catalogues published by the Musée Picasso (Bozo; Richet), as well as Seckel 1 and Rubin 5, in which a number of photographs were attributed to Picasso.

10. See Billeter, Scharf, Schmoll, and Coke. Scharf refers to Picasso's major photographic experiment at Horta in the summer of 1909 only in a note at the end of his book (p. 369).

11. In Z. III, published in 1949, the mention "based on a photograph" is attributed to numbers 354 (fig. 171), 355 (fig. 173), 359 (fig. 208), 362 (see Baldassari 4, fig. 226), 413 (fig. 169), and 431 (see Baldassari 4, fig. 170), plus 412 (fig. 183), which is "based on an illustration."

12. For an analysis of this immediate postwar period, see Silver. Warncke significantly titles the chapter of his book devoted to the years 1916–1924, "Classicism and Photography"(p. 245). His analysis of the period is based on complex relationships between features specific to photography—notably the non-hierarchized nature of its depiction of reality—and a primarily linear style.

13. Although there are indications that Ingres made precocious use of daguerreotypes in his work (Scharf, pp. 49–52 and 332), he was concerned to defend the specificity of his pictorial expression. He spearheaded a "protest of major artists against any assimilation of photography to art" in response to a court ruling that, for the first time, extended the protection of a 1793 law on artistic property to a photograph (Mayer and Pearson, Paris Court of Appeals, 10 April, 1862).

14. Penrose 2, p. 222.

15. *Ibid.*, pp. 217 and 222.

16. Brodersen, pp. 341–350.

17. Z. IV, 1429. There also exists a small oil centered on Paulo's face (Z. V, 180). The painting and photo taken in a public park were published in Penrose 1, figs. 122, 123, and Coke, figs. 147–149. This example was the only instance of Picasso's work included in the *Malerei nach Fotographie* exhibition at the Münchner Stadtmusuem in 1970; see Schmoll, nos. 958–960.

18. The printed reproduction, moreover, often obscures the crucial difference in format between the photo and the painting.

19. The *carte de visite* was a small format photo—approximately 6 x 9 cm—invented by André-Adolphe-Eugène Disdéri in 1854 and widely used for inexpensive studio portraits up to 1914, thereby greatly contributing to their spread. See Freund, pp. 59–69.

20 See, for example, an embroidered postcard of the actress Bella Chelito, in Baldassari 2, p. 133, fig. 105.

21. Olivier 1, p. 171.

22. Quoted in Florent Fels, *Les Nouvelles Littéraires*, no. 42, 4 August, 1923, reprinted in Seckel 1, vol. 2, p. 622.

23. These comments were recorded on two handwritten sheets by Guillaume Apollinaire, preserved in the Bibliothèque Littéraire Jacques Doucet, Paris, quoted in Seckel 1, vol. 2, p. 637.

24. See Man Ray 1.

25. The photogram technique, as independently developed by Christian Schad, László Moholy-Nagy, and Man Ray, produced what are variously known schadographs, rayograms, and rayographs. The "natural image" usually recorded by the lens of a camera is abandoned in favor a direct imprint of the outline and texture of an object placed directly onto the light-sensitive paper. William Henry Fox Talbot's nineteenth-century "photogenic drawings" represented a primitive form of this same effect.

26. Tzara, pp. 425–426.

27. Marius de Zayas Manuscripts, Beinecke Rare Books and Manuscripts Library, Yale University. This letter of 11 June, 1914 as well as Stieglitz's reply are published in Zayas, pp. 174–179. De Zayas also added that Picasso admired Stieglitz's 1907 photograph *Steerage*, and that Picasso considered Stieglitz as "the only one who has understood photography."

28. Stein 2, p. 99, and Stein 1, pp. 8–9.

29. Stein 2, p. 121. Stein establishes a link between these photographic compositions (fig. 128) and the paper constructions executed by Picasso two years later, without however mentioning that the paper constructions themselves became the object of photographs. See below, pp. 116–117, fig. 133.

30. *Transition* (Paris), no. 11, 1928.

31. Stein 2, p. 99. Stein claimed that the canvases could be accused only of being "too photographic a copy of nature."

32. Stein 1, p. 18.

33. Tucker, pp. 288–289.

34. Fry 1, p. 146.

35. Zervos 2, p. 38.

36. Daix 2, p. 289.

37. See Grundberg.

38. Fry 2, p. 306 (n. 31).

39. Fry 1, p. 146.

40. Sabartés 2, p. 312n. and fig. 87. There exists a print of this photo with a 1904 dedication by Picasso to his friends Suzanne and Henri Bloch (Département des Estampes, Bibliothèque Nationale, Paris). Canals was another painter who used photography, as testified by comparing a double portrait of his wife and Fernande Olivier, posing in Andalusian dress, with his canvas *At the Bullfight* (1904). It may have also been Canals who initiated Picasso into the glass monotype technique in 1905, Picasso's first example being *Portrait of a Woman in a Mantilla* (Baer, vol. 1, no. 251). This work on transparent support bears a certain analogy with photographic techniques.

41. One print has a comment written in Picasso's hand in French: "Portrait of the painter Ricardo Canals from Barcelona / in the mirror is me, PICASSO / on the fireplace a photo of Benedetta, wife of Ricardo Canals / photo taken in Paris in Canals's studio in 1904."

42. These photographs, showing works in progress, exhibited at Picasso's first show at Vollard's gallery, can be dated to early 1901. See below, p. 19.

43. Vidal Ventosa, a trained sculptor and restorer, took photographs of old Catalan buildings and statues, and later became the official photographer of Barcelona's municipal museums.

44. The photo was taken in *Guayaba*, Vidal Ventosa's studio.

45. A photograph dating from the early 1920s—a self-portrait of Picasso reflected in a mirrored wardrobe—shows a reflection of a similar camera (fig. 6). Amateur pictures taken in the early 1930s, during a visit to Gertrude Stein in Bilignin, also show Picasso and Olga using a camera of the same type (fig. 1).

46. Sabartés 1, p. 82. See also Olivier 1, p. 62.

47. Stein 1, p. 15.

48. These developers were designed to correct the frequent under-exposure of turn-of-the-century "snapshots" which, when developed with ordinary chemicals, came out too contrasty.

49. Prints were obtained by exposure to sunlight, using a frame holding both the negative and the sensitized paper.

50. This visual inventiveness and the attention given to chromatic variations of prints coexisted with a certain indifference on Picasso's part to the physical presentation and preservation of the photograph, resulting in paper cut unevenly, frequent under- or over-exposed, insufficiently fixed prints, etc. Such characteristics are part of the "signature" of these prints.

51. Letters of 24 and 27 May, 1912. Certain excerpts from the letters of 1912–1914 cited here have been published in Monod-Fontaine, pp. 93–170, and in English in Cousins, pp. 391–400.

52. Letters of 15 and 17 June, 1912. It was probably Braque (letter of 23 July, 1912) who brought Picasso the camera. Several pictures were taken at Sorgues, including a shot of the summer's paintings hung outdoors, a portrait of Georges and Marcelle Braque (taken, like the paintings, on the porch of the Villa des Clochettes) and, with less certainty, a portrait of Eva in a kimono (see below, n. 370).

53. Letter of 15 June, 1912.

54. By the 1880s, various devices made it possible either to control the camera from a distance or to delay the shutter release, using a flexible cable, dark thread, or even a fuse. In 1906, a method dubbed *autophotographe* ("self-photography") was advertised as giving "the photographer all the time needed to go stand, should he desire, in the field of view before the shutter is released." Gravillon, pp. 332–335.

55. Letter dated 5 June, 1912.

56. Picasso seems to have had dealings with Delétang as early as 1905. The correspondence with Kahnweiler nevertheless shows that he also took his own photos of his work: "If I had my camera, I'd soon send you photographs of their different stages, but maybe I'll find somebody with one so I could do it. . . ." Letter from Céret dated 15 June, 1912.

57. Letter from Céret dated "Good Friday" [21 March], 1913.

58. Zervos 2, pp. 173–178.

59. Letter from Céret dated 20 June, 1912. See also the letters dated 15 June , 1912, 11 April, 1913, and 21 July, 1914.

60. Brassaï 1, p. 224.

61. Quoted in Olivier 1, p. 165, and Olivier 2, p. 11.

62. In addition to Olivier 2, pp. 222–223, see Palau i Fabre 1, p. 468.

63. Moholy-Nagy, pp. 29–30. Moholy-Nagy contrasts the photogram, "a luminous image which must respond to the deepest feelings of inner life," to "photography with a black box" which, he claims, expresses "the documentary concept of the external world such as vision presents it to us." He concludes that photography "should be the brilliant instrument of our optical education; for many years it has been misused, giving an image of rigid forms instead of recording the heretofore ungraspable play of shadow and light."

64. Brassaï 1, p. 248. (26 November, 1946).

65. *Ibid.*, p. 249, (28 November, 1946).

66. *Ibid.*, p. 261 (13 December, 1946).

67. *Ibid.*, p. 278. In a footnote, Brassaï nevertheless explained: "In the end I was never able to photograph them. . . . I fear they have been lost forever." Ultimately, Brassaï photographed only a set of "sculpted papers" belonging to Dora Maar. See Kahnweiler 2, figs. 133–152, and Baldassari 2, pp.174–187.

68. "Tell me, what's the origin of all these sometimes light, sometimes dark tones in places that have the same value on the canvases?" Brassaï 1, p. 99.

69. See below, pp. 223–227, figs. 252–255.

70. André Villers, letter to the present author, May 1995.

71. Fagus.

72. This photograph was first published and discussed in 1994 in Baldassari 1, pp. 43–48.

73. The hypothesis I proposed in 1994 (see preceding note) has been

taken up and developed in Daix 6, pp. 67–70 and Varnedoe, pp. 120–124.

74. Paris, May or June 1901, Z. XXI, 192 / D.-B. V, 2.

75. Paris, late summer 1901, Z. I, 113 / D.-B. V, 1. It is also worth noting the similarities between this photograph and *Self-Portrait in Top-Hat* (Paris, summer 1901, Z. XXI, 251 / D.-B. V, 41).

76. Paris, late 1901, Z. I, 91 / D.-B. VI, 35 / MP 4.

77. See the "Third Canto," where the witness reports the criminal god's flight from a convent-bordello: "The walls drew aside to let him pass" (Lautréamont, p. 125). Richardson 1, p. 287, sees this same canto as a source for the inscription that Picasso reportedly painted on the walls of Jaime Sabartés's studio prior to leaving Barcelona in 1903: "Although separated from me, the hairs of my beard are gods just as much as I am."

78. Parmelin, p. 98.

79. The exhibition catalogue lists sixty-five works.

80. As I established in Baldassari 4, p. 28–31, the paintings titled *Greedy Child* (Z. I, 51 / D.-B. V, 53, called *The White Child* in Vollard's catalogue) and *Little Girl with a Pendant* (Z. I, 75 / D.-B. V, 68, exhibited the following year at Berthe Weill's gallery) derived directly from *carte-de-visite* photographs, colored in gouache, titled *Die kleine Köchlin* (*The Little Cook*) and *Die ersten Blumen* (*Early Blossoms*), respectively.

81. Barcelona, 1902, Z. I, 132 / D.-B. VII, 13.

82. The other works include a landscape, an engraving (or photo) of Rodin's *Thinker*, and a drawing of a man's head. As pointed out by to me by Anne Tucker, the shadows in the photograph suggest that it is these works, and not the main painting, that are hanging right-side up.

83. Z. I, 84 / D.-B. V, 64.

84. Note the floral pattern covering the sofa. This is probably the version exhibited at Vollard's gallery.

85. It should not be forgotten that the unequal chromatic sensitivity of negatives then in use meant that yellows and reds, when printed, appeared dark, whereas blues appeared almost white. Thus in the photos of the *Portrait of Gustave Coquiot* (figs. 12 and 13), the navel of the dancer on the left (represented by a yellow comma) and the yellow pattern of the couch appear dark in the prints.

86. In the few months that elapsed between the *Portrait of Gustave Coquiot* and the paintings in question, Picasso seems to have obtained orthochromatic plates which, while not as effective as the panchromatic negatives used later, reproduced a scale of values closer to the original; yellows appear light and blues appear gray, although reds and greens remain very dark.

87. Thus a photograph shows an unsigned version of *The Absinthe Drinker* in which the bottle lacks its white highlight and the background seems more solid. Similarly, it is possible to note a strengthening of the dark values of the bottle in *L'Apéritif* (Z. I, 98 / D.-B. VI, 24), and the repainting of the feet of the dancer in the background of *La Gommeuse* (Z. I, 104 / D.-B. VI, 18). *Woman with a Chignon* (Z. I, 96 / D.-B. VI, 23), meanwhile, still bears the "Picasso Ruiz" signature, the second name of which would later be painted out. As to *Mother and Child* (Z. I, 115 / D.-B. VI, 30), it was photographed in a state prior to signature, and the background values may have been modified after the photo was taken.

88. Alberti, p. 89, stressed that it "is remarkable how every defect in a picture appears more unsightly in a mirror. So things . . . should be emended with the advice of the mirror." Similarly, Leonardo da Vinci asked, "why are paintings seen more correctly in a mirror than out of it?" (no. 528, p. 320).

89. Leonardo da Vinci, nos. 529–530, pp. 320–321.

90. On Manet's *Spanish Guitarist* of 1861, see Proust, pp. 40–41. Scharf, pp. 61–66, moreover, stressed that the sharp contrasts in Manet's painting were due to photographic effects of the day, when artificial light and insensitive negatives eliminated a whole range of middle tones.

91. Proust, pp. 31–32.

92. See above, p. 16, n. 58.

93. Regarding the influence of Marcantonio's engraving of Raphael's *Judgment of Paris* on Manet's *Déjeuner sur l'herbe*, see Cachin and Moffett, p. 168.

94. The first two publishers cited were active in Florence, the latter two were based in Madrid. On Alinari, see Fratelli Alinari; on Laurent, see Collado.

95. Paris, autumn 1901, D.-B. VI, 4.

96. *Joventut*, no. 22, 12 July, 1900.

97. Palau i Fabre 1, pp. 197–198.

98. This was an illustration for another Bridgman poem, "Ode to Phryne," *Joventut*, no. 11, 26 April, 1900.

99. MPB 110.341, 110.341 R, and 110.669.

100. This cutout figure, probably using a photo taken by an itinerant photographer, was first published and discussed in 1996 in Baldassari 3, pp. 204–206.

101. The drawing is an integral part of a letter written to Max Jacob in July 1902. Seckel 3, pp. 9–10.

102. See Oberthür. Pere Romeu, the future manager of Els Quatre Gats, and Miquel Utrillo frequented Le Chat Noir and joined Léon-Charles Marot's troupe, Les Ombres Parisiennes.

103. Doñate, pp. 223–236, notes that the shadow plays that premiered in December 1897 ended before the following summer. Therefore it is not certain that Picasso, who returned from Madrid in June, personally attended a performance. On the other hand, he was in Barcelona early in 1897, when these shows were being prepared with the help of the painters Ramon Pichot and Ramon Casas.

104. As a child, Picasso had displayed exceptional virtuosity in using embroidery scissors to cut out "funny figures" as well as "animals, flowers, strange garlands, and combinations of figures." Sabartés 2, p. 305.

105. On the myth of Dibutades' daughter, who outlined her lover's shadow, see Pliny the Elder, p. 101.

106. Palau i Fabre 1, p. 184.

107. Picasso had employed non-realistic monochrome as early as 1896, notably in two portraits of his father, where red and blue dominate, respectively (oil, MPB 110.027; watercolor, MPB 110.281).

108. *L'Univers Illustré*, 1881, cited in Pickvance, p. 204.

109. Huysmans, p. 257.

110. Quoted in Coquiot, p. 81.

111. Huysmans, p. 259. Generalizing his comment, Huysmans wrote, "Most of them developed a monomaniacal eye; one [painter] saw hairdresser's blue everywhere in nature, transforming a river into a laundrywoman's bucket; another saw violet—lands, sky, water, flesh, everything in his work became similar to lilac and eggplant; most of them, finally, could confirm Dr. Charcot's experiments on the altered perception of color, observed among many hysterics at La Salpêtrière

and among people afflicted with nervous illnesses" (p. 255).

112. Brodersen (pp. 290–291) shows several postcards from the turn of the century printed in tones of blue.

113. On the use of tinted and toned movies in the early years of the twentieth century, see Cherchi Usai, pp. 95–109, who mentions the blue-tinted sky scenes in R.W. Paul's 1906 film, *The Motorist*.

114. As early as 1842, Sir John Herschell noted the property of certain iron salts to produce blue-colored prints.

115. A sign of aesthetic refinement, the fan opening in the plane of the image evokes Japanese prints of actors and numerous Impressionist portraits with fans, rather than Spanish tradition.

116. See especially the photograph taken in Joan Vidal Ventosa's studio, (fig. 7).

117. Barcelona, 1900; not in Z. According to Cirici Pellicer, p. 59, Suriñach was a young Catalan writer whose "terrible tales of madmen and wretches were in the same black vein" as paintings by Nonell and Picasso at the turn of the century.

118. A left-right inversion of the image often occurs in Picasso's transpositions of photographs.

119. The subject and muted chromaticism of the drawing *La Boja* (*The Madwoman*, Z. VI, 271 / D.-B. I, 125), illustrating a poem by Suriñach ("Anyorament," *Catalunya Artistica*, 4 October, 1900), also make it a direct precursor of the Blue Period.

120. Z. XXI, 114.

121. Z. XXI, 165.

122. Z. XXI, 123 / D.-B. I, 22.

123. Z. VI, 241. See Palau i Fabre 1, fig. 515.

124. 28 February, 1901. Picasso would later confide (Daix 3, p. 47; Daix 1, pp. 239–245) that "It was while thinking that Casagemas was dead that I began painting in blue."

125. Barcelona, c. 1903, MPB 110.018. See Baldassari 4, figs. 24, 25.

126. Z. VI, 653 / D.-B. X, 11. See Baldassari 4, fig. 23.

127. Sabartés 1, pp. 107–108.

128. *Ibid.*

129. See Baldassari 4, fig. 22. This photograph, identified by Laurence Berthon of the Musée Picasso, was published along with the painting in McCully, pp. 240–241. From a representational standpoint, the only difference is the necktie.

130. See especially *Woman with Folded Arms* (Z. I, 105 and Z. VI, 543 / D.-B. VII, 7), *Portrait of a Man* (Z. I, 142 / D.-B. VIII, 1 / MP 5), and *Tragedy (Poor People by the Seashore)* (Z. I, 208 / D.-B. IX, 6).

131. Notably drawings in charcoal (Z. I, 135), pencil, (Z. VI, 402, Succ. 352 R), and ink (Z. IV, 464 / MP 453)

132. Picasso reportedly said that *Portrait of a Man* was based on a madman in Barcelona (Daix and Boudaille, p. 215), all the while adding that "models remain, but artists travel."

133. Note, for example, the strange projection of the legs to the left in *Woman with Folded Arms* (Z. I, 165), the hip-level cropping of *Bearded Man with Arms Crossed* (Z. XXII, 9 / MP 472), and the way that the horizon line cuts the male figure at mid-body in *Tragedy* and the drawing of *El Loco* (Z. I, 135). A mid-hip composition of figures with crossed arms can been seen in many drawings of 1902–1903, notably Z. I, 105 / D.-B. VII, 7; Z. I, 139; Z. I, 114 / D.-B. VII, 10; Z. I, 112.

134. Z. XXII, 128.

135. For the face, Picasso also referred to a *carte-de-visite* print ("Collection E. Desmaisons") showing a head-and-shoulders portrait.

136. The photo (fig. 27) is embossed "Copyright 1900, Ey. G. Fiorini, München."

137. Paganini died in 1840. Neil, p. 332, asserts that no photograph was ever taken of the violinist.

138. Fregoli's show, presented at the Trianon Theater on boulevard Rochechouart in Paris early in 1900 (the date of Picasso's first stay in Paris) enjoyed a lively success. The second half of his program included an "imitation of several famous men" and "famous music composers conducting their orchestras." Fregoli made a second tour to Paris in 1903–1904, shortly before the execution of the drawing discussed here.

139. 1904–1905, Z. I, 291 / D.-B. XII, 1. According to Penrose 2, p. 107, the model for this canvas was a neighbor.

140. 1905, Z. I, 285 / D.-B. XII, 35.

141. This was probably not the sole occasion on which Picasso showed interest in a theatrical photograph. Reff 1 (pp. 237–248) has suggested that the *Les Bateleurs (Family of Saltimbanques)* may have been inspired by photographs of circus folk. Picasso's archives include a photograph of four young acrobats,

one of whom may have suggested a costume proposal for the 1917 production of the ballet *Parade* (Z. XXIX, 248 / MP 1570 and 1571). See Baldassari 4, p. 127, figs. 116 and 117.

142. Z. I, 203 and 204 / D.-B. IX, 23.

143. Found in Picasso's estate in 1994, this photograph was first published and discussed in Baldassari 1, p. 19.

144. For other references to Manet in Picasso's oeuvre, and on his 1960s variations on *Le Déjeuner sur l'herbe*, see Bernadac 1, pp. 33–46.

145. Cachin and Moffett, pp. 170–171.

146. Daix 5, p. 326.

147. Z. I, 199 / D.-B. IX, 22. See Baldassari 4, fig. 31.

148. Z. I, 200 / D.-B. IX, 24. See Baldassari 4, fig. 29.

149. Penrose 2, p. 89. In Picasso archives there is a record of Kahnweiler's payment to Picasso for the "restoration" work.

150. For the sketchbooks, see Glimcher 33 and 34. Léal 3, vol 1. p. 81–96 (MP 1855 and 1857).

151. Z. I, 260 / D.-B. XIII, 1.

152. See Richardson 1, p. 381.

153. Moreover, a great number of postcards showing women in regional dress have been found in Picasso's archives. Spies 1, pp. 150–153, also mentions an image of a woman in Breton dress and coif that Picasso pasted onto a page of Carnet 213, which Spies compares to two drawings of 1929.

154. Z. I, 261 / D.-B. XIII, 2.

155. Picasso would have simply arranged these close-up photographs into the circular composition found in other drawings from his trip to Holland (MP 1855, 4r and 5r).

156. For Penrose 2, p. 117, for example, a painting like *La Toilette* "shows the most complete mastery of the 'Greek' idiom." On antiquity and Picasso's early "classicism," see especially Pool, pp. 122–127, and Parigoris, pp. 23–32. On the influence of Egyptian art, see Dagen.

157. Reff 3, p. 26, for instance, refers to the new tonality as being "neither spiritual like blue nor sentimental like rose, but warm, luminous, and natural like the red ocher soil of Gosol itself."

158. Tériade.

159. Z. I, 308 / D.-B. XIII, 14.

160. Z. I, 325 / D.-B. XV, 34.

161. See Schapiro 1, pp. 111–120, who also stresses that the upraised arm of the *Woman with a Fan* (fig. 33) is indebted to Ingres's *Tu Marcellus Eris*.

162. See especially Penrose 2, p. 114; Leymarie, p. 1; and Daix 5, p. 337.

163. The photograph is signed Zangaki (fig. 35). Beginning in the 1870s, the Greek brothers C. and G. Zangaki published numerous views of Egypt, the Sudan, and the banks of the Red Sea.

164. Note, on the other hand, that in a preparatory ink drawing (Allen Memorial Art Museum, Oberlin College, see Schapiro 1, p. 115), the left hand is not raised but instead rests on the other forearm, whose position is identical to that of the photograph. Richardson 1, p. 422 asserts that the model for this painting was a Montmartre woman named Juliette; a drawing (Z. VI, 651) showing only a face in profile, does indeed bear that name, but it hardly furnishes all the visual sources condensed into the 1905 painting.

165. This is more explicit in *Nude Holding a Mirror* (fig. 34) (Z. XXII, 430 / D.-B. XV, 29), where the object is reduced to a line seemingly balanced on a fingertip.

166. Respectively Z. XXII, 431, 432, and 433 / D.-B. XV, 30, 31, 32.

167. Z. VI, 720 / D.-B. XV, 8 / MP 7.

168. Z. I, 305 and VI, 715 / D.-B. XV 10.

169. See Eppendorfer and Poschmann as well as Lemagny; Barthes; Pohlmann; and, in a somewhat fictionalized interpretation, Peyrefitte. Photographs by Plüschow were published as early as 1893 in *The Studio* (vol. 1) and in Klary in 1902. According to Pohlmann, p. 9, Plüschow sojourned in Egypt in 1896–1897. The presence of this print (fig. 43) in Picasso's archives was not known to Judson Clark and Burleigh-Motley when they compared a photograph by Wilhelm von Gloeden with *The Pipes of Pan* (1923, Z. V, 141 / MP 79). At almost the same moment that I published and discussed Plüschow's photograph for the first time (Baldassari 4, pp. 62–64, fig. 54), Rosenblum, pp. 271–273, raised the hypothesis of the influence of images by Plüschow and Von Gloeden on Picasso's classicizing male figures from the Gosol period, notably *Two Youths*.

170. Z. XXII, 406 and Z. VI, 662 / D.-B. VX, 1 and 2.

171. Z. I, 324 / D.-B. XV, 11.

172. This figure with raised arms could also be compared to the young women in the sketches (figs. 34 and 37) for *La Toilette* as well as to *Nude Child with a Goat* (1906, Z. I, 249 / D.-B. XV, 35), which feature the same linear, flat model animated only by a shadow down the right side. The triangular composition also bears analogy with the arrangement of the youth and two little boys flanking him.

173. The works in question are D.-B. XV, 3 (Z. XXII, 390), 4 (Z. VI, 713), 6 (Z. XXII, 313), and 8 (Z. VI, 720 / MP 7).

174. Z. I, 340 / D.-B. XV, 18.

175. Z. I, 321 / D.-B. XV, 40.

176. Leonardo da Vinci, no. 585, p. 342.

177. See Lebensztejn.

178. Kahnweiler 4, unpaginated.

179. See especially Seckel 1, the magisterial catalogue of the 1988 exhibition at the Musée Picasso in Paris.

180. Rubin 4, p. 67. On page 135, n.208, Rubin quotes Leja, pp. 76–77, when observing that this format—"a group of prostitutes in poses signifying solicitation directly addressing the viewer"— was a common one in contemporary erotic and pornographic photography. Daix 2, p. 265, had already noted that the three women on the left seem to have been frozen by a snapshot.

181. Brodersen, pp. 342–343.

182. Photographs of "ethnic types" and genre scenes were widespread in the early twentieth century, when "native exhibitions" were held in places such as the Jardin Zoologique d'Acclimation in Paris (see Gala), as well as at colonial expositions such as the key one held in Marseilles in the spring of 1906.

183. David 1 and 2. The dating employed here is indebted to these publications and to their very helpful author. On Fortier, see also Prochaska, pp. 40–47. Another Fortier, Alphonse, is known to have been a founding member of the Société Française de Photographie (SFP) and was active in Paris until his death in 1882. Alphonse's son, Georges, was also a photographer (see Auer, vol. 1, unpaginated.). In 1881, Alphonse Fortier delivered the first paper on the use of celluloid as a photographic substrate at the SFP. No family relationship has as yet been established, however, with Edmond Fortier.

184. These postcards, none of which has been used for correspondence, all bear the imprint "Collection Fortier, Dakar" or "Collection Générale Fortier, Dakar." They are hereafter inventoried as CF or CGF followed by the series number. Certain print characteristics unmistakably distinguish them from the reprints published from 1913 to 1928 (the so-called "green ground" or "late" CGF series, with "colorized" variants).

185. According to David, the postcards were printed in France, probably in Paris where Fortier had an office (perhaps at 35 rue Jussieu). They may therefore have been available in France before being distributed in Africa (the earliest known African post office cancellation marks for the CF and CGF series are dated September 1906).

186. In addition to the works compared here to the Fortier postcards, it is worth calling attention to a drawing of a *Seated Negro* (Z. XXII, 382 / D.-B. XVI, 4) which in all probability derives from a colonial photograph that has not as yet come to light. This case is all the more interesting insofar as the figure's pose and nudity, plus the presence of a vase by his side, quite directly evoke the male figure in *The Harem*, fig. 41.

187. Winter 1906–1907, D.-R. 4 / not in Z. Daix 4, p. 507, relates this canvas to the abandoned project of a painting on the subject of horses and riders in the Bois de Boulogne.

188. CGF 1405.

189. Note, in particular, the formal similarities between two photographs of the same *Timbo Woman* (CGF 1388 and 1390) and a *Head and Shoulders of a Nude* and *Head and Shoulders of a Woman* (Z. II*, 31 / D.-R. 32; Z. II*, 16 / D.-R. 33), between a *Bambara Woman* (fig. 56) with impressively sculpted breasts (CGF 1329) and a *"Demoiselle" d'Avignon* dated June-July 1907, fig. 55 (Z. II*, 23 / D.-R. 38) and between three Fortier photographs of a *Foulah Girl* (CGF 1342, 1364, and 1368) and yet another Picasso bust of a female (Z. II*, 34 / D.-R. 37).

190. On a somewhat more hypothetical basis, perhaps, attention could be drawn to the compositional and expressive affinities between the two photographs of a *Timbo Woman* mentioned in the preceding note and the famous *Portrait of Gertrude Stein* (Z. I, 352 / D.-B. XVI, 10). On returning from Gosol, Picasso painted out Stein's original face, then repainted it in a single session.

191. Paris, autumn 1906, Z. I, 366 / D.-B. XVI, 15.

192. CF 1057.

193. *Two Nudes* (D.-B. XVI, 11 / not in Z.); *Two Nudes* (D.-B. XVI, 12 / not in Z.); *Two Nudes* (D.-B. XVI, 13 / Z. I, 360); and *Nude from the Front and Nude in Profile* (Z. I, 361 and VI, 888 / D.-B. XVI, 14).

194. The similarity with the woman on the left is particularly clear. The man's forearm and biceps directly suggest the pictorial motif of arm and breast. The line of the torso, with the bulge at the navel and sharp turn to the pubis, plus the profile of buttocks, legs, and feet are all identical.

195. CF 1032 (fig. 49) and 1034. The symmetrical gesture with which the African model opens her head scarf into a triangle finds an exact equivalent in the two hands on either side of the head of the right-hand woman in Picasso's painting. Postcard CF 1032 (fig. 49) would also seem to have an even more direct bearing on *Nude on a Red Background* (summer-fall 1906, Z. I, 328 / D.-B. XVI, 8). The canvas imitates the pensive expression, the dark line of the shoulder encountering the closed hand, the complex shadow cast by the breast on the armpit, the folded hand, and the protuberant belly indicated by a dotted pattern evoking the beads of the belt. See Baldassari 4, fig. 69.

196. CF 1034

197. MP 535, 536, and 537. Not in Z.

198. Z. VI, 906 / D.-R. 16; Z. XXVI, 190 / D.-R. 17 / MP 13.

199. Z. II** 662 / D.-R. 26 / MP 16.

200. Z. XXVI, 18 / D.-R. 23.

201. CF 1006. The most literal transcription of this photograph would be a full-length drawing (Z. VI, 922 / D.-B. XVI, 29), figs. 50, 51. Four other works (*Bust of a Man*, Z. II*, 1 / D.-B. XVI, 26 / MP 8; *Head of Young Man*, Z. I, 371 / D.-B. XVI, 27; *Self-Portrait with a Palette*, Z. I, 375 / D.-B. XVI, 28; *Head of Boy*, Z. VI, 892 / D.-B. XVI, 29) reflect the strong asymmetry of the light between the model's two eyes. The heavily drawn mouth, with the lower lip appearing white between two dark zones, is clearly identifiable in *Head of Boy*. The position of the hand was retained in *Self-Portrait with a Palette*, which might thereby illustrate the equivalence of fan/stick/mirror/palette as expressed in *Woman with a Fan* of 1905. Also note that, like the sexual reversibility characterizing many of Picasso's figure studies in the winter of 1906–1907, this young girl looks more like a young boy.

202. Drypoint on celluloid. Baer, I, nos. 19 and 20 / MP 1906–1908.

203. Z. XXII, 468 / MP 523.

204. Especially fols. 14r, 24r, 26r and, for studies of hands and feet, 11r and 28r.

205. CF 1055.

206. CF 1021.

207. Carnet 3, 37v (Z. XXVI, 45), 18r (Z. XXVI, 73) , and 17v (Z. XXVI, 74). Some of the graphic designs for the head of that male figure (*Man's Head in Profile*, Z. XXVI, 16 / D.-R. 10 / MP 530; *The Medical Student*, Z. VI, 904 / D.-R. 11 / MP 531; *Faces*, Z. XXVI, 14, and fols. 23r, 25r, 32v, and 33 v of Carnet 3, MP 1861, fig. 47, display clear correspondences with the Bobo figure, such as the curved patterns of hair whose "primitive" appearance has traditionally been seen as an "Iberian" allusion.

208. CGF 1368

209. Z. VI, 992 / MP 540 R.

210. CGF 1402.

211. CF 1032, fig. 49. The triangular breast projecting into the shadow and the cross shape dividing the torso into diamond sections might also be indebted to the photograph, where the chest is patterned by the intersection of a bead necklace and two fine strings.

212. Rubin 4, p. 87.

213. The faces of these African models also merit comparison: G is similar to the *demoiselle* with raised arms, while the face of C (fig. 60) evokes a gouache study, *Nude with Raised Arms* (Z. VI, 906 / D.-R. 16), see Baldassari 4, fig. 87, in the ellipse of the blank eye socket, the play of shadows on the curve of the face, and the head truncated by the band of cloth.

214. Z. XXVI, 190 / D.-R. 17 / MP 13.

215. Z. XXVI, 189 / D.-R. 19 / MP 12.

216. The two figures occupy the same position and similarly define themselves by two angles, one extending from the right elbow, the other hollowed from the left flank.

217. Note the head and chignon nestling in the crook of the arm, the shape of the ear, the angle of the bust, the cloth draped at mid-thigh. This *demoiselle* may also have borrowed her asymmetrical shoulders from figure F, along with a barely modified left arm, a slight triangle between arm and body, and the hand just brushing the cloth.

218. A study for this *demoiselle*, fig. 64, (Z. XXVI, 26 / Carnet 3, MP 1861, 47r) shows her turned toward the viewer, sitting on a small seat-like object (as is the African model) and placing her arms on her knees, chest forward (as does the African woman). Ultimately depicted from

the back, this *demoiselle* continues to gaze at the viewer, over her shoulder, her left hand sharply turning her head. The strange shape of this hand corresponds to the shadow cast by the inclined head of the woman marked H in the diagram. Similarly, the line suggesting the wide-open spread of the woman seen from the back echoes the symmetrical curves of the African model's calabash and buttocks. The architecture and expression of H's face crop up, moreover, in several of the sketchbook studies in Carnets 1, MP 1858 (fols. 22r, 37r, and 38r) and 2, MP 1859 (fols. 2r, 9r, 22r, and 24r).

219. Steinberg 2, pp. 59, 60.

220. Goethe, p. 94, noted that if, after staring at a window with light coming through, the gaze is shifted to a blank surface, the window panes appear dark and the cross-bars appear light.

221. This postcard belongs to the "Collection Raquez" and probably uses a photograph taken during a photographic expedition conducted in 1899. See Raquez.

222. See, in particular, the drawings *Bust of a Man* (Z. II**, 630) and *Head of a Man* (Z. VI, 977 / D.-R. 44), or a sheet from Carnet 13 (8r / Z. VI, 966). Another *Head of a Man* (Z. I, 346 / D.-B. XV, 52) displays the hairy head of the old Maori man, whereas Fontdevila is usually shown bald.

223. See, for example, Succ. 875 and 876; Z. VI, 967; and Z. XXVI, 284.

224. See Daix 4, pp. 514–517, and Rubin 7, "Reflections on Picasso and Portraiture," pp. 30–32.

225. Gouache, Z. II*, 39 / D.-R. 165 / MP 575 R.

226. Baldassari 1, p. 155.

227. Burgess, p. 408, quoted in Richardson 2, p. 17. In the same vein, cf. the comment reported by Daix 2, p. 267.

228. Picasso 1, p. 25.

229. Research published on the occasion of the 1988 Paris *Demoiselles* exhibition (Seckel 1), along with previous debates over "primitivism" (Paudrat, Rubin 3), suggest that Picasso only discovered the Trocadero Ethnographic Museum in Paris once the development period of the *Demoiselles* had ended, so that direct knowledge of primitive art would have played only a limited role. See, on this point, a 1970 article in Daix 2. These assertions are nevertheless still challenged by Richardson 2, pp. 24–25.

230. Comments reported by Kahnweiler 2, p. 113, who dismissed them as "naive mistakes."

231. See especially Barr 1.

232. Paris, 1908, Z. II*, 108 / D.-R. 131. In the photos of Salmon, fig. 73, and of Dolly with Fernande, fig. 76, *Three Women* is next to *Les Demoiselles d'Avignon*, covered with a piece of printed fabric.

233. Picasso took several other photographs of the child Dolly, one with her mother in front the *Demoiselles*, fig. 75, the others in front of the uncompleted *Three Women*. The extant prints have probably been cropped to center on the people.

234. Z. II*, 38 / D.-R. 52 / MP 19. Note the position of the child in front of the mother's bust, the divergent angle of the heads, Fernande's chignon and gaze, and the face of Dolly reduced to a mask with primary features. The background also retains a trace of the line separating the two paintings in the photograph, whereas the printed fabric covering the *Demoiselles* inspired the foliage motif.

235. Paris-Barcelona, winter 1902–1903, Z. I, 142 / D.-B. VIII, 1 / MP 5. The photo shows that by 1908 the painting bore traces of scraping and scratches.

236. Paris, [summer] 1907, Z. II**, 631 / D.-R. 75.

237. Spring–summer 1908, Z. II*, 63 / D.-R. 177.

238. Spring–summer 1908, Z. II*, 89 / D.-R. 173.

239. Paris, spring–summer 1908, Z. II*, 50 / D.-R. 172.

240. Paris, spring 1908, Z. II*, 103 / D.-R. 116.

241. Z. II**, 630. The coincidence of these two motifs literally concretizes the title under which *Composition with Skull* would enter the Shchukin collection: *Senile Skull*. Podoksik, 1989, p. 162.

242. The earthen bowl seen in a number of photographs from this series, to the left of the painter's rag and bottle of spirits, is also present in the foreground of the painting, represented by an orb of similar size.

243. Although I suggested in 1994 that the sitter was the painter Auguste Herbin, I have since established that the subject is the Spanish academic sculptor Ignacio Pinazo Martinez, fig. 81, (1883–1970), who was commissioned to copy the famous bust in order to place it in the museum in Madrid, the original having been acquired by the Louvre on its discovery in 1897.

On 23 July, 1908, moreover, the Louvre accepted Pinazo's gift of a "cast of a copy of the *Lady of Elche*." Pinazo's Paris address was listed as 13 rue Ravignan, that is to say, the Bateau-Lavoir. It is in all probability this "cast" that is featured in the photograph.

244. More precisely, between Fernande's return to rue Ravignan (late November 1907) and Picasso's departure for La Rue-des-Bois (August 1908). Note that the 1906 drypoint *Portrait of Fernande* (Z. XXII, 332 / Baer 1, vol. 1, no. 18 bis), which Daix 6, p. 256, published opposite this photo of Fernande, in fact stems from another photographic portrait dating from 1905 (see Penrose 1, figs. 59 and 60, p. 35; and Rubin 2, p. 56). On *Woman with a fan*, of 1908 (Z. II*, 67 / D.-R. 168) see. below, p. 162.

245. Palau i Fabre 1, p. 492, reproduced this sculpture opposite "hieratic" and "romanesque-like" portraits executed by Picasso in 1907. Moffit, pp. 262–263, in an essay questioning the authenticity of the *Lady of Elche*, stresses its influence on "early modernist primitivist experimentation," especially in reference to *Les Demoiselles d'Avignon* and the *Portrait of Gertrude Stein*.

246. Paris, spring 1909, Z. II*, 129 / D.-R. 270.

247. This formal link is confirmed by the literal depiction of a rolled, blank canvas.

248. Bertillon's system of anthropometry for identifying criminals was developed by the French police between 1890 and 1914. On the history of mug shots, see Phéline.

249. See Gimpel.

250. "The combination of accurate profiles, joined by exact intermediates, gives a true model," quoted in Dujardin-Beaumetz, pp. 11–13.

251. Rodin, p. 68.

252. See above, p. 14.

253. This series of photographs was exhibited for the first time as part of an exhibition held in Paris in 1994, *Picasso Photographe 1901–1916*, and partially published in Baldassari 1, pp. 156–163, figs. 118–123.

254. Nor do Fernande Olivier's memoirs make any mention of *Les Demoiselles d'Avignon* or *Three Women*, whose creation she witnessed.

255. Fernande Olivier, letter to Alice Toklas, 15 June, 1909, Stein Collection, Beinecke Rare Book and Manuscript Library, Yale University.

256. 24 June, 1909, *ibid.*

257. In a letter probably written in July, Fernande asked, "Have the photos of the village made you want to see it?" Gertrude Stein kept the photographs, and bought *The Reservoir* (Z. II*, 157 / D.-R. 280) and *Houses on the Hill*, fig. 92, (Z. II*, 161 / D.-R. 278) on Picasso's return from Horta.

258. Stein 2, p. 100.

259. The first two of these three photographs were already known (Tucker, 1982, p. 291); the third remained unpublished until 1994 (Baldassari 1, pp. 170–171).

260. Tucker, pp. 292–296.

261. Cf. Tucker, p. 293.

262. In addition to these photographs of the village, there are two known photographs showing Mount Santa Barbara, which overlooks Horta. A comparison of the two shots reveals a turning movement that modifies the respective position of various elements, including the landscape in the foreground. Picasso also painted this subject twice.

263. Stein 2, p. 99. Elsewhere, Stein 1, p. 24) stressed that "the landscape and the houses do not agree . . . the movement of the earth is against the movement of the houses. . . ." Rosalind Krauss, meanwhile, has extensively analyzed the visual contradictions of Picasso's diamond-shaped construction of *Houses on the Hill*, fig. 92, (Krauss 5, pp. 266–268). Finally, *The Reservoir* has been described as an example of a "device" employed by Picasso "to converge several forms at a point in such a way that none takes precedence and all seem placed in the same plane." Wallis, pp. 279–283.

264. Z. II*, 169 / D.-R. 294.

265. Z. II*, 172 / D.-R. 291.

266. Z. II*, 174 / D.-R. 302.

267. Z. II*, 167 / D.-R. 287.

268. Picasso's archives contain numerous nineteenth-century stereoscopic views.

269. A similar shift of perspective occurred in Alvin Langdon Coburn's photography, in particular the 1912 *Octopus*, which was contemporary with Picasso's photo. In the 1920s, meanwhile, advocates of a "new vision" such as Alexander Rodchenko and László Moholy-Nagy also explored the visual potential of an overhead view.

270. *La Calle de la Riera de Sant Joan*, Barcelona, 1900, charcoal and pencil on paper; *La Calle de la Riera de Sant Joan*, Barcelona, 1900, oil on canvas, Museu Picasso, Barcelona. There is also a "street sketch" of Madrid or Barcelona dated 1898, Museu Picasso, Barcelona.

271. Ink and watercolor on paper, Paris, 1904, also known as *The Suicide*. The townscape seems to have been modeled on a photograph taken by Picasso, looking out of the Bateau-Lavoir.

272. See Léal 1, p. 31.

273. Paris, 1991, Z. II*, 268.

274. Although the painting was done in winter, the arrangement of pictorial values corresponds well to structures suggested by the photograph, in which the summer sun casts strong shadows.

275. India ink drawings such as *Composition, Landscape* (1909) and *Landscape* (1911–1912) make systematic use of the principle of a high-angle view and subsequent effect of flattening shapes to the ground.

276. An oil of *The Basilica of Sacré-Coeur* (Z. II*, 196 / D.-R. 339 / MP 30) was painted during the same period, winter 1910–1911, probably from the same viewpoint.

277. A similar grid appears in two canvases of 1900, *Snowy Landscape Seen from the Interior* and *Lola, the Artist's Sister, in the Studio on Calle de la Riera de Sant Joan*, Museu Picasso, Barcelona.

278. Z. II*, 177 / D.-R. 330.

279. Daix and Rosselet, p. 252, no. 330. The hat in the canvas does not have the fullness of the panama seen in the photograph. It probably alludes to the derby that Braque purchased in honor of Cézanne, which already figured in the painting of *The Hat* (early 1909, Z. II*, 84 / D.-R. 215).

280. The only known print of this photograph was cropped to center on the sitter.

281. 1912–1913, MP 688.

282. The brass button on the uniform may be echoed in the black-ringed circle located in the upper right of the drawing.

283. Z. XXIX, 151 / D.-R. 872. Pierre Daix associates this painting with the work of 1915–1916 in terms of the speckling technique typical of that period.

284. In addition to the portraits of Guillaume Apollinaire discussed below, war inspired Picasso's drawings of *Jean Cocteau in Uniform* (1916, Z. XXIX, 199),

Léonce Rosenberg in Uniform (1916, Z. XXIX, 201) and *Riccioto Canudo in Uniform* (1918, Z. VI, 1351). On this subject, see Silver, pp. 110–114, figs. 77, 79, and 80.

285. Olivier 1, p. 113.

286. The photograph dates from 1910, and was probably taken prior to Picasso's departure for Cadaquès at the beginning of summer. *Monkeys in the Virgin Forest* was the last large canvas executed by Le Douanier Rousseau, who died in September 1910.

287. Olivier 1, pp. 166–169.

288. Letter of 17 September, 1910: "I am enclosing your photograph with this letter," Caizergues and Seckel, p. 82. The photo seems to have been taken before the large sofa— visible in other pictures— was placed there.

289. Letter from Picasso to Apollinaire, autumn 1910, Caizergues and Seckel, p. 82.

290. Olivier 1, p. 245, states that Picasso "worked a long time" on each of the portraits from that period.

291. *Portrait of Daniel-Henry Kahnweiler*, Paris, autumn 1910, Z. II*, 227 / D.-R. 368. On the portraits of Frank Burty Haviland, see Daix 6, pp. 280 and 286–287, and Karmel, pp. 156–158.

292. Olivier 1, "Le nègre et la photographie," p. 219–220.

293. Rubin 3, p. 310.

294. Céret, summer 1911, Z. II**, 738 / D.-R. 422.

295. Shared features include the volume of the head, the handling of the eye, the facial expression, the ridge of the nose, the angle of the pipe, the buttons on the vest, the wing collar, and the curve of the knee.

296. A little higher on the left can be seen the flat oval of the face, the flattened right nostril, and the trapezoidal nose. Lower down, the canvas echoes the two crossed lines found on the chest of the Tiki figure. Also identifiable are a reference to the balustered legs of the low chair and the small carafe visible on the table.

297. Z. II*, 285 / D.-R. 423. The double signature "Picasso, 1910" and "Picasso, Céret" (which means summer 1911) would suggest that the work was completed in two stages, taking advantage of the photographs dating from the fall and winter of 1910.

298. This method recalls the approach used by Francis Galton —toward entirely different ends— in his "composite photography,"

where the multiple superimposition of negatives of different individuals produced a unique print that "depicts no man in particular, but rather an imaginary figure possessing the average features of a given group of men" (Galton, p. 340). On this subject, see Phéline, pp. 64–66.

299. Freud, p. 157.

300. Zervos 2, p. 174.

301. Bella Chelito was a cabaret artist who become the object of an "interminable series of images" (no longer extant) during Picasso's 1902 stay in Barcelona. Sabartés 1 (pp. 98–100) also mentions the rediscovery of several photos of Bella Chelito in Picasso's papers in 1941. Such images may have inspired the *Nude* studies for the engravings that illustrated Max Jacob's *Saint Matorel* in the spring of 1910. Z. II**, 193, 194, 205, and 209 / D.-R. 348, 349, 351 and 347, respectively, as well as Z. XXVIII, 10 / D.-R. 351.

302. Winter 1909–1910 or spring 1910, Z. II*, 226 / D.-R. 340. The title refers to the heroine of Max Jacob's *Saint Matorel*, a title suggested by Jacob himself. See Daix and Rosselet, p. 254.

303. Z. XXVIII, 2.

304. The sitter's features are more immediately readable in the painting, notably the curve of the cheek, the highlight on the lock of hair on the forehead, the pupil, the tilt of the neck, the line of the necklace, the scooped neckline of the dress, the pale highlights on the left elbow, and the pictorial shimmer of the bust that echoes the glittery dress.

305. "I'm working on *Poet and Peasant—The Pearl of Roussillon—* and a Christ right now. If I'm able, I'll send photos to you." See Cousins, p. 376.

306. Z. II*, 264 / D.-R. 412. There also exist negatives and prints for *Landscape at Céret* (Z. II*, 281 / D.-R. 419), *Glass, Violin, and Fan* (Z. II*, 263 / D.-R. 411) and *The Accordionist* (Z. II*, 277 / D.-R. 424).

307. See Daix and Rosselet, p. 266. In the summer of 1911, cubism combined the pyramidal grid, non-iconic signs, and typographic lettering with more figurative emblems, which led to the label of "informational" or "hieroglyphic" cubism. See Bois, p. 184.

308. Some of these postcards were sent to Apollinaire (notably those titled *Roussillon: Young Catalan Woman Going to the Fountain*, *Céret: Catalan Woman Going*

to the Fountain (fig. 209), and *Céret: Gates and Towers of the Old Ramparts*. See Caizergues and Seckel, nos. 55, 56, and 59). Others were sent to Kahnweiler (a postcard dated 22 August, 1911, showing the Grand Café at Céret, see Richet, p. 115).

309. MP 643, not in Z. The drawing Z. XXVIII, 81, meanwhile, constitutes a less complex variation on the same subject. Both of these works are sometimes assumed to allude to Apollinaire.

310. A *barettina* is a red felt cap. On two occasions—27 July, 1911 and 13 August, 1913—Picasso sent Gertrude Stein a postcard of a *Group of Merry Catalans*, showing three men in traditional caps. The second card bears a handwritten caption below one of the figures: "(Portrait of Matisse)" (Beinecke Rare Book and Manuscript Library.) See Richardson 2, p. 274.

311. Visual references to other postcards from Céret, probably bought during stays in 1911, 1912, and 1913, would resurface during the 1919 exploration into the theme of women at a spring. See below, p. 177, figs. 209–212.

312. This postcard was reproduced for the first time in Baldassari 6, fig. 124.

313. The term *trabucaire* comes from the Spanish *trabuco*, or "blunderbluss." The outlaw gang convicted for theft and murder in 1846 had banded together during the collapse of the Carlist insurrection (1830–1839). See Mare.

314. Victor Hugo evoked the *trabucaires* in a poem entitled "Memories of Old Wars," published in *Les Chansons des Rues et des Bois* in 1865 (see Hugo, p. 34). This collection of poems, as well as the travel journal *Alpes et Pyrénées* (a posthumous work re-published in 1910) may also have inspired an oval canvas of 1911, *Palette, Brush, and Book by Victor Hugo* (Z. II*, 260 / D.-R. 418).

315. The sacrificial figure of a condemned man may thus have been behind the planned painting of a "Christ" mentioned by Picasso in a postcard to Kahnweiler (13 August, 1911, see Cousins, p. 376). All the canvases of that period were organized, moreover, around a clearly cruciform plan. Iconographic correlations could be established between the symbolism of Masonic documents and Picasso's 1930 *Crucifixion* (Z. VII, 287 / MP 122). One of the points of departure

for the preparatory sketches for *Guernica* and for *The Charnel House* (see below, pp. 208–214, figs. 241, 245) was also a martyred figure on a post directly evoking the cross. A formal equivalent for the *trabuco* can be seen in the virile symbols of pipe and *tenora* (Catalan clarinet), which recur frequently in the works of summer 1911.

316. Several copies of this postcard were found in Picasso's estate.

317. On the distinction between icon and symbol, see Krauss 5, p. 261. Here the compass and ruler are contrasting signs, one being a closed and perfect form and the other a virtually infinite straight line. This duality is summed up in the purely abstract sign, visible in the upper right corner of the scarf, combining two concentric circles with two parallel tangents.

318. This is depicted to the right of the temple on the scarf.

319. This diagrammatic schema governs most of the ritual objects: crossed feathers, keys and swords, level, square, and compass.

320. The fan here formally echoes the compass, the square, and the sunbeams, and also depicts the paradoxes of a folded and unfolded volume that identifies with the support even as it appears to lift away from it. The emblematic drawing of a flower also echoes the "ear of corn" and the "sprig of acacia" flanking the scarf. It is also worth noting that in *Mandolin Player* (Z. II*, 270 / D.-R. 425), Picasso's motif of cabled rope—frequent since early 1911—is accompanied by a tassel inspired by the "chain of alliance." The sign of the double circle and double lines also recurs at least three times in *The Fan*, notably underscoring the pivot around which the fan unfolds as well as the overall composition; it also appears in several other canvases from this period, such as *Bottle of Rum* (Z. II*, 267 / D.-R. 414), *Clarinet* (Z. II*, 265 / D.-R. 415), and *Man with a Pipe* (Z. II**, 738 / D.-R. 422). This abstract motif is a complex version of the "sickle" mark which, ever since Picasso's 1910 stay in Cadaqués, constituted the first codified sign of a non-representational nature. See Bois, p. 182.

321. In Masonic symbolism, the rungs of Jacob's ladder bear capital letters alluding to Faith, Hope, and Charity. The capital G refers to the divine being.

322. Although, like Braque, Picasso sought to fuse figure with form at this point, "his real interest in the fragmentation of objects lay in the opportunity it gave for pushing the physiognomic [of particular forms] into a world of new signs" (Rubin 5, p. 26).

323. The "ashlar" is depicted on the right of the scarf in a perspective recalling the famous Bouillon Kub to which Picasso ironically alluded in several canvases of 1912, such as *Bouillon Kub* (Z. II*, 303 / D.-R. 454) and *Landscape with Posters* (Z. II*, 353 / D.-R. 501). It was in the summer of 1911 that Apollinaire spread the legend that Matisse, on seeing the new advertising poster for Kub on a wall in Collioure, took it as a provocation aimed at Picasso and his cubist friends.

324. Stein 2, p. 121.

325. Stein 1, p. 18.

326. Paris, spring 1912, Z. II**, 374 / D.-R. 465.

327. Paris, spring 1912, Z. II*, 294 / D.-R. 466.

328. Rubin 5, p. 36. Furthermore, the caning motif represents a metonymic equivalent of the table's braided surface. The caning is also linked to the rope and fringe of the tablecloth in the 1916 canvas *Still Life "Job,"* Z. XXIX, 168 / D.-R. 885.

329. This hypothesis agrees with Krauss's interpretation of *Still Life with Chair Caning*, fig. 129, as "a literal table top down onto which one looks at objects in plan. . . " (Krauss 1, p. 33).

330. Kahnweiler 1, p. 418. Rubin 3, pp. 18–20 fully analyzed the formal relationships between a Grebo mask and Picasso's *Guitar* construction of 1912. The pedestal table stood beside this mask in Picasso's Montrouge dining room in 1917, as witnessed by a drawing (Z. III, 106 / MP 795).

331. Several drawings executed between 6 and 11 November, 1919 (Succ. 2523, 2425r, 2526, 2536, 2537, and 2540, not in Z.) and Z. VI, 1352 and 1353. See Baldassari 4, figs. 265 and 266, and Léal 2, pp. 35 and 37. To this series could be added a canvas titled *Table with Guitar in Front of Window* (1919, Succ. 12220).

332. See below p. 189, n. 520 and fig. 223.

333. Zervos 4, pp. 281–282.

334. Daix and Rosselet, p. 285, assign them to the "first generation" of *papiers collés*, which they date between autumn 1912 and early

1913 (scraps of several newspapers have been dated to December 1912).

335. Paris, autumn 1912.

336. In fig. 130 (I), *Violin* (Z. II**, 409, D.-R. 525) does not yet have anything pasted to it; the same is true of *Table with Guitar, D.-R., 508)* in fig. 131 (II).

337. Rubin 5, pp. 31–32, suggests that the *Guitar* was executed in October 1912, that is to say, between the initial collages and the start of the *papiers collés*.

338. Kahnweiler 6, p. 90.

339. Rubin 3, pp. 18–21.

340. Paris, winter 1912–1913, Z. II**, 773 / Spies 27 / D.-R. 471.

341. Salmon, p. 240.

342. Palau i Fabre 2, p. 241.

343. Rubin 5, p. 35.

344. 1913, Z. II**, 378 / D.-R. 557.

345. Fry 2, p. 301.

346. The composition of the guitarist's face can be compared to *Head of a Man* (Z. II**, 431 / D.-R. 615) and *Head of Harlequin* (Z. II**, 425 / D.-R. 617 / MP 377). Other works that take up the essential lines of the composition include the drawing *Guitar Player* (MP 731) and the series of sketches called *Idea for a construction* (notably *Guitar Player and Guitar* (Z. XXVIII, 129 / MP 702); *Guitar Player* (Z. XXVIII, 130 / MP 703); *Guitar Player* (Z. XXVIII, 146 / MP 700); *Study for "Guitar and Bottle of Bass,"* (Z. XXVIII, 173 / MP 709).

347. Céret, spring-summer 1913, Z. II**, 436 / D.-R. 616.

348. Such elements include, for example, the enigmatic motif of hatched lines added to the left of the photo, just above the pedestal table, and the word BASS that typographically echoes the cropped poster showing only the end of the artist's name: ASSO.

349. At the spot where the musician's arm was stuck to the canvas is a black mark perhaps left by the string holding the guitar, the outline of which was subsequently drawn onto the canvas. It is also worth noting the lettering, LAGUE. I feel that the studio photos were probably taken prior to the first stay in Céret in 1913 (March–June) and the self-portrait after 20 June, the date of Picasso's return to Paris. Various dates have been proposed for this latter photograph: 1912 according to Zervos 4, p. 282; 1914 in the rue Schoelcher studio according to Sabartés 2, fig. 104 and p. 316; and prior to autumn 1913 in the boulevard Raspail studio according to Fry 2, p. 305.

Given the poster and the newspaper articles, Fry places the start of the assemblage in February–March 1913. The cropped and retouched photograph would thus probably predate the stay in Céret, since it shows similarities with several works executed there. The masked prints more immediately pave the way for the constructions done in the fall, and may have been done later.

350. Notably the no longer extant *Bottle and Guitar* (Paris, autumn 1913, Z. II**, 578 / Spies 56 / D.-R. 631) and *Guitar and Bottle of Bass* (Paris, autumn 1913, Z. II**, 575 / Spies 53 / D.-R. 630 / MP 246, fig. 137).

351. Note the same general contour, the similar arrangement of light and dark values, a correspondence between the rectangular hole in photographic mask and the rectangular body of the guitar, between the real bottle and the Bass bottle, and between the mask revealing the poster and the angular white shape on the construction.

352. *Les Soirées de Paris,* no. 18, November 15, 1913. *Guitar and Bottle of Bass* was reproduced on p. 27 under the title *Still Life,* fig. 139.

353. As the work of copper engraving proceeded and the engraved lines became denser, the contrast of the original photograph was slowly reestablished.

354. Baer, vol. 1, no. 220 / MP 3169.

355. 1895, La Coruña, Z. I, 3 / MP 2.

356. D.-R. 763 / MP 53. The work only came to light after Picasso's death.

357. Z. VI, 1202 / Succ. 1692.

358. Z. XXIX, 67.

359. Z. II**, 528 / D.-R. 784.

360. Z. II**, 845 / D.-R. 783.

361. Z. XXIX, 12.

362. Z. XXIX, 13, see Baldassari 4, figs 152, 153.

363. MP 759.

364. 1914, Avignon, Z. II**, 845, D.-R. 783.

365. The three Abdullah brothers, of Armenian descent, were official photographers to Sultan Abdul Aziz (1863) and members of the Société Française de Photographie (1870). Their Pera studio remained active until 1899. See Khemir.

366. Succ. 1678, not in Z.

367. Z. VI, 1205 / Succ. 1677.

368. Z. XXIX, 77 / MP 744.

369. Silver, pp. 65–66, figs. 35–36, has identified pictorial sources for the melancholy seated painter in the work of Géricault and Cézanne.

370. Penrose 1, p. 40, fig. 82 claimed that this photograph was taken in Sorgues in 1912. The date

of 1914 was proposed by Rubin 5, p. 340. Another photo, in which Eva is wearing a kimono is generally dated from the summer of 1912 in Sorgues; the "model" in the 1914 oil painting displays a curve quite similar to the Eva's left side and arm. Both photographs were taken from the pronounced low angle typical of Picasso.

371. Notably the following works in the Musée Picasso: MP 399; 747 (Z. VI, 1194); 749 (Z. VI, 1228) 750 (Z.VI, 1195); 752 (Z. VI, 1215); 753 (Z. XXIX, 54); 754 (Z. XXIX, 61); 755 (Z. XXIX, 60); 756 (Z. VI, 1196); and 757 (Z. VI, 1233); to which should be added *Man in a Bowler Hat* (Z. II, 506), and *Man Leaning on a Table with Playing Cards* (Z. II, 507), *Man Leaning on a Table* (Z. VI, 1214) and *Man with a Pipe Leaning on a Table* (Z. II**, 520).

372. Z. II**, 564 / D.-R. 842. This canvas may have borrowed features from a *carte-de-visite* portrait showing a man in a top hat leaning on a table, as well as from a 1907 postcard showing composer Edvard Grieg. See Baldassari 4, pp. 157–158, figs. 154–156.

373. 1916, Z. II**, 550 / D.-R. 889.

374. Daix 5, p. 444 stresses "the scope of final modifications" compared to the state pictured in the photographs.

375. Paris, 1914–1915, Z. II**, 533 / D.-R. 810. This photo makes it possible to estimate the previously unknown dimensions of this work at approximately 130 cm by 80 cm.

376. Paris, 1914?, Z. II**, 470 / D.-R. 760 / MP 39.

377. Paris, 1916, Z. II**, 550 / D.-R. 889.

378. The Musée Picasso possesses only a single original print from this series, showing Picasso in shorts. It was rediscovered in 1994 in a leather folder bearing the inscription "Eugénia, 23 September 1916," along with three other prints of the same size (8.8 cm x 6.3 cm). Because these three prints were not properly fixed, the images have vanished. Concerning the canvas *Seated Man,* see Richardson 2, pp. 407–417.

379. At this stage, it can be seen how the canvas was unfolded or extended to include an upper edge that functions as a framing device to push the plane of the figure toward the foreground. The self-portrait in three-piece suit would therefore have been taken near the completion of the work, the whole series having been taken in the second half of 1915.

380. Z. II** 845 / D.-R. 783 and Z. II** 518 / D.-R. 762. These two canvases were begun in Avignon in 1914. Also visible is a very sketchy version of *Head of a Man with a Mustache* (Z. II**, 468 / D.-R. 759 / MP 40). The photo may therefore be dated from Picasso's return to Paris in 1914, or from 1915, which would mean that he left the summer works in a half-completed state.

381. See, for instance, *Self-Portrait with Palette* (Barcelona, 1902, Z. I, 129 / D.-B. VII, 8), the numerous sketches in which Picasso depicts himself in brothels, and the magnificent celebration of his first night with Fernande (*The Lovers,* Paris, 1904, Z. XXII, 104 / MP 483).

382. *Hieratic Self-Portrait* (Z. VI, 456), *Self-Portrait with Raised Arm* (Z. VI, 507), and *Self-Portrait in Three-Quarter Pose* (Z. XXII, 117 / D.-B. D. XI, 24).

383. Z. VI, 926 / MP 527.

384. Zervos 4, pp. 283–284; Sabartés 2, figs. 105–107; Penrose 1, p. 44, figs 94–95.

385. Stein 2, p. 52.

386. Z. II**, 555 / D.-R. 844.

387. Daix 5, p. 41.

388. Varnedoe, pp. 145 and 177; Richardson 2, pp. 387 and 474. In my interpretation, the white rectangle itself takes its visual pattern from the canvas *Guitar and Clarinet on a Mantelpiece* (Z. II**, 540 / D.-R. 812) such as it appears, in progress, on the right side of the photo.

389. "Picasso Repenti," in Picabia.

390. 1915, Z. VI, 1284.

391. Morning, pp. 343–344.

392. Bibliothèque Littéraire Jacques Doucet, Paris.

393. "I am posing for Pablo Picasso, at his place: he is doing a pencil portrait that is truly fine, it simultaneously resembles my grandfather, an old Catalan peasant, and my mother." Letter from Max Jacob to Guillaume Apollinaire, 7 January, 1915, quoted by Seckel 3, p. 116.

394. The "invention" of photomontage is generally dated summer 1918, when Raoul Haussmann became aware that it was "possible to create images by using photographs." See Ades, p. 10. The heterogeneous use of fragments of photographs, drawings, and engravings had already existed in popular illustrations. Photomontage also owed a great deal to Méliès-style experiments in cinematic special effects, as well as cubist *papiers collés.* See Scharf, pp. 275–289.

395. *Portrait of Max Jacob,* gouache on paper, Z. II*, 9 / D.-B. 48.

396. Kahnweiler 4, p. 22.

397. Mahaut, p. 12.

398. The background of these two portraits (Z. XXIX, 200 et Z. II**, 923), figs. 164, 165, is recognizable in the 1915 portrait of Max Jacob, fig. 163. For the bust portrait of Apollinaire (Z. VI, 1324 / MP 1993–5), see Baldassari 4, fig. 159.

399. Seckel 4, p. 188.

400. For example the Croix de Guerre medal, the position of the arm on the back of the chair, the hand on the knees, the gleaming boots, etc., figs. 164–166.

401. A detailed account of this incident is given in Read, pp. 69–74. Picasso kept a set of press photos of the story.

402. Apollinaire 3, vol. 2, p. 865.

403. Z. IV, 60 / MP 911; Z. IV, 59 / MP 910; Z. IV, 62 / MP 915. There also exists another head-and-shoulder drawing of Satie, again dating from May 1920 and very probably based on a photo published in May 1917 in a Ballets Russes program. See Volta, no. 120, pp. 138–139. In addition to this drawing of Stravinsky and the one done in Rome in 1917, Picasso executed a third portrait in December 1920 (Z. IV, 220), showing the composer seated in a low, upholstered chair seen for the first time in *Olga in an* Armchair, fig. 190.

404. Z. III, 413.

405. Z. III, 300 / MP 838.

406. Paris, 1920, not in Z.

407. Rome, 1917, Z. III, 24. This portrait may have been inspired by a group photo taken in Rome, see fig. 199, below.

408. Stravinsky, p. 106.

409. Z. III, 413, "based on a photograph." The comparison with the photograph is one of the examples that Coke mentions with regard to Picasso, pp. 63–63. The picture was published in a wider format in Rivière with the credit "Photo Vollard." Silver, p. 243 n. 55, cites this source, but attributes the photo to Léon Marotte, who would seem to be responsible only for the photogravure.

410. Pächt, pp. 144–149.

411. Z. III, 431. Expanding on the Zervos catalogue entry, Penrose 2, p. 217, asserts that this drawing was based on a postcard showing "a young Tyrolean couple in national costume." This source not having been more precisely identified so far, another hypothesis (Carandente, pp. 71-82) holds that its shows

a decorative pottery theme in the manner of Bartoleomeo Pinelli, further asserting that Picasso would probably have worked from a photo of such an object.

412. Parmelin, p. 41.

413. Bransburg, sometimes spelled Brandbourgh, was a photographer of the Ballets Russes as early as 1910. The photographs used by Picasso probably depict the troupe of the ballet *Les Papillons*, which premiered at the Monte Carlo opera house on April 16, 1914, fig. 170.

414. The White Studio was perhaps headed by Clarence H. White (1871–1925). These photos might have been taken when the Ballets Russes performed at the Metropolitan Opera House in New York in January 1916. Olga Khokhlova was part of that touring troupe, whose repertoire notably included *Les Sylphides*, figs. 172, 175.

415. Z. III, 354, "based on a photograph."

416. Succ. 2309. See Baldassari 4, figs. 171 and 172.

417. Z. III, 355, "based on a photograph"; Succ. 2301.

418. Formerly titled *Le Ballet* , Z. III, 353 / MP 841. A third drawing done in October 1919, *Ballerina*, recently auctioned in New York (Phillips, November 11, 1995), shows only the ballerina with clasped hands on the right of the *Sylphides* photograph.

419. Z. IV, 292; also MP 923 (Z. IV, 128) and 930 (Z. IV, 129). This connection was first made by Rubin 7, "Reflections on Picasso and Portraiture," p. 39.

420. Z. III, 352 / MP 834.

421. Z. XXIX, 432 / MP 840. Silver, pp. 243-244, nevertheless views this drawing as a "pure invention."

422. Early 1919, Z. III, 301 / MP 839. The direct source was a photograph by Count Jean de Strelecki, fig. 178.

423. Paris, 1920, Z. IV, 61 / MP 912.

424. This drawing, not listed by Zervos, is part of a private collection and was published for the first time in 1996 in Baldassari 3, p. 213.

425. Paris, 1920, Z. III, 412, "based on an illustration (never completed)."

426. On this subject, see Schapiro 2, pp. 47–85.

427. Benjamin. p. 155.

428. According to Charles S. Peirce's theory of semiotics, an "index" is a sign that has a material connection to the object it denotes. Peirce himself suggested that photographs, as luminous imprints of their objects, belong to this category of signs, at least when they are

produced in such circumstances that they are physically forced to correspond to their object point by point. See Peirce, p. 151. For a semiotic analysis of photography and certain aspects of contemporary art, see Krauss 4, pp. 63–91, and Vanlier, pp. 22–28. André Bazin, meanwhile, argued back in 1945 that because photography was an imprint of an object taken by means of light, "it shares, by virtue of the very process of its becoming, the being of the model of which it is the reproduction." He added, regarding old photo albums: "Those gray or sepia shadows, phantomlike and almost undecipherable, are no longer traditional family portraits but rather the disturbing presence of lives halted at a set moment in their duration, freed from their destiny; not, however, by the prestige of art but by the power of an impassive mechanism" (Bazin 1, p. 14).

429. Scharf, p. 272, following Coke, has related the disproportion in some of Picasso's 1920s paintings to distortions resulting from amateur photographs where parts of the body are placed too close to the foreground. He also quotes (p. 369) an analysis previously developed by Barr 1, p. 130: "The grotesque foreshortening of the running figure in the background of *By the Sea* suggests snapshots of reclining picnickers whose feet are comically magnified by the camera."

430. Sabartés 1, p. 37.

431. See Brassaï 1, p. 123.

432. MP 984. *Excelsior*, founded in 1909, was one of the first dailies to make extensive use of photography and half-tone engraving. Picasso seems to have been a regular reader of the paper—Sabartés 1, p. 114) noted its presence on rue La Boétie. It would also appear that during his stay at the Hôtel du Cap in Antibes during this summer of 1923, Picasso had his own copy delivered every day, as suggested by his name written on the preserved copy.

433. Rubin 6. *Woman in White*, Z. V, 1.

434. The scrap of newspaper includes the following quotation set in a box next to the date: "Feeling is everything; name is but noise and smoke, a fog that hides the splendor of the heavens from us. The better part of man is that which throbs and vibrates in him."

435. See Baldassari 2, figs. 80–82 and pp. 103–104.

436. Silver, p. 291.

437. *Ibid.*, p. 291.

438. Picasso 2, p. 319.

439. Marie-Laure Bernadac, in Bozo, p. 25.

440. Z. III, 83 / MP 55.

441. See Baldassari 3, pp. 216–220; Fitzgerald, pp. 306–312; Silver, p. 140; Warncke, vol. 1, pp. 288–289.

442. Two glass negatives have been located in the Kahnweiler collection (Louise Leiris Gallery) by Quentin Laurens (letter of October 25, 1996 to the present author). These negatives have the format used by Emile Delétang (17cm x 23 cm) for the photographs of paintings that he took at Kahnweiler's request. The second negative, offering a somewhat wider view and sharper background, makes it possible to identify the canvas on the easel to the left—*Table, Guitar, Bottle* (Z. III, 437), here shown half completed and upside down in relation to the orientation indicated by the signature. Also visible in the upper right is a cutout paper mask used in the execution of the painting *Harlequin with Violin (Si tu veux)* (Montrouge 1918, Z. III, 160, see Henning), fig. 189.

443. Letter of 26 April, 1918 (The Beinecke Rare Book and Manusript Library, Yale University). Picasso indicated that he was having some recent works photographed by Émile Delétang and said he would send several of the photos, including the portrait of *Olga in an Armchair*. Stein replied on 9 May that she liked the two harlequins and more particularly the portrait.

444. Zervos assigns *Olga in an Armchair* the date of 1917, fig. 190. Comparison of painting and photo, fig. 189, suggested a date of execution shortly after Olga moved into Montrouge, which occurred in the fall of 1917.

445. Succ. 2286, not in Z. Cf. also *Portrait of Olga* (Z. III, 125 / Succ. 12192), dated 27 January, 1918.

446. Rubin 3, vol 1, pp. 276–278 suggests that these two figures were acquired by Picasso at the time he did two "primitive" drawings of 1907, titled *Head*. However, a letter from Gertrude Stein to Picasso, writtten in Nîmes on 23 February, 1918, accompanied by a sketch of one of the two statues, indicates that it was the writer who urged the artist to purchase them; Picasso agreed, suggesting a price of one hundred francs (see especially the letter of 28 February, 1918, The Beinecke Rare Book and Manuscript Library, Yale University). This information makes it possible

to date the photographic portrait of Olga after late February 1918 (because the statues figure next to the sitter), and the execution of the canvas sometime between that date and the month of April when Picasso had Delétang take a photograph of the painting.

447. This pale expanse could be read as the metonymic transcription of the white rectangle behind Olga's head in both the photograph and one of the preparatory drawings (Z. III, 82).

448. Describing the exhibition at the Paul Rosenberg Gallery in 1912, Uhde, p. 55 wrote, "I found myself before a large portrait in what is called the Ingres style. The propriety of the pose and a deliberate soberness seems to repress a moving secret—the baroque only emerged a little in the line, in the organization of the main masses." This canvas has notably been compared to two portraits by Ingres, *Madame Rivière* (Blunt, pp. 187–191) and *Madame Devauçay* (Daix 5, p. 716).

409. Z. II*, 67 / D.-R. 168.

450. See above, p. 62.

451. The fan motif recurred regularly in the years 1909–1910. See especially *The Fan* (Paris, autumn 1909, Z. II*, 229 / D.-R. 315), *Woman with a Fan* (Paris, summer 1909, Z. II*, 137 / D.-R. 263), *Woman with a Fan* (Cadaquès, summer 1910, completed 1918, Z. II**, 944 / D.-R. 364), *The Fan (L'Indépendant)*, fig. 123, (Céret, summer 1911, Z. II*, 264 / D.-R. 412, see above p. 102, fig. 123. It can also be compared to the cyanotype *Young Man with a Fan*, discussed above pp. 22, 26, fig. 21.

452. In his interpretation of the photograph, Picasso also decided to pull the fan into a plane almost parallel with the panel that combines the decorative patterns of upholstery and garment.

453. Z. IV, 14. The canvas is signed and dated 1920, but Zervos records that it was begun in Montrouge in 1917.

454. Also recognizable are the folds of the sash at Olga's waist and the rectangle behind the sitter's head, here inverted from light to dark. The face, moreover, is almost reduced to the curving geometry of the Baga figures, fig. 188.

455. Z. IV, 226 / MP 65.

456. Sutherland Boggs and Bernadac, p. 192.

457. Z. III, 160. See note 442.

458. The red-and-black contrast evokes two paintings by Cézanne, *Mardi Gras*, 1888, and *Harlequin*, 1888–1890. Picasso had seen *Mardi Gras* at Vollard's gallery prior to its acquisition by Shchukin.

459. Gasquet, p. 130.

460. Novotny, p. 12.

461. Zervos 1, pp. 352–354, has sharply criticized C. G. Jung's "more or less rash psychological conclusions" on Picasso's "infernal" identification with Harlequin. This subject has been taken up in a more classically iconological way by Reff 3.

462. See above, p. 126 and n. 386.

463. Notably Z. IV, 68, 69, 71 and 73.

464. Z. IV, 69, in which Harlequin's hand rests on Pierrot's right shoulder.

465. Picasso 2, p. 4.

466. These turn-of-the-century postcards all employ photographs taken in Madrid in 1878 by the French photographer Jean Laurent. See Collado.

467. Thus in *Harlequin Playing the Guitar* (Z. II**, 518 / D.-R. 762), "the face is transformed only by the mask in conjunction with the hat, which turn the guitar player into Harlequin" (Daix and Rosselet, p. 333). The initial version of the painting is visible in the photographic self-portraits in shorts, figs. 159, 160.

468. Z. VI, 1244 / D.-R. 761. Picasso reportedly told Douglas Cooper that this drawing was inspired by a customer in a café in Avignon. See Tinterow, p. 124. Richardson 2 (pp. 340–341) interprets it as a portrait of Francisco Iturrino. See Baldassari 4, figs. 210–212.

469. Z. XXIX, 126.

470. These photographs, probably staged by Picasso, may have been taken using an automatic shutter release.

471. Z. III, 23. The overall composition has been established but the painting has not yet received the stippled treatment of the frame and certain areas, nor the final details in the placing of the blacks.

472. The photographic series includes, moreover, a shot showing the model of the set of *Parade*.

473. Spies 4 discusses an iconographical source for the curtain.

474. It also reflects the fusion of organic and mechanical forms found in many works from 1914. Similarly, the man wearing sandwich panels harks back to the drawings and paintings of men sitting or leaning, as compared here to a photograph of men in a café. See above, p. 125, figs. 142, 143.

475. Fontainebleau, summer 1921, Z. IV, 332 (Philadelphia Museum of Art); Z. IV, 331 (Museum of Modern Art, New York). See Baldassari 4, pp. 213–223. Reff 2 has proposed a biographical interpretation of the *Three Musicians* as an evocation of Picasso's youthful years in the company of Apollinaire and Max Jacob. Read, pp. 156, 160, has compared the paintings to a photograph of three actors in costumes during the performance of *Les Mamelles de Tirésias* on 24 June, 1917.

476. Note that the dimensions of the three canvases are nearly the same: 200 cm x 200 cm; 203 cm x 188 cm; 200.7 cm x 222.9 cm.

477. A third, earlier photograph shows that this canvas originally contained just two characters, Pierrot and Harlequin, fig. 201.

478. Daix 5, p. 876.

479. Z. III, 18.

480. Other Roman sources for this painting have been discussed by Giovanni Carandente. See also Boehme.

481. Succ. 2063 / Z. XXIX, 228; Succ. 2068.

482. Succ. 2064, 2065, 2066, 2067, and 2069 (Z. XXIX, 226, 229, 230, 218, and 242 respectively).

483. This effect may also have been inspired by a postcard titled *Harvesting Jasmine*, colored in a way similar to Picasso's ironically "post-impressionist" handling of *The Return from the Christening, after Le Nain* (Z. III, 96 / MP 56). On this latter canvas, see Brodersen, p. 294, who compares it to an autochrome photograph by Jacques-Henri Lartigue, and Krauss 1, p. 92.

484. This process can be traced across a sequence of four preparatory drawings (Succ. 2059–2062), some of which combine the pose of one model with the basket held by the other.

485. The two staggered gray-on-black rectangles forming the background even correspond perfectly to the traces of discoloration visible on the card of the *Italian Woman with Flower*, fig. 205.

486. Fermigier, p. 202.

487. *Italian Woman*, 1919 (Z. III, 363). See Baldassari 4, fig. 242. Metken, pp. 164–166.

488. See Baldassari 4, p. 239, fig. 244. A drawing from the same year, *Italian Woman with Pitcher* (Z. III, 362, "based on a photograph") also employs a motif similar to the *Italian Woman Leaning on a Fence*, fig. 204. For this drawing Picasso also used another photographic reference, namely a *carte-de-visite* (published by Nantes photographer Bazelais) showing a young woman in peasant costume. See Baldassari 4, fig. 243.

489. Z. III, 359, "based on a photograph."

490. This card bears the stamp of G. Lekegian, an Armenian photographer active in Egypt between 1860 and 1890, fig. 207. See Khemir.

491. A version in red chalk kept by Picasso is now in the Musée Picasso in Paris (MP 74, not in Z.). Another version, in oil, is now in the Museum of Modern Art, New York (Z. IV, 322). It is the right side of this last version of work in progress which is visible in a Fontainebleau photograph, fig. 201.

492. Especially *Standing Nude* (1921, Z. IV, 327), *Woman in Red Skirt* (1921, Z. IV, 305), and *Bust of a Woman* (1921, Z. IV, 328).

493. Catalan postcards purchased in Céret can be related to drawings such as Z. III, 294. One of them, fig. 210, displays many similarities with several of the figures and the background of *Women at the Spring*, fig. 212.

494. Daix 5, p. 875.

495. MP 1990-6.

496. A bust, *Communicant with Missal* (1919, Succ. 12212) and a head study, *Head of a Communicant* (1919, Succ. 12223).

497. 1895–1896, Z. XXI, 49. The model was Picasso's sister, Lola.

498. Z. III, 286.

499. A similar monochrome approach can be noted in portraits from 1920 such as *Olga Reading* (MP 1990-7), and *Olga in a Fur Collar* (MP 1990-9).

500. Notably *The Soler Family* (1903), fig. 29, *The Artist and His Model* (1914), fig. 151, and *Olga in an Armchair* (1918), fig. 190.

501. *The Communicants*, 1919, Succ. 12216.

502. Seckel 2, pp. 24–25.

503. Z. III, 438 / MP 62.

504. The formal relationship between the two subjects rests on the realistic features shared by both scenes: males in black suits, the alms-purse carried by both females.

505. The name "Manet" is handwritten, like a signature, in the upper right corner of the canvas. Susan Grace Galassi has, moreover, linked this painting to Manet's 1877 *Nana*. She sees the strict frontality as a theatrical effect stemming from Picasso's work for the stage. This frontality is an equally direct evocation of studio photographs.

506. The photo is stamped "Lotus."

507. Photo taken in the J. Yrondy studio in Paris.

508. It is also worth stressing the relationship between *The Lovers*, fig. 219 and several other works from that period which also reflect the conventions of studio photography and portraits of couples, notably a drawing, *Couple on a Balcony* (11 April, 1920), a study of *Spectators in a Box* (Z. IV, 247 / MP 1822) used for the set of *Cuadro Flamenco*, and three variations on Renoir's *Les Fiancés*, titled *Sisley and His Wife* (1919, Z. III, 428 / MP 868; Z. III, 429; Z. III, 430).

509. First published and discussed in Baldassari 1, pp. 82–87. A second negative has recently been found showing only the drawing on the wall, without Picasso's shadow.

510. A dark profile can thus been seen on the right of *The Studio* (1928–1929, MP 111; see Baldassari 1, fig. 61), while *Figure and Profile* (1928, Z. VII, 129 / MP 103; see Baldassari 1, fig. 60) shows the same form in white, on the opposite side of the painting. This "negative" version of the motif can also be seen in *Harlequin* (1927, Z. VII, 80) and *Head of a Woman* (1928, Z. VII, 125). Another painting, *Head* (1928, Z. VII, 126), combines a white profile of Picasso with a face reduced to linear abstraction. More complex variations appear in *Two Women Before a Window* (1927–1929, Z. VII, 76), where a doubled profile is set against the window panes, and in *Composition* (1927, Z. VII, 78), where a black profile confronts a white one.

511. 1929, Z. VII, 248 (*Head and Shoulders of a Woman*).

512. Penrose 2, p. 244.

513. Paris, 1931, Z. VII, 346 / MP 135.

514. Breton 1, p. 16.

515. Spies 2, no. 82, p. 376, dates this piece to 1931, whereas Kahnweiler 3 assigns it the date of 1928 and the title of *Plant, Feather Duster, and Rope* (no. 19). According to this latter hypothesis, it would predate Georges Bataille's text, "Soleil pourri" (published in a special issue of *Document*, no. 2, 1930, devoted to Picasso), which, as Yve-Alain Bois has pointed out, refers to "a fantastic, impossible version of roots teeming below the surface of the ground, disgusting and naked as vermin." See Bois and Krauss, p. 75.

516. Rubin 3, vol. 1, p. 316.

517. See Guillaume, Bouret, Paudrat. The portfolio merits comparison with a set of twenty photographs by Charles Sheeler, published in 1918 by Marius de Zayas, *Exhibition of African Negro Sculpture*, Modern Gallery, New York, 1918. See Lee Webb, pp. 55–62. Picasso's archives contain seventeen work prints most of which bear the stamp "Collection et Procédé Paul Guillaume." Two of them correspond to photos published in *Sculptures nègres* in a slightly cropped format: M'galli Fertility Fetish (pl. IV) and *Ritual Head from the Congo* (pl. XII).

518. This is the opinion of Jean-Michel Huguenin, a Paris-based expert.

519. I would like to thank Madame Gilberte Brassaï for permission to examine Brassaï's sheets of annotated work prints.

520. See above, p. 106. As demonstrated by a series of photographs taken by Jacqueline Picasso at the villa known as La Californie (see Baldassari 4, pp. 264–265, figs. 268–270), this same pedestal table would be used by Picasso thirty years later as a plinth for his paper models and metal cutouts.

521. For a historical analysis of this project from the initial commission in 1921 to the 1959 inauguration of the bust of Dora Maar, see Read, pp. 147–288.

522. Apollinaire 3, p. 68.

523. 1 September, 1929, MP 118. See also *Playing with a Ball on the Beach* (15 August, 1928, Z. VII, 224), a drawing of a *Bather with a Ball* (18 September, 1939, MP 1032), and the oil painting *Large Bather* (1932, Z. VIII, 147).

524. The petrification of the body into a minimally anthropomorphic statue also evokes the "sand reliefs" executed at Juan-les-Pins in 1930, especially *Standing Bather* (Spies 118 / MP 124).

525. Ovid, p. 1. Picasso illustrated a version of the *Metamorphoses* in 1931.

526. Notably the drawings titled *An Anatomy: Three Women* (MP 1091 to 1098), figs. 228–229.

527. The back of the photograph, fig. 227, bears the date 1920 and a handwritten text which restoration of the object should render legible.

528. See above, p. 26.

529. Malraux, pp. 17–19.

530. Picasso made this comment after a visit to Matisse, as quoted by Françoise Gilot. See Gilot and Lake, p. 266.

531. Ovid, p. 13. This passage describes the regeneration of humankind following the Flood.

532. Cox and Povey, p. 62 observe that, thus depicted, the horse is "neither white nor black, but made, like the moon, of both." They also point out that the Greeks symbolized the bright side of the moon by a white horse and the dark side by a black horse.

533. India ink, on the inside covers and pages of a Maison du Trousseau catalogue (Boisgeloup), 29 October, 1930, MP 1038 to 1043.

534. The same association can be seen operating in a 1927 canvas which combines the white shape of a hand with the monogram M.T., *Composition with White Hand*, oil and charcoal on canvas.

535. Baer, vol. 2, p. 474.

536. *ibid.*, no. 572b.

537. *ibid.*, pp. 474–479.

538. Brassaï 1, p. 37. When in 1967 Brassaï published the remarkable clichés-verre that he himself had executed in 1935, he remembered to cite Picasso as inspiration for his own project (see Brassaï 2).

539. The torn newspaper is dated August 15, 1933. The political and military background to this article is worth recalling: in 1933, the "pacification" of Morocco had been going on for over seven years, following an uprising by Abdelkrim that was checked thanks only to the deployment of French and Spanish troops led by Marshal Pétain.

540. Picasso preserved the folded article along with the drawing (executed on the first page of a sketchbook). The drawing is thus literally presented as an enlarged version of the original subject.

541. 1934, Baer, vol. 2, no. 443.

542. See above n. 202; see also below and p. 228. The artistic use of celluloid, a material employed as photographic support as early as the 1880s, had illustrious forebears, notably Edgar Degas, who used it for some of his monotypes (see Adhémar and Cachin, no. 30). Picasso bought several of Degas's monotypes, including *In the Omnibus*, a "Parisian snapshot" of 1878. The profile of a veiled woman may have inspired the 1937 "rayograph" titled *Woman in a Mantilla* (see below, p. 205) and fig. 237.

543. Breton 2, p. 51.

544. Manuscript dated 7 January, 1940. See Picasso 4, p. 213.

545. In addition to the work of 1937, I am thinking especially of the experimental prints made

with cutout masks in 1913 (see above, p. 116 and figs. 135, 136) and of the photographic cutouts done in collaboration with André Villers after the war (see below, pp. 223–227, figs. 252-255).

546. Text written in French on 7 November, 1935. See Picasso 4, p. 38. The various engravings on photographic substrates could also be understood as an intaglio use of the thickness of the photographic medium.

547. In 1937, Picasso asked Lee Miller for a print of a photo showing the shadow of a woman wearing a Rolleiflex, because he liked the idea of her being "pregnant with a camera" (Penrose, pp. 78). It might also be stressed that Freud (pp. 456–460), in his attempt to describe the configuration of the unconscious, employed this same metaphor of inner camera, an apparatus capturing images and mnemonic traces of optical input.

548. Man Ray 1, p. 165.

549. The published engraving was part of a series, *Nude in the Studio*, fig. 235, comprising three states and nine versions, eight of which are held by the Musée Picasso. See Baer, vol. 3, pp. 103–105. The version reproduced in *Cahiers d'Art* is number 614.

550. *Cahiers d'Art*, 7–10, 1935, published in 1936. The photograph was taken by Bernès and Marouteau.

551. *Ibid.*, p. 48.

552. Baer, vol. 3, p. 105. The copper-plate engraving *The Artist Drawing from a Model*, c. 1639, is also known as *Artist and Model in the Studio*. Its very incompleteness has been analyzed as a "glorification of drawing" by Bussierre, p. 123. On the Picasso-Rembrandt relationship, see Cohen.

553. Baer, vol. 3, p. 105. See also Prechtl. In one of the articles in that catalogue, Kahnweiler mentions that he occasionally sent Picasso postcards of works by Cranach during his various travels.

554. At the same time, another half-tone plate of the 1934 canvas *Woman Leaning on Her Elbow* was being worked with scraper and graver. See Baldassari 2, figs. 40, 41. The various states of the photographic-and-engraved image play on the same positive/negative inversions seen in *Nude in the Studio*. Picasso subsequently executed several works on half-tone plates, notably his 1943 illustrations for a text by Georges Hugnet, *La Chèvre-Feuille* (Baer, vol. 3, nos. 683–688.

555. Baer, vol. 3, pp. 103–105.

556. State II.B.

557. State II.B.a.

558. State II.B.b.

559. See Bussierre, p. 271, who refers to a Rembrandt etching titled *Doctor Faustus*, 1652.

560. Purchased by the Musée Picasso in 1989, this print was published for the first in 1995. See Baldassari 2, p. 52, fig. 42.

561. Dubbed "rayographs," the first photograms by May Ray were exhibited in a 1922 show called *Les Champs délicieux*, accompanied by the publication of a text titled *La Photographie à l'envers*. See Tzara. It was Dora Maar who employed the term rayograph—or rayogram—to describe Picasso's 1937 experiment.

562. Neusüss, p. 92, calls them "cliché-verre-photograms."

563. Dora Maar, letter of 15 February, 1989, to Pierre Georgel, director of the Musée Picasso.

564. See Cuvelier. The composition was usually executed in one of two ways. The first consisted of "covering a glass plate with an absolutely opaque layer that is then scratched with a needle, thereby baring the glass," while the other entailed "simply painting with oil color on bare glass" (Hédiard, pp. 408–426). Because it afforded great freedom of execution, the process was used in the nineteenth century by Jean-Baptiste Corot (see especially Larin and Mason) and subsequently by Barbizon School artists. The modernists of the 1920s and 1930s then rediscovered the technique. Man Ray also used it for a 1917 self-portrait titled *Egg-Beater* or *Le cliché-verre*. Max Ernst, meanwhile, illustrated a 1931 René Crevel text, *Mr. Knife, Miss Fork*, nineteen drawings employing thin smears on translucent paper which were subsequently reproduced photographically via contact prints. On the history of the process, see Glassman and Symmes, and Paviot.

565. Reproduced in Baldassari 2, p. 52, fig. 42, under the title *Profile of a Woman*.

566. *Woman in Lace* and *Woman with a Chignon*, see Baldassari 2, figs. 44 and 45; *Portrait of Dora Maar* displays two intensities of black, the darkest where the paint was probably scraped away completely, the softer black of the face apparently being obtained by partially diluting the coating. The irregular granularity of the ground is probably due to the fuzziness that resulted when the glass plate was flipped over.

567. Man Ray did two portraits of Dora Maar in 1936, including a solarized one (Martin, p. 159) that strongly interested Picasso (Man Ray 2, pp. 179, 181). "Solarization" leads to a partial reversal of values in a photographic print, notably in dark shadows near strong outlines. As noted by a critic (C.S. in Baqué, pp. 128–129) of solarized photos exhibited by Maurice Tabard in 1936, this coexistence of positive and negative modalities reintroduces *lines* into a representational medium theoretically based exclusively on the spatial play of values.

568. As noted above, the title of Man Ray's 1922 exhibition of rayographs was *Les Champs délicieux*.

569. A magnificent photographic portrait executed by Dora Maar in 1931–1935 combines frontal and profile views in a way that strikingly prefigures Picasso's new style. See Combalia, fig. 63.

570. Picasso and Brassaï met in 1932. On their collaboration, see Brassaï 1 and Bernadac 2.

571. 1937, Z. IX, 65.

572. For a detailed analysis of the evolution of the composition and motifs, see Arnheim, pp. 286–290.

573. The photos were published in a special "Guernica" issue of *Cahiers d'Art*, nos. 1–3, 1937, pp. 146–154.

574. In 1949, Alain Resnais's film *Guernica* included some of these press photos in a montage primarily featuring the 1937 painting along with other works by Picasso from various periods. See Bernadac and Breteau-Skira, pp. 19–27.

575. Picasso's first sketches were begun the day after a story appeared in the 30 April edition of *Ce Soir*, a daily founded by Louis Aragon. Ferrier 2, pp. 47–49, analyzes the painting as a visual echo of all the various elements on the front page: not only two photos of the city in flames and a shot of a victim with a face wound, but also a picture of a violent car crash and a reproduction of Jean Fouquet's *Madonna and Child*. Ferrier, pp. 49–50, also compares several of the painting's motifs with images from the May 1 edition of *Paris-Soir*. In addition to the bombing, the pages reported that "bird-man" Clem Sohn had fallen to his death. The prostrate body on the left of the painting, incorporated right from the earliest sketches, could also be compared to a photograph published in *L'Humanité* on April 28, showing "several

woman—mothers, probably— slain during a bombardment."

576. The source for the "sun-eye" suggested by Ferrier 1, pp. 46–47, is a juxtaposition of images of Guernica in ruins with a shot of street lighting at night in Paris, published in the 1 May, 1937 edition of *Paris-Soir*, fig. 240.

577. The spotlight is visible on the photographs of states I and II.

578. Henry Moore, p. 202, described the canvas at an early stage of execution as "a cartoon just laid in black and gray," adding that Picasso "could have colored it as he colored the sketches."

579. See Larrea, pp. 200–201, and Bergamin, pp. 201–202.

580. Ferrier 2, p. 72.

581. See Leiris, p. 128.

582. This anxiety is also reflected in a photograph found in Picasso's archives showing a heap of stones, with the artist's comment on the back: "My studio in Royan." It was taken after the city was bombed. See Baldassari 1, fig. 64.

583. Royan, 11 August, 1940, Z. XI, 81 and Z. XI, 82.

584. The work had traditionally been dated to the Germans' entry into Paris in June 1940; in 1995, a newspaper search in fact identified the source photo as dating from 8 June, 1941. See Baldassari 2, p. 98.

585. The Paris edition of *Paris-Soir*, which had become "a major illustrated daily" under Jean Prouvost and Pierre Lazareff, was placed under the control of the Occupation authorities right from June 1940. See Cotta, Lazareff, Quéval.

586. Brassaï 1, p. 61.

587. See especially the oils on newspaper *Head of a Woman* (Paris, November 1941, MP 1990–72), *Head of a Woman* (Paris, 1941), and *Study of Feet* (Paris, 1943).

588. *Head*, India ink on newspaper (Paris, 1943).

589. Steinberg 1, 224.

590. *Ibid.*, 226

591. 1945, Z. XIV, 76.

592. Rubin 1, p. 166.

593. None of the pictures from this series, moreover, was found in Picasso's estate–unlike those taken by Dora Maar, figs. 241, 242, 243.

594. Rubin 1, p. 169. In contrast, Greenberg, p. 346, sees this modification as giving the painting "more ease of space [and] more air" than *Guernica*.

595. Peter D. Whitney, "Picasso Is Safe," *San Francisco Chronicle*, 3 September, 1944, quoted in Barr 1, p. 223.

596. See especially Rubin 1, p. 166.

597. Coke, figs. 258–260, pp. 109–111.

598. Although Picasso's archives contain many illustrated periodicals from that period, neither the photograph cited by Coke nor those by Lee Miller have been found.

599. Penrose 2, p. 318, dates it, probably by mistake, to summer 1945. On the other hand, Picasso told Pierre Daix during their first meeting that the painting had been begun before concentration camp pictures were published (Daix 5, p. 184). The comment probably refers to the massive wave of publications that occurred in mid-April, both in France and abroad.

600. Reference cited in Léal 4, note 22. The photograph shows the Maidanek camp. For a chronology of articles published in the French press, see Delporte.

601. This photograph, visually similar to the shots of charnel houses taken in the camps, was presented as "a picture found on a German soldier" showing "the horribly mutilated corpses of Soviet victims, heaped in a pile" (fig. 244). As early as 7 December, *L'Humanité*, the daily paper of the Communist Party of France (CPF), published an article on the freeing of the French camp at Struthof, illustrated by a photo of two shirtless survivors. Picasso joined the CPF in October 1944.

602. Note that the geometry of the crates visible in the 13 December photo is identical to the verticals and diagonals depicting the right corner of the table. Dora Maar claimed that one of the visual sources for the painting was a Spanish film showing the massacre of a family in its kitchen. See Rubin 2, p. 380.

603. See notably *Pitcher, Candlestick, and Enamel Pan* (Z. XIV, 71, donated to the Musée National d'Art Moderne in 1947), *Skull, Leeks, and Jug* (Z. XIV, 97), and *Skull, Sea Urchin, and Lamp on a Table* (Z. XIV, 290).

604. Mili, p. 13. On Mili's photographic oeuvre, see Sartre 2.

605. Mili, p. 13.

606. The experiments conducted with Mili also hark back to Man Ray's 1937 *Space Writings*, in which he inscribed multiple traces of a luminous object onto glass.

607. "Statement by Gjon Mili Accompanying His Photographs of Picasso," 1950, Archives, The Museum of Modern Art, New York, 500124-8a. the statement was prepared in conjuction with

the exhibition *Photographs of Picasso by Gjon Mili and by Robert Capa*.

608. Press release and introductory wall text for the exhibition cited in note 607, Archives, The Museum of Modern Art, New York, 50019-8.

609. Mili, p. 16.

610. This aspect notably distinguishes the work from the *Space Writings* that Man Ray condensed onto the surface of a pane of glass.

611. Mili, p. 15.

612. Saint Lucy of Bologna is traditionally depicted bearing a dish with her two eyes, which had been torn out of their sockets.

613. "When the bull with his horn—opens the door of the horse's belly—and places his muzzle on board—listening to the deepest of all in the deep of the hold —with the eyes of Saint Lucy . . .— and sees . . . and sets the photographer's eye—above the banqueting table— and pulls the thread out little by little—and makes a ball—that portraits his fine figure— on a plate of silver—which drips—clearly—pummeled—with sun." Text written in French, dated 15 November, 1935, Picasso 4, pp. 43–44.

614. *Ibid.*

615. Brassaï 1, p. 268.

616. Notably the series *Harlequin with a Bat*, 1918, pencil or India ink on paper, MP 810-830.

617. A series of drawings in ink or pencil, 1919, MP 1621-1625.

618. *Mercure* was a ballet choreographed by Léonid Massine to a score by Erik Satie. It premiered on June 18, 1924.

619. Unpublished drawings done in pencil on blue paper (27 cm x 18 cm), in preparation for the etchings that illustrated Aristophanes' *Lysistrata*, preserved in Picasso's estate. See Aristophanes.

620. André Breton held hypnagogic images—glimpsed in that nether state between sleep and wakefulness— to be one of the ways to discover psychic automatism.

621. This comment, quoted in Mili, p. 13, was originally addressed to Picasso's nephew, Javier Vilato.

622. *Visite à Picasso*, described in Bernadac and Breteau-Skira, pp. 40–45.

623. In a remarkable coincidence, a film by Hans Namuth, shot in the fall of that same year of 1950, shows Jackson Pollock also working on a pane of glass. See Namuth. Haesaerts's film was screened

at the Venice Festival in September 1950, where it won the International Documentary Prize; Namuth shot his film in September–October. The show of Mili's photographs was held at The Museum of Modern Art in the spring of 1950.

624. Bernadac and Breteau-Skira, pp. 60–71.

625. Bazin 3, p. 128.

626. *Ibid.*, p. 129.

627. *Ibid.*, p. 136.

628. *Ibid.*, p. 138.

629. Villers, unpaginated.

630. André Villers, letter to the present author, May 1995.

631. Villers, unpaginated.

632. *Ibid.*

633. As examples of photograms printed by contact from this negative silhouette, see Baldassari 2, figs. 182, 183.

634. W. H. Fox Talbot, who invented the first negative, or calotype, used this method to make "photogenic drawings" that reproduced the shapes and transparency of plants and objects by direct contact. See Talbot. Hippolyte Bayard, a French precursor of paper photography, also made similar images through contact exposure. See Gautrand and Frizot.

635. Villers, unpaginated.

636. André Villers, letter to the present author, May 1995.

637. Villers, unpaginated.

638. See Villers and Prévert.

639. *Ibid.*

640. *Ibid.*

641. Villers, unpaginated.

642. See above, p. 198.

643. Villers, unpaginated.

644. On another plate, *Corrida*, dated 3 October, 1957, black-on-black lines could be due to marks made with a felt pen.

645. Mili, p. 45.

646. *Ibid.*

647. Prints pierced or engraved on the emulsion of a blackened photograph also seem to be works in themselves rather than negatives. Mili published two of them exactly as they were produced—white figure on black ground—namely *Rider and Dancer* and *Circus Rider.* Two other slides of the same type are known at present, *Rider* and *Chase.*

648. On this specific aspect of slides, see Vanlier, pp. 60–61.

649. Brassaï 1, p. 37, similarly states that Picasso forbade him to make a positive print from the plate engraved in 1932, and that the artist never saw it reproduced.

650. Pierre-André Benoit, letter to Picasso dated 22 May, 1956 (Picasso Archives).

651. See Coron.

652. See Pindar.

653. Each of three fragments taken from the plate *Warrior with Spear and Shield* (Baer, vol. 5, no. 1078) thus yielded, respectively, *Sleeping Woman in a Landscape* (*ibid.*, no. 1081), *Nude* (*ibid.*, no. 1082), and *Triangular Face* (*ibid.*, no. 1083).

654. André Villers, letter to the present author, May 1995.

655. Zervos 2, p. 40

656. *Vogue*, French edition, May 1951, figs, 261–263. This issue notably reported the simultaneous release of two recent films by Henri Haesaerts, *Visite à Picasso* and *De Renoir à Picasso*.

657. The following year, during a photo session at the villa known as *La Galloise*, photographer Robert Doisneau showed Picasso holding one of the *Vogue* photos he had decorated, fig. 262. For the Paris version of the *Picasso and Portraiture* exhibition, all the photos retouched by Picasso were republished in facsimile form. See Baldassari 5.

658. Published in the form of vignettes in *Subirana*, nos. 12 to 22, these works are reproduced in color in Baldassari 2, pp. 128 and 134–141, figs. 104 and 106–113.

659. Bazin 2, p. 159.

660. Two other graffiti works are related to this series: a 1962 *Madonna and Child* in which the bambino is given a cap and Sabartés's glasses, and a photographic montage combining images of writer Paul Claudel and a classic ballerina in a tutu, fig. 264.

661. Baer vol. 5. nos. 1331–1333 and 1337, and lithographs Z. XXIII, 2–5, and Bloch nos. 1029, 1030, 1032.

662. The source behind this series of engravings is an Ingres drawing, *The Gatteaux Family*, which was exhibited at the Paul Rosenberg Gallery in New York in 1961. Picasso was perhaps ironically comparing, by drawing rapid additions, the photograph of his own family group with the peaceful bourgeois gathering pictured by Ingres. See Baldassari 2, pp. 163–171, figs. 134–137.

663. Issue dated 16 November, 1959. These colorful graffiti might have been inspired by a game between Picasso and his children, Paloma and Claude.

664. See above, p. 248, 249.

665. *Self-Portrait*, 30 June, 1972, Z. XXXIII, 435, and *Self-Portrait*, Z. XXXIII, 436–437

666. According to Sabartés 2, pp. 10–11, "If he hates the brilliant sheen of smooth surfaces, that's because of the way they stare at you as steadily as he usually does when something grabs his attention."

667. Brassaï 1, p. 147.

668. *Ibid.*

669. Béalu, p. 183.

670. Barr 2, p. 7.

671. Villers, unpaginated.

672. On Picasso's relationship with photographers, see Bernadac 3. See also Karmel 1 for an interesting critique of the *Looking for Picasso* exhibition at the International Center of Photography, New York, 1980.

673. The Picasso Archives also contain a Spanish banknote bearing a portrait that has been endowed with a Charlie Chaplin mustache and bowler. See Baldassari 2, fig. 126.

674. Clergue, p. 170.

675. Sartre 1, p. 106.

676. Morin, pp. 41–42.

677. Letter of 9 May, 1918.

678. Stein 2, p. 53.

679. *Ibid.*, p. 60

680. 1936, Z. VIII, 289.

681. Concerning the role of vision in Picasso's cubism, Stein 1, p. 19, wrote, "The things that Picasso could see were the things which had their own reality, reality not of things seen but of things that exist."

Bibliography

Ades
Ades, Dawn, *Photomontage*, New York, Pantheon Books, 1976.

Adhémar and Cachin
Adhémar, Jean, and Françoise Cachin, *Edgar Degas, gravures et monotypes*, Paris, Arts et Métiers Graphiques, 1973.

Alberti
Alberti, Leon Battista, *On Painting*, trans. Cecil Grayson, London, Phaidon, 1972.

Apollinaire 1
Apollinaire, Guillaume, "À propos de l'art des noirs," *Sculptures nègres*, Paris, Paul Guillaume, 1917.

Apollinaire 2
Apollinaire, Guillaume, *The Poet Assassinated*, trans. Ron Padgett, San Francisco, North Point Press, 1984.

Apollinaire 3
Apollinaire, Guillaume, "Présentation du Ballet *Parade*," (May 1917), in *Œuvres complètes en prose*, Paris, La Pléiade, vol. 2, 1991.

Aristophanes
Aristophanes, *Lysistrata*, etchings by Pablo Picasso, trans. Gilbert Seldes, New York, The Limited Edition Club, 1934.

Arnheim
Arnheim, Rudolf, "Guernica: The Genesis of a Painting" (1962), reprinted in *Picasso's Guernica*, ed. Ellen C. Oppler, New York and London, W. W. Norton & Company, 1987.

Auer
Auer, Michel, and Michèle Auer, *Encyclopédie internationale des photographies de 1839 à nos jours*, 2 vols., Hermance, Camera Obscura, 1985.

Baer
Baer, Brigitte and Bernhard Geiser, *Picasso, peintre-graveur*, Bern, Kornfeld, 7 vols., 1986-1996.

Baldassari 1
Baldassari, Anne, *Picasso photographe 1901-1916*, exh. cat., Musée Picasso, Paris, Réunion des Musées Nationaux, 1994.

Baldassari 2
Baldassari, Anne, *Picasso et la photographie: "À plus grande vitesse que les images,"* exh. cat., Musée Picasso, Paris, Réunion des Musées Nationaux, 1995.

Baldassari 3
Baldassari, Anne, "'Heads Faces and Bodies': Picasso's Uses of Portrait Photographs," *Picasso and Portraiture: Representation and Transformation*, exh. cat., ed. William Rubin, The Museum of Modern Art, New York, 1996.

Baldassari 4
Baldassari, Anne, *Le Miroir noir: Picasso, sources photographiques 1900-1928*, exh. cat., Musée Picasso, Paris, Réunion des Musées Nationaux, 1997.

Baldassari 5
Baldassari, Anne, "Vogue 1951, Photo-graffiti de Picasso," *Vogue revu par Picasso*, facsimile of the May 1951 issue with alterations by Picasso, Paris, Condé Nast, 1996.

Baldassari 6
Baldassari, Anne, "Caméra et 'planche à tracer': Outils visuels du cubisme", *Picasso, dessins et papiers collés, Céret 1911-1913*, exh. cat., Musée d'art moderne, Céret, 1997.

Baqué
Baqué, Dominique, *Les Documents de la modernité: Anthologie des textes sur la photographie de 1919 à 1939*, Nîmes, Jacqueline Chambon, "Rayon photo" collection, 1993.

Barr 1
Barr, Alfred H., Jr, *Picasso: Fifty Years of His Art*, New York, The Museum of Modern Art, 1946.

Barr 2
Barr, Alfred H., Jr, "Preface," in Roland Penrose, *Portrait of Picasso*, London, Thames & Hudson, 1981.

Barthes 1
Barthes, Roland, *Wilhelm von Gloeden*, Naples, Amelio Editore, 1979.

Barthes 2
Barthes, Roland, *La Chambre claire: Note sur la photographie*, Paris, Les Cahiers du Cinéma, Gallimard, Seuil, 1980.

Baudelaire
Baudelaire, Charles, "Salon de 1859: Lettre à M. le directeur de la Revue Française," reprinted in *Baudelaire: Critique d'art*, Paris, Gallimard, 1992.

Bazin 1
Bazin, André, "The Ontology of the Photographic Image," (1945) reprinted in *What Is Cinéma?*, vol. 1, trans. Hugh Gray, Berkeley, University of California Press, 1967.

Bazin 2
Bazin, André, "The Entomology of the Pin-Up Girl," (1946) reprinted in *What Is Cinéma?*, vol. 2, trans. Hugh Gray, Berkeley, University of California Press, 1967.

Bazin 3
Bazin, André, "Un film bergsonien: 'Le Mystère Picasso,'" (1956), reprinted in *Qu'est-ce que le cinéma*, Paris, Cerf, 1994.

Béalu
Béalu, Marcel, "Dernier souvenir de Max Jacob," *Confluence*, April 1945.

Benjamin
Benjamin, Walter, "Petite histoire de la photographie" (1931), reprinted in *Essais I, 1922-1934*, Paris, Denoël-Gonthier, 1983.

Bergamin
Bergamin, José, "Naked Poetic Truth" (1971), reprinted in *Picasso's Guernica*, ed. Ellen C. Oppler, New York and London, W. W Norton & Company, 1987.

Bernadac 1
Bernadac, Marie-Laure, "De Manet à Picasso: L'éternel retour," in *Bonjour, Monsieur Manet*, exh. cat., Centre Georges Pompidou, Paris, 1983.

Bernadac 2
Bernadac, Marie-Laure, *Picasso vu par Brassaï*, exh. cat., Musée Picasso, Paris, Réunion des Musées Nationaux, 1987.

Bernadac 3
Bernadac, Marie-Laure, *Picasso/Visages*, exh. cat., Musée Picasso, Paris, Réunion des Musées Nationaux, 1991.

Bernadac and Breteau-Skira
Bernadac, Marie-Laure and Gisèle Breteau-Skira, *Picasso à l'écran*, Centre Georges Pompidou, Paris, 1995.

Billeter
Billeter, Erika, *Malerei und Photographie im Dialog, von 1840 bis heute*, exh. cat., Kunsthaus, Zürich, 1977.

Blunt
Blunt, Anthony, "Picasso's Classical Period (1917-25)," *Burlington Magazine*, vol. 110, no. 781, April 1968.

Boehm
Boehm, Gottfried, "Pablo Picasso: Les tableaux italiens," in *Canto d'Amore: Modernité et classicisme dans la musique et les beaux-arts entre 1914 et 1935*, exh. cat., ed. Gottfried Boehm, Ulrich Mosch and Katharina Schmidt, Kunstmuseum, Basel, 1996.

Bois
Bois, Yve-Alain, "The Semiology of Cubism," in *Picasso and Braque: A Symposium*, organized by William Rubin, The Museum of Modern Art, New York, 1992.

Bois and Krauss
Bois, Yve-Alain and Rosalind Krauss, *L'Informe, mode d'emploi*, exh. cat., Centre Georges Pompidou, Paris, 1996.

Bouret
Bouret, J., "Une amitié esthétique au début du siècle: Apollinaire et Paul Guillaume (1911-1918) d'après une correspondance inédite," *Gazette des Beaux-Arts*, December 1970.

Bozo
Bozo, Dominique, ed., *Musée Picasso: Catalogue des collections, I: Peintures, papiers collés, tableaux-reliefs, sculptures, céramiques*, Paris, Réunion des Musées Nationaux, 1985 (English edition, *Catalogue of the Collection, 1: Paintings, papiers collés, picture reliefs, sculptures, ceramics*, trans. Alexander Lieven, London, Thames & Hudson, 1986).

Brassaï 1
Brassaï, *Conversations avec Picasso* (1964), Paris, Gallimard, 1986.

Brassaï 2
Brassaï, *Transmutations*, Lacoste, Galerie Les Contards, 1967.

Breton 1
Breton, André, "Picasso dans son élément," *Le Minotaure*, no. 1, 1933.

Breton 2
Breton, André, "Picasso poète," *Cahiers d'Art*, nos. 7-10, 1935, off-print published in 1936.

Brodersen,
Brodersen, Waltraud, "Medienreflexion als Methode künstlerischer Arbeit: Pablo Picasso, von der Blauen Periode bis Guernica," in *Absolut Modern Sein: Culture Technique in Frankreich 1889-1937*, exh. cat., Staatliche Kunsthalle, Berlin, 1986.

Burgess
Burgess, Gellet, "The Wild Men of Paris," *Architectural Record*, vol. 27, May 1910.

Bussierre
Bussierre, Sophie de, *Rembrandt: Eaux-fortes, Collection Dutuit*, exh. cat., Musée du Petit Palais, Paris, 1986.

Cachin and Moffett
Cachin, Françoise, and Charles S. Moffett, eds., *Manet*, exh. cat., Galeries Nationales du Grand Palais, Paris, Réunion des Musées Nationaux, 1983.

Cachin and Rishel
Cachin, Françoise and Joseph J. Rishel, eds., *Cézanne*, exh. cat., Galeries Nationales du Grand Palais, Paris, Réunion des Musées Nationaux, 1995.

Caizergues and Seckel
Caizergues, Pierre and Hélène Seckel, *Picasso, Apollinaire, Correspondance*, Paris, Gallimard, Réunion des Musées Nationaux, 1992.

Carandente
Carandente, Giovanni, "Picassos 'Italienische Reise,'" in *Pablo Picasso: Eine Ausstellung zum hundertsten Geburtstag: Werke aus der Sammlung Marina Picasso*, ed. Werner Spies, exh. cat., Haus der Kunst, Munich, Josef-Haubrich-Kunsthalle, Cologne, Städtische Galerie im Städelschen Kunstinstitut, Frankfurt am Main, Kunsthaus, Zürich, 1981.

Cassou
Cassou, Jean, *Picasso*, Paris and London, Hyperion Press, 1940.

Cherchi Usai
Cherchi Usai, Paolo, "Le nitrate mécanique: L'imagination de la couleur comme science exacte (1830-1928)," in *La Couleur en cinéma*, ed. Jacques Aumont, Paris, Mazotta, Cinémathèque française, 1995.

Cirici Pellicer
Cirici Pellicer, Alexandre, *El Arte Modernista Catalan*, Barcelona, Ayma, 1951.

Clergue
Clergue, Lucien, *Picasso, mon ami*, Paris, Plume, 1993.

Cohen
Cohen, Janie, *Picasso Rembrandt Picasso*, exh. cat., Museum het Rembrandt Huis, Amsterdam, 1990.

Coke
Coke, Van Deren, *The Painter and the Photograph, from Delacroix to Warhol* (1972), Albuquerque, University of Mexico Press, 1986.

Collado
Collado, Gloria, ed., *J. Laurent: Un photographe français dans l'Espagne du XIXᵉ siècle*, exh. cat., Paris, Institut Cervantes, 1996.

Combalia
Combalia, Victoria, ed., *Dora Maar, Fotógrafa*, exh. cat., Centre Cultural Bancaixa, Valencia, 1995.

Coquiot
Coquiot, Gustave, *Cézanne*, Paris, Librairie Ollendorff, 1913.

Coron
Coron, Antoine, *PICasso. & PABenoît, 1956-1967: Livres en jeu*, exh. cat., Musée-bibliothèque Pierre-André Benoît, Alès, 1991.

Cotta
Cotta, Michèle, *La Collaboration 1940-1944*, Paris, Armand Colin, Collection "Kiosque," 1964.

Cousins
Cousins, Judith, with the collaboration of Pierre Daix, "Documentary Chronology," in *Picasso and Braque: Pioneering Cubism*, exh. cat., ed. William Rubin, The Museum of Modern Art, New York, 1989.

Cox and Povey
Cox, Neil and Deborah Povey, *A Picasso Bestiary*, London, Academy Editions, 1995.

Crevel
Crevel, René, *Mr. Knife, Miss Fork*, trans. Kay Boyle, Paris, Black Sun Press, 1931.

C.S.
C.S., "Exposition Tabard," *Photo-Illustrations*, no. 18, February 1936.

Cuvelier
Cuvelier, [Adalbert] "Sur plusieurs méthodes de dessin héliographiques," *Bulletin de la Société Française de Photographie*, Paris, 1856.

Dagen
Dagen, Philippe, "'L'exemple égyptien': Matisse, Derain et Picasso entre fauvisme et cubisme (1905-1908)," *Bulletin de la Société des Historiens d'Art Français*, 1984.

Daix 1
Daix, Pierre, "La période bleue de Picasso et le suicide de Carlos Casagemas," *Gazette des Beaux-Arts*, April 1967.

Daix 2
Daix, Pierre, "Il n'y a pas d''art nègre' dans *Les Demoiselles d'Avignon*," *Gazette des Beaux-Arts*, October 1970.

Daix 3
Daix, Pierre, *La Vie de peintre de Pablo Picasso*, Paris, Seuil, 1977.

Daix 4
Daix, Pierre, "L'historique des *Demoiselles d'Avignon* révisé à l'aide des carnets de Picasso," in *Les Demoiselles d'Avignon*, exh. cat., vol. 2., ed. Hélène Seckel, Musée Picasso, Paris, Réunion des Musées Nationaux, 1988.

Daix 5
Daix, Pierre, *Dictionnaire Picasso*, Paris, Robert Laffont, 1996.

Daix 6
Daix, Pierre, "Portraiture in Picasso's Primitivism and Cubism," in *Picasso and Portraiture: Representation and Transformation*, exh. cat., ed. William Rubin, The Museum of Modern Art, New York, 1996.

Daix and Boudaille
Daix, Pierre and Georges Boudaille, *Picasso, 1900-1906: Catalogue raisonné de l'œuvre peint*, Neuchâtel, Ides et Calendes, 1966 (original English edition, *Picasso. The Blue and Rose Periods: A Catalogue Raisonné of the Paintings, 1900-1906*, Greenwich, Conn., New York Graphic Society, 1966).

Daix and Rosselet
Daix, Pierre and Joan Rosselet, *Le Cubisme de Picasso: Catalogue raisonné de l'œuvre peint, 1907-1916*, Neuchâtel, Ides et Calendes, 1979 (original English edition, *Picasso. The Cubist Years, 1907-1916: A Catalogue Raisonné of the Paintings and Related Works*, Boston, New York Graphic Society, 1979).

David 1
David, Philippe, "Voyage Fortier au Soudan ex-français (Mali) en 1906," *Catalogue Neudin de la carte postale*, Paris, 1986.

David 2
David, Philippe, *Inventaire général des cartes postales Fortier*, Paris, published by the author, Roneo-duplicated, 3 vols., 1986-1988.

Delporte
Delporte, Christian, "Les médias et la découverte des camps de concentration (presse, radio, actualités filmées)," in *La déportation, le système concentrationnaire nazi*, exh. cat., ed. François Bédarida and Laurent Gervereau, Bibliothèque de Documentation Internationale Contemporaine, Nanterre, 1995.

Doñate
Doñate, Mercè,
"Las actividades artísticas
de Els Quatre Gats,"
Picasso y Els Quatre Gats,
ed. María Teresa Ocaña,
exh. cat., Museu Picasso,
Barcelona, 1995.

Dujardin-Beaumetz
Dujardin-Beaumetz,
Entretiens avec Rodin
(1913), Paris, Musée Rodin,
1992.

**Eppendorfer
and Poschmann**
Eppendorfer, Hans and
Lothar Poschmann, *Wilhelm
von Gloeden, Wilhelm von
Plüschow, Vincenzo Galdi:
Italienische Jünglings-
Photographien um 1900*,
exh. cat., Galerie Janssen,
Berlin, 1991.

Fagus
Fagus, Félicien, "L'invasion
espagnole: Picasso,"
La Revue blanche, vol. 27,
no. 195, July 15, 1901.

Fels
Fels, Florent, "Propos
d'artistes: Picasso,"
Les Nouvelles Littéraires,
no. 42, August 4, 1923.

Fermigier
Fermigier, André, *Picasso*,
Paris, Le Livre de Poche,
1969.

Ferrier 1
Ferrier, Jean-Louis, *Picasso,
Guernica: Anatomie
d'un chef-d'œuvre*, Paris,
Bibliothèque Médiations,
Denoël Gonthier, 1977.

Ferrier 2
Ferrier, Jean-Louis,
*De Picasso à Guernica:
Généalogie d'un tableau*,
Paris, L'Infini, Denoël, 1985.

Fitzgerald
Fitzgerald, Michael C.,
"The Modernists' Dilemma:
Neoclassicism and
the Portrayal of Olga
Khokhlova," in *Picasso
and Portraiture:
Representation and
Transformation*, exh. cat.,
ed. William Rubin,
The Museum of Modern Art,
New York, 1996.

Fratelli Alinari
*Fratelli Alinari, 150 Years
of Photographies*, C.D.
portfolio, Florence, Alinari,
1995.

Freud
Freud, Sigmund,
L'interprétation des rêves,
1900, Paris, Presses
Universitaires de France,
new edition 1976.

Freund
Freund, Gisèle,
Photographie et société,
Paris, Seuil, 1974.

Fry 1
Fry, Edward F., "Picasso,
Photography and Cubism,"
Art Bulletin, vol. 65,
March 1983.

Fry 2
Fry, Edward, "Picasso
Cubism and Reflexivity,"
Art Journal, vol. 47, 1988.

Gala
Gala, Isabelle, *Des sauvages
au jardin (les exhibitions
ethnographiques au Jardin
zoologique d'acclimatation
de 1877 à 1912)*, Paris,
Roneo-duplicated document.

Galassi
Galassi, Susan Grace,
"Picasso's *The Lovers*
of 1919," *Arts Magazine*,
vol. 56, no. 6, February
1982.

Galton
Galton, Francis, *Inquiries
into Human Faculty and Its
Development*, London, 1883.

Garnier
Garnier, François, ed.,
Max Jacob: Correspondance,
Paris, Éditions de Paris,
vol. 1 (1876-1921), 1953,
vol. 2 (1921-1924), 1955.

Gasquet
Gasquet, Joachim, *Cézanne*,
Paris, Berheim-Jeune, 1926.

Gautrand and Frizot
Gautrand, Jean-Claude
and Michel Frizot,
*Hippolythe Bayard:
Naissance de l'image
photographique*,
Amiens, Éditions des Trois
Cailloux, 1986.

Gilot and Lake
Gilot, Françoise
and Carlton Lake,
Life with Picasso, New York,
McGraw-Hill, 1964.

Gimpel
Gimpel, Léon,
"La Sculpture photographique,"
L'Illustration, November 12,
1910.

Glassman and Symmes
Glassman, Elisabeth
and Marilyn F. Symmes,
*Cliché-verre: Hand-Drawn,
Light-Printed, A Survey
of the Medium, from 1839
to the present*, exh. cat.,
The Detroit Institute of Arts,
1980.

Goethe
Goethe, J. W., *Traité des
couleurs* (1810), Paris,
Triades, 1980.

Golding
Golding, John, *Le Cubisme*,
Paris, Julliard, 1962
(original English edition,
*Cubism: A History and an
Analysis, 1907-1914*, rev.
American ed., Boston,
Boston Book and Art Shop,
1968)

Gopnik and Varnedoe
Gopnik, Adam and Kirk
Varnedoe, High & Low:
Modern Art and Popular
Culture, exh. cat.,
The Museum of Modern
Art, New York, 1990.

Gravillon
Gravillon, M. H.,
"Le Chronopose
et l'autophotographe,"
*Bulletin de la Société
Française de Photographie*,
no. 16, 1906.

Greenberg
Greenberg, Clement,
"The Charnel House—
Picasso's Last Masterpiece?,"
(1966), reprinted in
Picasso's Guernica,
ed. Ellen C. Oppler, New York
and London, W. W Norton
& Company, 1987.

Grundberg
Grundberg, Andy,
"When Picasso Used Film
for a Palette," *The New York
Times*, August 1, 1986.

Guillaume
Guillaume, Paul,
Sculptures nègres, portfolio
of 24 photographs, Paris,
Paul Guillaume, April 25, 1917.

Hédiard
Hédiard, Germain,
"Les Procédés sur verre,"
Gazette des Beaux-Arts,
Paris, November 1903.

Henning
Henning, Edward B.,
"Picasso: Harlequin
With Violin (Si Tu Veux),"
*The Bulletin of
The Cleveland Museum
of Art*, January 1976.

Hugnet
Hugnet, Georges,
La Chèvre-Feuille, Paris,
Robert J. Godet, 1943.

Hugo
Hugo, Victor, "Souvenir
des vieilles guerres,"
*Les Chansons des rues
et des bois* (1865), Paris,
Poésie/Gallimard, 1982.

Huysmans
Huysmans, Joris-Karl,
"L'Exposition des
Indépendants en 1880,"
L'Art moderne, Paris,
Charpentier, 1883, reprinted
in *Les Écrivains devant
l'impressionnisme*,
ed. Denys Riout, Paris,
Macula, 1989.

Jacob
Jacob, Max, *Saint Matorel*,
Paris, D. H. Kahnweiler,
1911.

**Judson Clark
and Burleigh-Motley**
Judson Clark, Robert, and
Marian Burleigh-Motley,
"New Sources for Picasso's
'Pipes of Pan,'"
Arts Magazine, vol. 55,
October 1980.

Kahnweiler 1
Kahnweiler, Daniel-Henry,
"Negro Art and Cubism,"
Horizon, vol. 18, no. 108,
1948.

Kahnweiler 2
Kahnweiler, Daniel-Henry,
Les Sculptures de Picasso,
Paris, Editions du Chêne,
1948.

Kahnweiler 3
Kahnweiler, Daniel-Henry,
"Huit entretiens
avec Picasso," *Le Point*,
Mulhouse, October 1952.

Kahnweiler 4
Kahnweiler, Daniel-Henry,
"Picasso et le cubisme,"
in *Picasso*, exh. cat., ed.
Madeleine Rocher-Jauneau,
Musée de Lyon, 1953.

Kahnweiler 5
Kahnweiler, Daniel-Henry,
*Mes galeries et mes
peintres: Entretiens
avec Francis Crémieux*,
Paris, Gallimard, 1961.

Kahnweiler 6
Kahnweiler, Daniel-Henry,
*Juan Gris, sa vie, son œuvre,
ses écrits*, Paris, Gallimard,
1990.

Karmel 1
Karmel, Pepe, "Photography
Portraits of the Artist
as Picasso," *Art in America*,
Special Issue no. 10,
December 1980.

Karmel 2
Karmel, Pepe, "Picasso's
Laboratory: The Role
of His Drawings
in the Development
of Cubism, 1910-1914,"
Ph.D. dissertation,
New York University, 1993.

Khemir
Khemir, Mounira,
*L'Orientalisme, l'Orient des
photographes au XIXᵉ siècle*,
Centre national
de la photographie,
Institut du monde arabe,
Photo Poche, Paris, 1994.

Klary
Klary, C.,
La Photographie de nu,
Paris, 1902.

Krauss 1
Krauss, Rosalind,
"The Cubist Epoch,"
Artforum, 9 February
1971.

Krauss 2
Krauss, Rosalind,
"Re-presenting Picasso,"
Art in America, special
issue no. 10, December
1980.

Krauss 3
Krauss, Rosalind,
"Photographie et surréalisme"
(1981), *Le Photographique:
Pour une théorie des écarts*,
Paris, Macula, 1990.

Krauss 4
Krauss, Rosalind,
"Notes sur l'index" (1977),
in *L'Originalité de l'avant-
garde et autres mythes
modernistes*, Paris,
Macula, 1993
(original English edition,
"Notes on the Index",
in *The Originality
of the Avant-Garde
and Other Modernist Myths*,
Cambridge, Mass.,
MIT Press, 1985).

Krauss 5
Krauss, Rosalind,
"The Motivation of the Sign,"
in *Picasso and Braque:
A Symposium*, organized
by William Rubin,
The Museum of Modern Art,
New York, 1992.

Larin
Larin, Jean, *Estampes
et dessins de Corot*, exh.
cat., Bibliothèque nationale,
Paris, 1931.

Larrea
Larrea, Juan, "The Unveiling"
(1970), reprinted in *Picasso's
Guernica*, ed. Ellen C. Oppler,
New York and London,
W. W. Norton & Company,
1987.

Lautréamont
Count of Lautréamont
(pseudonym for Isidore
Ducasse), *Les Chants
de Maldoror*, trans. Alexis
Lykiard, Cambridge, Mass.,
Exact Change, 1994.

Lazareff
Lazareff, Pierre,
Dernière édition, New York,
Brentano's, 1942.

Léal 1
Léal, Brigitte, *L'Enfance
d'un chef, Picasso, jeunesse
et genèse*, exh. cat., Musée
Picasso, Paris, Réunion
des Musées Nationaux, 1991.

Léal 2
Léal, Brigitte, "La nature
morte entre cubisme

et classicisme: Essai sur
le 'donjuanisme' de Picasso,"
in *Picasso & les choses:
Les Natures mortes*, exh. cat.,
ed. Jean Sutherland Boggs
and Marie-Laure Bernadac,
Galeries Nationales du Grand
Palais, Paris, Réunion
des Musées Nationaux, 1992.

Léal 3
Léal, Brigitte, *Musée Picasso,
Carnets, Catalogue
des dessins*, 2 vols.,
Paris, Réunion des Musées
Nationaux, 1996.

Léal 4
Léal, Brigitte, "'Le taureau
est un taureau, le cheval
est un cheval': Picasso,
peintre d'histoire de *Guernica*
au *Charnier*," in *Face
à l'Histoire*, exh. cat.,
Centre Georges Pompidou,
Paris, 1996.

Lebensztejn
Lebensztejn, Jean-Claude,
*L'Art de la tache:
Introduction à la* Nouvelle
Méthode *d'Alexander
Cozens*, Paris, Limon, 1990.

Lee Webb
Lee Webb, Virginia, "Art
as Information: The African
Portfolios of Charles Sheeler
and Walker Evans,"
African Arts, January 1991.

Leiris
Leiris, Michel, "Faire-part,"
Cahiers d'Art, special issue
on *Guernica*, nos. 5-6, 1937.

Leja
Leja, Michael,
"'Le vieux marcheur' and
'Les deux risques': Picasso,
Prostitution, Veneral
Disease, and Maternity,
1899-1907," *Art History*,
vol. 8, March 1985.

Lemagny
Lemagny, Jean-Claude,
Taormina, début de siècle,
photographs of the Baron
of Gloeden, Paris, Chêne,
1975.

Leonardo da Vinci
Leonardo da Vinci,
*The Literary Works
of Leonardo da Vinci*,
ed. Jean Paul Richter, 2 vols.,
London, Phaidon, 1969.

Mahaut
Mahaut, Henri, *Picasso*,
Paris, C. Grès, 1930.

Malraux
Malraux, André,
La Tête d'obsidienne,
Paris, Gallimard,
1974.

Man Ray 1
Man Ray, "Picasso
photographe," *Cahiers
d'Art*, nos. 6-7, 1937.

Man Ray 2
Man Ray, *Self-Portait*
(1963), Boston, Little,
Brown and Company,
1988.

Mare
Mare, A.-F., *Crimes et mort
des Trabucayres ou
les Bandits espagnols
en Roussillon (1840-1846)*,
Paris, Les Éditions
du Cadran, 1968.

Martin
Martin, Jean-Hubert ed.,
Man Ray Photographe,
exh. cat., Centre Georges
Pompidou, Philippe Sers,
Paris, 1985.

Mason
Mason, Rainer Michael,
*Le cliché-verre: Corot et la
gravure diaphane*, exh. cat.,
Musée d'Art et d'Histoire,
Cabinet des Estampes,
Geneva, 1982.

McCully
McCully Marilyn,
"To Fall 'Like a fly into
the trap of Picasso's stare':
Portraiture in the Early
Work," in *Picasso and
Portraiture: Representation
and Transformation*,
exh. cat., ed. William Rubin,
The Museum of Modern Art,
New York, 1996.

Metken
Metken, Günter,
"Pablo Picasso: L'Italienne,"
*Canto d'Amore: Modernité
et classicisme dans
la musique et les beaux-arts
entre 1914 et 1935*,
exh. cat., ed. Gottfried
Boehm, Ulrich Mosch
and Katharina Schmidt,
Kunstmuseum, Basel,
1996.

Mili
Mili, Gjon, *Picasso
et la troisième dimension*,
Triton, 1970.

Moffit
Moffit, John F., *Art Forgery:
The Case of the Lady
of Elche*, Gainesville,
University Press of Florida,
1994.

Moholy-Nagy
Moholy-Nagy, László,
"La photographie, ce qu'elle
était, ce qu'elle devra être,"
Cahiers d'Art, no.1, 1929.

Monod-Fontaine
Monod-Fontaine, Isabelle,
ed., *Daniel-Henry
Kahnweiler: Marchand,
éditeur, écrivain*, exh. cat.,
Centre Georges Pompidou,
Paris, 1984.

Moore
Moore, Henry, "With
Picasso" (1961), reprinted
in *Picasso's Guernica*,
ed. Ellen C. Oppler,
New York and London,
W. W. Norton & Company,
1987.

Morin
Morin, Edgar, *Le cinéma
ou l'homme imaginaire:
Essai d'anthropologie*
(1956), Paris, Arguments,
Les Éditions de Minuit, 1985.

Morning
Morning, Alice (pseudonym
for Beatrice Hasting),
"Impressions of Paris,"
The New Age, vol. 16,
January 28, 1915.

Namuth
Namuth, Hans,
"Photographier Pollock",
in *L'Atelier de Jackson
Pollock*, Hans Namuth,
Paris, Macula, 1978

Naumann
Naumann, Francis M.,
*Marius de Zayas:
How, When, and Why Modern
Art Came to New York*,
Cambridge, Mass. and
London, MIT Press, 1994.

Neil
Neil, Edward, *Niccolo
Paganini*, Paris, Fayard,
1991.

Neusüss
Neusüss, Floris M.,
*Das Fotogramm
in der Kunst des 20.
Jahrhunderts*, Cologne,
DuMont, 1990.

Novotny
Novotny, Fritz, *Cézanne*,
Vienna, Phaidon Press,
New York, Oxford
University Press, 1937.

Oberthür
Oberthür, Marie, *Le Chat Noir*,
exh. cat., Musée d'Orsay,
Paris, Réunion des Musées
Nationaux, 1992.

Olivier 1
Olivier, Fernande, *Picasso
et ses amis*, Paris, Stock,
1933.

Olivier 2
Olivier, Fernande,
Souvenirs intimes, Paris,
Calmann-Lévy, 1988.

Oppler
Oppler, Ellen C., ed.,
Picasso's Guernica,
New York and London,
W. W. Norton & Company,
1987.

Ovid
Ovid, *Les Métamorphoses*,
original etchings by Picasso,
Lausanne, Albert Skira, 1931
and
Ovid, *Metamorphoses*,
trans. A. D. Melville,
New York, Oxford
University Press, 1986.

Pächt
Pächt, Otto, "Alois Riegl:
Optique et haptique,"
*Questions de méthode
en histoire de l'art*, Paris,
Macula, 1994.

Palau i Fabre 1
Palau i Fabre, Josep,
Picasso vivant, 1881-1907,
Paris, Albin Michel,
1990.

Palau i Fabre 2
Palau i Fabre, Josep,
Picasso cubisme, 1907-1917,
Paris, Albin Michel, 1990
(English edition, *Picasso
Cubism (1907-1917)*,
New York, Rizzoli
International Publications,
1990).

Parigoris
Parigoris, Alexandra, "Picasso und die Antike," in *Picassos Klassizismus*, exh. cat., ed. Ulrich Weisner, Kunsthalle, Bielefeld, 1988.

Parmelin
Parmelin, Hélène, *Picasso dit*, Paris, Gonthier, 1966.

Passuth
Passuth, Kristina, *Moholy-Nagy*, Paris, Flammarion, 1984.

Paudrat
Paudrat, Jean-Louis, "From Africa," in *Primitivism in 20th Century Art: Affinity of the Tribal and the Modern*, exh. cat., ed. William Rubin, The Museum of Modern Art, New York, 1984.

Paviot
Paviot, Alain, *Corot, Delacroix, Millet, Daubigny: Le cliché-verre*, exh. cat., Musée de la vie romantique, Paris, 1994.

Peirce
Peirce, Charles S., *Écrits sur le signe*, ed. Gérard Deledalle, Paris, Seuil, 1978.

Penrose
Penrose, Antony, *The Lives of Lee Miller*, London, Thames & Hudson, 1988.

Penrose 1
Penrose, Roland, *Portrait of Picasso*, London, Lund Humphries, 1956.

Penrose 2
Penrose, Roland, *Picasso, His Life and Work*, New York, Harper, 1959 and London, Victor Gollancz, 1958.

Peyrefitte
Peyrefitte, Roger, *Les Amours singulières*, Paris, Jean Vigneau, 1947.

Phéline
Phéline, Christian, *L'image accusatrice*, Paris, Cahiers de la Photographie, no. 17, 1985.

Picabia
Picabia, Francis (as Pharamousse), "Odeurs de partout," *391*, no. 1, January 1917.

Picasso 1
Picasso, Pablo, "Opinions sur l'art nègre," *Action*, April 1920.

Picasso 2
Picasso, Pablo, "Picasso Speaks: A Statement by the Artist," remarks collected by Marius de Zayas, *The Arts*, no. 5, May 1923.

Picasso 3
Picasso, Pablo, "Lettre sur l'art," excerpts published in *Formes*, no. 2, February 1930.

Picasso 4
Picasso, Pablo, *Picasso écrits*, preface by Michel Leiris, ed. Marie-Laure Bernadac and Christine Piot, trans. of Spanish texts by Albert Bensoussan, Paris, Réunion des Musées Nationaux, Gallimard, 1989.

Pickvance
Pickvance, Ronald, *Edouard Manet*, exh. cat., Fondation Pierre Gianadda, Martigny, 1996.

Pindar
Pindar, *VIIIᵉ Pythique*, trans. Jean Beaufret, Alès, Pierre-André Benoit Éditeur, 1960.

Pliny the Elder
Pliny the Elder, *Histoire Naturelle*, Paris, Les Belles Lettres, Book XXXV, 1985 (English edition, *Natural History*, trans. H. Rackham, Cambridge, Mass., Harvard University Press, 1968).

Podoksik
Podoksik, Anatoli, *Picasso, la quête perpétuelle: Œuvres de l'artiste dans les musées soviétiques*, Leningrad, Aurora, Paris, Cercle d'art, 1989.

Pohlmann
Pohlmann, Ulrich, *Guglielmo Plüschow (1892-1930): Ein Photograph aus Mecklenburg in Italien*, exh. cat., Schloss Plüschow, Mecklenburgisches Künstlerhaus, Munich, 1995.

Pool
Pool, Phoebe, "Picasso's Neo-Classicism: First Period, 1905-1906," *Apollo*, vol. 81, February 1965.

Prechtl
Prechtl, Michael Mathias, *Cranach & Picasso*, exh. cat., Kunsthalle, Nuremberg, 1968.

Prochaska
Prochaska, David, "French Postcards Views of Colonial Senegal," *African Arts*, no. 4, October 1991.

Proust
Proust, Antonin, *Édouard Manet: Souvenirs*, Paris, Librairie Renouard, H. Laurens, 1913.

Quéval
Quéval, Jean, Première Page, cinquième colonne, Paris, Arthème Fayard, 1945.

Raquez
Raquez, A., *Pages laotiennes: Notes de voyage*, Hanoi, Schneider, 1902.

Raynal
Raynal, Maurice, *Picasso*, Paris, C. Grès, 1922.

Read
Read, Peter, *Picasso et Apollinaire: Les métamorphoses de la mémoire 1905-1973*, Paris, Jean-Michel Place, 1995.

Reff 1
Reff, Theodore, "Picasso and the Circus," in *Essays in Archaeology and the Humanities*, Mainz, Verlag Philipp von Zabern, 1976.

Reff 2
Reff, Theodore, "Picasso's Three Musicians: Maskers, Artists and Friends," *Art in America*, October 1980.

Reff 3
Reff, Theodore, "Themes of Love and Death in Picasso's Early Work" (1973), reprinted in *Picasso in Retrospect*, New York, Harper & Row, 1980.

Richardson 1
Richardson, John. *A Life of Picasso, 1881-1906*, New York, Random House, 1991.

Richardson 2
Richardson, John, *A Life of Picasso, 1907-1917: The Painter of Modern Life*, New York, Random House, 1996.

Richet
Richet, Michèle, *Musée Picasso, Paris, Catalogue des collections, II, Dessins, aquarelles, gouaches, pastels*, Paris, Réunion des Musées Nationaux, 1987.

Rivière
Rivière, Georges, *Renoir et ses amis*, Paris, Floury, 1921.

Rodin
Rodin, Auguste, *L'Art: Entretiens recueillis par Paul Gsell* (1911), Paris, Grasset, 1986.

Rosenblum
Rosenblum, Robert, "Picasso in Gosol: The Calm Before the Storm," in *Picasso: The Early Years, 1892–1906*, exh. cat., National Gallery of Art, Washington, 1997.

Rubin 1
Rubin, William, "The Charnel House," in *Picasso in the Collection of the Museum of Modern Art*, New York, The Museum of Modern Art, 1972.

Rubin 2
Rubin, William, ed., *Pablo Picasso: A Retrospective*, exh. cat., The Museum of Modern Art, New York, 1980.

Rubin 3
Rubin, William, ed., *Primitivism in 20th Century Art: Affinity of the Tribal and the Modern*, exh. cat., The Museum of Modern Art, New York, 1984.

Rubin 4
Rubin, William, "The Genesis of the *Demoiselles d'Avignon*," *Studies in Modern Art 3, Les Demoiselles d'Avignon*, The Museum of Modern Art, New York, 1994.

Rubin 5
Rubin, William, ed., *Picasso and Braque, Pioneering Cubism*, exh. cat., The Museum of Modern Art, New York, 1989.

Rubin 6
Rubin, William, "The Pipes of Pan: Picasso's Aborted Love Song to Sara Murphy," *Artnews*, vol. 93, no. 5, May 1994.

Rubin 7
Rubin, William, ed., *Picasso and Portraiture: Representation and Transformation*, exh. cat., The Museum of Modern Art, New York, 1996.

Sabartés 1
Sabartés, Jaime, *Picasso: Portraits et souvenirs*, Paris, Louis Carré et Maximilien Vox, 1946.

Sabartés 2
Sabartés, Jaime, *Picasso documents iconographiques*, Geneva, Pierre Cailler, 1954.

Salmon
Salmon, André, *Souvenirs sans fin*, Paris, Gallimard, 1955 (1903-1908), 1956 (1908-1920).

Sartre 1
Sartre, Jean-Paul, *L'Imaginaire: Psychologie phénoménologique de l'imagination* (1940), rev. ed. Arlette Elkaïm-Sartre, Paris, Folio Essais Collection, Gallimard, 1986.

Sartre 2
Sartre, Jean-Paul, untitled text published on the occasion of the Gjon Mili exhibition in 1946, reprinted in *Gjon Mili, photographies*, exh. cat., Musée des Arts Décoratifs, Paris, 1971.

Schapiro 1
Schapiro, Meyer, "Picasso's *Woman with a Fan*: On Transformation and Self-Transformation" (1976), reprinted in Schapiro, *Modern Art: 19th and 20th Centuries, Selected Papers*, New York, George Braziller, 1982.

Schapiro 2
Schapiro, Meyer, "Courbet and Popular Imagery: An Essay on Realism and Naïveté" (1941), reprinted in Schapiro, *Modern Art: 19th and 20th Centuries, Selected Papers*, New York, George Braziller, 1982.

Scharf
Scharf, Aaron, *Art and Photography* (1968), Harmondsworth, Penguin, 1974.

Schmidt
Schmidt, Katharina, "Le sentier vers les sources," *Canto d'Amore: Modernité et classicisme dans la musique et les beaux-arts entre 1914 et 1935*, exh. cat., ed. Gottfried Boehm, Ulrich Mosch and Katharina Schmidt, Kunstmuseum, Basel, 1996.

Schmoll
Schmoll gen. Eisenwerth, J. A., *Malerei nach Fotografie, V. der Camera obscura bis zur Pop Art: Eine Dokumentation*, exh. cat., Münchner Stadtmuseum, Munich, 1970.

Seckel 1
Seckel, Hélène, ed., *Les Demoiselles d'Avignon*, exh. cat., 2 vols., Musée Picasso, Paris, Réunion des Musées Nationaux, 1988.

Seckel 2
Seckel, Hélène, "Les Premiers communiants," *Picasso: Une nouvelle dation*, Paris, Réunion des Musées Nationaux, 1990.

Seckel 3
Seckel, Hélène, *Max Jacob et Picasso*, exh. cat., Musée Picasso, Paris, Musée des Beaux Arts, Quimper, Réunion des Musées Nationaux, 1994.

Seckel 4
Seckel, Hélène, "Three Portraits-Manifestos of Poets: André Salmon, Guillaume Apollinaire, and Max Jacob," in *Picasso and Portraiture: Representation and Transformation*, exh. cat., ed. William Rubin, The Museum of Modern Art, New York, 1996.

Sheeler
Sheeler, Charles, *Exhibition of African Negro Sculpture*, New York, Modern Gallery, Marius de Zayas, 1918.

Silver
Silver, Kenneth E. *Esprit de Corps: The Art of the Parisian Avant-Garde and the First World War, 1914–1925*, London, Thames & Hudson, 1989.

Spies 1
Spies, Werner, *Pablo Picasso: Eine Ausstellung zum hundertsten Geburtstag: Werke aus der Sammlung Marina Picasso*, exh. cat., Haus der Kunst, Munich, Josef-Haubrich-Kunsthalle, Cologne, Städtische Galerie im Städelschen Kunstinstitut, Frankfurt am Main, Kunsthaus, Zürich, 1981.

Spies 2
Spies, Werner, *Picasso: Das Plastische Werk*, Stuttgart, Verlag Gerd Hatje, 1983.

Spies 3
Spies, Werner, "Vendre des tableaux, donner à lire," in *Daniel-Henry Kahnweiler: Marchand, éditeur, écrivain*, exh. cat., ed. Isabelle Monod-Fontaine, Centre Georges Pompidou, Paris, 1984.

Spies 4
Spies, Werner, "*Parade*: La démonstration antinomique. Picasso aux prises avec *le scene popolari di Napoli* d'Achille Vianelli," in "*Il se rendit en Italie*": *Etudes offertes à André Chastel*, Paris, Flammarion, 1987.

Stein 1
Stein, Gertrude, *Picasso* (1938), Boston, Beacon Press, 1959.

Stein 2
Stein, Gertrude. *The Autobiography of Alice B. Toklas* (1933), Harmondsworth, Penguin, 1966.

Steinberg 1
Steinberg, Leo, "The Algerian Women and Picasso at Large," in *Other Criteria: Confrontations with 20th-Century Art*, New York, Oxford University Press, 1972; excerpted as "Who Knows the Meaning of Ugliness?" in Gert Schiff, ed., *Picasso in Perspective*, Englewood Cliffs, Prentice-Hall, 1976.

Steinberg 2
Steinberg, Leo, "The Philosophical Brothel," *Art News*, vol. 71, September and October 1972, revised ed., *October*, no. 44, Spring 1988.

Stravinsky
Stravinsky, Igor, *Stravinsky: An Autobiography*, New York, Simon & Schuster, 1936.

Subirana
Subirana, Rosa M., ed., *Picasso Erotico*, exh. cat., Museu Picasso, Barcelona, 1979.

Sutherland Boggs and Bernadac
Sutherland Boggs, Jean and Marie-Laure Bernadac, eds., *Picasso & les choses, Les Natures mortes*, exh. cat., Galeries Nationales du Grand Palais, Paris, Réunion des Musées Nationaux, 1992 (original English edition, Sutherland Boggs, Jean, *Picasso and Things*, with essays by Marie-Laure Bernadac and Brigitte Léal, exh. cat., The Cleveland Museum of Art, 1992

Talbot
Talbot, William Henry Fox, *The Pencil of Nature* (1844), New York, H.P. Krauss, Jr. 1989.

Tériade
Tériade, Elfstratios, "En causant avec Picasso," *L'Intransigeant*, June 15, 1932, reprinted in *Verve*, nos. 19-20, 1948.

Tinterow
Tinterow, Gary, *Master Drawings by Picasso*, exh. cat., Fogg Art Museum, Cambridge, Mass., 1981.

Tucker
Tucker, Paul Hayes, "Picasso, Photography, and the Development of Cubism," *Art Bulletin*, vol. 64, June 1982, no. 2.

Tzara
Tzara, Tristan, "La photographie à l'envers," *Les Feuilles libres*, no. 30, December 1922-January 1923.

Uhde
Uhde, Wilhelm, *Picasso et la tradition française*, Paris, Les Quatre Chemins, 1928.

Vanlier
Vanlier, Henri, *Philosophie de la photographie*, Paris, Les Cahiers de la Photographie, special edition, 1983.

Varnedoe
Varnedoe, Kirk, "Picasso's Self-Portraits," in *Picasso and Portraiture: Representation and Transformation*, exh. cat., ed. William Rubin, The Museum of Modern Art, New York, 1996.

Villers
Villers, André, *Photobiographie*, exh. cat., Éditions des Villes de Belfort et de Dôle, 1986, unpaginated.

Villers and Prévert
Villers, André and Pierre Prévert, *Diurnes: Photographs of André Villers and of Pablo Picasso*, Galerie Berggruen, Paris, 1962.

Volta
Volta, Ornella, ed., *Erik Satie: del Chat noir a Dadá*, exh. cat., IVAM Centre Julio González, Valencia, 1996.

Wallis
Wallis, Anne Armstrong, "A Pictorial Principle of Mannerism," *Art Bulletin*, vol. 21, 1939.

Warncke
Warncke, Carsten-Peter, *Pablo Picasso 1881-1973*, 2 vols., Cologne, Benedikt Taschen, 1995.

Zayas
Zayas, Marius de, *How, When and Why Modern Art Came to New York*, ed. Francis M. Naumann, Cambridge, Mass., MIT Press, 1996.

Zervos 1
Zervos, Christian, "Picasso étudié par le Dr Jung," *Cahiers d'Art*, nos. 8-10, 1932.

Zervos 2
Zervos, Christian, "Conversation avec Picasso," *Cahiers d'Art*, nos. 7-10, 1935.

Zervos 3
Zervos, Christian, "Introduction aux dessins de Picasso," *Cahiers d'Art*, no.1, 1948.

Zervos 4
Zervos, Christian, "Œuvres et images inédites de la jeunesse de Picasso," *Cahiers d'Art*, no. 2, 1950.

Photographic Credits

All photos © Réunion des Musées Nationaux
(photos M. Bellot, J. G. Berizzi, G. Blot, B. Hatala et al.)
except for the following (numbers refer to figure numbers):

© ADAGP: **161**
The Art Institute of Chicago: **107**
Bibliothèque Littéraire Jacques Doucet, Paris: **162**
Bibliothèque de Documentation Internationale Contemporaine,
Nanterre: **246**
Gilberte Brassaï: **222**, **223**
Richard Checani: **250**, **251**, **256**, **259**, **260**
Lucien Clergue: **271**, **272**
The Cleveland Museum of Art: **41**
Robert Doisneau (Agence Rapho, Paris): **262**
David Douglas Duncan: **267**, **269**, **270**
Foundation E. G. Bührle Collection, Zurich: **206**
Hamburger Kunsthalle (photo Elke Walford, Fotowerkstatt): **85**
Alex Hillman Family Foundation, New York: **37** (photo Sarah Wells), **40**
Hermann und Margrit Rupf-Stiftung, Kunstmuseum Bern
(photo Peter Lauri): **53**
L'Humanité: **240**, **244**
Life Magazine: **268**
Galerie Louise Leiris, Paris: **139**
Dora Maar: **241**, **242**, **243**
Médiathèque de Perpignan, **16**, **17**
The Menil Collection, Houston (photo Hickey-Robertson): **67**
Collection du Musée d'Art Moderne et d'Art Contemporain
de la Ville de Liège: **29**
Musée National d'Art Moderne, Paris (collections Mnam/Cci/Centre
Georges Pompidou; photothèque des collections du Mnam-Cci):
55 (photo Ch. Bahier, Ph. Migeat), **62** (photo Ph. Migeat)
Museu Picasso, Barcelona:, **18**, **23**, **264**, **265**
The Museum of Modern Art, New York: **46**, **59**, **92**, **157**, **245**
National Gallery of Art, Washington: **33**, **197** (photo Dean Beasom)
Marina Picasso Collection, courtesy Galerie Jan Krugier,
Ditesheim & Cie., Geneva: **122**, **141**, **270**
Pushkin State Museum of Fine Arts, Moscow: **203**
Queensland Art Gallery, Brisbane: **32**
Paul Sacher Foundation, Basel: **121**
Santa Barbara Museum of Art, California (photo Scott McClaine): **208**
Staatliche Museen zu Berlin; © Bildarchiv Preussischer
Kulturbesitz, Berlin: **104**
André Villers, **252**, **253**, **254**, **255**, **257**, **258**
Vogue, **261**, **263**
Jeanine Warnod Archives, Paris: **10**, **75**, **76**
Mrs John Hay Whitney Collection, New York (photo Jim Strong, Inc): **11**

Private collections: **2**, **45**, **269** (photos P. Baudoin); **20**; **26**, **50**
(Succession Picasso); **34**; **66**; **100**; **117**; **118**; **136**; **163**; **164**; **165**; **171**, **173**
(Photographie IMAGEART Antibes (France); **183**; **185**; **188**; **211**;
213 (C. J., Jakarta, Indonesia); **214**; **226**, **248**.

All works by Pablo Picasso © Succession Picasso 1997.

All rights reserved for photographs supplied by unnamed
private collectors.

All rights reserved for the unidentified rights holders
of certain documents published in this publication.

Copy-editing
Sheila Schwartz

Editorial coordination
Alexandra Keens

Design
Compagnie Bernard Baissait, Paris
Bernard Lagacé

Photoengraving and films
Welcrome, Paris

Printed on R-400 mat satin 150g/m2,
Cartiere Borgo, Italy
Printed and bound by G. Canale & C.,
S.p.A., Borgaro Torinese

Dépôt légal : September 1997
Printed in Italy